STUDio CARDS
Funny Greeting Cards and People Who Created Them

by Dean Norman

To Oscar and Glen,

Love from Nellie Caroll

Dean Norman

Beaver Creek Features & Trafford Publishing
Cleveland, OH Victoria, BC

Printed in Victoria, Canada

Other books by Dean Norman

Wally's Woods Vol. 1: The Mystery of the Beaver Creek Beast
On the Lewis and Clark Trail, Wally's Woods Vol. 2
COLLEGE CARTOONS 50th Anniversary Edition

Available from Trafford Publishing

National Library of Canada Cataloguing in Publication Data

A cataloguing record for this book that includes the U.S. Library of Congress Classification number, the Library of Congress Call number and the Dewey Decimal cataloguing code is available from the National Library of Canada. The complete cataloguing record can be obtained from the National Library's online database at: www.nlc-bnc.ca/amicus/index-e.html

ISBN 1-4120-1700-9

TRAFFORD

This book was published *on-demand* in cooperation with Trafford Publishing.
On-demand publishing is a unique process and service of making a book available for retail sale to the public taking advantage of on-demand manufacturing and Internet marketing. **On-demand publishing** includes promotions, retail sales, manufacturing, order fulfilment, accounting and collecting royalties on behalf of the author.

Suite 6E, 2333 Government St., Victoria, B.C. V8T 4P4, CANADA
Phone 250-383-6864 Toll-free 1-888-232-4444 (Canada & US)
Fax 250-383-6804 E-mail sales@trafford.com
Web site www.trafford.com TRAFFORD PUBLISHING IS A DIVISION OF TRAFFORD HOLDINGS LTD.
Trafford Catalogue #03-2077 www.trafford.com/robots/03-2077.html

10 9 8 7 6 5 4 3 2

THIS IS DEAN

THIS IS DEAN'S BOOK
DEAN IS A WRITER
AND
AN ARTIST

DEAN CAN WRITE
IN HIS BOOK
OR
DEAN CAN DRAW
FUNNY PICTURES
IN HIS BOOK

... BUT HE'LL PROBABLY
PRESS LEAVES IN IT !

Tom

Tom Wilson, Director of the Hi Brows department at American Greetings, wrote and drew this in a sketchbook he gave to me when I joined his staff in 1966. I did all the things he mentioned in the sketchbook, and now have put some of the caricatures of artists and writers I met in Hi Brows in this book. And I want to give thanks to many people who helped me.

Thanks to people who contributed writing and art and helped correct my memories: Fred Slavic, Rosalind Welcher, Barbara Dale, Bill Box, Nellie Caroll, Bill Brewer, Mort Walker, Paul & Rosemary Coker, John Annarino, Phil Hahn, Mary Edith Flynn, Carol Wimsatt Fuss, Jan Coffman North, Jim Krekovich, Thad Nugent, Pete Seymour, Jack Jonathan, Jeanne Van Meter, Larry Bowser, Jimmie Fitzgerald, Bruce Cochran, Jerry Roach, Bill Cunningham, Dodo Denney, Gordon Long, Lou Marak, John Stith, Carl Goeller, Kimball Williams, Virginia McCloskey, Dick Stensrude, Kathy Davis, Russell Myers, Tom Eaton, Jim Bray, Nancy Saulsbury, Tom Wilson, George Burditt, Ralph & Anni Shaffer, Pat Repp, Jack Hanrahan, Jim Elliott, Jane Farrell Berkeley, Maureen Farrell Norman, Kathryn Mahon, Gayle Steinberger Adams, Rayner Burrows, Bill Bridgeman, Myra Wiley Zirkle, Barbara Henrich, Oliver Christianson, Carol Gibbons, George Hart, Belinda Hart, Les Taylor, Robert Crumb, Dennis & Barbara Brown, Jack Clements, Jack Reilly, Jan Olin Berk, Kay Rudin, Maxine Masterfield, Mary Ellen Kotnick Kindt, Jack & Matt Schneider, Lily Fueger, Gloria Gedeon, John Kuchera, Dyan Noro Zourelias, David Helton, Brent Cottrell, Mike Ricigliano, John Dragan, Dave Schecter, Sue Dreher, Linell Nash Smith, Sharman Robertson, Stephen Scharf, Mary Frances Ink.

Thanks to people who contributed but I was unable to locate: Don Branham, Larry Raybourne, Pat White, Glen Imhoff, Alyce Weber.

Thanks to people who contributed much inspiration, but are no longer with us: Joyce C. Hall, Jacob Sapirstein, Irving Stone, Robert McCloskey, Alan Denney, Kent DeVore, Conrad Knickerbocker, Dick Bennett, Sam Van Meter, John Gibbons, Clark Wiley, Dan Henrich, Joan Kerber, Bob Harr, Kipp Schuessler, Harold Kemper, Maurice Nugent, Gordon MacKenzie, Teresa Satow, Greg Nelson, Ray Abrams, Walter Lee, Lyle Metzdorf, Bill Kennedy, Herb Gardner.

Cartoon art used with permission from: American Greetings, Hallmark Cards, Panda Prints, Box Cards, Nellie Card Co., Country Cousins, Dale Enterprises, Comicana Cards, Joy&Cheer, Ziggy & Friends, DuPont, MAD Magazine, and the Dwight D. Eisenhower Library.

CONTENTS

In the Beginning There Was Seriousness

There were few funny greeting cards before 1946. OK, if you were born after 1946, that is ancient history. But consider this--in the 1920s, 1930s, and 1940s there were lots of funny radio shows, funny movies, funny books, and funny cartoons in magazines and newspapers. So why was there little good cartooning in greeting cards?

I was a cartoonist for Hallmark Cards from 1956 to 1960, and for American Greetings from 1960 to 1990. This book is a collection of stories about writers and artists I met who created funny greeting cards. As you might suspect, some of them were sort of funny, too.

© Hallmark Cards, Inc.

Paul Coker, artist

1

Funny Postcards

Before there were greeting cards there were postcards, and some of them were funny. The founders of Hallmark and American Greetings may have sold the two postcards shown here. Joyce Hall and Jacob Sapirstein started their companies in the early 1900s by selling postcards to stationery stores.

The cartoon showing the old man putting out a gas light by pouring water on it was a good joke in the days when gas lights were replacing candles for indoor lighting. And coincidentally, when Joyce Hall was 70 years old he looked a lot like the cartoon character on the card. Jacob Sapirstein lived to be 104, and he also resembled the old guy pouring water on a gas light. Well, I guess any skinny old guy would look like that. I expect to soon.

And the rhyme below, a humorous excuse for not writing a letter, is a theme that is still used in funny greeting cards today. What goes around comes around...just in different shapes and flavors.

"SOME PUNKIN-HEADS WOULD BLOW IT OUT, BUT NOT YOUR UNCLE HIRAM!"

I could write about my friendship
By the ream, aye, by the yard;
You know I am a modest fellow,
So, I'll condense it on this card.

Chapter 1: Studio Cards

Pansies always stand for thoughts - -
At least that's what folks say,
So this just comes to show my thoughts
Are there with you today.

That verse is one of Hallmark
Cards' all-time best sellers. Always
illustrated by a pretty painting of
pansies in a little white wheelbarrow.
It is what Hallmark considers the ideal
card...one that can be sent for almost
any occasion. One day two very serious
men entered the Hallmark
headquarters, and asked to see the best
Hallmark card. They wanted to send it
to a friend in the state penitentiary who
was going to be executed. They bought
a pansy card for the occasion.

When I was hired at Hallmark in
1956, I was expected to learn how to
write sweet verses. After much
struggling, I finally came up with this:

Oh happy day when you were born
Long ago on a sunny morn
The world rejoiced, and the doctor said
"Whoops! I dropped it on its head"

Gotterdammerung it!

I forgot Your Birthday

© Panda Prints Rosalind Welcher, writer/artist

WHOOPS!
I DROPPED IT
ON ITS HEAD!

G!☆!*

Well, I actually wrote that for American Greetings in the
1970s when cartoon studio cards were popular. Hallmark
and American Greetings published their first really funny
greeting cards in 1956 and 1957. Writers at Hallmark told
me that studio cards appeared sometime after WWII when
commercial artists began designing and publishing their
own greeting cards. Hallmark writers began buying and
sending these cards in preference to the sweet humorous
verse they were required to write.

Fred & Rosalind

Fred Slavic and Rosalind Welcher were pioneers in
creating studio cards. Way back in the middle of the last
century, 1945, Fred was in the Merchant Marine when he
met Rosalind at a USO dance in New York City. After the
war they struggled with the problem that confronts young
married couples today...how to earn a living and have fun at
the same time? They began a greeting card company called
Panda Prints.

3

"Why a Panda?" I asked, thinking there must be some connection with the cute Asian forest animal that is so coveted by zoos.

"Because nobody else had a company using that name in the New York City phone book," Fred told me. "We co-founded Panda Prints in 1946. Rosalind did the designs, and I handled the manufacturing and business end. There were a few small companies doing what were called "studio" cards. They were mostly peasant, "arty" or decorative designs, intended for a different market than the commercial cards. I think we were the first to do humorous studio cards. We didn't have enough money to buy a printing press so we used the silk screen process to start. It took us a year to get production organized and find a good sales representative, but once they got into the stores they became an instant success. One of Rosalind's early cards showed a Shakespearian actor declaiming, "Alas and alack, turn the calendar back" and inside said, "Methinks I've forgotten when you were begotten". Another showed a goofy looking tiger lying under a tree saying: "Ah me, had I a poet's soul" and inside: "I would in verse this day extol - Happy Birthday". One of her Valentine cards is in the collection of the Museum of the City of New York, and others are or were in the Metropolitan Museum of Art. When I received a phone call from the Print Curator of the Metropolitan asking for samples of our cards, I thought it was a gag, and asked him to send a letter. Two days later we got the official letter, and during the late 1940s and early 1950s we sent our cards to the museum.

"We were followed by numerous imitators and so I suppose we could claim to have originated the modern studio genre. I remember Box Cards, Oz, Forer, Citation, Encore and many others whose names escape me at the moment. We were also credited with originating the tall cards, although these were actually started by some small company whose name I don't remember. Of course we always assumed that Hallmark was eyeing our cards and it is satisfying to hear you confirm it."

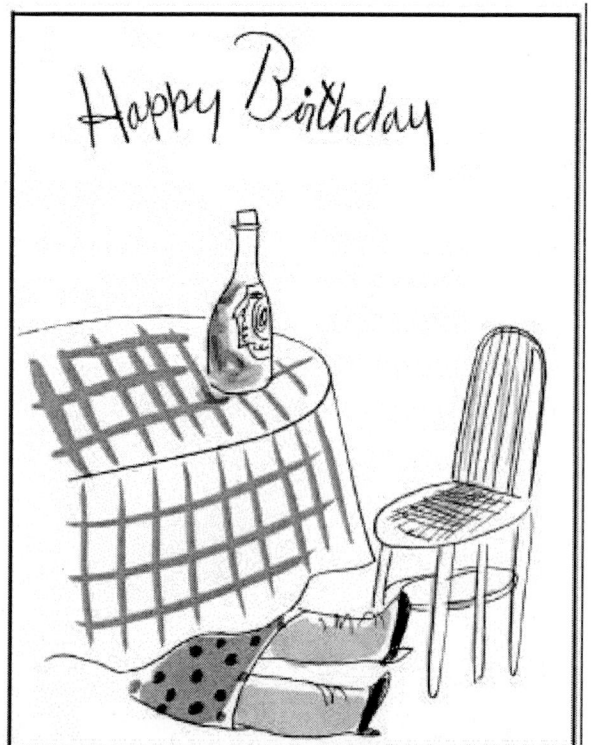

Stay as sweet as you are

Happy Birthday

© Panda Prints Rosalind Welcher, writer/artist

4

The card shown here was published by Panda Prints in 1948, and became their all time best seller. "Stay as sweet as you are!" was a line taken from a popular song. Rosalind originally drew it as a Mother's Day card, but decided it was too ornery to show a mother drinking herself under the table, so changed it to a general birthday card for a woman.

As Panda Prints grew they hired more employees, and in later years Fred and Rosalind were able to spend summers cruising the coasts of Europe and the Mediterranean in their 44 foot yawl after sailing it across the Atlantic. At the end of one summer they decided to dock the boat at Gibraltar, and got tangled up in a dispute between Britain and Spain over who owned Gibraltar. As Fred was on the phone at the airport in Spain trying to get their boat safely docked, Rosalind began writing and sketching ideas for the next season of greeting cards.

In 1966 Panda Prints created another first in humorous greeting cards...the 24 page greeting booklet. At first these were sold only as books, but when an envelope was included, the sales increased dramatically.

Fred Slavic and Rosalind Welcher, founders of Panda Prints and West Hill Press, at their home in New Hampshire in 2002.

Page from book "Somebody's Thinking of You" by Rosalind Welcher

American Greetings saw these booklets, and quickly followed with a line of Hi Brow Funny Books in 1967. Hallmark soon produced a similar line of books.

When Hallmark entered the studio card field in 1956, Fred and Rosalind didn't mind the competition, and actually welcomed it. "A lot of studio card companies had begun printing very insulting and ugly cards," Fred said. "Hallmark elevated the image of studio cards with a kinder and funnier type of humor. And they still didn't compete too directly with us, because we produced a more intellectual type of humor rather than gags for a mass market." However, after 31 years in business Panda Prints closed its doors in 1977.

"Hallmark bought up the franchises in shopping malls, and insisted that only Hallmark cards be sold in them. We lost a lot of accounts," Fred said.

"And after 31 years I found it difficult to think of new ways to say Happy Birthday," Rosalind added.

Rosalind is a native New Yorker, and Fred was an adoptive New Yorker. Besides sailing they liked to hike in the woods, and eventually bought 300 heavily wooded acres on the side of Little Monadnock Mountain in New Hampshire. They still live and work in the house that they built at the top of a rise, although they now winter in another house they built closer to the road. They have placed most of the property under protective easement so it will remain forever wild.

They now publish Rosalind's new books through their new company, West Hill Press. (You can find it on the Internet as *www.westhillpress.com*). They are thinking of publishing a collection of Rosalind's Panda Prints greeting cards. Rosalind's books are already collectibles sold in used book stores and on the Internet, and her greeting cards may become collectibles also.

Nellie and Bill

Nellie Caroll may have been the first person to write and draw a funny studio card. In 1935 when she was 12 years old, Nellie drew a funny greeting card and sent it to American Greetings. They returned the card and told Nellie she was ahead of her time.

Time caught up with Nellie's sense of humor in 1957 when she started the Nellie Card Company, and published a line of studio cards. "Deck them halls with matzoh balls!" was one of her popular Christmas cards. I remember seeing that card in a shop and thinking Hallmark would never dare to print a funny card that some people might think was in poor taste. In fact a store in Washington D.C. was closed by the police for selling that particular card which was deemed too offensive. When I told that to Nellie recently, she laughed and said, "That's why studio cards were popular... because the humor was in poor taste. Did you hear what Marilyn Monroe once said about matzoh balls?"

I said I hadn't, so Nellie told me. "When Marilyn was married to the playwright, Arthur Miller, they often went to Arthur's parents home for dinner. Matzoh ball soup was always served, and one time Marilyn said, "Don't Jewish people ever cook any other parts of a matzoh?"

Don't Jewish people cook any other parts of a matzoh?

Bill Kennedy of Box Cards saw Nellie's work, and asked her to join Box Cards. Nellie and Bill Box became lifelong friends, for many years living as neighbors in nearby apartments in West Hollywood. Their similar taste in humor was mutually inspirational. I asked her to recall some of the good times at Box Cards, and Nellie wrote...

"So many fun things happened at Box Cards, it's hard to know what to tell. But this might be my best. We were having a little get together in Bill Kennedy's office—going over some ideas for Easter—I suggested a large cross with a floppy eared bunny on it. What? 1960? A couple of years ago (2001?) someone did it in *Time* magazine!"

In 1960 even Box Cards considered an Easter bunny on a cross too outrageous to publish. But once again *Time* caught up with Nellie's sense of humor. Nellie concluded her letter by saying...

"Bill Box and I have always been close friends, we even found apartments close together. Now we live far apart, but talk on the phone at least once a week. Bill has had a wonderful career outside of cards, and we always have lots of laughs."

Nellie has had a pretty good career, too, writing and drawing for books, comics and for TV productions. A cartoonist likes to hear people laugh at her work. She likes to see the cartoons published, and to receive nice fat checks in the mail. And it is a bonus when someone occasionally offers some serious compliments, such as a letter Nellie received in 1966 from Syracuse University:

"...many students in our graduate and undergraduate programs are deeply concerned about the problems twentieth-century America must resolve. Since cartoonists make penetrating observations on politics as well as the morals, manners, and social goals of society, your drawings and papers will provide a unique source of information about our civilization in the years to come.

"Therefore, we would like to establish a Nellie Carroll Manuscript Collection at Syracuse University in recognition of your outstanding past and future achievements. This material would be a boon to social historians, artists, and illustrators, and to the university and scholarly world as well. Scholars for generations to come will be able to gain a better understanding and fresh appreciation of your career in all of its various aspects."

Nellie sent the Syracuse University Library a batch of her works, so now scholars may go there and see the Nellie Caroll Papers. "Original and published drawings, caricatures, cartoons, comic strips, costume sketches, greeting card and record album artwork; also correspondence (1964-1968). Size of collection: 4 linear ft."

So "Deck them halls with matzoh balls" is not only funny, but may be profound.

I MEANT To WRITE

BUT it took ME ALL YEAR To STRING THESE DAM BEADS....

Nellie Caroll, writer/artist

Nellie's daughter inherited the funny gene. "When my daughter was about 10, I asked her what she'd do if I died. (Probably to make her cry for something she did.) But OH NO...she said, "Well, I'd prop you up in bed, keep putting rouge on your face, and keep on doing greeting cards." She did some very funny ones too....they're also at Syracuse. She went on to be a wonderful artist."

Nellie said the years on the Box Cards staff were wonderful. The cartoonists would go to trade shows, and autograph cards for the fans. When the company got into financial trouble it was sold to Gillette. This was o.k., because they still worked together in the same way. But then Gillette sold it to Buzza-Cardozo, and Nellie and Bill were not so happy.

"Our card line was blended in with the rest of their cards. The art directors kept saying, "Do the characters have to be so ugly?" so we would sweeten up the art and eventually it just descended into nothingness. Bill and I lived more than an hour away from the Buzza studios, so we never worked inside...we just mailed in our work. But then we both got into TV and other work, so it was o.k.

"One year I had a contract with Hallmark. I sent them one card each week, and they sent me a check. At the end of the year they sent me a letter saying they hadn't used all of my cards, so I owed them a lot of money. Isn't that terrible thing to do to a poor artist? I didn't have the money, so I declared bankruptcy. The judge got really mad at Hallmark, and I didn't have to pay them back anything."

Nellie was relieved when I told her Hallmark did the same thing to many contract artists, and most of them didn't have to pay back any money.

--

Bill Box told me how his company got started.

"My first outing with cards were four Christmas cards I called "Bop Cards". This was about 1951. When I tried to sell them in the Mom and Pop gift stores I was met mostly with that stare that George Gobel called "The Trout Look".

"I had only printed 100 of each design and I was about to give up after selling only a few dozen when I called on a shop on Hollywood Boulevard called Athena. The owner questioned why anyone would be selling Christmas cards in November. She bought in August. She agreed to take a look and said, "I have to have these!" She ordered 1500 to 2000 of each design. I had to confess that I couldn't afford to print that many. She gave me a check for the entire order in advance. Happily she re-ordered twice before Christmas.

"I learned that there was terrific acceptance for these cards at the UCLA and USC student stores and other locations that attracted a younger hip audience. The cards attracted the attention of a Los Angeles TV station and they sent their cameras and an interviewer to a Robinson's Department store. One of the customers, an elderly lady, was asked for her opinion of these new radical Christmas cards and said, "I believe they are the work of Communists!"

"After the success of the Bop Cards in a limited market I decided to attempt to spread my wings to birthday and other "card days", and after a short while on my own my friend Bill Kennedy joined me, and with our inventory in the trunk of the car we hit the road. (Bill Box and Bill Kennedy met while working as parking lot attendants in Los Angeles in 1954.) After establishing some accounts in California we went to New York for the Stationery Show where we garnered more accounts and some representatives. That in a nutshell was the beginning of Box Cards. By the way, they were tall cards for two reasons...one, I felt more comfortable drawing a standing figure, and two, a number 10 envelope was the least expensive I could find.

the merriest

it's christmas

so have a ball

No.1 © Wm Box

No.4 © Wm. Box

Two of Bill Box's "Bop Cards"...the work of Communists?

"Nellie was the first artist/writer added to Box Cards and a valuable addition she was. We have remained close friends ever since and we generally talk about once a week. Incidentally, the card years served as a warm up for the career that followed. After freelancing at Buzza I began to write monologue material and made sales to Phyllis Diller, Pat Paulsen, George Gobel, Milton Berle and others. Then with an agent I began writing for TV variety and sit-com shows including Jonathan Winters and Dean Martin roasts, the Steve Allen Show, Sanford, Barbara Mandrell and the Mandrell Sisters. I retired in 1985 and still keep my pen damp doing some golf greeting cards for The Duck Press."

Bill Kennedy and Bill Box admire the book collection of Box Cards published in 1960.

NEXT WEEK WE'VE GOT TO GET ORGANIZED

© Herb Gardner 1981

Herb Gardner

In the 1950s Herb Gardner was learning to be a sculptor at Antioch College in Yellow Springs, Ohio, when he drew a few cartoons for the school newspaper. Bernad Creations published the cartoons in 1954 on greeting cards, and on ashtrays, mugs, posters, small figurines, "and just about every white surface but surgical masks," said Herb. Herb called his characters "Nebbishes". "Next week we've got to get organized" was printed first as a greeting card, and then as a huge poster to be hung in offices, college dorms and kids' rooms. *The Nebbishes* was also a syndicated Sunday comic strip for eight years. "My cartoons weren't really greeting card messages," Herb explained. "They were just points of view. I had always wanted to write plays, and wrote my first published play in 1962. My plays are sort of like the Nebbishes...just points of view."

KEEP IN TOUCH

Herb went on to write for TV and films, and is best known for his Broadway plays, *A Thousand Clowns*, *I'm Not Rappaport*, and most recently, *Conversations with My Father*. Not many people realize that the same guy drew the Nebbishes cartoons.

His 1958 novel, *A Piece of the Action*, (Simon and Schuster) tells just how hard it is for an artist to get an original cartoon character published and manufactured. Herb probably had similar experiences with his Nebbishes.

William Steig

Bernad Creations also published greeting cards by *New Yorker* cartoonist William Steig. A cartoon of a little grumpy man crouching in a box said, "People are no damn good!". This card sold so well that Steig earned about $250,000 in royalties. Steig was quoted in an interview as saying, "Greeting cards used to be all sweetness and love. I started doing the complete reverse...almost a hate card...and it caught on." He claimed to have originated the funny studio cards. Steig's cartoons were published first in 1942 in a book titled *The Lonely Ones*. I was not able to find out when the same cartoons were published as greeting cards, so Steig may or may not have been the first studio card cartoonist.

now that you're older

go play in the street

© Box Cards, Inc. Bill Box, writer/artist

thanks

a heck of a lot

© Box Cards, Inc. Bill Box, writer/artist

JUST KEEP SAYING

i AM WELL

i AM WELL

i AM WELL

YOU MAY NOT FEEL BETTER BUT YOUR DICTION WILL IMPROVE

© Box Cards Nellie Caroll, writer/artist

JUST BETWEEN US GIRLS

HOW'S TRICKS

© Box Cards Nellie Caroll, writer/artist

Mort Walker

It is interesting to speculate what might have happened if Hallmark had been ready for studio cards in the 1940s. Mort Walker began selling cartoons to magazines when he was 11 years old, and when he was 18 in 1942 he was a student at Kansas City Junior College. Mort had borrowed $25 for tuition, and then also took a night shift job in the Hallmark shipping department. Mort answered a newspaper ad for a sketch artist in Hallmark's editorial department. At the interview a vice-president asked, "How do you like our cards?"

"I don't like them at all," the cheeky Mort answered. "They're too mushy and sentimental. I wouldn't send one to my grandmother." They hired him anyway, and for a year Mort drew idea sketches for all the humorous card ideas written by the Hallmark writers — about 50 to 75 sketches each week.

I wrote to Mort in 2003 asking about his greeting card work, and he sent me a letter and several art samples which are on the following pages. Although Hallmark valued his work, they didn't publish much of it. "Usually the art department re-did my cards poorly, much to my dismay," Mort told me. If Hallmark had hired him as a writer/artist, he might have produced cards like the ones he later drew for his own Comicana Cards company. When Mort left Hallmark in 1943 to attend Missouri University, he was told, "You have a good job at Hallmark if you want to come back after college." After college and after WWII Mort was anxious to sell his work where it would be published as he created it. He moved on to magazine and comic strip cartooning with *Beetle Bailey*, *Hi and Lois* and many other syndicated comic strips.

© Comicana Cards Mort Walker, writer/artist

13

Mort
WALKER

MAY 28, 2003

DEAR DEAN,

HERE ARE A FEW OF MY HUNDREDS OF
HALLMARK DESIGNS. I WAS THE FIRST EDITORIAL
DESIGNER HIRED BECAUSE THE WRITERS WEREN'T
HAPPY THE WAY THE ART DEPARTMENT INTERPRETED
THEIR VERSES.

I ALSO DID ALL THE DISNEY AND BLONDIE CARDS
AND DID ORIGINAL CARDS FOR J.C.HALL FOR
HIS PERSONAL FRIENDS.

I MADE $17.50 A WEEK, BUT WHEN I QUIT
TO GO TO M.U. THEY CONTINUED SENDING ME
VERSES TO ILLUSTRATE AT $1.00 EACH. I USED
TO BAT OUT AS MANY AS 75 A WEEK AND
MADE MORE MONEY THAN MY ARCHITECT
FATHER MADE AT THE TIME.

LATER ON I HAD A SERIES OF BEETLE
BAILEY 2-COLOR CARDS WITH HALLMARK,
A LINE OF CARDS WITH AMERICAN GREETINGS
AND MY OWN LINE OF COMICANA CARDS.

IF YOU NEED ANYTHING MORE, LET ME
KNOW.

GOOD LUCK WITH IT!

SINCERELY,
MORT

Missin You

VEN YOU HAFF KNOCKED DER MASTER RACE
RIGHT IN DER ZEIDER ZEE,

AND HEILED RIGHT
IN DER FUEHRER'S FACE

PLEASE HURRY
BACK TO ME!

366

TO HOME

writer unknown
 Mort Walker, artist

SMILE IF YOU
LIKE SEX

MORT
WALKER

BUT DON'T GO
AROUND ALL THE
TIME WITH THAT
SILLY GRIN
ON YOUR FACE

Mort Walker, writer/artist

"Der Fuehrer's Face" design at left is the idea sketch Mort Walker drew, not a published card. The V-mail design on the next page is one of the few times Mort's actual art was published by Hallmark.

No._____

(CENSOR'S STAMP)

(Sender's name)

(Sender's address)

(Date)

A MESSAGE BY V-MAIL
TO BRING A "HELLO"
AND TELL YOU SOME STUFF
THAT YOU MIGHT LIKE TO KNOW!

DID YOU KNOW THAT:

V-···-MAIL

© Hallmark Cards, Inc.

writer unknown Mort Walker, artist

In 1956, on their 50th Anniversary, Rust Craft published a new edition of Ernest Dudley Chase's book *The Romance of Greeting Cards.* In addition to companies mentioned by Fred Slavic, the book listed Bresillo's Inc., Carol Cards, Country Cousin, De Mael, Dolphin Designs, Jane Jarvis, Mantice Greetings, Red Farm Studio, Saya Studio, Shosha Cards, Soriano-Greetings, Tanylor Greeting Cards, Tessier Studio and Vasari, Inc. as prominent studio card publishers. The book just missed the entry of major companies into the field. Rust Craft and the other major card companies published their first studio cards in 1956.

In the 1950s the major card companies published very mild humor, almost always in verse. Joyce C. Hall, the founder of Hallmark Cards, was given credit for establishing standards for greeting card humor. Mr. Hall believed that a personal message in a greeting card should always be a compliment and should be cheerful and upbeat. "May you have a perfect day, that is great in every way! Happy Birthday!" was a typical humorous greeting card. A cheerful compliment that rhymed, and was illustrated by a fuzzy bunny wearing clothes and dancing around a birthday cake. It was so easy to rhyme "way" and "day", or "you" and "to", that Hallmark editors sometimes told the writers, "No more way-day or you-to rhymes!" The ban would be lifted when enough verses had been written to give the card line more variety.

Why a fuzzy bunny? Well, if you drew a human character it would look more like some people than other people. But a bunny could represent anyone. A fuzzy bunny wearing only a shirt didn't look like a man or a woman. It was a "neuter critter" that could represent the sender or the receiver of the card, who might be a man or a woman or a child. The idea was that every card was so pleasant and looked so little like any specific person, that it would be suitable for everyone and anyone.

Joyce C. Hall started as a salesman of post cards in 1905, then began printing and selling his own greeting cards in 1914. With the help of pansies and neuter critters he built his company to dominate the industry. The commercial success of Hallmark convinced rival companies like American Greetings, Rust Craft, Norcross and Gibson that Mr. Hall knew what he was doing. Those companies looked to see what Hallmark was publishing as guidelines for their cards.

Panda Prints, Box Cards and The Nebbishes inspired Hallmark writers to attempt to create new funny studio cards. The projects went nowhere until 1956 when a new Hallmark line called "Fancy Free" was finally published and put into a few stores for a test of public reaction. I saw these cards in a bookstore in Iowa City where I was a student at the University of Iowa. I had been offered a job at Hallmark when I graduated, but had decided not to take it because I didn't think I could succeed at writing sweet verse and drawing fuzzy bunnies. But the Fancy Free cards broke me up, and I quickly said I would take the job next June. I ended up working 35 years in the greeting card business, and eventually realized how fortunate I was to have gotten into it at the time when this new form of humorous entertainment was being created.

Chapter 2: Hallmark Editorial, a Tight Ship

WRITER WAITING FOR AN IDEA TO HIT HIM

DEAN

Pat White and Kathy Davis were my mentors when I started work in the Hallmark Editorial department in June 1956. They were veterans who told me war stories. Six years before they had gotten a new boss who had no experience as a writer or supervisor. He had been a traveling salesman who filled out his weekly reports so perfectly that J.C. Hall believed he was the man to shape up the Editorial department.

"I'm not a writer," he told the staff. He should have stopped there, but he went on. "If I was a writer, I would come to work 15 minutes early every day so I could take off my coat, sharpen my pencils, and put a stack of 3 x 5 index cards on my desk. When the bell rang at 8:00 a.m., I would be sitting at my desk with a sharp pencil resting on a blank piece of paper. As soon as an idea hit me, I would be ready to write it down."

The rest of his rules for writers were:

DON'T....
1.....talk to anyone while you are supposed to be working.
2.....read any magazines, newspapers, books or anything except greeting cards and the rhyming dictionary.
3.....listen to a radio.
4.....laugh or make any loud noises.
5.....leave your desk except at break times, lunch time and quitting time, unless you are called to a meeting.
6....disagree with the boss.
7....smoke, eat or drink anything at your desk.
8....come to work late.

DO......
1....write only the cards on your "requisition slips" for the day.
2....write as many cards as you can every day. Ask for more requisitions slips if needed.
3....turn in your work at the end of each day with card verses neatly typed on 3 x 5 index cards.
4....share a typewriter and a rhyming dictionary with the rest of the staff.
5....attend meetings when invited and behave properly.
6....go to the bathroom before starting work, at break times, and lunch time so that it won't be necessary to leave your desk for this purpose at other times.
7....keep your desk neat and clean at all times.

There were stories about people who had broken these rules.

THE GIRL WHO FIRED HERSELF

Susan Bartush often came in late. She was a good writer who had trouble waking up early. Sometimes she crawled to her desk behind a row of filing cabinets so she wouldn't be seen arriving late. The boss warned her, "If you come in late again, you will be fired!" Susan arrived on time for a while after that, but one morning she was on the elevator on her way up to the Editorial department when she heard the 8:00 a.m. bell ring. So instead of going to her desk, she went into the Personnel office and sat down. The Personnel Director asked why she was there. "I've been fired," she said. The Personnel Director hadn't received any notice of her dismissal, so he called the Editorial department boss, who said no, he hadn't fired her. Susan explained, "Well, he said I would be fired the next time I came in late, and I am late today, so I think I'm fired." The boss and the director decided if she was that accepting of being fired, they might as well let her be fired.

THE GIRL WHO THREW THE DONUT

Another writer had been warned not to eat treats at her desk. But she just couldn't get through the morning without a sweet. She was eating a donut, chewing very quietly, and keeping her face in a paper bag, when she heard the boss' footsteps approaching. She didn't have time to hide the donut in her desk. He was too close! She threw the donut in the air. It took off right in the boss' face, sailed over a wall, over an aisle and landed in another department. She had an innocent face when the boss looked in, but she couldn't speak because she hadn't swallowed the last bite yet. And her sweater and skirt were covered with crumbs. She was fired.

THE GUY WHO ARGUED TOO MUCH

Harold Kemper was a very funny writer and cartoonist. He drew cartoons to illustrate the cards he wrote, and wanted the company to print his art. But his style was too funny, and he was in the writing department and the art was done in other departments. He argued about this, and the boss told him to stop arguing about it. When Harold wrote what he thought was a particularly good card, and it got rejected, he would stomp up to the boss' office and argue for the card. This really made the boss mad, and Harold was told not to do that anymore. Then because Harold was such a good writer the boss gave him a raise. The boss thought Harold would be grateful and stop the arguing. But Harold read the signal wrong. He thought the raise meant he was so valuable that he didn't have to change his style. He kept arguing for his cards. He was fired.

THE GUY WHO WAS CAUGHT SLEEPING

To illustrate how much the boss like quietness, he once phoned the supply department and complained that a batch of 3 x 5 index cards had been cut against the grain. What difference did this make? "When I write on them across the grain," the boss explained, "It makes a lot of noise."

Kathy Davis said it was so quiet all day that writers just couldn't help nodding

off occasionally. One day a pleasant young writer who looked sort of like Charlie Brown in the *Peanuts* comic strip was caught sleeping at his desk just before lunchtime. He was summoned to the boss' office. "Charley Brown" was still around when the staff returned from lunch, but he told them sadly, "Well, I've been fired. I've seen more compassion in a glass eye."

THE PERFECT WRITER

One girl was hired who promised to become the perfect writer. She cheerfully obeyed all of the rules, and went a step further. She cut the corners off of the 3 x 5 cards that her verses were typed on. "When the cards are put in and out of the files, they sometimes get dog-eared. But that doesn't happen if you trim the corners," she explained. The boss praised her work often, and held her up as an example to the other writers. There was only one problem. The boss kept two lists—production and deportment. She was at the top of the deportment list, but at the bottom of the production list. After six months of employment she had not been able to write even one verse that could be accepted for publication. The boss very reluctantly fired her.

THE REALLY PERFECT WRITER

John Annarino was a new writer who learned the craft quicker than anyone ever had. In less than a year he was writing a lot of cards, and getting almost all of them accepted. He did it all, serious to funny themes, verse and prose. And he never broke any of the boss' rules. John was quiet, pleasant, hard working, and so nice the other writers envied his talent but never felt jealous of him. He didn't really kiss up to the boss, John was just too nice to irritate anyone. After a year he quit and moved to Los Angeles to try to break into song writing. He was a good friend of Harold Kemper, and when Harold was fired John probably made up his mind to leave as soon as he could. John and Harold collaborated for a while on freelance greeting card work from Los Angeles. Then John found a more lucrative job in advertising, and had a long career writing funny advertising copy for Doyle Dane Bernbach. "They called me the funny short guy," John said. "Because that described me and the ad copy I was best at."

In 1984 John and Pete Seymour, a former Hallmark editor, wrote a musical comedy called *Greetings* that was performed at Stephens College in Columbia, Missouri. The musical had many characters based on people John and Pete had worked with, and John's daughter, Karen, was then a theater arts major at the college. *Greetings* has not yet been performed on Broadway or on the Hallmark Hall of Fame, but perhaps it will be someday.

As I listened to Pat and Kathy tell me the war stories, I realized that I might not be at Hallmark very long. I might get fired for breaking rules, or I might not be able to learn how to write serious and sweet cards. I might get bored or freak out and want to quit. I had been offered the job because someone liked the daily cartoon feature *Doodles by Dean* that I had drawn for the *Daily Iowan* at the University of Iowa. I thought they wanted a funny cartoonist, but now I was expected to be a sweet humorous poet. I started working on my resume.

Doodles by Dean

"Will you wear a little bracelet to show that we're going steady?"

Doodles by Dean

"I don't want to butt into your personal life, Son, but I've heard that you're running with a pretty fast crowd at school."

Chapter 3: Loosening the Rigging on a Tight Ship

Pat and Kathy, attractive young women in the their late twenties or early thirties, were grizzled veterans of a war against a strict and humorless boss. I wondered how they had survived when so many others had fallen? First, they liked to write greeting cards and had become very good at it. And they knew that office rules didn't have to be so restrictive. When they hired on at Hallmark eight years before they had a wonderful boss, Louise Lutz, who ran a relaxed office. But when Louise quit to become head of Editorial at Gibson, Mr. Hall replaced her with the strict boss and expected him to run a tight ship.

DEAN

Pat and Kathy had kept from becoming completely discouraged by working to improve conditions. They convinced the boss that each writer should have his or her own typewriter and rhyming dictionary so there wouldn't be fights over these objects. When they asked for other improvements they were told, "You got typewriters and dictionaries! What more do you want?" But they did want more.

They convinced the boss that reading magazines was a way of doing research for a greeting card assignment. The boss would casually walk past a writer's booth without seeming to look at the person, and then summon her to his office. "I saw you reading an article in *Time* magazine about medical research. How does that relate to writing a verse for Mother's Day?" Pat and Kathy could usually think of some way to relate what they read to what they wrote.

They convinced the boss that it sometimes helped if two or more writers talked and worked together on an assignment. This wasn't just idle chatter for fun, it was brainstorming. So he allowed a bit of that, and of course the writers did a lot of idle chattering when they worked together. That's how I got these stories from them as they were tutoring me on how to write greeting cards.

But that was about all the progress Pat and Kathy could achieve. So rules they couldn't change or bend, they broke in sneaky ways that gave them pleasure, but didn't get them fired. For example, the rule about not laughing or making other loud noises. Well, they laughed quietly so it wasn't too noticeable. And on a long dull afternoon, Kathy would scream an imitation of a dog being run over by a car. It was such a loud, penetrating, shocking noise that it was impossible to know where it came from. It might have come from any department on the floor, not necessarily Editorial. There were no dogs or vehicles in the building, so the noise was both shocking and mysterious. Kathy was such a quiet, nicely dressed and refined person, she was never suspected. She would make the long, loud yelp, and then jump up to see where the noise came from. The boss was more likely to look for a wounded dog than suspect Kathy. He probably suspected everyone else, but could never find the perpetrator. It was such a good morale builder for the writers, they would sometimes request Kathy to perform.

Marian Standbridge was a writer who worked out a method to get a nice break from the pressure. She could prop her head in her hand with an elbow on the desk,

hold a pencil on a piece of paper, and take a long nap. The boss never realized that she was sleeping. Her long hair hung over her eyes. He thought she was doing as he had suggested, sit with your pencil resting on a piece of paper so you could start writing as soon as an idea came to you.

John Annarino would leave at 5:00 p.m. on a Thursday and say to the boss, "Have a nice weekend!" The boss would try to remind John that this was not Friday, but John was gone too quickly. So the boss would be left wondering if John would be at work the next morning.

The boss often repeated his desire that every writer get back a little early from lunch and be ready to start writing immediately when the "lunch-is-over" bell rang. Yes, there was such a bell. It rang at 8:00 a.m. when work began, at noon when lunch began, at 1:00 p.m. when work began again, at 5:00 p.m. when work was done. And there was a coffee cart that was pushed along the aisle with a little tinkle bell to notify you when your department break-time began, and when it ended.

Hallmark was very much a suit and tie, women wear hose, tinker bell kind of company. One cold winter morning I arrived wearing a suede hunting cap with ear flaps, and the guard wouldn't let me into the building at the main entrance. It didn't fit the Hallmark dress code for office and creative personnel. I had to walk around to a service entrance that maintenance and production employees used.

One day the writers and editors conspired to surprise the boss, and begin

KLACK KLACK WHACK
DING! SLAM
WHACKITY WHACK
TAP
DEAN

working right on the dot when the "lunch-is-over" bell rang. The bell rang and ten typewriters began chattering at high speed. The noise startled people in other departments, and they craned their necks over cubicle walls to see what had exploded in Editorial. The typewriters machine-gunned out copy for many minutes (but don't they just write little two and four line verses?) until all the fingers were tired, and heads bent down over desks to muffle the suppressed giggles. The boss sat stony faced in his office and didn't acknowledge the jest, but oh...they knew he heard it and hated it! If he had only laughed at a few of these things, it would have helped.

So they went further. The boss always kept his desk perfectly clear of anything except the piece of paper that he was currently reading or writing upon. He often waxed and polished his desk top. Someone noticed that after every card reading meeting in his office the boss would wipe his desk to clean up any fingerprints or bits of dust that might have accumulated. Once Kathy was wearing a bracelet when she reached across his desk to point to a card. When her bracelet tapped the desk top the boss winced. His desk had been hurt.

After that the writer who was invited to attend the meeting would be loaded up with watches and bracelets loaned by a generous staff. Pat especially delighted in reaching to point at cards, and drag the metal across the desk. No matter how hard she hit the desk, no matter how much the boss winced, he never said anything. He just gave the desk an extra massage and polish after the meeting. If only he had said, "Don't wear watches and bracelets and don't scratch my desk!" it would have helped. Apparently he thought it would be weakness to reveal that anything got to

him, and he thought he that was effectively concealing his emotions.

The writers were invited to regular meetings where they were expected to make presentations of card concepts they had developed. One writer would stand at the front of a room beside a panel of cards, read the verses, and explain how they were exciting and new. The boss and a few higher executives would sit in the front row. Some editors would sit behind them. In the back row were the other writers who were doing things to try to make the presenter break up and laugh. Since most of the projects were serious verses, it was hard to explain that you suddenly guffawed because Pat or Kathy was sitting in the back row wearing a huge cartoon elephant face mask. Or maybe a sign with a funny saying. Or just making a funny face and wiggling her ears. Pat and Kathy were quick. They were never caught, and no writer would rat them out, because they loved it.

Pat and Kathy genuinely liked and helped every new writer that was hired. At the time I came aboard there were two others, John Annarino and Mary Edith Smith. John left a few weeks after I met him. Before he left he told Pat White, "Dean will be a good writer someday." I took that as high praise. I thought I was pretty good when I came to Hallmark, but quickly realized it would be difficult for me to mold my cartooning mind into a greeting card format.

Mary Edith Smith had been there for two years, and was doing quite well. She was tall, pretty, funny, sweet and innocent. She had learned the knack of writing verse that was equally funny, sweet and innocent. She had a way of saying funny things that she didn't understand. For example, once I left my desk to throw out dirty water from a small pot I used to clean my drawing pens and brushes. While I was away the boss called a meeting. When everyone was assembled he asked, "Where is Dean?"

"Oh, he went to the bathroom to change his water," said Mary Edith. It got a big laugh, and she beamed. She was not criticized for being raunchy, because everyone knew she didn't realize the double meaning of what she said. At another meeting an executive obsessed with saving pennies for the company asked if anyone could think of a shortened version of Happy Valentine's Day, so the company could save money on time spent lettering the phrase. Mary Edith piped up, "Why not say Happy V.D.?" Another big laugh. We knew she knew not what she had said, and she beamed.

Mary Edith became known as "M.E.", because she signed her card verses, M.E. Smith. When M.E. came to work each morning she loved to tell people about her life. It was an entertaining life. She enrolled at Arthur Murray Dance School hoping to meet someone to date and marry. She met Neil Flynn, and was very excited to tell Pat White that she and Neil were going on a date. Pat wrote a special card, I drew a cartoon for the cover, and it was passed around the department for everyone to sign. Sam Van Meter added a cartoon inside that warned M.E. of the intentions of men. Forty five years later M.E. found the card in her scrapbook and sent it to include in this book.

DEAN

A special card prepared for M.E. Smith on the occasion of her first date with Neil Flynn

M.E's date with Neil went very well, and soon they were engaged. "Neil wanted to kiss me last night," she told Pat one morning, "and I said, O.K., just one goodnight kiss at the door, but no more! The priest says anything more than holding hands and a single goodnight kiss is Bad Happiness."

Of course Pat had to circulate the story, and Bad Happiness became part of our vocabulary. It was not a long engagement, both M.E. and Neil were anxious to get married and raise a family. The priest gave them a book about marriage, "but we're not supposed to read Chapter 9 until AFTER the wedding ceremony!" said M.E. Pat asked if they hadn't sneaked a peek at the forbidden chapter anyway, but M.E. insisted they HAD NOT and WOULD NOT! We wondered what kind of guy Neil was, and someone met him and said, "They are a perfect match! He's just like her. The guys at his office are breaking up over this romance just like we are."

Sam Van Meter drew another card for M.E. It showed her and Neil lying in bed on their wedding night with blushing faces as they read the previously forbidden Chapter 9. M.E. thought it was very cute. But when M.E. came back from the honeymoon, she was crying at her desk. Pat White asked what was wrong. Had she and Neil already had a fight? No, that wasn't it. "I've been married for two weeks, and I'm not pregnant yet !" M.E. sobbed.

"Don't worry, M.E.," Pat managed to say without smiling. "You might be pregnant already and know it. It can take longer than two weeks to know. And anyway, I'm sure you'll have a family very soon." Pat was right. M.E. was soon

gloriously pregnant, and bubbling with pleasure and excitement.

We all tested M.E.'s innocence in various ways to see if we could find just where it ended. Surely she must know something about the seamy side of life. Sam Van Meter had been promoted to Sketch Artist Supervisor, and a newly hired artist named Caroline seemed almost as sweet and innocent as M.E. So Sam tried for a double punch. He typed up a greeting card verse for a caption titled, To Be Sent to Someone Who Has Had an Operation. The card read, "Heard about your operation. Hope everything came off O.K.!" Then he typed instructions for an illustration on the cover of the card. "Illustrate by drawing a cute eunuch." He typed "M.E. Smith" as the card writer, and sent the card in a packet to Caroline's desk. Just as he suspected, Caroline was soon in his office asking, "Sam, what is a eunuch?"

"Gosh, I don't know," said Sam. "Ask M.E. She wrote it."

Caroline may have thought a eunuch was some sort of strange animal. Hallmark illustrated many humorous cards with cute bunnies, and the writers often liked to suggest other types of animals for variety—such as cute wombats or cute warthogs.

Then Sam hung his beady eyes over the partition of his booth to watch Caroline trot across the department to M.E's booth. He heard M.E. say "I didn't write that!" There was some quiet conversation between the two women, and then a silence as they were both looking at a dictionary. Then tall M.E. stood up, and her face was crimson and her eyes were shooting daggers at Sam. He collapsed in his booth in hysterical giggles. Caroline threw the card at him saying, "I refuse to draw this!" Sam drew the cute eunuch himself to circulate privately among us for our daily chuckle.

Sam just couldn't resist opportunities to tease M.E. When she ordered a raspberry pie from the Hallmark cafeteria take-out service as a gift for her future mother-in-law, Sam rolled his eyes and said, "Oh, M.E. That is very dangerous. Does your future mother-in-law wear dentures? Because if she does, she would consider a gift of a seedy raspberry pie as mocking the fact that she wears dentures." Then Sam listened as he heard M.E. call the cafeteria and cancel the order. Of course neither of them knew whether or not the future mother-in-law wore dentures. Sam just loved to plant a seed of doubt and see how it would grow.

When M.E. and Neil were showing off the samba dance steps they had learned at Arthur Murray's Dance School, Sam had to shout, "You're not allowed to dance like that until you're married!"

Sam and M.E. were polar opposites in personality. Sam the Lecher, M.E. the Innocent. Sam the Skeptic, M.E. the Believer. M.E. sometimes called him "Sam Dam Van Meter". The sparks that flew between them created an energy of fun that boosted morale for everyone in Editorial.

Heard about your operation...

Hope everything came off O.K.

Unpublished get well card by Sam Van Meter

Chapter 4: Lou and Stan

Mr. Hall once toured the Disney animation studios in California, and was so impressed that he organized the Hallmark art department along the same lines. Disney had a large number of specialized artists who did little bits of each animation cell. Animators drew pencil sketches, in-betweeners did pencil sketches of in-between action, inkers drew pen line art over the sketches, colorists added the color. So Hallmark had pencil sketchers, inkers, colorists and lettering artists work on each card design. Most of the artists were young women fresh out of high school. Occasionally a good professional artist would interview at Hallmark and run away. Someone who wanted to draw a complete card was not wanted.

Lou and Stan, former Disney artists, were exceptions. Lou and Stan—it sounded like a comedy team. Bud Abbott and Lou Costello, Oliver Hardy and Stan Laurel. I can't remember their last names, but when I met Lou and Stan I was not disappointed. They were middle-aged guys who looked and talked like a movie comedy team. One of them looked and talked like Jimmy Durante, and the other sort of looked and talked like Bob Hope. Their specialty was the sweet fuzzy bunny type of characters that Hallmark used so much in the regular humorous card line. I think they had worked on Disney's Bambi, and had the cute animal characters down pat.

"Geez, when we first came to work here, we thought we would go nuts", said Lou or Stan. "A whole building full of twittering young girls, and the stuffy work rules! We hated it, but it was good money, and we did get to do complete art on our cards. Mr. Hall loved our art. So after we had been here a few months, we told him our wives missed California so much that they were going to leave us. We was awful sorry, but we had to quit. Well, the Old Man did what we figured he might do. He offered us contracts to mail in our art from California."

"You won't believe this," added either Stan or Lou, "but when we first came here they said they didn't have space for us yet in the art department. They really just didn't want us to corrupt the sweet young girls that worked there, because our language can get sort of salty. So they made us work in a tent on the roof. It was hotter than hell in the summer in Kansas City. After a couple of weeks of sweating it out in the tent we came down off the roof, found an empty office and moved our stuff in. The Old Man thought the girl artists would be jealous, because we got an office while they worked in booths. But they didn't mind. We got along fine and didn't corrupt any of them."

When Lou and Stan returned to California they kept two studios for their work. One was very neat and looked just like a Hallmark office. Whenever Mr. Hall visited, Lou and Stan put on suits and ties and met him at this studio. The place where they really did their work was a dumpy little shack on the waterfront in Santa Monica. Here they kicked back, wore shorts, sandals and T-shirts, and had their

stuff strewn about in disorder. It was the sort of environment many writers and artists find more inspiring than a neat office. One day Lou and Stan were doodling in their real studio with the door and windows open so they could feel the ocean breeze, and they heard a rasping voice say, "How much is that fish?" They recognized J.C. Hall who was trying to strike a bargain with a fish seller a few doors from their messy digs. They managed to close the door and hide before the Old Man discovered them.

So Lou and Stan worked in California except for an occasional visit to Kansas City. They admitted it was mind numbing to have to illustrate sweet humor, but they kept their sanity by sneaking little naughty things into the art. "They sent us a card that read, "Just itchin' to wish you a Happy Birthday!" Lou said. "And we was supposed to illustrate it with a cute hillbilly wearing long red underwear and scratchin'. So we drew this hillbilly hound dog in long red underwear, and he was moving his arms everywhere to scratch everywhere at once. If you looked close you might see he was scratchin' his crotch. Well, the Old Man didn't look close, and they printed the card and it was a best seller. They kept reprinting that card for years, but sometimes the girls illustrated it, and they forgot to have the hillbilly scratch his crotch. The research department wondered why the card never sold as well as it did when we first drew it."

We wished Lou and Stan had visited Kansas City more often so we could have heard more of their stories. They were our heroes because they knew how to enjoy the Hallmark benefits and avoid the irritations.

Chapter 5: Good-bye Parties at Kelly's

When I interviewed at Hallmark in the winter of 1956 I thought I could choose a job in either the Editorial or Studio department. So I was disappointed to be assigned to Editorial when it was the funny new studio cards that had made me accept the job offer. I was told that Studio was so small it could not use another writer, but anything I wrote that was really funny would be sent to the Studio. The problem was the boss in Editorial did not want me to spend time writing funny stuff for Studio. He wanted me to learn to soften the humor and put it in verse for the standard humorous line of cards. And one important rule was, "Write for the assignment of the day."

The most unwelcome assignment was to write a sympathy card. There were about a dozen words that could be used in sympathy cards, and you had to try to rearrange them in a way that had not been used before. And of course, no humor was allowed. Sam Van Meter helped my morale by writing some funny sympathy cards. "Now that the old curmudgeon is six feet under, when do you vultures split the plunder?" and "Sorry your lover is pushing up clover. How soon can I start coming over?"

**Too ugly for Humorous.
Published by Contemporary.**

NO DOUBT ABOUT IT....

... you ARE a handsome dog !

© Hallmark Cards, Inc.
Dean Norman, writer/artist

I would struggle to come up with one or two verses that were directed to the assignment of the day, and then I would hit writers' block or just plain boredom. So I would spend the rest of the day writing and cartooning funny ideas for the studio line for any occasion that came to mind. Maurice Nugent, the writers' editor in Editorial was told by the boss, "Tell Dean to stop writing studio cards when he has other assignments." Mo didn't tell me this, because he knew I would just spend the rest of the day wasting time when I was empty of cute verse ideas. So he put the funny cards I wrote each day in a separate drawer in his desk, and only turned in the sweet stuff I wrote for the assignment of the day.

Mo was out sick one morning, so somebody else looked through his desk to collect the cards. He took a big pile of studio cards that had accumulated for a week from my efforts. When the boss saw that I had only written one or two sweet verses, and more than a dozen studio cards, I think my head was on the chopping block. Mo was back the next day, so he explained the mistake and bragged to me, "I saved your job!"

It didn't make me feel very secure. I knew by then I really didn't want to learn to create soft, sweet humorous verse. I had

29

focused on learning how to write and draw as funny as I could through high school, through five years of college, and two years in the Army. I had drawn a daily cartoon titled "Better Believe It!" for the bulletin boards at Fort Riley, Kansas and Fort Miles, Delaware. I had drawn a daily cartoon feature "Doodles by Dean" for the student newspaper at the University of Iowa, and published a book collection of them just before coming to Hallmark. I was pretty good at thinking of cartoon ideas by then, but very primitive at cartooning. I didn't take many art classes or practice much drawing. I had been told that good ideas and weak art can be acceptable in cartooning, but weak ideas and great art doesn't make it.

During the summer of 1956 the Hallmark Editorial department hired many new writers and cartoon sketch artists. Pat and Kathy said they had never hired so many new people before. Through the summer many of the new people quit or were fired. After a couple of weeks the boss would decide that someone didn't have the talent. Or a new writer would decide he couldn't take these sterile working conditions or write this silly stuff. I interviewed for a job as a writer for publications by a gas exploration company. I had done some straight journalism while in college, and figured I could do that better than write sweet verse.

One of the new people that summer was sketch artist Sam Van Meter, an art graduate from the University of Kansas. His first week in town Sam found a favorite bar, the Westport Inn, and began telling us funny stories about what happened at Kelly's last night. "It's named the Westport Inn, but everybody calls it Kelly's because Randal Kelly is the co-owner. Kelly has the night shift and his partner, Art Brock,

There's no place like home....after the other places close.

© Hallmark Cards, Inc. Dean Norman, writer/artist

Randal Kelly says goodnight to Sam Van Meter

30

has the day shift. Art Brock is retired from the police vice squad. There are guns hidden every few feet behind the counter. If someone tried to rob the place, he would be punched into a filigree of holes like Yosemite Sam shootin' a varmint.

"Last night a guy who once worked for the FBI came in and asked for a grasshopper. Kelly mixed the drink, and put a live four-inch grasshopper in it. Somebody had caught it that day and brought it in for show and tell. Anyway, the guy is talking and drinking, and never sees the grasshopper. The bug is pushing its legs against the guy's lips to keep from being swallowed, and he still never sees it. He finishes the drink and leaves, and Kelly passes around the glass with the grasshopper still in it and sitting on the ice cubes. Kelly says, "That FBI man couldn't find ducks on a pond."

"You gotta come down to Kelly's tonight," Sam went on. "It's the oldest building in Kansas City. It was a stop on the Santa Fe trail where wagon trains bought supplies before heading west. There's a slave block in the basement where slaves stood to be sold. It's the best family bar in town. People who can't get a baby sitter just bring the kids, and Kelly gives the kids free candy bars. Never any trouble there. You can nurse a ten cent draft of beer all night, and they never push you to buy more. Come on down to Kelly's!"

I was newly married, and couldn't afford a car or much of anything else. So on warm Saturday nights Bette and I would walk about two miles from our apartment to Kelly's, where we would always find Sam at a table with a group of regulars. Sam would grab chairs and move tables to include us, make introductions, and Bette and I would nurse two or three beers for an evening of entertainment.

John and Katie Heiman were inspirational regulars at Kelly's. One night John suggested I write a funny greeting card based on the lyrics of a Tom Lehrer song titled "Be Prepared". It was a bawdy song about Boy Scouts, and the last lines were, "If you're looking for adventure of a new and different kind, and you come across a Girl Scout who is similarly inclined. Don't be nervous, don't be flustered, don't be scared...BE PREPARED!" I couldn't see how to adapt this to a card until John said, "Draw a little Girl Scout peeking out of the Boy Scout's backpack." I sketched on a napkin, and John and I fiddled with some words until it seemed to work. The result was a good selling Contemporary Card designed by Paul Coker. On the actual card the Girl Scout wasn't visible until you lifted up the loose flap of the backpack.

Kelly was the unofficial Irish consul in Kansas City. There were always one or two young immigrants working behind the bar until they could find other work. One bartender was a local Kansas City singer, George Boice, who was trying to break into opera. He had recorded some operatic tunes with the Kansas City Philharmonic, and these records were in the juke box in the bar. There were also some Mario Lanza records in the juke box.

"George doesn't like to be asked to sing," Sam advised us. "But on Friday and Saturday nights, we wait until about 10:00 p.m. Then we just put nickels in the box and play his songs or Mario Lanza's. If George is in the mood he will sing with the record, and everyone will stop talking and listen. If anyone keeps talking, Kelly will get out his shillelagh and tell them to shut up or leave."

And that was the usual weekend show. Through the late hours people would play opera music on the juke box and George would sing. His singing would perfectly match and override the voice from the box, and the orchestra accompaniment was perfectly timed. *Ave Maria, Figaro, Surrey with the Fringe on Top, Oklahoma,* are some of the tunes I remember. But Kelly's didn't have an entertainment license. They couldn't pay George to sing. They paid him to serve customers at the bar. He

would take orders, mix drinks and make change while never missing a note. People ordering drinks while George was singing would either whisper or make hand signals, and George would nod as he sang to indicate he understood.

One night George said he was going on vacation to Florida early tomorrow morning, and he didn't have a bathing suit or time to buy one before getting on the plane. A friend and regular customer, John Corbett, said, "I can loan you a suit." He went home and got it. It was a long, red and white striped suit from the 1890s. When George said, "I can't wear that!" John put it on to show him how good it looked. Then John stood on the bar and started telling jokes from the days of Vaudeville. George knew these jokes, too, so they made it a team act.

John Heiman-Dean Norman, writers
Paul Coker, artist

"George, did you hear about the stagecoach with no wheels?"
"A stage coach with no wheels? What held it up?"
"Bandits!"

Then everyone in the bar would hum like a vaudeville stage band, "da da ta da da DA!" The jokes would go on as long as John could remember one, and he knew a lot. He was a paper salesman, and he said his hook was collecting jokes to tell customers. "Every paper company makes the same paper, and the prices are pretty much the same. So if the paper buyer at a company has more fun having lunch with me, he will buy paper from me. I try to give him a new joke he can take back to tell at his office. If I could ever get the toilet paper account at the Union Station, the commission would make me rich for life."

When somebody was fired or quit at Hallmark we held a good-bye party at Kelly's. Sam would get there right after work, which he usually did anyway, and reserve a few tables in the back. Editorial and Studio departments were invited, and a pretty fair number of each department showed up during the evening. We got to know each other better than we could at work, so it was a bonding experience that benefited the company, though J.C. Hall might not have thought so. One of the best going-away parties was when a sketch artist in Editorial, Lyle Metzdorf, quit to go back to art school and become a better cartoonist. Lyle had a hard time finding Kelly's, and we got several calls during the evening requesting directions. Nobody wanted to leave the fun to go and guide him, so we gave directions over the phone. Lyle finally arrived around midnight.

We thought Lyle was sort of a goofy guy, but he did well after leaving Hallmark. He opened an advertising agency in Houston, won many prestigious awards, and became an ocean sailor. We knew him as a guy who was almost always cheerful, except when he lost a game of ping pong at lunchtime and would sulk the rest of the afternoon.

While waiting for Lyle, Don Branham, a new Studio department artist, played a few tunes on the piano, and someone thought it would be a good idea to compose a song to sing when people left Hallmark. Many of us were writers, so Don began plinking the melody of "Give My Regards to Broadway", and whoever had an idea sang a line of lyrics. After numerous starts, this is what we came up with:

> "Give my regards to Hallmark, remember me to old J.C.
> Tell all the gang in Flock and Flitter to flock a critter for meeee!
> Give my regards to Hallmark, remember me to old Joe Kipp
> Give my regards to Old Hallmark, and.....da da da da da da!"

We never did get a last line that we liked, but we tried for about an hour. Everyone in the bar joined us Hallmarkers in singing the song, so it got belted out and wafted into the evening breezes. We all went home a little inebriated, and feeling better about our jobs. We thought the company policies sucked, but we loved to create funny cards, and we were meeting a lot of people who would become lifelong friends. The bar closed at 2:00 a.m., and Kelly always said goodnight by shouting, "You don't have to go home, but you can't stay here!" Sam would give Bette and me a ride back to our apartment. He would drop us off, and then motor off in his big yellow convertible to take his date home.

Kansas City was an affordable place to live in 1956. Sam and I both rented one room apartments on Armour Boulevard for $50 a month. A Murphy bed dropped down out of the wall, and there was a bathroom and a kitchenette with appliances

and thousands of cockroaches. For $70 an exterminator got rid of the roaches from the apartment Bette and I inhabited, and guaranteed they wouldn't return for at least a year. The roaches probably ran into the adjoining apartments and started turf wars, because the landlord soon exterminated the entire building.

Sam and I both experienced being locked out late at night, and getting into our apartments through the tiny garbage pick up doors. This inspired a Hallmark Christmas booklet where Santa delivers toys in an apartment building by squeezing through garbage doors.

Sam found his bed in the wall useful for hinting to guests when they should leave. He concluded a party by saying, "Ho hum! You folks do what you want, but I have a big day tomorrow, so I'm going to hit the hay." Then he pulled the bed out of the wall. It nearly filled the apartment. A few guests that lingered got to see Sam undress, turn off the lights, and tuck himself under the covers.

When Bette and I tucked ourselves into bed after the parties, I wondered how soon they would have a good-bye party for me at Kelly's? I hoped I could find another job before the boss fired me.

Dean Norman, writer/artist

Chapter 6: Mutiny on the Tight Ship

One day Pat and Kathy walked into the Personnel office, and asked to be transferred to another department. The Personnel Director, Bill Harsh, couldn't believe they were serious. They were the best writers, had been at Hallmark for eight years, and no other department needed their card writing skills. Pat decided to act like she was freaking out.

"He had glass walls and people walking by could see into his office, but couldn't hear anything," Pat told me. "I started stomping around, waving my arms and talking hysterically. Kathy didn't know I was going to do this, and she thought I was losing it, too. I said, I just can't take it any longer. I can't work for that man! I've seen talented people hired and fired by him all these years, but never so many as this summer. This is the last straw! I can't work for him another day. If you can't transfer us to another department, me and Kathy QUIT!"

Bill Harsh and Pat both looked at Kathy. Kathy had not agreed to quit with Pat. They were only going to ask for transfers. Kathy gulped and said quietly, "That's right. We'll both quit."

Bill said, "Please go back to your desks for the rest of today, and don't say

Dick

anything. I'll see what can be worked out, and get back to you."

Pat and Kathy agreed, and the next morning it was announced to us that our boss was being promoted to another job. Carl Goeller, a young assistant to the boss, was the new department head. We restrained our cheers, and nodded acceptingly. Carl was one of us. Carl and almost everyone in the department was now a young single or young married twenty-something. As soon as the old boss was gone from the room, Carl relaxed the ridiculous work rules that had amounted to profound distrust of writers, and started pushing to get funnier cards accepted in the humorous line. He promised to have some of the cards we wrote illustrated by the many sketch artists that had been hired recently. There were about eight of them at one time, most of them were art school graduates with good cartoon styles. I hoped that even my primitive style could be pulled along by some of my better gags.

Pat and Kathy kept their promise and didn't say anything about their request for transfers THAT DAY. They had not promised to keep quiet about it forever, but they waited a while before talking about it so that Carl could get off on a good start as the new boss. The old boss was promoted to work on special assignments, and about a week later he received two copies of a sympathy card that said something like "Our thoughts are with you in your sorrow". He phoned Editorial and demanded to know who did this, because he didn't think it was funny! A clerk had sent him the cards, because his name was listed as the writer, and writers were always given two copies of new cards. He had changed a few words on the card in an acceptance meeting, and his secretary listed him as the writer.

In his new job of Special Projects the old boss had one secretary to type his letters and memos. In a few weeks that secretary was in the Personnel office asking to be transferred. I guess the moral of the story is that a perfectionist should work alone and do his work to perfection. Be a cartoonist or a salesman, but don't try to supervise anyone. The man who made everyone so unhappy for six years in Editorial had been one of Hallmark's best salesmen. His reports and sales records had been perfect, and he had been held up as an example for other salesmen. M.E. Smith said the boss once invited the staff to his house for Thanksgiving dinner...a very welcome invitation to several new hires who couldn't travel home for the holiday. "He was such a nice man at the dinner," M.E. said. "But he was not a good supervisor of creative people." I think most of us would have been equally bad if we had become bosses and supervised other writers and artists.

At one time during the bad old days in Editorial someone left the department to go the toilet and said, "I'll be right back. I have go to the..........", and instead of saying "john", they substituted the name of the boss. It got good laugh, and both Editorial and Studio department people started using the name instead of saying "going to the john".

Bob Harr, a Studio department artist, took a trip to New York City. He was eating dinner in a nice restaurant, and couldn't see where the men's room was located. So he asked the waiter, "Where is the?" (speaking our secret name for toilet.)

Without a pause the waiter answered, "Right over there, Sir", and pointed to the men's room door. As he walked to the men's room, Bob suddenly realized what had happened. Our little Kansas City joke had made it all the way to the big time in New York City. A man might become world famous because he annoyed the people he supervised at Hallmark. This did seem like going too far, and we stopped using the joke. It was an old joke by then anyway, and we liked to create new stuff.

Chapter 7: Carl Goeller

Carl struggled mightily to make the humorous card line competitive with the studio line. We wrote good stuff for many captions, took extra care in drawing cartoon sketches, and several times thought we were close to doing some finished art. But the weight of the established art departments was too heavy. They insisted on doing the finished art. So the sketchers began looking for other jobs, or hoped to be transferred to the Studio department.

Carl was put in a no-win situation by Mr. Hall's belief that only a lunatic fringe of new card buyers was buying studio cards. Mr. Hall thought that slipping sales in humorous cards had to be because the product was not good enough. Well, we agreed it was not good enough. Carl wanted to stop sending the funniest cards his writers produced to the Studio department. He wanted Sam Van Meter, Larry Bowser, Dick Stensrude, Bill Hunt, me and other Editorial sketch artists to do some finished art that was really funny instead of soft and sweet. But this wasn't allowed. Humorous cards had to stay the way they were, only get better and sell better.

Writers and sketch artists were often encouraged to work in brainstorming groups for cards that were especially difficult to create, such as humorous Mother's Day. Dick Stensrude, Mary Rita Hurley and Jimmie Fitzgerald got themselves into a good mood by thinking of wicked things to say to a mother, and then would try to write something sweet that could be published. One time a very sweet Mother's Day verse was concocted so that the capitalized first letters of each line spelled S-H-I-T. The card was being read at a final review when one of them snickered, and Carl stopped it from being published.

Sam Van Meter went too far when he wrote an eight line Christmas verse with the first letters spelling S-H-I-T-H-E-A-D. Carl wouldn't believe that Sam had done this unintentionally, and when the verse nearly got printed Sam nearly lost his job.

Dick Stensrude worked for one year at Hallmark, and then decided he enjoyed teaching more than working as a commercial artist. "As a teacher I don't have to specialize. I teach painting, drawing, sculpture, etc." He moved back to Vancouver, Washington to teach at a junior college. Dick continued to freelance greeting card writing for several years, and was the most published member of the faculty...much to the disgust of the English faculty.

Howard Lohnes was in charge of creating mechanicals for greeting cards. He had file cabinets stuffed with cards that did amazing things when you opened them. Things popped up, popped down, zoomed across the page, rocked and rolled, or expanded into 3-D scenes. Some he had adapted from other companies' cards, some he had invented. You could go to him and ask him how to make something magical happen in a greeting card, and he could usually pull something out of his files. Or he could advise you on how to build the mechanical apparatus you wanted.

Howard helped someone create a Christmas table centerpiece that was a paper cone covered with green feathers. When it went into production in the Flock and Flitter department an unforeseen accident occurred. A gun shot wet glue and feathers at the paper cones as they came down the assembly line, but the feathers took off in every direction—only a few of them hit the targets. The people from Flock and Flitter put us all into the Christmas spirit when they came into the lunch room that day covered with green feathers.

Jim Krekovich worked with Howard on the card mechanics. Jim had grown up with many hobbies, one of them building model airplanes. We also found out he had

an identical twin brother, John Krekovich. They amused us at a party by confusing everyone as to who was Jim and who was John. John had a small tattoo on one arm, but when he rolled down his sleeve there was no way anyone could tell apart. They both had been married several years, and even their wives and kids could not tell them apart.

The Krekovich brothers had joined the Navy at the same time, but had been stationed at different places. John entered a Navy contest to build model airplanes, and his model won him a trip to the finals. At the finals the judge was a popular radio and TV personality, Arthur Godfrey. John told us how the judging went.

SHE WORKS IN FLOCK AND FLITTER

"Godfrey was drunk as a skunk as he walked down the line looking at each model airplane. He came to one that was a model of the plane he had flown when he was in the Navy, so he gave it first prize. It was a piece of junk. The worst made model in the show. I don't know if I should have won first prize or not, but every other model was better than the one Godfrey chose. So when he stopped to look at my model, I told him off. Told him what a dumb ass drunk he was to give first prize to a junky model that just happened to be the plane he flew. Well, of course Godfrey was pissed, and the Lieutenant in charge of the event got chewed out by the Admiral for letting a VIP guest be embarrassed. The Lieutenant was shipped off to sea duty as punishment. I got reprimanded, too, but I didn't give a damn."

The rest of the story was told by twin brother Jim Krekovich. "I was on a ship in the Pacific and this new Lieutenant comes aboard. He takes one look at me and starts chewing me out...swearing and cussing and saying how he is gonna fix me for causing him trouble. I didn't know who the hell he was, but I wouldn't take that shit from nobody, so I cussed back at him. Well, the ship's Captain heard the ruckus and broke up our cussing match. It took a while, but we sorted out why the Lieutenant was so unhappy to see my face. He thought my brother John had been transferred there, too, just to keep tormenting him."

This take-no-shit-from-nobody attitude almost got Jim into trouble at Hallmark. He was a very cheerful person and did his job well, so he had no problems until one day when Sam Van Meter pulled one of his little pranks. Sam had a chair in his booth that squeaked when you rocked back. He found the squeak interesting, and sometimes just rocked and squeaked to pass the time. Unfortunately his booth was close to the boss' booth. The squeaking interfered with meetings and phone conversations taking place in Carl's office, and Carl told Sam to stop it.

So Sam stopped rocking and squeaking whenever Carl was in his office. One afternoon Jim Krekovich visited Sam's booth. Sam happened to rock once and the chair squeaked. "Hey, that's a cool sound!" Jim said. Sam invited Jim to sit in the

chair and rock it a bit. As Jim rocked and squeaked, Sam tip-toed away and watched from a distance. Carl sat stony faced in his office trying to ignore the annoying squeaks. Finally he could take it no longer, and strode out to lunge over the top of Sam's partition, expecting to find Sam in the chair. Carl shouted, "Don't you have anything better to do?"

Both Carl and Jim were surprised, and Jim reacted as he had when the Lieutenant suddenly started chewing him out on the ship. "No, I don't have anything better to do!" said Jim, and he rocked and squeaked violently.

The antagonists stared at each other for a moment, and then Carl said evenly, "Well, please try to find something better to do." Carl returned to his office, Jim returned to his booth, and Sam never told Jim that he had deliberately set him up for this encounter. Sam had expected Carl to be angry, but he hadn't expected Jim to fight back so vigorously.

"He came close to getting fired," Sam told me. "I just wanted to have a little fun."

What Hallmark really needed in their humorous line were some cartoon characters with more attitude. The company finally hit pay dirt when they licensed the Peanuts characters created by Charles Schulz. Snoopy was such a popular character that they could put almost any simple message on a card with Snoopy and it would be a good seller. They almost missed this opportunity, because when the Peanuts characters were first shown to Mr. Hall in 1960 he wasn't impressed. The comic strip had not yet appeared in the *Kansas City Star*, and Mr. Hall wasn't aware of how popular it was in most of the U.S. and in many foreign countries. The editors had to collect clippings from other newspapers, book collections, and statistics from the cartoon syndicate to convince Mr. Hall to give the Charlie Brown and his friends a chance to appear on Hallmark cards.

IT'S VAN METER'S VERSION OF
MUSICAL CHAIRS . . .

Meanwhile, Carl tried to think of ways to boost the morale of his staff. One afternoon five writers—Sam Van Meter, Jimmie Fitzgerald, Mary Rita Hurley, Pat White and Kathy Davis— were invited to a special meeting in Mr. Hall's private dining room. There was a thick carpet on the floor, and a cupcake beside a nameplate for each of the writers. At the head of the table was a panel with a cover. The cover was removed to reveal five greeting cards. Carl said, "Each of you wrote one of these cards, and each of the cards totaled more than a million dollars in sales."

As Carl continued his speech expressing gratitude that the company had for these talented writers, Sam Van Meter began dreaming about how big was the bonus each of them would receive. A million dollar card ought to be worth what...$10,000? Well, maybe that was too much. $5,000? Surely at least $1,000 dollars. As Carl talked and Sam

day dreamed, Sam gobbled down his cupcake. "When Carl stopped talking," Sam said, "I realized that I had just eaten my bonus."

"Now go back to work and write some more million dollar cards!" said Carl. The writers trudged back to their desks in a terrible funk. A cupcake and a pep talk just didn't do it for them.

I don't know how Carl got into Mr. Hall's bad books, but after a few years of struggling to improve the humorous cards, he was transferred to be a counter clerk in the downtown Hallmark gift store. This was an obvious insult to someone whose experience was in writing and editing. Carl accepted the transfer gracefully, and made his plans. Soon he sold a book about how to write greeting cards, and took a job as Editorial director at Rust Craft in Boston. Many years later Carl was my boss again when he became Editorial director at American Greetings and I was a writer there. In 1983 he left AG and concentrated on his own company, The Glass People, Inc. (www.glasspeople.com). Glass People designs custom gifts, personalized miniature cartoon sculptures made of leaded glass and doll house furniture.

But to get back to the 1950s, I got my wish and was transferred to the Studio department while Carl was still the new boss in Hallmark Editorial. The working conditions with Carl were relaxed, but I was still frustrated by not being able to draw the finished art on my card ideas. I figured if I was going to have to change jobs to do this, I might as well do it before I was too old and afraid to try it. By 1958 Bette and I had three month old twins, Susan and David, and our living expenses were mounting quickly. I contacted a few greeting card companies, and from their replies decided I could take a chance on freelance work. So I told Carl I was going to try that, and he quickly arranged my transfer to the Studio department to keep me working for Hallmark. He could have just let me quit, and Studio would probably not have hired me. I kept quiet about why my transfer occurred for many years until it made no difference to anyone. I was very grateful that Carl helped me get the job I had wanted from the beginning, and I didn't want to tell a story that might encourage other artists to try the same gamble. Carl was having a hard time keeping artists on staff doing sketches, and was still hoping to get the approval for them to draw finished art.

Carl went along with much of our fun during his reign in Editorial. We continued to test Mary Edith's gullibility, trying to think of a joke that she would see through and tell us, "You can't expect me to believe that!" We wanted to help bring her into the real world, but maybe that wasn't a favor.

When I got in touch with M.E. to see how she felt about having these stories in the book, she called and said, "Well, I read them to my kids who are 40 years old now, and they thought they were hysterical. It was a side of me they never knew, because I was a tough Mom and they never fooled me."

Then M.E. told me about her life after Hallmark. She quit the Hallmark staff when her first baby was born, but continued to write freelance verse for several years while she lived in Kansas City. Then Neil was transferred to a new job in Baltimore, Maryland, they had another child, and M.E. decided to stop writing cards. It was difficult to know what the latest editorial requirements were when located in another city, and writing wasn't so much fun without co-workers to play with during the day. As her kids grew up M.E. went back to school and earned a masters degree, then worked at several jobs including tax assessor. "You couldn't be gullible in that job!" she said.

I asked M.E. to add memories of her Hallmark days to this book and she

recalled this one:

"For a while the mystery of the dysfunctional pencil sharpener had the staff puzzled. People couldn't figure out what was wrong with the only pencil sharpener in the department. One day as I was blithely sharpening my Maybelline eyebrow pencil someone shouted, "You're the one!" From that day forward I was regarded with suspicion every time I sharpened a pencil."

And then M.E. corrected a story about thumbprints which we thought was our best prank. Here is her version.

THE THUMBPRINT PRANK by Mary Edith (Smith) Flynn

I was in a dither. My wedding date was eminent and I had a million things to do. The day before I left for St. Louis for my wedding I got a telephone call. It seems that for my marriage license to be official, I needed to provide the Marriage License Bureau with my thumbprints. There was no time for another visit to the courthouse, but a kindly official told me that if I would mail my left and right thumbprints to the Bureau, that would be just fine.

I borrowed a stamp pad from Carl, and diligently went about making the best thumbprints I could on 3 x 5 cards. What a mess! Black ink was all over my hands. At that point Carl peered over my cubicle, and asked me to come to his office for a minute. Once in his office I told him how hard I was working at the thumbprints for the Marriage License Bureau. Eyes twinkling, Carl said, "You don't really think you have to do this, do you?"

I looked at Carl and realized I had been "nailed" again. We both agreed not to mention that I knew it was a practical joke, or that Carl had tipped me off. I kept my best set of left and right thumbprints in an envelope addressed to the Marriage Bureau. Those thumbprints have been tucked away all these years as a reminder of the lengths to which a group of hilarious writers would go to test my gullibility.

At a going away party held in the home of Carol Wimsatt's parents, Phil Hahn recited a farewell verse about each member of the staff. When he got to me he said:

> "You murdered your mother?
> Good Heavens, what with?
> Stay as sweet as you are
> Dear gullible Smith!"

After 45 years of marriage and seven grandchildren, I'm no longer gullible, but I hope I'm still sweet.

It was very sweet of M.E. to let us gullible pranksters believe that she mailed her thumbprints to the Marriage License Bureau. For the past 45 years whenever two or more of us met we recalled the story and had a good chuckle...not knowing that in this instance M.E. had fooled us. We speculated about what happened to the thumbprints when they arrived at the Bureau. Were they routinely filed with her marriage license? Did the clerks pass them around and have a laugh? Or did they just shrug and pitch them in the waste basket? And all those years Mary Edith's thumbprints were in her scrapbook, and serving a very useful purpose.

WE'RE FABULOUS!

HOW EVER DO WE DO IT?

HAPPY BIRTHDAY

M.E. Smith, writer
Bob Harr, artist

HEEE HEEE SNORT HAWHAW GIGGLE GIGGLE

OH— THAT'S FITZGERALD AND STENSRUDE BRAIN-STORMING SYMPATHY CARD IDEAS.

I DON'T CARE IF PURCHASING BOUGHT 8 TRILLION OF THEM... I'M NOT INSPIRED BY ONE HOLE BUTTON ATTACHMENTS!!!

YES, JIM, IT'S A MOON-JUNE RHYME ... BUT YOU GOT THE WRONG MOON.

CLEVER MECHANICAL, JIM, BUT I DON'T THINK MR. HALL WILL GO FOR IT.

FOR MOM ...
She's just about perfect you see,
Her manner is flawless to me.
I love her to pieces, Oh Boy!
To see her real happy is Joy!
LOVE 'YA MOM

Dick

Dick Stensrude recalls
Hallmark Editorial
brainstorming sessions

THE CREATIVITY TEST

At a time when Hallmark Editorial was hiring a lot of new writers and sketchers, the company was disappointed that many of the new hires didn't turn out to be very creative. A Creativity Test was given to the staff. We were not told where the test came from....a university? A think tank? A Hallmark exec? Anyway, the test had questions like:

Which would you rather do?

A. Watch a baseball game?
B. Enter a mud wrestling contest?
C. Write a poem?

The boss, Carl Goeller, told us the test was not going to be helpful, because the people in the department who he already knew were most creative had scored low on the test. "In fact, MY score was the worst," he laughed. Was it mean of us to think this proved that the test worked? Not really.

Some years later Rosie Smithson and I recalled the Creativity Test, and tried to solve the mystery of creativity by analyzing the creative people we knew, and finding out what they had in common. We decided there was no common background or personality trait in the bunch. Then Rosie had a flash of inspiration.

"Creative people will never take an apple to the teacher!" I didn't get it, so she explained. "You know, the kid in class who sucks up to the teacher. That kid is never creative. For example, Marjean Phillips, who was my roommate for years, is a very intelligent person, and a good writer for the Kansas City Star. But she could never create a joke if her life depended on it. Once Marjean and I took a dance class. After the first lesson Marjean said, "Let's stay and talk to the teacher." I said, "What!? She's the TEACHER! We don't want to suck up to her."

"Well, we talked to the teacher, and all three of us became very good friends. You see, Marjean's gut reaction was to take an apple to the teacher. She wanted to be the friend of someone who was an authority figure in her life. My gut reaction was NOT to be a friend of someone who was a boss over me, and could tell me what to do. That is the one thing all of the good creative writers and artists we know have in common. Our first gut reaction to an authority is to avoid them. We would NEVER take an apple to the teacher!"

That is why we giggled when our boss scored the lowest on the creativity test. He was the boss. Our gut reaction to any authorities was to make fun of them. As Irving Stone, the CEO of American Greetings once said, "Creative people are rebels". Even when our cause is stupid, we are rebels.

Chapter 8: Hallmark Studio Department

When I transferred to the Hallmark Studio department in 1958, there had already been a lot of changes since its creation in 1955. In the early 1950s Hallmark writers and artists made several attempts to create a line of funny studio cards. As the insulting jokes and ugly cartoons worked through the editing and art review process they were revised to make the thoughts complimentary and the art pretty. When finally shown to Mr. Hall, he would ask, "How is this different than what we are already doing?" So it was decided to work outside of the usual process. Create a new department, hire new artists, put them in isolation and see what they would come up with. The new line would then skip the review process and go directly to Mr. Hall for his approval or rejection.

Vice president Ed Goodman told art director Robert McCloskey to recruit new people. Phil Hahn and Pete Seymour were hired as writers. Paul Coker, Bob Harr, George Hackney and Dick Bennett were hired as artists. Later, Rosemary Leitz was transferred from Editorial department to be a writer/editor. After several months a bunch of cartoon greeting cards were ready to be shown to Mr. Hall, but he was in the hospital. When J.C. Hall had been sick before, it was his routine to keep running his company from a hospital room. Panels of art work would be hung on the walls, and meetings would be conducted while the doctors and nurses worked around the situation. This time the doctor put his foot down. He told the family that Mr. Hall might not survive this illness. His chances of survival were greater if absolutely no business was conducted on the phone or in the hospital. Only the immediate family would be allowed to visit, and they would be banned if they snuck any greeting cards into the room. There was no prediction about how long Mr. Hall might be hospitalized.

So what to do with the new line of studio cards? Most of the executives at Hallmark were reluctant to say they approved or disapproved of any new ideas until they heard Mr. Hall's opinion. Ed Goodman looked at the cartoon cards and decided to print a few copies of about 12 designs, put them on sale in a few stores, and see how the public reacted. There was no publicity that Hallmark was launching a new

Before I met you I was a lonely social outcast....

Now I'm no longer lonely.

© Hallmark Cards, Inc.

Phil Hahn, writer Paul Coker, artist

46

product.

The cards were so popular they blew out the Hallmark rating system. All of the new studio cards sold much better than the Hallmark humorous cards. A card with an angry person holding a giant fountain pen said, "Write Da**it!", and it sold 64 times the rate of the average humorous card.

When Mr. Hall returned to work and saw the cards he was quoted as saying, "These cards sure don't look like Hallmark quality to me. I don't like them...I don't get their humor...but Jack Jonathan tells me they are selling like hotcakes in the test stores, so go ahead and print them up but I won't put my J.C.H. on the back of this artwork. Bob McCloskey can darn well sign off on them." J.C. Hall may not have

Hey, Joe, have we got any of those "lonely social outcast" cards left?

Cartoon by Paul Coker for Crown magazine

understood the humor in the new studio cards, but he had excellent math skills. The name "Fancy Free" didn't appeal to him, so after some brainstorming the name of the line was changed to "Contemporary Cards". Contemporary Cards almost became the generic name for funny cards, replacing the name "studio cards" that had been used within the industry.

Mr. Hall wanted to meet the new writers and artists who had created the new funny cards, and give them the benefit of his years of experience. The young group felt intimidated as they waded through the deep plush carpet in Mr. Hall's office. To avoid embarrassing the Humorous department, Contemporary cards were now rated against each other, so each group had best sellers, average sellers and poor sellers. Mr. Hall pointed to a panel where the latest Contemporary cards were exhibited with the ratings posted, and he explained why the best sellers were best sellers. Because they were complimentary messages and had pretty art work. He explained why the poor sellers were poor sellers. Because the messages were insults and the art work was ugly. Actually most of the cards were insult jokes, and all of the art work was ugly compared to humorous fuzzy bunnies.

After his critique Mr. Hall asked, "Have I helped you young folks?"

Everyone was murmuring variations of "Yes sir, Mr. Hall", when Paul Coker spoke softly but clearly. "Well, anyone could analyze the best sellers and poor sellers AFTER the ratings are posted. But could you do it BEFORE the cards went on sale?" Coker's question was treated like a fart at an elegant dinner party. Everyone pretended not to hear it, and the meeting was over.

Chapter 9: Paul Coker

By the time I transferred to the Hallmark Studio department in 1958, Bob Harr and Dick Bennett were the only original artists still there. George Hackney didn't want to draw cartoons, so he quit and looked for other commercial art employment. Paul Coker was in New York on freelance contract with Hallmark, but the legacy of his short term as Contemporary department Art Director was strong. As I recall those days I keep skipping back and forth between Studio and Contemporary as the name of the department. That is because it became officially titled Contemporary, but it was always called the Studio department by people who remembered its beginning.

Paul Coker graduated from the University of Kansas in 1951. As a student he had illustrated a few ads in the student newspaper. He told me he never submitted any cartoons to the paper, because, "I don't believe in doing free work. They wouldn't pay for cartoons, but the advertisers paid for the cartoon illustrations." He went into the Navy for two years and drew visual aids for recruit training. Then he was hired by WHB-TV in Kansas City, and after a year or two began freelance cartooning.

Jeannette Lee, Hallmark Art Department Director, bought freelance cartoon sketches from Paul for humorous card verses written by the staff. When Paul drew a fuzzy bunny with grinning teeth, other artists removed the teeth on the finished art. Hallmark art philosophy was that teeth indicated aggression, so the artists drew happy bunnies with no teeth. After a few months of freelance sketching, Paul was hired to be one of the artists for the new line of studio cards. He took all of the teeth that had been removed from his bunny sketches, and put them into a grinning face that said "Keep Smiling!" It was a best seller at 25 cents, and later sold in a giant size card for $1.00.

Carol Wimsatt Fuss, a Hallmark writer in 1955, says she heard that the reason J.C. Hall agreed to hire Paul Coker was because Hallmark salesmen found Gibson studio cards being put into a corner of some Hallmark card racks. *The Gift and Art Buyers Directory* for 1955-56 lists Gibson Art Company as a publisher of studio cards. The general belief is that Hallmark was the first major card company to publish studio cards in 1956, but perhaps Gibson was the first.

When Paul arrived at Hallmark he was a very skilled and determined cartoonist. He wanted to develop a unique cartoon style. He resisted any suggestion that he

Keep Smiling

© Hallmark Cards, Inc. Paul Coker, writer/artist

"draw like _____", fill in the name of any cartoonist. Years later a Hallmark art director suggested that Paul draw "sort of like Blechman", a popular cartoonist who draws very small and sketchy characters.

Paul answered, "If you want Blechman, hire Blechman. If you hire me, you get what I draw." The Contemporary department director Robert McCloskey knew from the start not to give art suggestions to Paul Coker. You could hire him or fire him, but you couldn't bend him. Because most of the first Fancy Free cards were illustrated by Paul, and because they were such a huge success, no one messed with his art style. After two years Paul moved to New York City to try to break into magazine cartooning, and Hallmark kept him under contract to continue to design greeting cards. Paul sold cartoons to many publications, and is probably best known for his illustrations of *Mad Magazine* features. For several years I sold stories to *Mad*, and some of these were illustrated by Paul. Years later I would get a job in animated cartooning because of Paul's *Mad Magazine* illustrations. In 1969 I moved to Los Angeles and sent samples of my work to Filmation Associates. As soon as one of the owners, Lou Scheimer, opened the mail, he phoned me and asked me to come to the studios. "I've seen your stuff for years, and have always wanted to hire you." He was looking at a copy of a story I had written for *Mad* that was illustrated by Paul Coker.

I needed work bad, and was tempted to say very little and just take the money. But if Lou Scheimer thought I could draw like Coker, he was going to be disappointed when he saw my cartoons. So I reluctantly said, "Uh, I wrote that story, but I didn't draw it. Well, I did idea sketches, but the finished art you are looking at was done by Paul Coker." Then I pointed to the credits under the title that confirmed what I had said.

"Oh," said Lou. "Well, you can draw a little, can't you?"

"Sure. Look at the next page," and I tried to pull another page from his hand that was a sample of my cartooning.

But without even looking at my cartoons, Lou said, "Great! We only need simple sketches. Stick figures would be all right. Just so you can think in terms of pictures." What he wanted was someone to listen to the songs recorded by The Archies, and sketch ideas for action to be shown on TV while the band was singing. My first job in animation was doing idea sketches for a music video of The Archies hit song "Sugar Sugar". I did videos for nine more songs, and then got assignments for writing and sketching storyboards for the *Archie Comedy Hour*. If I hadn't included a Coker illustrated story in my samples, Filmation Associates might not have been in such a hurry to hire me.

When Hallmark discontinued their Contemporary cards in the 1990s, (and suggested that Paul draw like Blechman), Paul continued to cartoon for Hallmark cards that were sold in Europe where his style was still appreciated. I wonder if Blechman was ever asked to draw like Coker?

Paul wrote some of the ideas for the cards he illustrated when he was in residence at Hallmark studios in Kansas City. But many of the ideas came from freelance or staff writers. After moving to New York, Paul didn't attempt to write, and only did finished art on assignments. Most of his work for *Mad* and other publications was done in the same way, Paul illustrated ideas written by other people. Paul is a funny writer, and I wish he wasn't so determined not to do "free work". He told me he didn't want to submit ideas to editors, "because writers always get some of their work rejected. I prefer to only do work for an art director that likes my style enough to give me an assignment for finished art with guaranteed payment."

You will have to decide . . .

. . . Between a thoroughbred pet . . .

SALE

. . . or one of mixed heritage.

From The Mad Pet Book by Paul Coker

He would meet art directors with a package of art samples, and sometimes they thought these were submissions and would start to sort them into piles of rejects and possible acceptances. "No," Paul would explain. "These are samples of art that has already been bought and published. They aren't for sale. It shows you what I could do if you have any assignments for me."

One art director turned the drawings over and over and said, "But I don't see any printers marks on this art. You say it has been published?"

"I redrew the finished art exactly as I drew it for the publication," Paul explained. "The original art they photographed has the ugly finger prints and printers marks you were looking for. I want you to see what it will look like when I deliver the art to you."

"That's a lot of unnecessary work," said the editor. "You could have shown me the published sample, or the original art with the printers marks."

"I prefer to show you what it looks like without fingerprints on it," Paul insisted.

When Paul was asking a county zoning board to approve a remodeling project on a garage he was going to convert into an art studio, he built two miniature models. One was the garage as it was, complete with one broken window pane. The second model was what the art studio would look like. These were not drawings, they were perfect little doll houses that took many hours to construct. The zoning board was overwhelmed and approved his project. Paul explained, "You can't expect an art director to imagine what something will look like from a rough sketch. Even when I am asked to draw a rough sketch, I do finished art, but they have to agree to pay me for it."

One time Paul did both the writing and art for a complete project, *The Mad Pet Book* published by Warner Books in 1983. It is his best stuff. The writing, if you mean only the words, is completely straight and serious. It could be in any book about pets that is only attempting to give information and not be entertaining. But the way the words are illustrated turns every thought upside down and inside out to create hilarious situations.

Every year Paul writes and designs a personal Christmas card. Sometimes it is about his experiences that year, but in most years it is a funny editorial cartoon. A collection of Paul's Christmas cards would be a cartoon summary of the last half of the 20th century. One of my favorites was for Christmas 1961 when people were really worried about nuclear war between the U.S and Russia. Russia was building fallout shelters for people in their cities, but the U.S. decided that it would be too expensive to do that. And anyway, we are a free enterprise democracy, so every family should build their own fallout shelter in their backyard or basement.

There were serious debates on TV talk shows and in letters to the editors of newspapers about how to deal with your neighbors. What if you built a fallout shelter and stocked it with enough food and water for your family, but your lazy and cheap neighbor did not? Then war happened, and your neighbor wanted to bring his family into your shelter? Should you let him in, or should you get a gun and shoot anyone who tried to enter your shelter? Paul's Christmas card was the most intelligent comment I saw or heard about the dilemma.

Most people decided that nuclear war was just too awful to prepare for. Very few built fallout shelters in their backyards. It might be better to go in the first blast than to be a survivor who is shooting neighbors and Santa Claus.

Paul Coker's personal Christmas card in 1961. Paul drew another version for the Jan. 1963 issue of MAD Magazine that showed the staff of MAD cowering in a bomb shelter.

Richard Watson, writer Don Branham, artist

© Hallmark Cards, Inc.

Don Branham came into the Hallmark Contemporary department like an exploding comet. His art style and personality was the definition of eccentric genius. Don graduated from the University of Oklahoma with a business degree. His parents had insisted he study business. Then he enrolled at the Kansas City Art Institute, and was hired for the Hallmark Studio department soon after the first group of Fancy Free cards were published in 1956. He remained a student at the Institute and worked flex time. He was in and out of the Hallmark building at all hours of day and night. The quantity and quality of his art was so good that no one worried about how many hours he actually worked. He drew wildly distorted characters with a shaky pen line and lots of swirly details. We used to say, "Well, I could draw like that. Just put an outboard motor on the back of my chair, and fire it up."

Dick Winslow told us that he taught Branham how to draw froo froo. "I was a

senior at the art institute when Branham was a freshman. One day Don came up to me and said how much he liked some posters I had drawn. He especially liked the little frilly details, and said, "Will you teach me how to draw froo froo?" So I showed him how to draw froo froo, and you can give me credit for his success."

Don wrote some of the cards he illustrated, and others were ideas he picked from freelance or from the Editorial department. Soon after I was hired at Hallmark, a college friend, Richard "Red" Watson, sent me a simple sketch of a person wearing a cap. Then the cap was taken off to reveal a burning candle on his head. Happy Birthday! Red had done similar cartoons for the humor magazine at the University of Iowa. His drawing was the most primitive I have ever seen, but he had funny thoughts. I urged Red to submit it as a freelance idea, and if accepted he would be paid $25. Red told me just to turn it in as my idea.. He was a philosophy major and didn't intend to continue cartooning after college.

The idea was deemed too funny for the general humorous line, and sent to the Contemporary department. The other artists passed it over as not funny enough, but Branham saw the possibilities and created a sad little man dressed like an undertaker, something that was not in Watson's or my sketch. This was one of Branham's major contributions to studio cards, to illustrate rather simple ideas with such wild and eccentric characters that they became "Branham cards" whether he had written them or not. The candle-on-the-head card sold very well, and Branham began to caricature himself as a little man wearing a black top hat. He drew several variations for other card sending occasions, such as a bottle of champagne under the hat for an anniversary.

Halloween was a fun holiday for studio cards because we could draw funny witches, vampires, ghosts, monsters, etc. Branham drew a Halloween card that had no cartoon character at all. It was just a long, silly letter written in such a weird shaky handwriting that you could imagine a funnier witch than anyone could ever draw. And we had expected him to top us by actually drawing a funnier witch than we could draw. The card sold so well that the funny letter with no art became a form that many of us used on other cards. Hallmark published a book collection of Contemporary cards in 1962 titled *Greetings, Dearie!* that included several letter

Have a nice trip, Komrade !

© Hallmark Cards, Inc. Don Branham, writer/artist

cards and a cover design by Branham.

Don and the rest of us wanted to sign our finished art work, but it was Hallmark policy not to have any signed art work except for famous artists like Norman Rockwell who did a few special Christmas card designs. So the artists would sometimes sneak signatures into the art, and if art reviewers didn't see it, the names were on the published cards. But they were so well hidden that the card buyers would rarely see them, so it was just a game we enjoyed playing.

When Branham was at the peak of his popularity he turned in a group of finished designs with his name prominently on them. I saw these designs as I was adding some of my designs to a group to be sent for reproduction. I rushed out to McCloskey's desk and said, "Great! Branham is signing his art now. Can all of us sign our art, or is this just a deal that he has negotiated with you? I'd like to put my name on the cards I'm designing today."

McCloskey put the brakes on quickly. "Oh, no. He's not supposed to sign his work. Finished art department will take the signatures off. I don't know why he did that."

"Well, maybe I could put my signature on my art work, too, and let finished art scrape it off," I suggested. "And if they miss doing that, hey! I've got my name on my work!"

McCloskey asked me not to do that, and assured me that if anyone was allowed to sign his work, all the artists would be allowed to do it. One of Branham's designs did slip through with his signature on the printed card, but most of them were erased. I figured Branham was pushing the system either with or without prior approval, and I hoped that his push would work and pull the rest of us along. I should have not brought this to McCloskey's attention. Maybe all of Branham's signatures would have been printed, and a better case could have been made for a change of policy. That policy didn't change for several decades until some upstart card companies made signed art work a positive thing. In the 1950s Hallmark said it was all Mr. Hall's art work, because he paid us to draw it.

When Paul Coker went to New York he reported that Branham's art was so popular with art directors that Don could make a fortune if he came to New York. American Greetings and other card companies immediately began looking for artists who could draw like Branham. Don never went to New York. He stayed in school and on the Hallmark staff, and got much attention when he began drawing full page color cartoons for *Esquire* magazine. *Esquire* had stopped using cartoons altogether, and stopped using pictures of pretty women, while *Playboy* magazine became what *Esquire* had been in the past. Don wrote a letter to *Esquire* with the shaky, demented handwriting that he used on his greeting cards, and they replied, "If you can draw as funny as you can write, we will buy your cartoons." He had not even sent a sample of art.

Following the *Esquire* cartoons, Branham drew a series of cartoon ads for DuPont that ran in many national magazines trying to persuade women to wear hose in a variety of colors. It worked on Jan Coffman who soon came to work in the studio with slim blue legs.

John Stith and Branham collaborated on animated titles for a movie *Happy Anniversary* (1959 starring David Niven, Mitzi Gaynor, Carl Reiner and Patty Duke). The producers of the film asked Hallmark to have their Contemporary department artists create funny bits that would be on the screen with the titles for the film. John and Don were sent to New York for the project. In a week they had written and sketched a series of gags with characters that looked like Hallmark cards. In fact

"Not our sort.
She doesn't wear stockings in the summer!"

I, for one, shall cut her dead. A faux pas of such magnitude is not easily forgiven. Not once this summer have I seen her in stockings. And this, of *all* summers, when tints in Du Pont Nylon are so distingué!...I have my standards, Olivia. She shall no longer be asked to my Wednesday evenings. Not until she learns that even in summer—**every fashion needs a stocking all its own!** DUPONT

some of the gags were taken from published cards. Branham came back to Kansas City while John stayed in New York another week to do all the finished animation art. John drew characters similar to Branham's, but without the shaky line. It was probably John who said he could draw like Branham if he had an outboard motor on the back of his chair.

Later Stith left Hallmark and started a commercial art studio in Kansas City. He got a nice deal for Branham to draw a series of funny ads for Hilton Hotels that would be published in national magazines. The ads were done and approved, but never used. Stith was extremely disappointed about this, and explained that it had happened because Branham became impatient to be paid for his work. Don made a long distance phone call to the head of Hilton Hotels who was in a business meeting in Hawaii at the time. When Mr. Hilton found out the "emergency" was an artist he had never heard of who wanted to be paid immediately, he told the ad agency to cancel the deal. It was one of several events where Don began to shoot himself in the foot just as his success was growing.

If Branham created excitement in the studio when his cartoons did so well, Linda Sage created excitement before she even arrived. Linda was an art student at the University of Iowa whose samples looked a lot like the cartoon style Branham had developed. She was offered a job when she graduated. Meanwhile, Don started a long distance romance with Linda by sending her long funny letters. She replied with equally funny letters. It seemed like a match made in heaven. She was apparently a female version of Branham. The entire department began quivering in anticipation of the sparks that might fly when she actually arrived, and began dating Branham and drawing Contemporary cards.

When Linda arrived her appearance fit the anticipation. Don always dressed conservatively even as he acted like a cartoon character. Linda came swinging in dressed like a beatnik artist...black tights...jeweled glasses...rings and bracelets.... and spoke very little and very softly which added to her mystique. Her card designs were terrific. And of course Don and Linda were an item as they began dating. Then in a short time Linda was leaving to teach school in Iowa. Very briefly and quietly she spoke of Don and told us, "He's crazy, you know." We thought that was a big joke. We knew Don. He was fine. But SHE definitely looked like a nut case. And to leave this job when she was off to such a great start? She was the crazy one.

I began by saying that Branham came to the Contemporary department like an exploding comet. He had emotional problems that caused him to self destruct as a writer and cartoonist in a few years. Linda was the first to see this, but she was too reserved to explain what she saw. Don almost literally did burn out. The stories of Don Branham's strange behavior in the early 1960s remain a legend among Hallmark employees who met him. Because he was a good cartoonist employed by Hallmark, many people just thought he was an eccentric genius, when he was really suffering mental illness. And this perception delayed attempts to help him.

The Branham stories could overwhelm his reputation as a cartoonist if told in entirety, so I think one example is enough. Branham bought a used Cadillac, and decorated it to his personal taste. The car body was spray painted with cans of artists' gold that is only meant to be used in small quantities on works of art. Then paint remover was poured on the paint to create dribble marks. Black felt was glued on the roof, and bright colored sequins were glued all over the car. A tall statue was attached for a hood ornament.

When Don failed to make some payments on the Cadillac, the car dealer

HAPPY BiRTH·day TO YOU......

......HAPPY BiRTH·day TO You.......

© Hallmark Cards, Inc.

......HAPPY BiRTH·day TO YOO·HOO......

......HAPPy BiRTH·day TO YOU !!!

...iTs THe BesT I could DO oN Such SHoRT NoTiCe!

Don Branham, writer/artist

considered repossessing the car. But when he saw what had been done to the finish, he decided to hope that Branham would pay for it eventually. Don outfitted himself with a black top hat, riding boots, an opera cape, a fancy walking stick, and a gold bikini swim suit that was also decorated with sequins. He persuaded Hallmark artist Kipp Schuessler to pose as a chauffeur, and wear a uniform hat. Then Kipp drove Don to the car dealership to make a payment. Work stopped as the entire staff at the dealership gathered to observe the event. Don entered with Kipp carrying a check ledger, an inkwell, and a quill pen. These items were set on the office manager's desk, and Don wrote a check while making a barrage of humorous comments to be remembered and quoted by the enthralled onlookers.

Don's performance at the Cadillac dealership could be seen as an artist creating a flamboyant image of himself as a way of promoting a reputation as an eccentric genius. So perhaps another story should be told. Rosie's Leitz' husband, Lowell Smithson, became Branham's attorney. Don sent letters to the law firm of Spencer, Fane, Britt & Brown and addressed them "Splinter, Fink, Bump & Grind". Lowell's senior partners were angry at first, but eventually began to look forward to receiving funny letters from the eccentric cartoonist. Lowell would sometimes chuckle at the dinner table and say, "Don did the strangest thing...but I can't tell you about it. It would be a violation of lawyer-client privilege."

One evening Lowell decided he could tell a story, because he had done something for Branham just as a friend, not as an attorney. "The police called me and asked me to come down to the jail. They were holding Don Branham, and Don had requested that I come to see him. The police said they picked Don up for what was termed "peculiar behavior", but no charges had been filed. Don could be released if I thought he was o.k. now. The police said Don had gone into a restricted room at the Kansas City Art Museum where there was a display of Marie Antoinette furniture including an antique piano. Don was playing the piano, and pouring Babo cleansing powder on a record player that he had brought with him. As he did this he was saying, "It's not working. It needs more Babo." It was not a recording device, it was just a portable record player. I asked Don, "What did you think you were doing?" He shrugged and smiled and said, "I don't know." He seemed o.k., so the police released him and I gave him a ride home."

When Branham first went off the rails in 1959, his parents took him to a mental clinic. He was there a few weeks, and then his mother felt sorry for him and took Don out and brought him back to Kansas City. He told people, "It was an awful place. The patients were sane, but the doctors were crazy." Then for the next two years Branham continued acting strangely, and many people thought it was acceptable behavior for an eccentric genius. A *Kansas City Star* columnist visited Branham's house during a three day New Years party and open house. The columnist was overwhelmed by the artistic decorations outside and inside the house, and wrote that Branham was a true eccentric genius. The outside was painted with gold spray paint, and the inside walls were all black. We who had known Branham before he became so eccentric saw something else. When Don began to act strangely, the quantity and quality of his cartooning declined. The ideas didn't make sense, and the colors changed from bright yellows and reds to muddy browns and blacks.

When Branham's checks began to bounce, his actions were finally seen to be something other than eccentric genius. Don returned to live at home in Oklahoma City. I don't know if he received effective treatment then, or just settled down on his own. He continued to work for Hallmark for many years. Kent DeVore, an Editor of the Contemporary department in the late 1960s, often made trips to Oklahoma City

to take assignments to Branham. "He always met me at the airport, and was funny and charming," said Kent. "I enjoyed meeting him, and never heard of any problems down there like he had in Kansas City."

One of Branham's best cartoons was a group caricature of the Hallmark Contemporary department in 1957 which is on the cover of this book and in more detail at the end of this chapter. Don drew it just to entertain the staff. He did a lot of drawing just to make people laugh. When he worked alone at night he sometimes drew cartoons on the glass walls of his booth that he knew would amuse us when we came to work in the morning. Everyone on the staff envied Branham's genius for cartooning, and liked him personally. He had a bubbling, charming, sarcastic, whimsical personality. Well, he was like a comedian who was always performing. You could meet him for the first time, and he would praise you, insult you, and make you laugh in a moment. His cartoons and presence were great stimulation for a job that could get boring and routine on a long afternoon at the drawing board. A Girl Scout group once toured the Hallmark building, and they asked to see the Contemporary department where the funny cards were created. Branham did not disappoint them. He tossed them a note that read, "Help! I'm a prisoner in a greeting card factory."

Maurice Nugent entered the studio one afternoon to look at the new funny cards in process, and Branham announced grandly, "It's Maurice Nugent!" Then Don began singing the melody of the Hallelujah Chorus but using "Maurice Nugent" for the words. "Mau...au...rice Nooo..ooo...gent. MauriceNugent! MauriceNugent! MauriceNugent!" We all joined in. Maurice tried to think of a snappy comeback, but our raucous singing was too loud to overcome. Mo just grinned, shook his head, and ran out of the studio. Having Branham's work mailed in from Oklahoma didn't benefit the company nearly as much as having him there on the staff.

Nancy Saulsbury was Contemporary editor for many years and issued assignments to Branham while he continued to live in Oklahoma City. She told me that it was sad to see Don gradually lose the ability to create good new material. In the early 1990s he began submitting ideas that made little sense, and when these were rejected he would resubmit the same ideas with different art. She had to tell him that Hallmark could no longer use his work.

While writing this book I tried to find Don, but no one could tell me what has become of him. One person said he saw Branham playing piano in a bar in New Mexico, but that was about 15 years ago. In 1987 Don wrote a nice letter to Rosemary Smithson to say he would be unable to attend the Hallmark Oldies reunion held that summer in Kansas City, but he appreciated being remembered.

When Hallmark converted their art to digital files in the 1980s they threw away a lot of original art. Employees rescued some of Branham's original card art for their personal collections. I think the early Branham cards are mostly likely to become valuable collectibles when people begin collecting studio cards from the 50s and 60s. Hallmark ought to publish a book of his designs in full color, especially some of the large cards that unfolded to become poster size. A million monkeys with a million pens might eventually recreate all the cartoons that most of us draw, but there will never be another Branham in this universe or any other.

Hallmark Contemporary Cards Department 1957

Caricatures by Don Branham

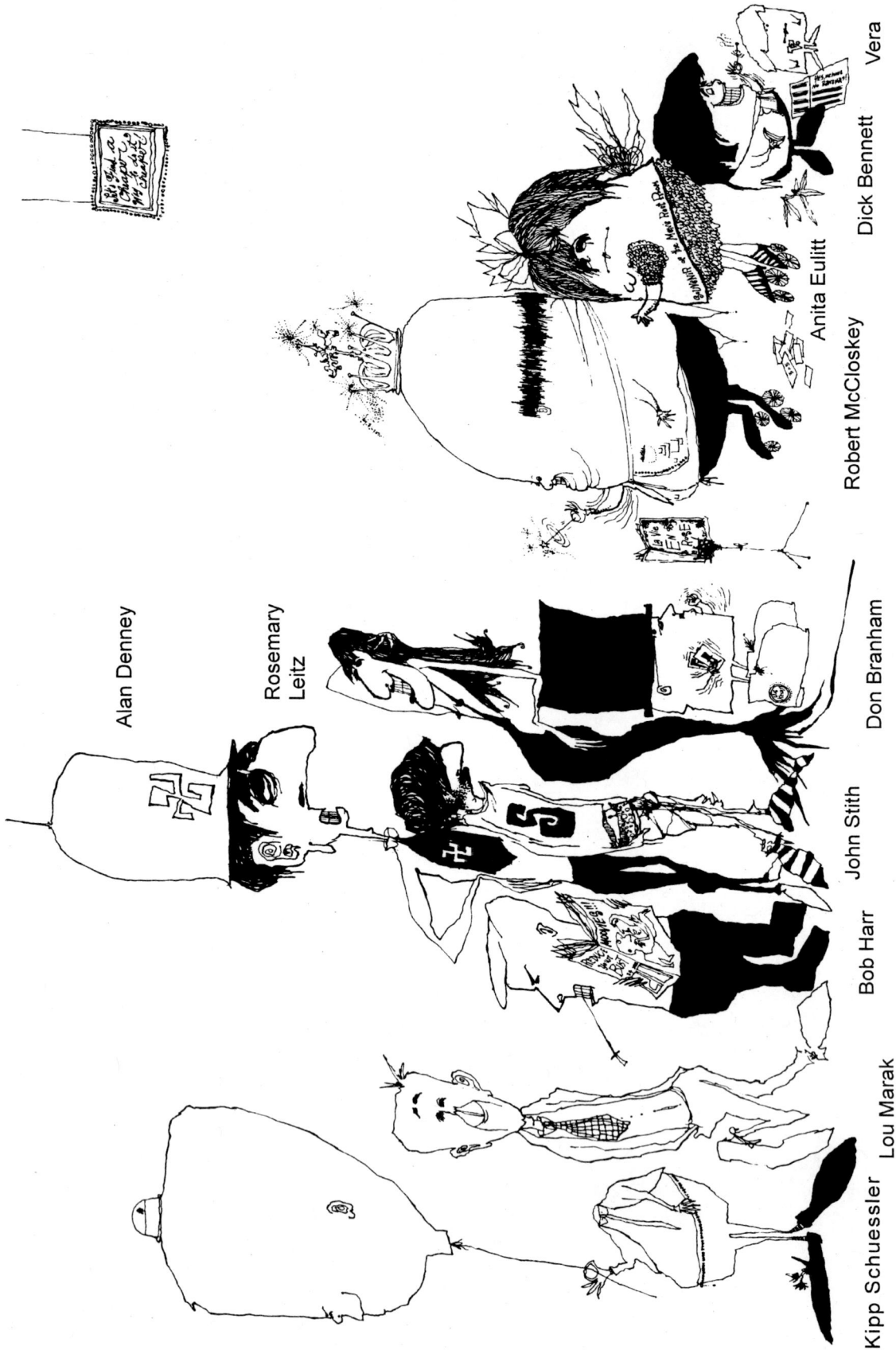

Alan Denney

Rosemary Leitz

Don Branham

John Stith

Bob Harr

Anita Eulitt

Dick Bennett

Vera

Robert McCloskey

Kipp Schuessler

Lou Marak

Chapter 11: Bob Harr

Bob Harr was one of the first artists hired to create Hallmark's line of studio cards. He was illustrating Bible stories when McCloskey recruited him. Bob's art style was more suited to fashion illustration than cartooning, but he enjoyed the company of the funny people in the studio, so stayed with Hallmark for a career. He experimented with different cartoon styles during the first few years and I think did his best work then. But because he didn't have a set style that he preferred, he was persuaded by art directors to draw differently.

A good editor or good art director is perhaps the most rare creature on this planet. I have met only one or two. Well, maybe three or four. But companies large and small have these positions to fill, and the people who fill them do great damage to creativity. Often the position of editor or art director is a reward that is offered to a good writer or a good artist. The companies look at people who actually create the product as doing entry level jobs. If you are good, you can stop writing or drawing and become a manager who harasses other writers and artists. I was once promoted to editor for a brief period. I knew I would be a bad editor, because my taste in humor is very specialized. Anyway, I quit the job before I did much damage.

But this chapter is about Bob Harr. Bob drew some excellent cartoons for Hallmark studio cards with tall people filling most of the space. At the same time Don Branham was drawing very short people on his cards. Branham's cards attracted so much attention that Hallmark art directors decided the public found short characters more appealing than tall characters. They were always looking for rules by which to judge new art work. Bob was told to draw short characters. Coker and Branham had set cartoon styles, and they would not have changed what they were doing. But Bob had not developed a definite style yet, and didn't want to fight the art directors, so he began drawing short characters. They never had the appeal that his tall cartoons had, but the directors were happy to be able to influence someone.

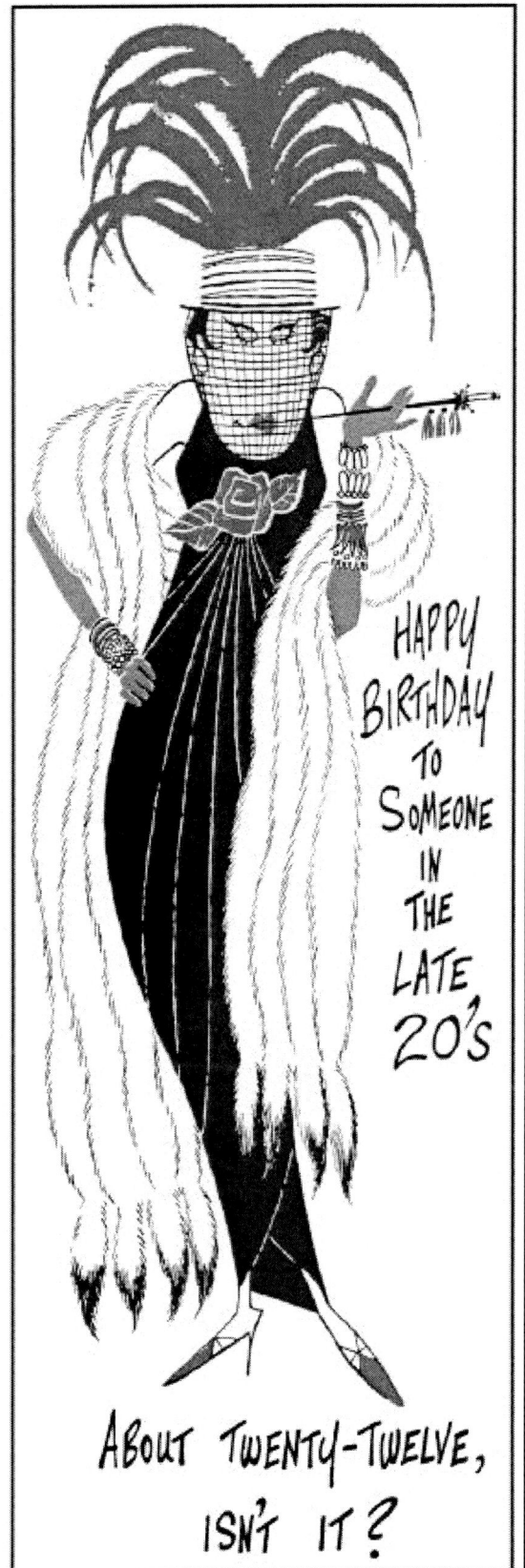

HAPPY BIRTHDAY TO SOMEONE IN THE LATE 20's

ABOUT TWENTY-TWELVE, ISN'T IT?

© Hallmark Cards, Inc. Dean Norman, writer
Bob Harr, artist

61

All of us who worked with Bob remember him best for his pleasant manners, impeccable taste in clothes, and skeptical sense of humor. Bob chuckled a lot, but he only laughed hard on rare occasions. One day he was reading *Time* magazine and went into one of these rare fits of extreme laughter. It wasn't very loud, but his face turned bright red and his body went limp as he slumped in his chair and couldn't talk for a few minutes. We noticed his condition and rushed to see what had amused him so much in a magazine that wasn't noted for extreme humor.

When he was able to talk, Bob said, "This article about a holy day in Italy. A group was carrying a huge iron cross to the top of a mountain. It is something they did every year to honor Jesus. A thunderstorm came up, a bolt of lightning hit the iron cross and killed several people."

"That's not very funny, Bob," Rosie said. "People being killed by lightning?"

"I know," Bob apologized, "I'm not laughing because people got hurt. But I'm thinking how will the priest explain this to them? Why would God hit them with a thunderbolt when they were honoring God by carrying an iron cross to the top of the mountain? Why didn't God make the thunderstorm go away? Why do people do such things, and think God will stop nature from hurting them?" He collapsed into his condition of limp hysteria again, and we tiptoed away hoping God wouldn't throw a thunderbolt at us for being a friend of someone who had a sick sense of humor. This from a former illustrator of Bible stories!

Another time I remember Bob going into a complete comic coma was when the staff attended a performance by Hal Holbrook at a junior college. Mr. Holbrook had just put together his impersonation of Mark Twain, and was making the junior college circuit before hitting the big time on the Ed Sullivan Show. No one in the audience knew whether this was supposed to be really good or not. Of course, we were impressed that a 30 year old man could look and sound like he was 70 years old. The laughter developed slowly, however. About midway in the performance Holbrook told a story of an old woman who was sick and went to her doctor.

"The doctor told her to give up smoking, and drinking, and staying up late, and using bad language, and her ailments would go away. She said she couldn't give up any of those things, because she had never done them. So there was no saving her. She was a sinking ship with no freight to throw overboard. It is important to cultivate your bad habits in life, so when you get sick you can give them up and regain your health."

Bob slumped in his seat and went red in the face. It was amusing him so much that Rosie, Alan Denney, Lou Marak and I began laughing extremely loudly. Every line Hal Holbrook delivered after that got an immediate burst of loud laughs from our group. At first the rest of the audience jumped and turned to look at us to see what was wrong. When they saw we were just laughing because we enjoyed the jokes so much, they started laughing in sync with us. Holbrook killed them the rest of the hour, and no doubt went away very pumped up by the great audience reception. Maybe some people thought we were shills paid to laugh, but Bob was never a shill who granted anyone undeserved laughs. If you made him laugh, you were really funny. Not many people know that Bob Harr may have been the comedy critic that launched Holbrook on his long career as a Mark Twain impersonator.

After several years in the Hallmark studio, Bob quit and moved to New York City. A week or so after Bob left, a group of approved card sketches came back from a meeting, and I remember McCloskey saying, "Well, who should draw the finished art on the sketches Bob did?"

HAPPY BIRTHDAY

© Hallmark Cards, Inc.

PIN-UP GIRL.

Dean Norman, writer Bob Harr, artist

Jimmie Fitzgerald had become editor, and she said immediately, "We should send them to Bob and ask him to draw them."

"Oh, of course," said McCloskey.

So Bob got some freelance work, and a contract to continue to work for Hallmark. We weren't sure McCloskey would have done this if Jimmie hadn't been so quick and positive to suggest keeping Bob on the payroll. Bob stayed in New York City for nine years, and then moved back to work on the staff again at Hallmark. I asked him what he had done in New York and why he came back. "I never did much work in New York except draw my freelance assignments for Hallmark, and a little fashion illustration. So I decided I might as well come back here."

"But I thought you moved to New York like everybody else...to try to break into other art or cartooning fields," I said.

"I never took samples to anyone," Bob confessed. "I know it's silly, but I have too much fear of rejection. I just couldn't face having someone look at my work and say they didn't want it."

It was surprising to hear Bob admit he had an irrational fear of rejection. He was so quick to make snide remarks to people when he had a friendly joking relationship with them. He gave me a working over every time I ate a piece of pie at lunch. I like to get all the juices of a pie filling, so I eat pie with a spoon instead of a fork. Bob never stopped trying to shame me out of this. He would threaten to move to another table so people wouldn't know he associated with such a primitive dolt. He wondered if everyone in Iowa ate pie with a spoon, when even people in Kansas where he came from had better table manners.

I visited Kansas City after being

63

gone for many years, and the old gang held a welcome back lunch for me at Kelly's. The food at the bar was limited, so they brought a pie and a package of spoons. "In honor of your return, Dean, we are all going to eat our pie with spoons." And they did. Even the impeccable gentleman from Kansas who had never before embarrassed himself in public...except for the excusable laughing fit at Hal Holbrook's performance.

The last time I met Bob was in 1969 when I had just moved to Los Angeles to try animated cartooning. Bob was back on the Hallmark staff then and visiting Los Angeles to contact several Hallmark freelance people. Bob and Alan Denney invited me to meet them for lunch at a small restaurant in the San Fernando Valley. As we sat down to order Bob said, "Do you remember how on your first day at Hallmark the company paid for your lunch?" I didn't remember that, but said it was a nice thing to do. "Well," Bob continued with a big grin on his face, "This is your first day in Los Angeles, and we don't do that here."

Politics of management at Hallmark forced Bob into early retirement, and he was angry for a while. But he had saved enough to live well, so in a few months he began to enjoy retirement. Then he was hit with cancer, and didn't have another year to live. Jan Coffman came from New York to help him in his last months. Bob had an irrational fear of rejection, and I have an irrational fear of expressing plain sympathy. I had to write something, but I couldn't just say I was sorry to hear he was fatally ill. I said that, and then had to add, "The secret to good health is eating your pie with a spoon. Try that if nothing else works." I hope he laughed. But if he didn't, I hope he forgave me. He was the first of the Old Gang at Hallmark to go, and not able to attend the 31 year anniversary of the Hallmark Contemporary department in 1987.

I LOVE TO CHEER UP SICK PEOPLE!

I'LL COME BACK WHEN YOU'RE FEELING BETTER.

© Hallmark Cards, Inc.

Dean Norman, writer
Bob Harr, artist

64

DEAN

Chapter 12: Rosie and Alan

When Rosemary Leitz interviewed for a job at Hallmark in 1952, an executive showed her a writing requisition form that asked for a four line verse to wish a Mother Happy Birthday. "Do you think you could do that?"

"Oh, that would be hard!" Rosie said. She was hired anyway, because a lot of writers had quit recently and the Editorial department needed new bodies.

When a few artists and writers with no previous experience in greeting cards were hired for the Studio department in 1955, McCloskey wanted one writer-editor with greeting card experience. Rosemary Leitz was transferred to the Studio department, because she was the writer the boss of Editorial most wanted to get rid of. Rosie often came to work a few minutes late, and spent a lot of time chatting with fellow workers. She produced about four card verses a day, half as many as the boss would like to get from a writer. When she had been at Hallmark for one year, she asked for an extra week of unpaid vacation so she could take a three week trip to Europe with an old friend. The boss said she would have to quit, and hope she could get her job back when she got home from Europe. She quit, and he was unable to hire a replacement in three weeks, so he grudgingly took her back. Now he had his revenge, by sending her to the new Studio department which might fail and be eliminated soon.

Rosie had an interesting way of explaining why she was chronically late to work, to movies, to any event. "I think if I have to be somewhere at 8:00 o'clock, I should be able to do something else up until 8:00 o'clock. I resent having to stop my other activity an hour or so before 8:00 o'clock just to get ready and travel." When she married Lowell Smithson he tried to trick Rosie into being on time by setting their clocks ahead. But she caught on to this and began to delay preparations for events even more. People who were going with them to a play would say, "We'll meet you there!" If they traveled with the Smithsons, all of them would arrive after the first act had begun.

But once Rosie was actually at work she was prompt to attend meetings etc. She would get back to her desk maybe 30 seconds before lunch hour was over, or maybe exactly when lunch hour was over. When she was a writer in Editorial it made the boss very tense. He would always notice exactly when any writer arrived back from lunch. The boss, of course, would be back from lunch ten minutes early to be able to monitor this important factor. One day when Rosie came back from lunch exactly at

the end of lunch hour, the boss couldn't stand it any longer. "If you keep cutting it so close, some day you WILL be late!" he told her. Getting chewed out for ALMOST being late was really too much to endure. So she was glad when the Editorial boss transferred her to the Studio department where performance at writing and editing would be more important than prompt attendance.

Rosie continued to come to work a few minutes late on most days, chatted a lot with the artists, and wrote about half as many cards as a top writer might produce. But she wrote good stuff, and organized the editing of the card ideas. However, she did not organize things very efficiently. McCloskey would ask her to make a big chart of where things were and where they were going. A week or so later he would ask about the chart, and Rosie would say, "Gosh, I asked all of the artists, but none of them wanted to do it." A tough boss might have said, "It's your job to ORDER them to do it!" But McCloskey was cool enough to let it go. A bit of disorganization and procrastination became her style. Technically her job would make her supervisor of writers, but there were no other writers in the early Studio department. When some more writers were hired, she didn't supervise them closely either.

When I asked Rosie to check this chapter for accuracy, she mentioned several things that I had failed to notice while I was busy writing and drawing cards. Her words correct my ignorance. "Actually, I made assignments to the artists, did all the contacts with freelance writers, planned idea sessions, worked with the line planning, Jack Jonathan for everyday cards & Ed Clatworthy for seasonal cards, and went to OK Committee meetings with Joe Kipp. It was really a supervisor's job, BUT they didn't have supervisor's salaries for women. Alan Denney, the Art Director, made almost double what I made. The company was quite sexist then, and women like me were too dumb to know it. But I don't mean you should put this in the book." (Oops, sorry Rosie, I just did.)

Hallmark was shameless about their sexist wage policy. They published a card that said, "How can a working woman get a man's salary? Get married." I don't think Rosie wrote it.

Paul Coker was the Art Director of the department, and he and Rosie had similar supervision styles. If an artist asked Paul, "How should I draw this?" Paul would say, "Draw it the way you want to." When Paul went to New York, Alan Denney became Art Director. Rosie and Alan became the team of supervisors that directed the Contemporary department to its best work.

McCloskey wanted to hire Alan Denney after his first interview, but Alan wanted to get a raise if he changed jobs, and this meant a salary about $100 a month more than any artist in the department was earning. Rosie and the others had seen samples of Alan's work, and they pleaded with McCloskey to hire Alan. "We won't be jealous and ask for raises. Well, not right away, anyhow. Alan is so good, please hire him." Alan had been a student at The Kansas City Art Institute, and was Art Director at KCMO-TV doing occasional drawings and lettering signs. He didn't have a lot of cartoon art to show, but his lettering was very funny. Some of the best were signs he made for his wife, Dodo, to use on her TV show. Dodo created a character named "Marilyn the Witch" who introduced late night horror movies. When I saw the show one night Marilyn the Witch was taking a belt from a big jug of black liquid labeled "Grasshopper Juice".

So Alan came to Hallmark and maybe to justify his high salary he was made Art Director. He was sent to Hallmark supervisor training meetings, and given a supervisor's manual. Alan was told not to reveal any of the supervisor secrets to his

DEAN

subordinates, but he couldn't resist sharing some goodies with us. "May I have your attention everyone!" he shouted one morning. "I just want to read you something from the supervisor's manual. It says that whenever I am going somewhere in the building, I should look busy and important by walking swiftly and carrying some papers. I have to make a swift walk to the toilet now, so does anybody have some toilet paper I can carry?" Then he shut the book and told us if we were good children, he might read us more goodies from the supervisor's manual from time to time.

Alan gave the manual to a friend who was a psychologist to see if he could analyze what was wrong with Hallmark. And though the manual was entertaining, Alan said the supervisor meetings were too dull and he never attended another one. He had even less desire than Paul Coker to supervise people. Alan not only advised artists just to draw the way they wanted to, he teamed up with Rosie to distort the corporate system. When Mr. Hall wanted to reward Contemporary artists with bonuses for good work, Alan told us we would all get the same amount of bonus money each month. There were categories such as Best Selling Card of the Month, Most Innovative New Art Technique, Best Idea of the Month, Best use of Color, Best Lettering, etc. He and Rosie decided who got the awards. Alan explained, "If we do this legitimately, some people will get more bonus money than others, and that will just make us jealous of each other. We're all doing our best work anyhow, and these bonuses won't make us work any harder. I asked McCloskey just to give everybody a raise, but he said we could only have the extra money as bonuses, and it would make Mr. Hall mad if we turned down the bonuses."

Alan had a similar system for keeping attendance. "I have to fill out this tardy report every week, so I am going to give everybody two late marks each week. I know some of us come to work on time every day, and some of us come in late every day. But if management sees that on a report they will just come down on the people who come in late. Everybody is doing as much work as they would do if they were on time, so there's no point in a legitimate tardy report. When management sees everybody is late sometimes, what can they do? Do they want to fire all of us, or harass all of us and make us unhappy? Probably not, so long as we're doing good work."

As Art Director Alan could assign the finished art to the artists he wanted to draw each particular card. He handled this in a relaxed fashion also. Artists would do sketches of ideas that they got from freelance or wrote themselves. When a sketch was approved for finished art, the same artist did the finished art. This could mean that one artist was doing a lot of finished art, and another doing very little. But this gave the artist who had bombed out at approval meetings more time to do more sketches for the next group, so he would probably catch up. It also gave every artist incentive to do really good sketches, and no one could accuse the Art Director of

giving the best stuff to his favorites.

Rosie assigned the ideas for sketches in a similar relaxed fashion. All the ideas without sketches were put in an envelope and circulated to the artists, not in any particular order. If you wanted work you asked for the envelope, picked out ideas you thought would make good cards, and passed the bunch on to someone else. Branham was often not there during the day, and would get last look at the ideas. This was when we noticed his knack of seeing potential in ideas others had passed up. Any ideas that no artist wanted to sketch were considered rejected.

If Rosie really liked an idea that nobody picked she would beg somebody to sketch it. "Please, Mr. Alan, just do a little quick drawing for this really great potential best seller that will make you look like a genius." She would say this in a voice imitating radio comedienne, Portland Hoffa, who was married to Fred Allen. All of us had grown up on a diet of radio comedy--Jack Benny, Fred Allen, Fibber McGee and Molly, Charley McCarthy. We looked to them for inspiration rather than to former funny greeting card greats of whom there were none.

Mr. Alan was likely to answer, "What do I get if I do this favor?" in a voice that implied lechery. Rosie might lift her skirt and show a bit of leg, and Alan would sigh, "That's not good enough, Leitz. You'll have to rewrite this dumb gag and make it funny."

Most of us were just out of school and on our first jobs, and we didn't appreciate how much creative freedom this job gave us. Anything we wrote was passed around to a group of artists, and if just one of them liked it, it got by the first hurdle. Anyone who could do sketches, even just stick figures, could get by this first hurdle by sketching his or her own ideas. Some writers with no previous art training taught themselves how to draw just to get their ideas by the first hurdle. Then they got better and started doing finished art. Similarly, some artists taught themselves how to write when they thought the pickings from the envelope didn't amuse them. There was no supreme Editor or Art Director who rejected material at the first step. Well, Rosie rejected some freelance submitted from outside the company, because she had to justify payment otherwise.

After the sketches were done, there was another group process that subverted the corporate system of Editor and Art Director. The sketches were passed around in an envelope, and each artist and writer voted "yes" or "no" on all the cards. "I know you will all vote "yes" for your own cards," Rosie explained, "but do try to be impartial on the others. Don't let your hatred or love for any particular individual influence your judgment. Just think of what is best for the company, because we are all Hallmarkers, right?" The card sketches that received mostly "yes" votes went on to the next hurdle. The sketches that got mostly "no" votes were rejected, not by Rosie or Alan, "but by a Jury of your Peers."

The sketches that received nearly an equal number of yes and no votes then might be sent on or rejected depending upon how Rosie felt about them. She did exercise some editorial judgment here. She might say something like, "Of course I love this idea, and some others loved it, but you can see that some of us hated it. Please don't try to find out who they are and seek revenge. But after due consideration it is an idea that is very much like many that have been done before, so we would like to try something more different. Do try to come up with something different next time."

We just couldn't get mad at Rosie or Alan. They would push our best stuff to the top, and give us every reason to do good work. Many of us voted along the same

lines. We would vote "yes" on ideas and art that was different, and "no" on ideas that were o.k., but were very much like something that had already been done a lot. We didn't want to get bored with our work. We wanted to try new stuff, and see the new stuff get approved for publication.

I have never worked at any other creative job where the inmates ran the asylum, so to speak. Rosie used to tell us she was our nurse, not our editor. It was her job to cheer us up each day and get us in a good mood to do good work. I believe Alan may have named her the nurse. The two of them chatted a lot as we worked, mostly insulting each other and the rest of us.

One quiet day as the pens were scratching on paper Alan remarked, "Rosie, why do you wear THAT dress? When you stand in the light, I can see right through it."

Rosie stood up, lifted her skirt a little above her knees and said, "That's WHY I wear it, Mr. Alan."

Alan sighed, "And that's WHY I asked you why you wear it."

Rosie might have given Alan the nickname as the department NAZI. During a game of "What movie star do you look like?" someone recalled that Alan looked like an actor who had portrayed a NAZI officer in a war movie. He was so laid back, gentle, and unauthoritarian that it was a reverse nickname, like calling a fat person "Tiny".

They looked at Bob Harr and Rosie said he resembled Leslie Howard who had been Ashley Wilkes in *Gone With the Wind*.

"Yes, but he's not as skinny," Alan said. "Bob is sort of a fat Ashley". So "Fat Ashley" or just Ashley became Bob's nickname, and he proudly signed notes and letters "F.A."

Bob was not able to give Rosie a similar nickname, but he retaliated by making jests about her small boobs, and described her in a way that she treasures today. "Rosie, if you weren't too tall, you would be nothing."

happy birthday

to a very sweet girl!

Rosemary Leitz, writer Alan Denney, artist

I should say that Alan was also an excellent cartoonist. He looked at Coker and Branham's work, and borrowed thoughts, but did not copy a style. He worked out a unique style more similar to Branham than anyone else, and added wildly funny lettering. All the artists created their own distinctive lettering styles, or used a variety of styles. Alan's lettering where all the letters were of a different size and yet of the same style, and never set on a straight line, almost became universal in studio card lines. Some artists at other companies copied it continuously, and many of us at Hallmark did variations of it on our cards. American Greetings even had the style set in Art Type, and copyrighted it, so their artists could use it by just pasting it up. But Alan loved to letter so much he did it new on each design. One time he and Lou Marak collaborated on a group of cards. Lou drew all the characters, and Alan did all the lettering. Two versions of Denney lettering fonts are available on a web site *www. haroldsfonts.com.*

Rosie and Alan's system of encouraging new ideas, discouraging repetition of old themes, and giving every writer and artist a say in judging the ideas, had this effect-- Mr. Hall and his final judging committee only saw good new stuff. They could reject some of it, but they had to print something. If a good card was rejected for a silly reason, Rosie would put it away and bring it back to the OK Committee later. Then it would seem familiar to them, and it was usually approved. So everything that was approved for publication was good new stuff. It made Hallmark Contemporary Cards the funniest new thing in greeting cards. Rosie and Alan should have written a supervisor's manual. But then, a good supervisor would throw away any manual and invent his/her own style.

Chapter 13: The New Boys--Lou, Dean and Dick

Each new person hired for the Contemporary department was called "The New Boy". Rosie would pretend that she couldn't remember the person's name, and say, "Oh, New Boy! Will you come here a moment?" Then she would critique the New Boy's writing or art. "This shows a lot of promise. I think if you stick with it you'll catch on someday. Everybody come here and see what the New Boy has done. Isn't it wonderful?"

It was a test to see if you could take some kidding and come back with anything amusing. Most New Boys got through the testing period without any resentment, and the period was usually short because soon someone else would be hired and become the New Boy. When I transferred to Contemporary, Lou Marak was no longer the New Boy. When Dick Noel was hired, I was no longer the New Boy. Dick was a smart aleck who delighted in sarcastic repartee, and seemed to take the New Boy title in good spirit. He had been there about two weeks when Rosie invited the staff to a party at her apartment. Dick cornered Rosie and said, "Now that I have broken bread at your place, you won't call me the New Boy anymore, will you?"

"Oh, no!" Rosie exclaimed. "You are the New Boy until we hire another one. You can't get out of it any other way no matter how long it takes." Dick tried several arguments and we could see that being called the New Boy really bugged him. So we kept at it. Dick had no problem dishing out ridicule to others, so he had to learn to take it to really be one of us.

One day we were brainstorming ideas for Valentine cards, an artist had drawn a couple of turtles in love, and we were trying to think of a funny gag line. Someone said, "I wonder how turtles make love?" Dick Noel took the question to Lou Marak.

"Lou, you are a country boy. Do you know how turtles make love?" Lou was indeed a country boy. We had enjoyed his stories about his boyhood, thinking at first he was making them up to amuse us, but he insisted they were true. His farm in Oklahoma did not have rich soil. In 1930s and 1940s Lou grew up like Li'l Abner in Dogpatch. "I went to this one room country school," Lou said. "When the weather was warm I went barefoot to save my shoes. A girl sitting at a desk in front of me was too shy to ask to go the bathroom, and one day she peed on my feet.

"My mother used to bake bread for the week every Saturday. I was ashamed of my school lunch sandwiches, because they were made from homemade bread. The rich kids had store-bought bread. I used to hide my sandwich in the paper bag as I ate it so nobody could see the bread. Man, I wish I had some of that good tasting bread now!

"One time our family yeast almost died. My mother baked bread from a yeast culture that had been in the family for generations. She fed it cracker crumbs, flour and a little water and other stuff, and used a bit of it for every batch of bread. Well, Mom was sick in the hospital for a long time, and our aunt who came to keep house for us couldn't figure out how

to properly feed the yeast. Mom told her, "Just a pinch of flour, a smidgen of crumbs, and a little water that is warm, but not too warm." Mom never cooked with any exact measurements. The yeast got weaker and weaker and the bread got tougher. Mom got out of the hospital just it time and saved its life. But it took a long time to get the Marak family yeast back up to full strength, and our bread back to its best flavor.

"There was a neighbor family that always brought homemade ice cream to church picnics. Nobody wanted to eat it, because they let their cow get into the onions in their garden. I guess they got used to milk and ice cream with onion flavor, but nobody else liked it.

"I hated sports, but there were so few boys in our school they made me play them. Because I was a big kid they thought I should be good at sports. I would be in the outfield on the baseball team just praying no one would hit the ball at me. The only thing I was good at was art. I got poor grades in everything else. That's why I came to Kansas City to enter the Art Institute. I didn't have to take any academic courses there. When I told people at home I was going to study art in Kansas City, they said, "You better be careful in the big city, Lou. There's lots of them queers up there. You gotta watch out for 'em."

"So when I got to my room in the dormitory, my new roommate had taken off the Army blanket I put on my bed, and replaced it with a frilly quilt just like he put on his own bed. It had little puffballs all around the edge. I thought I was in trouble now, but it turned out the guy was just fancy...not homosexual."

But to get back to the question, how do turtles make love? Before Lou could answer Dick, I said, "I'm sort of a country boy, too. I played with my cousins on a farm in Iowa, and played in the woods and fields behind our house at the edge of town in Cedar Rapids. I've seen turtles make love. Of course, they have to take off their shells to do it."

Dick thought I was making this up, and turned it back to Lou, "Is that true?"

Lou wasn't a writer. He never made things up. He just amused us by telling true stories. So Dick believed it when Lou said, "Yeah. If you go down a country road on a warm spring night, you can see empty turtle shells by the side of the road—lined up in pairs. And you can hear the turtles making love back in the bushes."

Dick was delighted by this picture, so both Lou and I added more strokes to it. I forget which of us said what, but we both made up stuff and the other added to it. "Sometimes we would take flashlights and sneak back into the bushes. Then snap on the lights and holler. The turtles

would come running out and jump into their shells. That sure was funny to see."

"Yeah, and sometimes we would mix up the shells before we chased the turtles out. Switch big shells and little shells. You would see a little turtle with his legs barely sticking out trying to run in a big shell. And a big turtle trying to stuff himself into a shell that was too small."

Dick laughed at our story, and we thought he knew it was a hoax when it got so extreme. But Dick went to another department and started telling it to a friend. The friend broke up with laughter, because he thought it was funny that Dick really believed it. Dick argued, "Lou Marak told me, and he's a country boy! He knows!" Dick came back to us for confirmation and we had to tell him the truth, because now the truth amused us more than the fiction. Dick swallowed his pill of humiliation, but he still wanted to know. Did Lou know how turtles REALLY made love?

"Yeah," Lou answered. "It looks like two little Volkswagens bumping back to back."

Dick Noel came to Contemporary as a potential writer. It took a while for him to write something that got approved. It bugged him when all the artists passed over his ideas, so he began doodling sketches to get his ideas past the first hurdle. He had no art training and appeared to have no potential for becoming an artist. But he kept doodling until his doodles became wild and funny cartoon characters that fit his unique humor. Then Dick was a writer/artist doing finished art on all his accepted ideas. He had a long career in greeting cards with Hallmark, The Drawing Board and Oz Cards.

Stop feeling so sorry for yourself — I have an uncle who's been a shut-in nearly all his life and he still manages to keep busy and alert.....

..he runs the prison newspaper.

Dick Noel, writer/artist

Dick Noel was one of the few who especially got the attention of Mr. Hall. Not long after the day in 1963 when President Kennedy was assassinated, Dick was delivering some freelance work to the Hallmark studio. He had been in and out of the building many times over a period of several years, but the guard at the desk in the entryway didn't recognize Dick on this day.

"Who are you? What are you doing here?" shouted the guard.

Always good at spur of the moment comedy, Dick replied, "I'm going to shoot J.C. Hall." Before the guard could react the elevator doors closed. Dick's edgy sense of humor didn't always get a laugh, and certainly not on this day. Dick delivered his

drawings to McCloskey, chatted a while, and then went home unaware of the frantic search for an assassin that was going on in the building. When the search reached Contemporary, McCloskey figured out whodunnit, and told the guards that Dick was weird but not really dangerous. Dick was barred from the building for a while, but managed to keep his freelance contract. You can't blame Mr. Hall or the guards for taking the joke as a serious threat. Mr. Hall always remembered how a disgruntled freelance writer had shot and killed Paul Volland of Volland Card Company. It's surprising that Mr. Hall was generous enough to allow Dick to continue to sell work to Hallmark after the bad joke.

Several versions of the story developed in the retelling. In one version Dick was supposed to have said he was going to blow up the building. In another a guard supposedly caught Dick, slammed him against a wall, and McCloskey got between them to protect Dick from a beating. Nancy Saulsbury, a Hallmark editor, said Dick once visited her home, told her all the versions, and insisted that the first one told here is correct.

Phil Hahn and Dick were roommates for a while when they both lived in Kansas City. Phil moved to New York, and invited Dick to visit him one winter at a rental cottage near a Vermont ski lodge. They were both working freelance then and they figured, "What does it matter where we are or what we are doing so long as we knock out a few greeting card gags each day?"

Phil was a good skier and spent a lot of time on the slopes. After a few days of hanging out in the ski lodge bar, Dick figured he might as well try skiing. He fell off of the lift chair into deep powder snow and couldn't get up. Fortunately he was face up, and he hadn't spilled his beer. He waved the beer bottle and shouted to people going by above him on the chair lift, "I need help! Send the ski patrol." A rescue arrived in due time, helped Dick to his feet and down the slope.

HELP !

DEAN

Dick decided the hell with skiing, and got a part time job tending the bar. One afternoon he was alone on duty, and a big guy at the bar was harassing a nice lady. The guy got more aggressive and the lady got more distressed. Dick looked around for a bouncer, but he was the only one working. Dick was a short guy with coke-bottle glasses, so he would need some help to throw out the big harasser. He remembered a scene from bar fights in western movies--break a beer bottle and charge with the jagged glass end.

So Dick suddenly grabbed an empty bottle and whammed it on the edge of the bar. It didn't break, so he whammed it several times. The bottle still didn't break, but Dick's wrist almost did. He dropped the bottle, grabbed his wrist in extreme pain, and said to the damsel in distress, "Aw the hell with it! You're on your own!" Everyone in the bar laughed, including the mean harasser and the distressed lady. Dick went outside and smoked while people in the bar took care of themselves. It took a week for his wrist to heal enough so he could pull the tap in the bar, and he decided never to try to be a hero again.

Years later Phil Hahn recalled the last time he spoke to his old skiing buddy. Dick called Phil and said, "Guess what? I'm an alcoholic."

"Of course you are," said Phil. "Everybody knows that."

"Why didn't somebody tell me?"

"We thought you knew."

"And guess what? I'm depressed."

"Of course you are," said Phil. "That's why you are an alcoholic. Are you getting any help?"

"Yes," said Dick. "I'm taking some medicine, and I feel better except for one thing."

"What's that?"

"I've got cancer."

Dick didn't live much longer after that phone call. He may have hit some people pretty hard with his edgy humor, but he hit himself just as hard.

I can't remember any tough hazing when I was the New Boy, but I remember the day when most of the staff poked fun at me when I thought I might be choking to death. They weren't being cruel, because they didn't think that I was choking. I began to talk while swallowing a bite of lettuce at lunch, and the lettuce caught for a moment in my throat. I coughed and slugged some water, and it seemed to go down. But then when I tried to speak, my throat slammed shut. Rosie, Alan, Lou, Bob, Dick and others were asking me if I was O.K., and making jests while I tried to explain my problem. I took several long breaths through my nose, and everything seemed fine. But each time I tried to talk my throat would slam shut, and I couldn't speak or breathe for a moment.

I never was any good at charades, so my gestures only stimulated my friends to make more jests. I looked for something to write with or on, and couldn't find either. So I got up and calmly walked from the table, took the elevator to the 8th floor, and returned to my desk in the Contemporary department. No one else was there as I wrote a note saying, "I can breathe, but I can't talk. I think something is caught in my throat. Will you drive me to the hospital?"

Lou Marak walked in just as I finished the note, so I handed it to him. He grinned as if he thought this was another jest, but when he looked at my pitiful face he took the note seriously. I kept expecting the piece of lettuce to slip into my windpipe and stop me from breathing, so it seemed like a long drive to the hospital. A doctor assured me that nothing was blocking my throat or windpipe. The lettuce had scratched my throat slightly, and every time I tried to use my vocal chords the muscles would temporarily spasm and shut off my breathing. The remedy was to avoid talking for a day or so, and eat soft food. I wrote a note for my wife, and Bette enjoyed the few days of being able to say things to me without fear of contradiction or ridicule.

Chapter 14: More New Boys

Another New Boy, Jerry Roach, had eaten lunch with us in the cafeteria for only three days, when he said, "Well, I've had the weak stomach test for three days now, so I guess this means I'm accepted." We didn't know what he meant so he went on, "Well, the disgusting subjects of conversation at these lunches would make some people vomit. But I haven't, so you might as well stop trying." We denied that we had been talking disgustingly, and couldn't even recall anything we said that would turn someone's stomach. We insisted we just had fun, and let our conversation go wherever anyone wanted to take it. Then Jerry did something that gave us enormous joy. "Damn, I've done it again," he snorted, and coffee was dripping from his nose.

"Did what?" we asked. "Why are you snorting coffee?"

"My nose is so long I have to be careful when I drink, or I dip my nose in the cup. See?" and he took another sip to demonstrate. He had to purse his lips far out and sip very carefully, and the end of his nose was just barely above the surface of the liquid. With another person we might have run with this and made nose jokes. But Jerry was good looking, and no one had even noticed that his nose was longer than average. Jerry was one of us with no intensive teasing needed to improve his sense of humor.

Bruce Cochran was a New Boy who came to us with an odd story. While a student at the University of Oklahoma, he entered and won a college cartoon contest sponsored by Box Cards. First prize was a trip to Paris, and a chance to work for Box

Sorry I made one of myself

© Hallmark Cards, Inc. Bruce Cochran, writer/artist

Cards. Bruce had just returned from two years in the Philippines with the Army and was a newlywed. He had no desire to travel, especially not without his new wife. So Bruce declined first prize. Box gave him second prize, $250, and told him to start mailing them greeting card ideas. He did this for a few weeks, and got no response. Bruce needed a job right away, so he applied at Hallmark and was hired.

Bruce was a moderately tall, handsome guy who stuttered. It would have been cruel for us to give him a nickname that called attention to his stuttering. So we called him by his real name. "B-B-B-Bruce," Jimmie called out. "Would you please come here and try to explain the humor in this idea you submitted?" Bruce appreciated our sensitivity and was immediately one of us. He had a long career with Hallmark and has drawn cartoons for many publications including *USA Today*. Box Cards either dropped the ball, or they just couldn't hire another person at the time.

Bruce told me, "I'm not surprised that Box Cards didn't offer me a job. The card ideas I sent to them were shitty."

Bill Box wrote to me about the Box Cards contests... "Bill Brewer was the winner of the first event. (1958) The judges were Al Capp, Steve Allen and Groucho Marx. Bill had an enjoyable trip to Paris and a job with Box Cards. We had the benefit of Bill's talent, and his appearances with Steve Allen and Groucho was an added publicity bonus for our company. The second contest didn't have the same success. The winner, Bruce Cochran, didn't wish to take the first prize trip to Paris and settled for the second place prize. There were only two contests."

Kipp Schuessler, a close friend of Bruce since high school days, was a big guy who had a big head. A handsome face, but a really big head even on a big guy. Alan Denney had a small head, and when Alan and Kipp walked side by side it looked like Contemporary department was a freak show. Branham initiated Kipp by drawing a caricature of the staff depicting Kipp holding his head on a string like a huge party balloon. When other attempts at nicknames failed, Rosie fell back on an old trick that had worked on a southern boy. She called him Kippy Joe even though he had no Deep South roots. Kippy Joe was drafted soon, and we didn't believe the Army would keep him. How could they find a helmet big enough to fit? Would they have one custom made just for a draftee? Would he frighten the enemy when he peeked out of a foxhole, or just make them laugh? Kippy Joe came back from two years in Germany bragging that he had seen Elvis Presley driving a jeep for a general. He seemed to resent that he had to do ordinary duty while Elvis got to be a VIP jeep driver. The general would impress people by saying, "You won't believe who my jeep driver is!"

The story in the newspapers was that Elvis refused to spend his two years of Army duty as an entertainer. He insisted he was just another draftee, and multi-million dollar movie contracts were cancelled while Elvis drove the jeep for the General. I always thought Elvis was sort of a folk hero for refusing to be a military celebrity. Anyway, Kipp got over his Elvis envy and enjoyed a long career at Hallmark.

The testing of New Boys for a sense of humor included people who didn't work in Contemporary, but visited us often. Bill Cunningham was a new writer for Hallmark company publications. Bill had known Alan when they both worked at KCMO-TV, and Alan and Rosie had persuaded Bill to apply for work at Hallmark. He came into the studio a few times for official reasons, but came back many times just for friendly conversation. We started calling him by his first two initials, W.W. He was a slender, good looking guy who did have one noticeable feature--a nose a bit larger than average. Rosie and Alan picked up on this and nicknamed him "Hawk".

He took this new nickname with good grace, so we figured it didn't bother him and he was one of us.

Bill didn't tell us that he didn't like being called "Hawk". The reason his nose looked sort of beaky was because he had broken it when he was 9 years old. This was during the depression years in the 1930s, and his parents couldn't afford to take him to a doctor for such a minor thing as a crooked nose. But when he was in a hospital to have tonsils and adenoids removed, Bill's father asked the doctor if he could straighten the kid's nose while he was at it?

"Sure", said the doctor, and he punched Bill to simply smash the nose and make it a bit straighter on his face. So Bill grew up with a beaky nose and a deviated septum, and never enjoyed it when kids teased him about it.

Dr. Leitz, Rosemary Leitz' father, once performed a similar operation on his daughter. Rosie had a lump on her wrist. Her Dad said, "That's just a harmless cyst. Nothing needs to be done about it." But Rosie said it looked awful and begged him to get rid of the lump. So Dr. Leitz said, "O.K., bring me that big medical book on top shelf of the bookcase." Then he told Rosie to put her hand on a table, and he slammed the cyst with the big book. It hurt like hell, just as Bill Cunningham's nose had hurt like hell when the doctor punched him.

But to continue Bill's story, one day we heard that Hawk had a bad auto accident and was in the hospital with multiple injuries. He would probably survive, but in what shape? His mother came to the hospital that night and when she saw Bill bandaged like a mummy she could only stammer an old cliché, "Didn't I always tell you to never wear holey underwear when you go out? I hope you weren't wearing holey underwear."

The nurse said, "Don't worry, Mrs. Cunningham. We had to cut it off him anyway, so it was a good thing he wasn't wearing new underwear."

Bill recovered from his injuries with no handicaps, and the near death experience led him to resolve to live a better life from now on. He decided to get his nose fixed and improve his breathing and appearance. It was about a year later when Bill took three weeks vacation for the nose job. He returned to work hoping nobody would notice, but Lou Marak who was always studying faces and sketching them spotted the change immediately.

Jimmie Fitzgerald said, "You didn't? You aren't Hawk anymore. Your nose gave your face character...like Cyrano. Now you are just a pretty perfect face. A nebbish."

"Should I get my old nose back?" Bill asked.

"Oh, don't bother to do that. But please understand that we can't call you Hawk

anymore. You are just plain Bill. Or we can still call you W.W. if you like that."
W.W. had a long career at Hallmark as a writer and director of creative departments.

I recall one artist who misunderstood the humor test. Bob Schneeberg was a New York artist hired to do some freelance work. We had seen his work in prominent magazines and liked it, though it was not cartooning that would be used in Contemporary cards. It was more high style design that would be used in conventional cards.

Bob visited the studio a few times, and the routine was to be very business like and polite to new visitors the first time around. No teasing unless they seemed likely to come back more than once and would enjoy teasing. Bob went back to New York and we heard that he had gotten married. "He's on a two week honeymoon now," McCloskey told us, "and after that he's coming to Kansas City for more assignments."

When Bob Schneeberg walked in the door one morning, Rosie, Alan and Bob Harr immediately began throwing spears at him. "We heard you got married. Is your wife pregnant yet? She must be a good cook, because it looks like you are putting on weight. Or maybe it just looks that way, because you are losing some hair."

Schneeberg didn't say anything and turned to walk out. Alan shouted, "Don't come back, or you'll get some more!"

When he was gone Rosie said, "Do you think he was offended?"

"How could he be offended?" said Alan and Bob. "We don't tease people like that unless we like them. Isn't he one of us? Doesn't he know we like him?"

Later that day McCloskey came into the studio and demanded, "What did you do to Bob Schneeberg? He's telling everyone that you are the meanest people he has ever met. He will never have anything to do with you again."

We repeated what had been said, and McCloskey agreed that it was pretty mild teasing, but apparently Schneeberg hadn't taken it that way. We considered sending an apology, and then decided not to. "If we have to be nicey nice to someone because he can't tell the difference between a real insult and a joke, it's no fun having them visit us," said Alan. "He could have told us when he was here that we were making him mad, but he sneaks off and tells everyone else we are bad people. Let him come back here if he wants an apology or an explanation, or let him stay away if he prefers." We all agreed with Alan's assessment, and Schneeberg never came back.

Jacques Ferrand could have been expected to misunderstand our teasing, but we gave him the humor test anyway. Jacques knew practically no English words. He came from France to do some freelance illustration for conventional cards. Jacques drew a little cartoon of a mermaid with bare breasts, and the conventional art department decided the lecherous Frenchman should not be close to the all-girl art staff over there. So Jacques was placed at an empty drawing board in Contemporary where he could work on his assignments. McCloskey explained that he wasn't doing any cartooning for us, and would only be there a couple of weeks. We weren't sure what Jacques understood, because there was no interpreter present. Rosie had studied a little French in college and remembered practically none of it, but tried a few phrases with Jacques anyway.

About 15 minutes before lunch time, when Jacques had been working quietly for an hour or so, Alan and Rosie had a plan for the humor test. Alan whispered it to me, "Rosie will go over to his desk and look at the drawing he has been doing. It's not supposed to be funny. It's a pretty Christmas scene. Rosie is going to laugh and call us all over, and we will all laugh and say it is the funniest thing we have ever seen." The plan was put into action, and Jacques sat with stunned perplexity on his face. What was so funny about his pretty painting?

Then Rosie borrowed his tiny pocket English-French dictionary, and looked up the word for "joke".

"Plaisanterie! Plaisanterie! We are only having plaisanterie...joke...with you," she said.

"Ah!," Jacques smiled. "Plaisanterie!"

"Yes, plaisanterie! plaisanterie!" everyone repeated many times.

Then Jacques walked to an empty table, beckoned all of us to come to him, and repeated "plaisanterie" as he took some items out of his suit pockets and put them on the table. Jacques carefully folded a cigarette paper lengthwise, and stood it on end inside of an ash tray. Then he lit a match and started the paper burning at the top end. As he did this he said "Russian sputnik." The paper slowly burned down to the bottom, and then a little piece of fine gray ash floated gracefully upward and across the room. We made admiring noises, because it was a surprise. But Jacques wasn't finished.

DEAN

Now he took a cigarette paper from a different brand package, folded and lit it in the same way. "American sputnik," he explained as the paper burned. When it burned down to the end, instead of lifting into the air, the ash fell sideways into the bottom of the ash tray. "Plaisanterie! Joke!" Jacques grinned elfishly. This was 1958, a time when the Russians had successfully launched satellites that orbited the Earth, but the U.S. rockets had crashed and burned on the launching pad.

Alan let Jacques know in no uncertain terms how we took his little plaisanterie. "Oh, shut up, you little French Frog. Put away your toys and come to lunch with us." As soon as we were seated in a restaurant, Alan said, "Are you Jewish?"

Jacques said, "Jewish? What kind of Jewish? Orange Jewish? Grape Jewish?"

The personal question had come out of nowhere, and apparently Jacques thought we were asking about what he wanted to order for lunch. Rosie laughed and grabbed his dictionary to find how to explain that Alan was asking about religion and not fruit juice. Then Jacques smiled and said, "Ah! No, not Jewish. Catholic." After a pause he added with emphasis, "But not church going!"

Rosie smiled and pointed to Lou Marak as she said, "Lou is church going Catholic!"

Whenever Jacques visited Hallmark he went to lunch with us, and learned English by exchanging plaisanteries. He nicknamed us "The Happy People", and was disappointed when they gave him an office instead of an empty desk in Contemporary. "They won't let me be with the Happy People," he said. We assured him that we wanted him to visit us as much as he could. He was one of us.

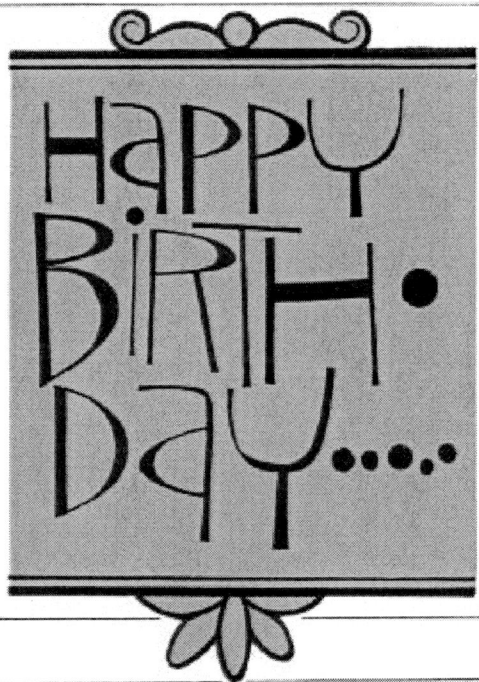

HAPPY BIRTH·DAY·····

···OLD TIGER···

writer unknown
Kipp Schuessler, artist

I'm kind of **FUNNY** about my friends...

...but then I have kind of **FUNNY** friends!

Jimmie Fitzgerald, writer
Jerry Roach, artist

Chapter 15: Conrad Knickerbocker

My professors at the University of Iowa told me the surest way to make big bucks in journalism was to work for company publications. Captains of industry are often inarticulate and dull when making speeches or writing motivational messages to the sales force. A person who can ghost write for the Big Man, and make his speeches and messages interesting will be richly rewarded. The students groaned at this advice, because we were looking for interesting and creative jobs in the media.

Conrad Knickerbocker arrived at Hallmark in the late 1950s, and became the editor of the Noon News. This was a one page newsletter distributed daily to employees in the Hallmark cafeteria. We found it so annoying that we hoped never to be mentioned in it. So when Conrad came to interview me in the Contemporary studio one day, I was very uncooperative.

"I hear you won a big table tennis championship over the weekend," he said. "I want to write it up in the Noon News."

"Uh...no...I didn't," I lied to him. I had won the Missouri State Men's Doubles championship with a partner, and was runner up in the Men's Singles. But table tennis is not a prestige sport with anyone except table tennis fanatics, and he would probably call it ping pong in the Noon News. So for several minutes I kept denying that I had won anything in table tennis.

"Then I guess I have been misinformed!" said Conrad, and he went away very angry. There had been a small article in the Kansas City Star, so he knew damn well I was lying. It was nasty and stupid of me to let my disregard for the Noon News make me lie to Conrad. He was a great guy, and would soon be interviewing much more important people than a local table tennis player.

Bill Cunningham worked closely with Conrad on Hallmark publications and came to know him better than most of us. Conrad was a brilliant man but with many demons haunting him from an unusual childhood. His father H. R. Knickerbocker was a famous author and news correspondent in Berlin in 1936. H. R. got kicked out of Germany for being the first newsman to say something critical about Adolph Hitler. At about the same time Conrad's parents divorced, and the seven year old boy was sent to a military school in Kansas.

After earning a degree at Harvard, Conrad worked for a while for newspapers in Missouri, and then came to Hallmark. Conrad started as the only writer for company publications, and the publications became so much better that his job mushroomed and he was soon hiring a staff to help him. Bill Cunningham was one of the first writers to work for Conrad. And just as my professors had said, when Conrad made Mr. Hall look good in messages to salesmen and Hallmark stores, the Big Man was enthralled. Conrad became the fair-haired boy at Hallmark. Actually, he had flaming red hair, and a personality and conversational ability that flamed also. He dominated a room at a party with his stories and wit, but this dominance did not diminish

anyone else who was there. He noticed everyone, and made you feel that you were almost as smart and talented as he was.

As Conrad got raises and promotions and greater responsibilities he did a good job of keeping a level head. He came around the Contemporary department a lot and became a good friend of many of us. It was clear he enjoyed the company of funny people his own age more than the company executives. He would often sneak us little bits of company secrets, and tell us funny stories about Mr. Hall. We knew he would not stay forever at Hallmark, because he aspired to greater literary achievements, and we knew he would achieve them. But the raises kept coming so fast, it was very helpful to a young man with a young family. He could live well. He bought himself a vintage restored Mercedes touring car. On really nice days he would drive it to work, but most days it stayed in his garage. He worried so much about the car that he wouldn't let his wife, Maggie, drive it. "Well, someday, you can drive it," he promised, "but not yet. It's still a new thing for me, and if it got the slightest dent I would be so upset."

One day Conrad saw an ad for fresh strawberries in the morning paper. "I love strawberry shortcake!" he exclaimed. Maggie promised to make some for dinner that day. "Yes !" Conrad exclaimed, and for comedic emphasis he added, "It will be your ass if there aren't fresh strawberries on the shortcake tonight!" Then he drove to work in Maggie's little Nash Rambler, and left the Mercedes in the garage.

Maggie thought long and solemnly about it. She was a shy woman, and seldom got a word in edgewise whenever she and Conrad visited people. She was not the sort of person to confront anyone. But she had been told, "It will be your ass if I don't have fresh strawberries on the shortcake tonight!", and the only car in the garage was the Mercedes that she had been wanting to drive.

She started the car and sat there trembling as the motor hummed. Finally she had her confidence built up, and she put it in gear and slowly backed...no, she didn't back out of the garage. She had put it in a forward gear and she rammed something at the front of the garage. Ashes from a charcoal grill rose in a massive black cloud, and covered the spotless car with a dark gray film. When she had the courage to look, Maggie saw that the impact was so slight there wasn't a dent or a mark on the car. The only problem was that the car was filthy. Maggie got neighbors and friends to come over and help wash the car and sweep the garage, so that when Conrad came home from work she wouldn't have had to tell him about the incident. But she figured it was better to tell him than to expect her friends and neighbors to strangle on this secret until it got out anyway. She told him and expected a chewing out, but Conrad laughed. If the car had not been O.K., well, no one can be sure how funny he would have thought it was.

Conrad seemed like a supremely confident person, but Bill often noticed little eccentricities that amounted to cracks in the confidence. Conrad only wore Brooks Brothers suits, and the only place to get them in Kansas City at that time was from a traveling Brooks Brothers salesman who would stay at the hotel near the Union Station on occasion. One day a woman in the office noticed Conrad wearing a tie with a bit more flash than usual and said jokingly, "Conrad, that tie isn't you!" The rest of the day Conrad seriously asked people what was wrong with his tie.

Conrad rocked constantly. He rocked in his office chair which was not a rocker. He rocked when he drove a car. It soothed him to be rocking.

Bill showed me a nice article Conrad wrote for Crown magazine about Rosemary Leitz. "He didn't just write it because it was his job," Bill said. "Conrad thought Contemporary was on the cutting edge of good new things at Hallmark. He wanted

the approval of you people in Contemporary. That was why he wanted to write the article about you and your table tennis victories." That information didn't make me feel any better about the lies I had told him.

Conrad wrote book reviews for the Kansas City Star, which confirmed Mr. Hall's opinion that he had a literary genius on the Hallmark staff. Conrad got an advance from a publisher to write a biography of Malcolm Lowry, author of *Under the Volcano*. At the same time Mr. Hall was working on his own biography, and wanted Conrad to write it for him. He wanted Conrad's undivided efforts for the project. Mr. Hall often spent vacations at his house in Malibu, California, but they were always working vacations. He took Conrad with him to work on the biography.

Conrad had spent the advance for the Malcolm Lowry biography on a vacation trip with his family, and now was facing a deadline from the publisher for a first draft which had not been done. The publisher kept calling Conrad at Mr. Hall's house in Malibu. Mr. Hall would be puttering in his garden and suddenly start walking toward the house. Conrad had to hang up quickly and take notes on something Mr. Hall had thought of. At one moment when conversation stalled Conrad said, "I really like that jumpsuit you wear for gardening. It looks very nice." Mr. Hall had his jumpsuits tailor-made. He had visited Winston Churchill when Winston was wearing a jumpsuit, and adopted the fashion. When Conrad complimented the jumpsuit, Mr. Hall said nothing but smiled mysteriously.

NICE JUMP SUIT, J.C.

DEAN

Back in Kansas City a package arrived on Conrad's desk one morning. In it were three tailor-made jumpsuits -- a present from Mr. Hall. The guy who only wore Brooks Brothers suits said, "When in hell can I ever wear these?" But then he had to go into Mr. Hall's office and thank him profusely for the wonderful gift.

One day in 1965 Conrad suddenly leaped to the big time. He was hired to be a book reviewer for the New York Times, so he left Hallmark and moved to New York. His reviews appeared for three months, and some of them are still acclaimed on Internet pages today. Then he died in a gun accident in his garage. It seemed that he had been cleaning an antique gun and accidentally shot himself.

Then an investigation suggested it might have been suicide. Bill Cunningham received a letter a few days after Conrad's death that had been mailed a few days before the tragic event. Bill didn't want to open it. If it was a suicide note, then Conrad's family would not receive double indemnity benefits from his Hallmark insurance policy. When Bill had the courage to read the letter, he was relieved to find it was just a funny, chatty letter such as he had often received from his friend and former boss. No hints that Conrad had been contemplating suicide.

Mr. Hall called the insurance company representatives and his company lawyers to a meeting. He told them he didn't care what the investigation decided—accident or suicide. He insisted that Conrad's family receive the full double indemnity benefits.

Chapter 16: Robert McCloskey

Reoccurring Nightmare

RUSSELL MYERS

"Genial, balding, Robert "Bob" McCloskey is the genius behind the success of the Hallmark Contemporary cards." That is what Fortune magazine said in 1958. McCloskey didn't write any gags or draw any cartoons. He had designed the Fancy Free logo for the first Hallmark studio cards, but we weren't aware of any other art by our boss. We writers and cartoonists felt much ignored by the article. McCloskey's genius was in the way he hired people, the way he let them follow their own creative impulses, and the way he provided a buffer between the staff and the owner of the company, J. C. Hall.

When McCloskey interviewed a prospective writer or artist, he would show samples of the person's work to the staff and say, "What do you think?" He didn't have to ask our opinion, but he usually deferred to the consensus of the staff. If the comments were mild, he passed on the applicant. But when the staff was enthusiastic he hired the person.

On one occasion, however, the result was different. McCloskey told me that the dean of the Kansas City Art Institute didn't understand what kind of people Hallmark was looking for. "He sent me an artist the other day, and when the guy came in... well, he was black!" I guess my eyes bugged and maybe my jaw went slack. I waited

for McCloskey to say something about the artist's samples. I may have said something like, "Is he a good cartoonist?"

"We can't hire a black person as an artist," McCloskey said. "I'm from Rhode Island, and I have no prejudice against blacks, but many people here come from the South, and they would feel uncomfortable working beside black people. The dean of the Art Institute should know that without our having to tell him."

McCloskey and I both felt very uncomfortable and there was a silence. Growing up in Iowa I had not realized how much prejudice and lack of opportunity there was in the Midwest even as we bragged about being "not like those terrible Southerners". I had been on the Hallmark staff for three years, and just at that moment thought about the complexion of the work force. The only black faces we saw were in the cleaning and food service staff. No other jobs were open for them. This situation was dramatized on Halloween when the cafeteria served some special Halloween entrees. I forget what the entrees were, but clearly remember the black serving women dressed in white witch costumes. Their expressions were rather surly, and we refrained from any joking as they put the food onto our trays. But back at our desks Sam Van Meter couldn't resist calling them "negative witches", like the negative of a black and white photographic print. It was another negative point in our books regarding Hallmark policies.

Attitudes of people from the South about race relations was demonstrated by a Southern lady and her black servant. The lady moved to Kansas City from the South and retained the services of a black man as a servant. "He has worked for our family for so long, we just couldn't leave him unemployed when we came to Kansas City," she explained to her co-workers at Hallmark. The servant drove her to and from work each day as one of his duties for the family. One day when he picked her up, co-workers were shocked to see the black servant kiss the lady on the mouth. It turned out he was her husband, not the family servant. In the 1950s they needed to move further north than Kansas City to find social approval for interracial marriage... perhaps as far as Siberia.

I knew by then that J.C. Hall ruled the company like an emperor. His opinions were never openly contradicted by the mid level executives he consulted. So the company rule had to be his rule. Then in the early 1960s Hallmark suddenly integrated their work force. I was not on staff then, and only heard about it second hand, so I may not have it exactly right. But the way I heard it the NAACP met with Hallmark executives, and said they would urge black people to boycott Hallmark cards unless the company hired some blacks for jobs other than janitor or food service. J.C. Hall had made a name for himself as a public servant by heading up a People to People program for exchange of people from foreign countries, many of them from Africa. Mr. Hall adored President Eisenhower who had appointed Mr. Hall to the position. It would be embarrassing for Mr. Hall to be showing a black African around Kansas City while his company's product was being publicly boycotted by American blacks.

For several months Hallmark secretly interviewed black people for all departments. Only the Personnel department knew this was happening. Then one morning all the new black employees came in 15 minutes early, and reported to the department heads who had been told what to expect. When the rest of the employees came to work at 8:00 a.m., they saw black faces at desks in every department. At mid-morning break all the department heads introduced the new employees to the rest of the staff. Nothing was said about the previous company policy. Everyone

understood that Mr. Hall had changed his mind, and if you wanted to keep your job you had better approve of the new policy. There were no incidents, and no publicity about what had happened at Hallmark. I don't know if the black artist who had been rejected a few years earlier got a job, but I hope he did.

This story highlights the way things worked at Hallmark. Mr. Hall was in complete charge. Nothing happened that he didn't approve of, and when he decided to approve of something...it happened. He was a remote figure to us, partly because of the way Coker had joked with him at a couple of meetings. Mr. Hall stopped asking any Contemporary artists or writers to meetings except for the card judging sessions which were only attended by McCloskey, Rosie and Alan. McCloskey provided a constant buffer between us and the Hallmark system. We could make fun of Mr. Hall behind his back. Ridicule his lack of humor. Complain about how we weren't appreciated. And cash our paychecks and keep our jobs. Mr. Hall may not have understood many of the jokes on the cards, but he allowed the Contemporary department to function as almost an outside operation within the building. We had walls between us and other departments...no one else did. Hallmark looked like a huge ballroom with low partitions separating desks and departments. In Contemporary we could smoke and drink coffee at any time...everyone else had two 10 minute breaks and that was it. We sometimes went out for coffee in midday, sometimes came back late from lunch...no one else did.

We made fun of McCloskey...his desk was outside of our wall. He could see through the glass, but could not hear what we said. One day Alan Denney was angry about something and started ranting and waving his fists — a very rare thing for Alan. Alan pointed toward McCloskey who was sitting at his desk and reading some papers and said, "Every person in this room has more talent in his little finger than HE has in his whole big pink body, and where does it get us?" Rosie laughed as she moved some large cardboard panels to block the view through the windows facing McCloskey's desk. The nickname "Big Pink" stuck on McCloskey, but we never used it within his hearing. We used it when we thought he wasn't fighting upper management to make things better for us.

McCloskey was a genius at supervising writers and artists in a way that kept us there at least for a while, and inspired us to create good work for the company. The basic problem was that none of us had ever wanted to write or draw greeting cards. We wanted to do something that paid more and gave us more recognition. Some wanted to write great stories, some wanted to draw fine art, some wanted to cartoon for magazines and newspapers. Until we got our break we felt trapped in greeting cards.

Russell Myers was one who got a break and became a syndicated newspaper cartoonist, writing and drawing his "Broom-Hilda" comic strip. Asked about his Hallmark days, Russell had this to say, "I worked for Hallmark from 1960 to 1970. At the time I was young, dumb, and unappreciative of the opportunity. Granted Hallmark, in the great tradition of Disney, did not lavish money on its peons. Or perhaps (gasp) we were just getting what we were worth. But we did get paid to learn a trade. During those ten years I wrote and drew an awful lot of greeting cards. From that springboard I was able to go on and do a comic strip which was what I had wanted to do since being very young.

"We griped about Bob McCloskey because he was the boss, and that's what you did about bosses. We knew everything and he was just a big pink nerd getting in our way. Uh huh. With that great genius hindsight affords us, and the perspective of

Gordon Long, Kipp Schuessler, and Russell Myers in Hallmark Contemporary Department, 1960

semi-maturity, it's clear now that McCloskey was one great guy who put up with an awful lot from a roomful of paid smart-alecks. He smiled benignly out at us through the walls of his glass office and let us do our thing, overlooking much that other bosses would not have. I wish he was around today so I could kiss his ring and apologize for a few things that seemed so darn hilarious at the time, but very probably weren't.

"At the time I also didn't realize I was meeting some of the most interesting people I would ever know. Funny, fascinating, offbeat, wonderful people that don't come along often in the real world. But right there in one place was a whole roomful of them. They came from all over to gather together to make each day fascinating, a job description they fulfilled admirably. And to top it all off I met Marina. This year we will celebrate our 38th wedding anniversary, a monument to her level of tolerance. Time has diminished the memories of small checks and big rejects and replaced them

to make sure i wouldn't
forget your birthday,
i told an ELEPHANT........then i forgot which elephant i told!

HAPPY BELATED
BIRTHDAY!

Gordon Long, writer/artist

with the recognition of having lived through a unique and fascinating period. Everybody should be so lucky."

An example of what McCloskey put up with is an unpublished card drawn by Don Branham that was obvious sarcasm directed at the boss. The silly story titled "Fighting Father Kloskie" had no meaning to anyone not working at Hallmark, and yet it was actually taken to a card review meeting before being rejected. Gordon Long rescued the art from a pile of Branham's original art that was being discarded when Hallmark converted all of their archives into digital files. Gordon was at Hallmark from 1960 to 1985. He came from McCloskey's alma mater, the Rhode Island School of Design, and over the years Gordon came to know McCloskey better than many others. Gordon told me something I had not known during the time I was at Hallmark. McCloskey was an excellent painter, but too shy to show his work anywhere but on the walls of his own home. He sometimes gave or sold paintings to friends who admired them.

Gordon told me, "Bob McCloskey was more than a balding "jovial individual", shielding Contemporary from the eccentricities of Hallmark's regimens. Bob recognized the creative potential in Hallmark, and wanted to develop and share with the first pioneers of Contemporary Design, and other operations under his supervision. Bob McCloskey's watercolors and oil paintings of New England waterfront scenes have the essence of salt air, and convey the ocean's many moods, in mists of peace and depth of power. Bob McCloskey's infectious joy and healing smile helped many people through a variety of challenges."

I never knew our boss had talent beyond supervising a bunch of young and restless writers and artists. Maybe he felt much like us...trapped in greeting cards. Big Pink's nickname for us was more complimentary..."The Old Gang". McCloskey genuinely liked us. In the long run we realized how much we liked him, and appreciated how he had kept things together.

J.C. Hall's book about Hallmark, *When You Care Enough,* says nothing about Robert McCloskey or Contemporary cards. McCloskey does appear in one photo of a group in Mr. Hall's office. In 1987 there was a reunion in Kansas City of Hallmark Oldies, people who had worked on the Contemporary staff while McCloskey was director. Hundreds were there, and many more wanted to be there but could not make it. McCloskey was the star of the party. Fortune magazine had it right. Genial, balding, Robert "Bob" McCloskey was the genius behind the success of Hallmark Contemporary Cards. Another reunion was held on January 1st of 2000, but McCloskey had passed away a year earlier and could only be there in spirit.

I talked to his wife, Virginia McCloskey, and she confirmed what Gordon had told me about how much Bob loved to paint, but was so shy about displaying his art work. "Bob never regretted any of his career at Hallmark", Virginia said. "Even in his last year when his health was so bad, people would come to visit and we would recall the Hallmark stories and the house would ring with laughter. Bob never lost his sense of humor."

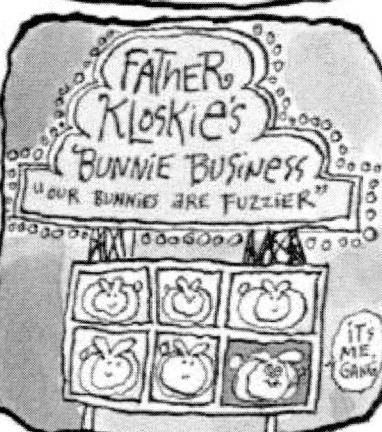

rejected and never published Hallmark card

Don Branham, writer/artist

Chapter 17: Jack Jonathan

Hallmark's studio cards were an immediate success when sold in small test groups in a few stores. But there were problems when the same cards were printed in quantity and distributed to all Hallmark accounts. The new cartoon cards were scattered throughout the racks according to the occasions...birthday, get well, anniversary, friendship, etc. Spreading the funny cards among many other types of cards diluted the impact. Customers who wanted this irreverent humor had to do a lot of searching to find it. The cards were printed in many different shapes. One shape called "Slim Jims" was tall and narrow. The Hallmark racks had not been designed for this, and a tall card would cover the view of the card behind it. Salesmen were supposed to arrange the cards in the racks so that every design was clearly displayed, and the tall cards made this impossible. So the studio cards were not selling as well as they tested, and some salesmen were asking Hallmark to discontinue the line.

The tall, narrow card about 9 by 4 inches, had been created by small companies that could not afford to buy envelopes in large quantities. So they printed their cards to fit in a standard business size envelope. The public had begun to recognize this shape as a funny card, and it would be an advantage if Hallmark could produce more of their new studio cards in that shape.

Jack Jonathan, the head of planning for Everyday cards, suggested that the studio line be created as if it were produced by an independent small company. Instead of having the Contemporary department only write and draw the cards, the department should also do the planning, printing, merchandizing and marketing of the cards. This meant having a special rack with only studio cards in it. It could be designed to display the tall narrow shape, and customers would know where to go in the store if they wanted this type of humor. Jack also suggested that new cards be created and distributed in a matter of weeks, instead of 9 to 12 months which was the usual Hallmark schedule. There should be a frequent turnover of new designs. This would make the studio card rack a place of entertainment where customers could find new and timely jokes.

Jack was given an O.K. to try his idea, so during 1958 some new cards bypassed the traditional design approval meetings. The customers judged them through sales in six test stores spread across the U.S. Small groups of cards were produced and tested within two weeks. Then Jack would drop the poor sellers, sometimes as many as half of the group, and save the rest. At the end of the year he had over 80 designs ready to go. Then Hallmark launched the new Contemporary line in specially constructed four foot racks in 10,000 stores .

While this project was underway, Lou Marak had said, "Jack, if this idea doesn't work, Mr. Hall will have your head on a platter." Jeanette Lee, head of Conventional and Humorous design departments, was aware that Contemporary design had bypassed the traditional approval process. She gave her tacit approval because she knew that Mr. Hall was not yet ready to accept this type of humor, unless it was proven to be successful in the marketplace. But would Jeannette and J.C. Hall really be happy that this had been done without their input? Would the Contemporary department director, Bob McCloskey, be happy that much of the project had been done without his help? McCloskey had slipped on ice in the parking lot, broken a hip, and spent many months away from his job while Jack was pushing the project along. Lou Marak drew a birthday card for Jack depicting his fate if the project bombed out.

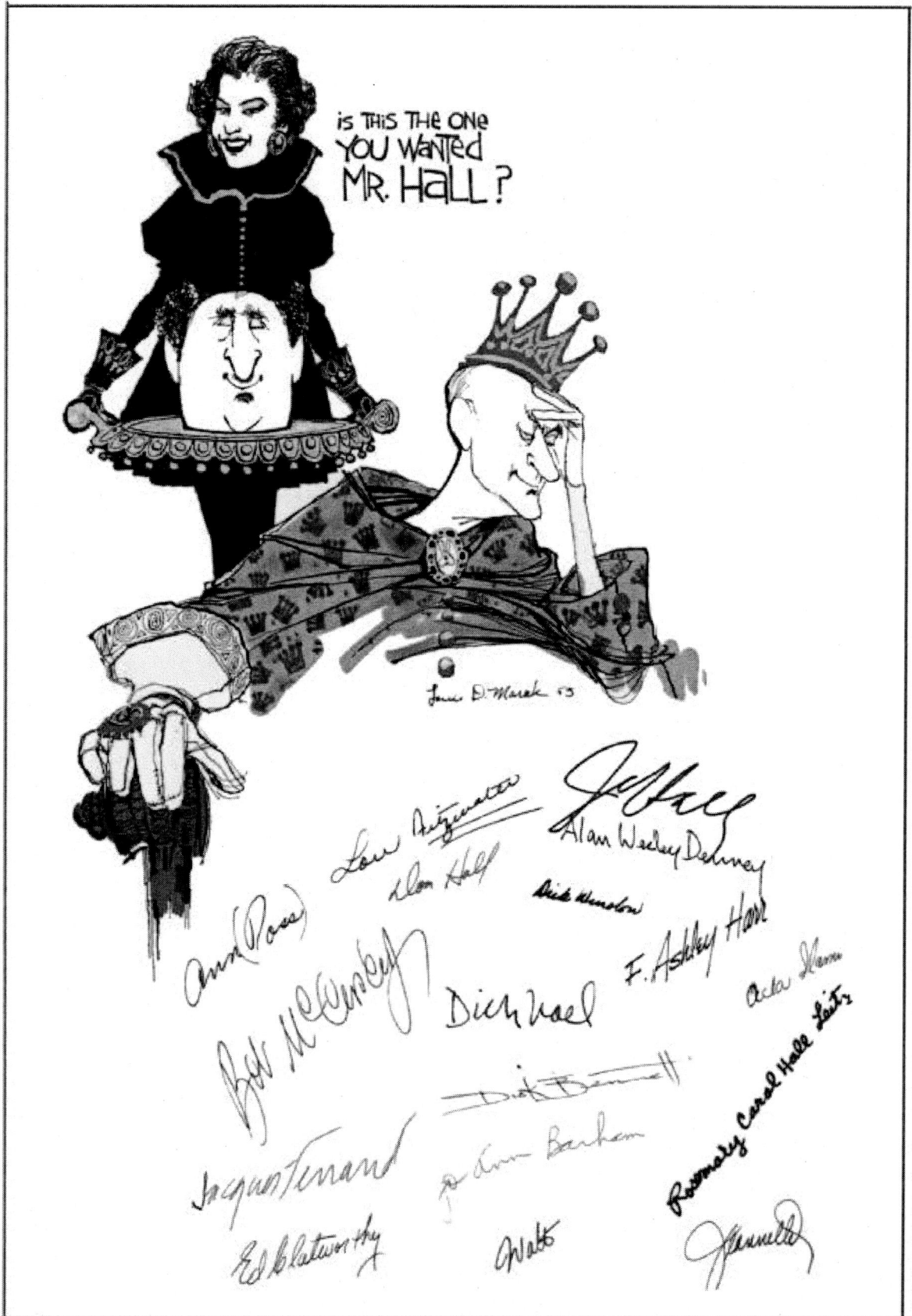

Birthday card for Jack Jonathan designed by Lou Marak

Customers gathered around the new Contemporary card racks, laughing and giggling and buying handfuls of cards. Jack's head remained on his shoulders, and the birthday card was signed by Jeanette Lee, Bob McCloskey, J.C. Hall, and his son, Don Hall, and the Contemporary department writers and artists.

Bob McCloskey was promoted to be in charge of all the new functions for Contemporary, and Jack continued to help on special projects such as the development of higher priced cards. For many years 25 cents was the standard price for studio cards. Some of the best selling cards were printed in a larger size and offered at 50 cents, but the sales of the more expensive cards were not good. Jack found a way to create a profitable 50-cent card. He selected the best selling 25-cent cards, and had a doll maker named Virginia Black construct dolls that looked like the cartoon characters. Color photos were taken of the dolls and printed on 50-cent or one dollar cards with the same jokes that had sold well at 25 cents. The novelty enticed the customer to pay more.

It was always fun to work with Jack on whatever scheme he had in mind, and he was open to almost anything you could suggest. One night he was working late in his office, and the guard called to tell him there was a slightly drunk man in the lobby who wanted to sell Hallmark some jokes. Most people would have told the guard to call the police, but Jack invited the guy up to his office. The man had been a writer on a hit TV show called *What's My Line* where a group of celebrities chatted with a guest and tried to guess what the guest did for a living. The writer was down on his luck, intoxicated, and on his way to Los Angeles to look for another comedy writing job. He needed some traveling money to get the rest of the way from Kansas City to the West coast.

Jack told him to sit in his office with him, and try to write some complimentary birthday cards for aging women. After a while the writer showed his efforts, and Jack bought two gags at $25 each. Jack gave the man cash from his pocket, and put in the paper work later to get reimbursed by Hallmark. He couldn't remember the man's name, but Jack did remember one of the gags, because it became a best selling card. "Don't worry, Dearie. We've got everything that Miss America has got..... except we've had it longer. Happy Birthday !"

HAPPY MORNING AFTER.

© Hallmark Cards, Inc. Dean Norman, writer
 Paul Coker, artist

Chapter 18: We Need a Wall !

"Our new studio will be right next to Mr. Hall's new office !" Bob McCloskey was thrilled to tell us this, and expected us to be thrilled too. We were too stunned to say much. He showed us the plans for the ninth floor that was being added to the Hallmark building. Mr. Hall would have a spacious office with big windows looking toward downtown Kansas City, and the Contemporary department would be located on the opposite side of a lobby just outside Mr. Hall's office. This arrangement indicated that we were the new big thing at Hallmark, and Mr. Hall probably wanted to show us off to visitors. Contemporary cards were only a small part of the Hallmark line, but they were new and attracting a lot of attention. Newspapers and magazines wanted to quote some Contemporary card jokes when they wrote about Hallmark, and the rapid growth of the card line was impressive.

The last thing we wanted was to have Mr. Hall and his visitors popping in on us. We knew he didn't get many of the studio card jokes, and we knew we couldn't hit him with insult jokes if he came visiting. Insulting visitors was one of our favorite things, and people who visited us expected and enjoyed it. But Mr. Hall's idea of a creative environment was the gray flannel suit. *The Man in the Gray Flannel Suit* was a popular book in the 1950s about how business environments had become uniform and standardized. Many executives at Hallmark wore gray flannel suits every day, and they were forbidden to take off the jacket or loosen the tie during working hours. In fact the exterior and interior of the Hallmark building were gray. None of us particularly minded wearing a suit and tie on our way into the building, but the first thing we did when we entered our studio in a back corner of the eighth floor was to take off the jacket and tie, and roll up the shirt sleeves. And many of us were messy desk workers. We didn't think we could look like Mr. Hall wanted us to look, and continue to create funny cards.

McCloskey should have been nervous about this, because he had witnessed two incidents when J.C. Hall visited Contemporary department. One time Mr. Hall came in asking for Rosemary Leitz.

"She's shopping," Alan told him. "She's always shopping."

"Well, when she comes back, tell her I want to see her," said Mr. Hall.

"Of course," said Alan. "And who are you?"

McCloskey laughed nervously to let Mr. Hall know that Alan was joking.

The second time I recall seeing Mr. Hall enter the studio, he decided to get into the spirit and joke with us. He said, "I'm looking for that place where the funny folks work. That...uh...Contemporary department."

Alan answered calmly without even looking up, "You're standing in it."

HALLMARK
CONTEMPORARY
DEPARTMENT
1959

J. C. Hall

Dick
Noel

Jimmie Fitzgerald

Sam Van Meter

Lou Marak

Bob McCloskey

Alan Denney

Jack Jonathan

Bob
Harr

John Stith

Don Branham

Dick
Winslow

Rosemary
Leitz

Imaginary
elf who does
all the work

Caricatures by Lou Marak

Mr. Hall then explained that he wanted a special funny card drawn for him to give to a V.I.P. friend. Alan took notes as Mr. Hall described what he wanted. Then as Mr. Hall was leaving, Alan said, "What is your name and department? I'll send the card as soon as it is done."

McCloskey laughed again to assure Mr. Hall this was a jest. I don't recall any other visits by the Big Man, and we all wondered how long Alan might pretend not to recognize the company founder. None of the rest of us would have tried it. But McCloskey found it hard to believe that we didn't want to be close to Mr. Hall, and be envied by other departments.

"We need a wall...not a glass wall that people can see through...but a wall that gives us some privacy," Rosie and Alan explained. "So we can sneak a smoke, have an extra cup of coffee, talk dirty, make jokes about the company. All of this stuff we do really helps us think of new funny cards. Put us in a glass cage right next to Mr. Hall so every time he comes out of his office he looks in on us, and you might as well put mannequins in our chairs. We won't be able to be funny."

"Gee, it's all been decided," said McCloskey. "We can't change it now." That was what we usually heard from him when we made a pitch for something that would be difficult to obtain and might annoy Mr. Hall.

So we were resigned to the beautiful but uninspiring new digs we would have in the new addition. It made me reflect on how superficially creative the Hallmark building was. The large Conventional and Humorous art departments had long rows of tiny cubicles in a huge open area. Nobody could sneak a smoke or talk dirty in a loud voice out there. The artists were mostly young women a year or two out of high school. Well, they WERE inspiring to look at. Sam Van Meter once came back to his cubicle in Editorial after a stroll through the Art department and said, "There is so much luscious, tempting, femininity over there, that some day I am going to lose control. I will just leap over a wall into one of those booths where a cute young thing is working and ravish her on the spot!" Sam managed to keep his urges under control, but he did begin dating an artist named Pat Davis and soon married her.

Sam also had an urge to grow a beard. At universities the art students often dressed weirdly and grew beards to show their creativity and independence from conventional fashions. During a time when Sam quit Hallmark and worked for an art agency he grew a magnificent beard. It only took about a week for his face to be covered with thick black fur. When that job ended and he was rehired at Hallmark, he sadly shaved off his beard before reporting to work and being told to get rid of it.

I took a two week vacation in the summer of 1957, and went canoeing on the Gunflint Trail in northern Minnesota's Boundary Waters. On the long drive north we saw guys in restaurants with a two week's growth of whiskers and beaming smiles on their faces. Without asking you knew they had just come out of the woods from a long canoe trip. So I decided to retain the feeling of freedom after my canoe trip, and didn't shave when I returned to work in the Editorial department. My face fuzz was very ugly, and it got a lot of laughs.

Carl Goeller called me into his office, and said, "The Personnel Director walked by this morning and saw your beard. He told me to tell you it was against company policy. I told him I thought you just kept it for a joke after your canoe trip, and you intended to shave soon. Is that right?" I told him that was true, and I would be clean shaven tomorrow. "The company policy is they won't hire anyone with chin whiskers," Carl added. "If you interview and are hired with a mustache, you are allowed to keep it. But if you are hired without a mustache, you are not allowed to

grow one." I guess that warning was just in case I stopped short of complete facial mowing the next morning.

The plans for the new studio location next to Mr. Hall didn't bother me too much. I decided it was time to try freelance. From the time I first decided to become a cartoonist I was enamored of the working conditions successful cartoonists enjoyed. They worked at home, worked their own hours, and mailed their cartoons to publications. No dressing up to impress anyone, no long commuting in traffic, and you could live anyplace where the mail was delivered.

Phil Hahn, Paul Coker and John Stith had negotiated freelance contracts with Hallmark, and I tried to get a similar deal from McCloskey. He was not very encouraging, because I could not be guaranteed enough to raise a family no matter how much work I did. I contacted American Greetings and negotiated a good contract with them. So in the early months of 1959 I left Hallmark and began working at home in Kansas City, but working for American Greetings. As soon as summer came I moved to the canoe country in northern Minnesota. I wanted to live in Ely or Grand Marais, but Bette wanted a larger town, so we compromised on Duluth.

When I left Hallmark, Personnel Director Bill Harsh interviewed me, and asked if I had any suggestions that would make Hallmark a more attractive place to work. "Yes," I said. "There should be a wall around the new Contemporary department studio so the writers and artists have privacy, and can be uninhibited when they try to create new jokes. They are all very upset about the plan to put them in a glass cage right next to Mr. Hall's new office. I guess that's part of the reason I'm leaving, but I would leave anyway, because I really want to work at home rather than in any studio no matter what the conditions are."

I don't know if my parting shot did any good or not. But when the ninth floor was completed, Mr. McCloskey's new office was close to Mr. Hall, but Contemporary writers and artists were put into a storage area where people had to walk through a maze of alleys to find them. It wasn't a pretty studio, but it was private and the fun continued in Contemporary.

Chapter 19: Off to the Races

By 1959, only four years after the beginning of the Studio department, Hallmark Contemporary cards were flying high. Sales kept increasing, the company got attention from the media for creating such a popular product, and McCloskey got promotions. Other executives were jealous of his new status as Mr. Hall's fair-haired boy. When he had transferred from Conventional Art to become head of the new Studio department in 1955 it was a job nobody else wanted. The experiment might have failed, and left him hanging.

One winter day in 1958 McCloskey slipped on ice in the parking lot and broke his hip. He was in traction in a hospital room for weeks. Paul Coker drew a get well card that showed McCloskey bandaged like a mummy and hung up in traction lines and weights. His beady eyes peered out of the bandages and he was saying, "I just want to know one thing. Who pushed?" He was such a nice guy that nobody we knew would have done it, but maybe some jealous executive?

The bad part of his new responsibilities was that it kept him away from his desk a lot of the time. So if we went to see him, he was often not around. He would pop into our area occasionally and ask, "How are things going?"

"Fine," we would say. But things were not going fine. We had always kept some of our gripes to ourselves, but there had also been a good deal of frank discussion with McCloskey. We trusted him not to repeat anything we said that might cause a problem. With him not around much of the time, this communication broke down.

For example, McCloskey had always shown samples of work by a prospective new artist to get the staff opinions before he hired someone. But he hired Bill Greer without doing this. Bill came from the Kansas City Art Institute as many others had, and had a Branham-like style of drawing with lots of froo froo. McCloskey failed to

tell the staff that Bill Greer was not hired to write or illustrate greeting cards. It was a new category of creative person who was just supposed to do his thing in order to inspire others. I guess he expected Bill to do paintings that we would hang on the walls of the studio and look at for inspiration in our own designs. Bill didn't quite understand this arrangement either, and he didn't try to explain it to us. He just started drawing things, and Rosie put him through the usual humor test, "Oh, New Boy! I love what you just did, but could you try to explain what it is supposed to be?"

Bill pretended not be annoyed, and went back to his booth and drew something else. After a few more of these barbs by Rosie and Alan and the rest of us, Bill went back to his booth and took a nap. I swear the guy slept in his booth for almost two years at Hallmark, and seldom wrote or drew anything. He was good company at lunch, so we liked him and decided it was not our problem if Bill Greer slept instead of working. McCloskey hired him so McCloskey could deal with it, if he ever noticed.

We got a dart board, and when the game got boring we made it more interesting by increasing the distance. Dick Noel was throwing darts the entire length of the room, about 50 feet, and most of the darts were hitting the wall instead of the board. The points were driving through the wall and appearing on the other side where a man was teaching an art class to newly hired artists for the Conventional Art department. His classes were very dull, and the students loved it when the booming started and dart points began poking through the wall.

Meanwhile, back in Contemporary, Bill Greer rose sleepy eyed from his booth which was right beside the dart board at the end of the room, and the last dart thrown by Dick nearly hit Bill. It shocked all of us. We had thought Bill was somewhere else. After that we always checked his booth to make sure he wasn't sleeping there before we threw darts. Eventually the art teacher complained to Personnel. McCloskey made a rare appearance in the studio to jerk the dart board off of the wall and announce, "NO MORE DARTS!" We agreed it had gotten out of hand, but wished the affair had ended more gracefully. Why didn't the art teacher come over and tell us what was happening, and we would have stopped. We didn't want our play to get out of the room and affect other departments.

Bill expected to be fired someday for sleeping on the job, but when it seemed he might never be found out, he quit to look for other work. He got a job as an artist for Neiman-Marcus, and later came back to Hallmark and did good work for them. For lack of communication he spent two Rip Van Winkle years at Hallmark when he might have been creating something the company could use.

Others were more restless than Bill Greer. Dick Winslow left to earn more money as a fashion artist, a type of work he preferred to greeting cards. Jan Coffman was hired away by Rust Craft to be Art Director at twice her Hallmark salary. Since Hallmark didn't pay women very well, that may have not been a lot of money, but it made a big difference to Jan. She was a cartoonist who also followed the Branham path of froo froo art work that sold so well in studio cards. After some years at Rust Craft she moved to New York City, and subsequently worked freelance for Hallmark again while also drawing various illustration assignments in New York.

Jan Coffman
by Lou Marak

Subway Riders by Jan Coffman won "Funny Bone" award from NYC Society of Illustrators

John Stith quit the Contemporary staff after a year, and worked on freelance contract while remaining in Kansas City and doing other commercial art work. Bob Harr, one of the original Studio artists, quit and moved to New York, but continued to work on contract for Hallmark. Working freelance at home on your own time has a powerful appeal to many writers and artists. You may not get company benefits, but young people don't value those much anyway. Hallmark had great health insurance, profit sharing and retirement plans. We didn't expect to get sick, and didn't expect to be there long enough to retire.

After a year in Contemporary I quit and began working on contract with American Greetings. My family moved to Duluth, Minnesota, because I wanted to be in the north woods canoe country. After six months of working for AG, Bette and I were both struck with extreme homesickness for Kansas City. I called McCloskey one afternoon, and he rehired me on the Contemporary staff.

We missed our friends, and I especially missed working with Alan and Rosie. They would go to meetings where J.C. Hall decided which of our cards were accepted and which were rejected. Jeannette Lee and Mr. Hall's secretary advised him if anything looked to be in bad taste. J.C. was determined never to publish anything in bad taste. He didn't understand many of the jokes, and the women didn't get all of them either. They all had such good taste they didn't recognize a lot of double meanings, and as a result some naughty cards got published. For example, a baby announcement showed a couple hanging a ton of diapers on a clothes line, and it read, "Do we have a new baby? Oui Oui!" Mr. Hall read the card aloud, "Do we have a new Baby? Oy Oy! What does Oy Oy mean?" McCloskey said it was a French word that meant, yes yes, but nobody told Mr. Hall that it was pronounced "Wee Wee", which of course was the joke. Mr. Hall and his nice ladies thought it was cute to say yes yes in French, and the card was approved.

Another example—an artist had turned in a Valentine sketch with no red hearts in the design. Almost all Valentines have one or more red hearts in the design. Rosie said, "Don't you think this would look better with...if you'll pardon the expression...a heart on?" It took a few seconds, but when the double meaning was appreciated it

was worked into a Valentine card idea. A cute little person who was wearing a big red heart on his chest was saying, "I've got this big heart on...because I'm thinking about you on Valentine's Day!" Mr. Hall and his ladies thought that was such a cute little card. No bad taste there.

Sometimes a card with a nonsense joke inspired strange thoughts. One card read, "Since I can't be with you to wish you a Happy Valentine's Day, I've asked your postman to give you big hug and a kiss." It was illustrated by a silly looking cartoon postman who was no sexual threat. One of the ladies said, "Well! I would certainly be offended if anyone sent that card to ME!"

Why? "Because my postman is...well...he's a BLACK man!" She wouldn't be offended if he was white? How would anyone sending her the card know what color her postman was, or why would it make any difference? The card was just plain silly, anyway. But everyone at the meeting said, "You're right. That's poor taste. We'll never print any cards like that."

Rosie and Alan would come back from these meetings, lean against the walls and laugh hysterically saying, "You won't BELIEVE what they said!" Then they would act out the conversations, and this little play would relieve the anger when a card you were especially proud of had been rejected.

After the darts were gone we needed another game to play when we had writer's block. Jack Jonathan often came up with ideas for us to develop. We ridiculed some of his ideas, refused to even try some of them, but he took this with such good grace that we liked him and often made efforts to please him. When Jack added lots of flitter and flocking and embossing to a group of cards he exclaimed, "What will the competition do when they see this?!" John Stith replied, "Gosh, Box Cards might start using some red on their cards." Box Cards were always just black and white, or

THOUGHT I'D TREAT YOU TO FLOWERS, DINNER, & A SHOW...

HAPPY MOTHER'S DAY!

your Loving Husband

Dean Norman, writer John Stith, artist

as Nellie Caroll said, "We never used full color art...we barely used one color." We kept trying to convince Jack that extra finishing processes didn't make a funny card any funnier.

Jack once asked me to design a fake dollar bill that could be put into a money enclosure greeting card. I drew what I thought was a very funny fake dollar bill. A silly cartoon instead of a President in the center, different numbers in all the corners, and very bad froo froo around the edges. Jack was pleased and took it away to print the card.

A week later he burst into the studio looking pale and panicky. "Where is the art for the funny money? Give it to me! Give me all copies of it!" Jack had shown the funny money to the U.S. Treasury Department, and been told that he and Hallmark could be prosecuted for forgery if all copies of the bill were not destroyed immediately. Neither Jack nor I had known that no matter how bad your fake money is, if it is green and the same size as real money, it breaks the law.

We created quite a few cards that implied you were going to get some money, and the joke was that you got nothing or very little. One card had a penny glued inside. People looking at cards in shops stole the pennies, and put the damaged cards back in the rack. So the stores asked us not to print any cards with real money in them, and we printed some with a fake penny inside...it was copper color and embossed to be 3-dimensional. These were not very popular.

I wrote and designed a card that looked like a wallet and said, "To show you how much I value our friendship I have enclosed a little check." When you opened the card you saw a little check mark. There was a newspaper story about a guy who was way behind in paying alimony and child support, so he sent this card to his ex-wife. She called the police and he was put in jail. We always intended our funny cards to be used for good instead of evil, and I was sorry to see that this one had fallen into the wrong hands.

But back to the fun and games in the studio. Another day Jack brought some Mexican jumping beans to me, and asked me to write and draw cards where a little package of jumping beans could be attached. "You know, like I'm just jumping to wish you a Happy Birthday!" Jack never had a complete idea that worked, but that was our job. He was just a concept man.

I took the beans and worked on it. I finally had a few ideas, but they weren't very good. I decided to research jumping beans, and found out they jump because there are little worms inside of a seed. Nobody knows why the worms make the beans jump, but if you warm them in your hand, they will jump more often. A moth lays eggs in the flowers of a Mexican desert plant. The larva eat the insides of the seed, in a few weeks a new moth drills a hole and flies out of the seed. So there was no way we could use them on greeting cards. They have a short shelf life of a few weeks during which the worms wiggle and make the beans jump. It took months for us to print and distribute a card design.

Then the muse struck! It came to me! The idea hit me! That's how writing works, isn't it? An idea just comes to you, or it hits you. AFTER you have done some research and muddled the information around for a while, and often after you give up and say to hell with it. I made a little race track. A slanting board with the start line at the top, and the finish line at the bottom. The slant was not so much that the beans would slide down the board when you placed them on it. But there was enough slant so whenever a bean jumped it would slide down the board a little distance. A really big jump could cause the bean to flip over on its round side, and

roll all the way across the finish line and off of the board. Then I inked a little number onto each bean, and we were off to the races.

Each person would pick a bean from the pile, and put a penny in the kitty. Bets were limited to a penny, because we didn't want anyone who might become addicted to gambling to go home in a barrel. Then we would warm up our beans in our hands for about ten seconds, place them on the start line...and GO! The cheering and waving of arms was loud and frantic. "Come on, Number One! Go Number 5! Get the lead out, Number 7!" The beans would jump at irregular intervals, and slide slowly down the board. Sometimes several beans would be neck and neck near the finish line, and a bean that had not even left the starting line would make one big jump and win the race. The winner would collect his handful of pennies and kiss his bean with gratitude.

These races became so popular that we limited ourselves to a few races at break time, a few before lunch, a few after lunch, etc. We were spending too much time at it, and knew we might neglect to write and draw cards if we didn't discipline ourselves. People from other departments heard the action in Contemporary, and they came by to place bets. A race was in progress when Jack Jonathan came back to see what card ideas I had come up with. "You're not using them as card attachments!" he shouted. "You're just playing with them like children!"

"I'll explain it to you in a minute, Jack," I said. "But please! My bean is trailing and he needs encouragement. Come on, Number 7!"

Jack got into the betting on the next race, and I forget whether he won a handful of pennies, but probably not. I had noticed that one particular bean tended to jump more than others, so I usually took it for myself and won more than other bettors. My conscience bothered me and I finally admitted to a few people that the race was sort of rigged. I let them have the best bean for a few races. Anyway, Jack cooled down when I told him why jumping beans wouldn't work for card attachments. Not real ones, anyway, with moth larvae in them. Maybe the plastic ones with little sliding weights would work, but they didn't have the charm of real Mexican jumping beans. So no cards ever came directly from it, but the fun of the races helped us relax and work better. We thanked Jack for bringing the beans to us, and a few days later he took us on a nice road trip.

He drove a station wagon full of writers and artists to Topeka, Kansas, where we visited a private collection of old phonographs and phonograph records. He didn't know how we could use this in greeting cards, but inspiration is always indirect. We were enchanted by machines invented by Edison that played music from what looked like plastic toilet paper rolls. The collector had several old machines that he sold to us at reasonable prices. I bought a stack of 78 rpm records made by the Original Dixieland Jazz Band in 1917, the first recording of traditional jazz music that made it popular outside of New Orleans and Chicago clubs. We came home that evening thinking Hallmark was a fun place to work in spite of our ambitions for higher pay and more recognition. The next day--black Friday--it was over.

Chapter 20: When the Laughing Stopped

When I was rehired by Hallmark in late summer 1959, I decided to stay there for a career. I liked to write and draw funny greeting cards, I liked the people I worked with, and that mattered more than trying for better pay and recognition in another field of cartooning. Rosie and Alan felt differently about their jobs at that time.

Alan tended to droop no matter what he was doing if things didn't keep changing for the better. Rosie used to say, "I have to fluff up Mr. Alan every day to get him in a good mood to work." Rosie had gotten really mad that she was paid much less than the guys. It was Hallmark policy to pay women much less than men for the same work, and there were other inequities. Women who got pregnant received no maternity benefits, but wives of men employed by Hallmark were covered for pregnancy expenses. In fact women received no medical benefits at all until they had been employed for two years, but men had medical coverage as soon as they were hired. When writer Jimmie Fitzgerald had worked at Hallmark for two years, her boss made a little joke that didn't amuse her by saying, "Now you can afford to get sick...ha ha!"

Rosie made a big pitch to McCloskey. "It isn't fair to pay me so much less than the guys. If you had to replace me with a man, you would pay him a lot more than me. And you pay $50 for each free lance idea whether it is written by a man or a woman."

McCloskey agreed with her argument, but he couldn't change company policy. So Rosie decided to work freelance and get equal pay for her work. But she wasn't sure how or when to make the move. It developed by accident. A friend outside of Hallmark came to Alan Denney, and asked him to do a few designs for a cute novelty product...fake gift boxes. Hallmark policy was that it was o.k. for employees to do freelance work at home for anything that didn't compete with Hallmark products. Hallmark didn't make any fake gift boxes, so it looked like no problem. But Alan and Rosie deliberately made it a problem.

DEAN

Alan couldn't write a lot of ideas, so he asked Rosie to help him. She wrote the gags and he drew the art. The product was a little rectangular box the same size and shape of a tall Contemporary card, but about an inch thick. On the cover was a cartoon and words such as, "For your birthday celebration, how would you like to have a date with Elvis?" When you opened the box you found a real date (a piece of dried fruit), and copy that read, "Put on your best dress, put your favorite Elvis record on the turntable, eat this date, and have a "date" with Elvis. Happy Birthday!" There were about 20 similar fake gift boxes named Hoohah Giftniks, each containing a trivial gift and a funny gag. A Hoohah Giftnik wasn't a greeting card, but it talked like a greeting card, and it looked just like the greeting card cartoons that Alan was drawing for Hallmark cards. He was drawing more of them than any other artist at the time.

Rosie and Alan figured Hallmark would see this product, and want them to work on freelance contracts rather than be part of the Contemporary staff. If it was my doing I would have just directly asked for a freelance contract, but Alan and Rosie liked to move in indirect ways, and sometimes that does work better.

When the gift boxes went on sale, a Hallmark executive, Joe Kipp, went to the Union Station barbershop for a haircut and saw the product. He bought some and showed them to the Hallmark legal department. The lawyers wanted to sue somebody and stop them from stealing "Mr. Hall's art work." This angered Alan. It was HIS art work. Mr. Hall didn't draw anything. McCloskey must have suspected Alan did the art, because McCloskey put one of the boxes on his desk during a meeting with Alan. Both of them pretended not to see it and didn't mention it. McCloskey was probably giving Alan a chance to confess before things got too hot.

The lawyers were frustrated because a traveling novelty salesman was the complete company producing the boxes, and he was out of town. The local printer denied any involvement other than the printing order he received. Then Don Branham ratted out Alan and Rosie by telling McCloskey whodunit. It was a widely known secret among the staff, because the culprits really wanted to be caught soon. McCloskey told the lawyers to stop the search for someone to sue, because he had found the enemy and it was us. (Well, McCloskey didn't really say that, but Pogo made that phrase so popular I just had to bring it back.) It was just before quitting time on a Friday when McCloskey told Rosie and Alan not to worry. He would meet with higher executives on Saturday morning and work something out. On Saturday morning McCloskey was told to fire the traitors. There was no possibility of them continuing to work for Hallmark. Rosie was not even allowed into the building to collect personal items from her desk. Alan was allowed to come in to be fired in person by Personnel Director Bill Harsh. This was another example of unequal treatment of the sexes that angered Rosie.

When work began the next Monday there was deep gloom in the studio. Jimmie Fitzgerald and Larry Bowser were immediately transferred from Editorial to fill the writing and art gap, but to quote an old card gag, "Nobody can fill those shoes." Jimmie and Larry had long wanted to work in Contemporary, but getting the jobs because somebody else got the ax made them as gloomy as the rest of us.

We wondered why Branham, a very close friend of Alan and Rosie, had ratted on them? About a week after the firing, Branham came into the studio dressed in a business suit, and told us that he was now the head of the department, and things were going to change. He made a long speech with no humor or giggles in it. This was not Branham. Who was in Branham's body and a J.C. Hall business suit? After haranguing us for about half an hour, Don asked if there were any questions?

Jerry Roach quietly asked, "By whose authority have you become head of the department?"

"Well, it hasn't happened yet," Don admitted. "But we can make it happen if we all pull together on this."

We realized that he had flipped out. His dreams and reality were out of sync, and we were too nervous to confront Don directly. I didn't know if this was harmless crazy or dangerous crazy, so said nothing although I had been composing a lot questions up until then.

The next morning Lou, Jerry and I appeared simultaneously in McCloskey's office with no prior planning. Before we could say a word, McCloskey said, "I know why you are here. I've called his family, and they're going to get help for him. Don't worry about it. He won't be allowed in the building to bother you." Branham went through a rough time for the next three years, then moved to his parent's home in Oklahoma City and continued freelance cartooning for Hallmark.

By lucky coincidence, the week after Rosie and Alan were fired, George Burditt, Editorial director from American Greetings, came to Kansas City to lure Hallmark employees away. He asked me to come back to American Greetings, but I was confused and still determined to live in Kansas City. I told him that two of the best people that Hallmark ever had in their Contemporary department were available, and gave him Rosie's phone number.

George immediately gave them nice freelance contracts. Now Rosie was earning as much as the guys, and more than most of us. Rosie and Alan called their fake gift boxes "Hoohah Giftniks". Now they called themselves Hoohah Studio. But the laughing had stopped in the Hallmark Contemporary department.

...WAS GOING TO MAKE YOU A BOTTLE OF MY NICE HOME-MADE WINE FOR YOUR BIRTHDAY

......BUT THOUGHT I'D WAIT TILL MY ATHLETE'S FOOT CLEARED UP A LITTLE.

© AGC, Inc.

Rosemary Smithson, writer
Alan Denney, artist

Chapter 21: Tee Many Martoonies for Lunch

Rosie and Alan settled into their freelance work for American Greetings, and we were happy that they had work. But we missed them, and still felt gloomy. We met them for lunch one day at The Majestic Steak House, and Rosie hugged Bruce Cochran and said, "Bruce! It's so good to see you again." B-B-B-Bruce was the Contemporary New Boy who had never met Rosie before, and it took him a minute to figure out that she was joking.

Another day Rosie called and invited us to lunch at Alan's apartment. "Just because we work for competing companies, that doesn't mean we can't still be friends." We agreed and the Contemporary staff came to lunch. Rosie was Martha Stewart before Martha Stewart, and she prepared a very cute little lunch. Alan mixed a pitcher of martinis. We sat around in his living room eating off of trays, and enjoying insult banter like the good old days. At the proper time half of the group got up to return to work. The other half promised to follow them soon. McCloskey was hardly ever around, and we had no fear of being noticed or punished for being a few minutes late.

Then just as I was about to take my last sip, Alan refilled my glass. He went around the room refilling all the glasses, except his and Rosie's, saying, "I don't want to keep this. Just finish the martinis so I can wash the pitcher." He and Rosie swear they never planned what happened next.

We stayed about another half hour sipping our drinks, and then stood up to leave. Larry Bowser fell against the wall on his way to the bathroom. Jimmie Fitzgerald tried to hold him up, and she fell against the wall. Lou Marak and I jumped up to help them, and we fell against the wall. We were all bombed, but didn't realize it until we stood up and tried to walk. If Alan's apartment hall hadn't been so narrow, we all would have fallen in a heap on the floor.

Alan made coffee and we drank this for a couple of hours and tried to sober up. It didn't do any good. We realized that to go back to work in this condition was worse than not going back until tomorrow morning. The problem now was how to get people to their homes. Alan's apartment was too small for all of us to sleep over, and we had families expecting us.

Lou insisted that he was sober enough to drive. So Lou and Alan drove us slowly through the streets of Kansas City in their cars. I remember the cars stopping beside each other at a stop light, and Lou hung his head out of the window and giggled like the What Me Worry Kid in *Mad Magazine*. He never acted like a fool in public, so I feared he was not all right to drive. For example Lou was once very embarrassed when he was riding a bicycle to work, and a teenager leaned out of an upstairs window shouting, "Hey, Fruit!" Lou was waiting at a stop light. He didn't look up, hoping that the teenager was yelling at someone else. But then the taunt became more specific. "Hey, Fruit! Fruit on a bicycle!" In the 1950s an adult riding a bike to

WOMAN WHO CAN'T REMEMBER WHEN SHE HAD SUCH A GOOD TIME.

© Hoohah Studio

NIPKINS...The napkin to use when you're having a nip

work was not considered an environmentalist.

When the party got to Jimmie's house, she could not stand up or walk, so four of us carried her across her front yard and into her house. She laughed as she could imagine how it looked with one person lifting each arm and leg to carry her cartoon-style into the house. No one was strong enough to attempt a more graceful method, even though she was not a heavy person. We told her two daughters that Mom was O.K., but she was drunk as a skunk and just needed to sleep it off. They led us upstairs to her bedroom where we tucked the still giggling Jimmie into her covers.

I KNOW A GURU WHO WILL HELP ME FIND BLISS

BUT I PREFER YOUR METHOD.

© Hallmark Cards, Inc. Larry Bowser, writer/artist

Larry also needed help getting up the stairs to his second floor apartment. No way we could have carried the burly bear if he lost the power to walk. We talked and laughed him slowly, one step at a time, and kept him leaned against the wall so he wouldn't topple over. His wife heard the commotion and looked out upon the scene. "Larry's O.K." we assured her. "He just had tee many martoonies at lunch, as did we all...hee hee hee!" We got Larry into his apartment and Caroline said she could take it from there. Yes, this was the same sweet Caroline that Sam Van Meter had pulled the cute eunuch joke upon. She had gotten used to our antics, and enjoyed them.

Larry Bowser was an art school graduate who came to Hallmark with good fine art skills. But he had never thought about cartooning until he needed to find work, and was hired as a sketch artist in Editorial. He was slow to develop a distinct cartoon style. But it happened, and then he began trying to write gags. The Hallmark studio was a unique department in which you could teach yourself to do new things. Other card companies expected people to meet a production quota of whatever they were hired for, and did not encourage new skill training. Larry was slow to learn how to write gags, but he persevered and became a good writer/artist with a long career at Hallmark.

His fine art was not neglected. He won awards in art competition for metal sculpture. In his bachelor days he put an award winning metal fish conspicuously

on a stand in his apartment. When he brought a date into his digs, she couldn't help noticing the fish and would ask about it, giving Larry the chance to brag a little. One evening Larry was fixing drinks in the kitchen and his date cooed, "Oh Larry, what is this wonderful thing?"

"Oh, that's just something I sculpted that won a prize at the art show," said Larry.

"It's so cute with that big green pickle in its mouth! Hee hee hee". Larry's roommate, Sam Van Meter, had placed the pickle there, and Larry wouldn't speak to Sam for a week.

At an annual art fair in the Kansas City Plaza shopping district, Larry pleased dozens of people who wanted to buy a cute little cartoon animal to hang in the kids' room. His best seller was a lion. He drew it by pouring yellow paint on wet paper to make a splash. When the paint dried he drew cute little lion toes and a lion face on the splash. Every one was different...an original. He worked long hours in his studio for several nights during the fair to fill orders for the cute lion that he could afford to sell for $5.00 each.

But back to the after effects of the martini lunch. Lou drove himself home, because he didn't have far to go and it was on slow city streets. But I had to drive on a freeway to a suburb. So I called Bette and explained why I was going to sleep over at Alan's. Bette was glad I wasn't taking a risk by driving drunk.

The next day no one criticized our absence, so we got away with it, so to speak. But it got Rosie and Alan to thinking how much fun it had been to have lunch with the old gang again. Well, overdoing the martinis wasn't fun, but just talking and laughing together. They wondered if American Greetings would like to expand Hoohah Studio by hiring more writers and artists to work in Kansas City?

Chapter 22: Hoohah Studio

Their indirect method had gotten Rosie and Alan just what they wanted, a freelance contract, but it was with the wrong company. They had wanted to continue working for Hallmark and continue playing with their old friends. Anyway, Rosie now had equal pay, and that gave her great satisfaction. This would be a good time to tell Rosie's story of her coming of age as an independent woman.

She grew up in Kansas City and left home to live in a women's dormitory while getting a degree from the University of Missouri in Columbia. Then she moved back home and went to work at Hallmark. After few years she and Marjean Phillips decided to rent an apartment and be roommates. When Rosie mentioned moving to her own apartment, Rosie's mother threw a fit. "Why would you want to do that? You have your own room here. You get free room and board, so you can save your money for when you get married and raise children. Absolutely not. Let's hear no talk about moving to your own apartment."

So Rosie gave up arguing and rented the apartment anyway. She planned to just announce on a Monday morning that she was moving, then leave for work and avoid the arguing. Let her Dad hear the crying and protesting. During the week before the move Rosie started sneaking little things from her room to the apartment to get some of the moving done. One thing she took was a tiny mirror that hung on the wall by a light switch. On Friday evening before the Monday move, Rosie's mother saw the blank spot on the wall and said, "What happened to your little mirror?"

Rosie couldn't think of a quick fib, so she answered, "Well, you might as well know. I'm moving into an apartment with Marjean Phillips next Monday." It was the worst weekend of Rosie's life. Her mother cried and protested and said to her Father, "You talk to her! Talk some sense into her head! Are you going to let your unmarried daughter live alone...?"

"Not ALONE, Mother. With Marjean Phillips, a very nice girl. You've met her. You know how nice she is."

"...let two unmarried girls live alone without supervision in an APARTMENT when they could be living at home?! Does that make any sense? You talk to her!"

Rosie's Dad just said, "I'm staying out it," and tried to read his newspaper.

The apartment building was located next to the very cool Kansas City shopping district known as the Country Club Plaza. Lots of young singles rented apartments in the building, and there was an active social life. Rosie met and soon married a tall strapping young lawyer, Lowell Smithson, so when Hoohah Studio was founded she was Rosemary Smithson instead of Leitz.

Rosemary's experience qualified her to counsel Bill Cunningham when he faced the same problem. "I told my parents I was moving to my own apartment, and my mother freaked out", he told us. "Crying and arguing. It went on for a week. She

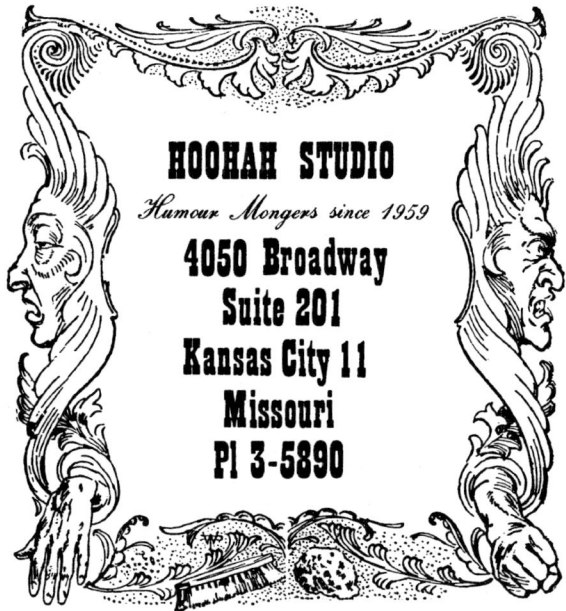

HOOHAH STUDIO
Humour Mongers since 1959
4050 Broadway
Suite 201
Kansas City 11
Missouri
PL 3-5890

told the neighbors, "I guess our son doesn't like his mother and father anymore. Bill is moving to an apartment." I couldn't take it. I cracked and stayed at home. But I'm almost 30 years old now. I should have my own place!"

"I know, Bill", Rosie sympathized. "Do it the way I did. Get it all set up and don't tell your parents until the last minute. Then just go and let them scream at you as you run down the street and claim your freedom and manhood."

Bill did the deed and came to tell us how it went. "When the moment came I said, Mom, I'm a big boy now. I'm moving to my own apartment today, and nothing you can say will change my mind."

"And what did she do?" we asked.

"She said, that's a good idea, Bill. It's time that you had your own place. I was really hurt and disappointed. I was all set for the fight. I wondered if Mom and Dad didn't like me anymore."

Back to Hoohah Studio. Alan's life had improved as Hoohah Studio was getting started. He had taken a big hit a year before when his wife, Dolores "Dodo" Denney, surprised him by wanting a divorce. Dodo and their two young children moved out of town, and Alan was devastated. Then he met a pretty young woman who came to his apartment selling something. Nothing he wanted to buy, but he liked her. Alan and Pat dated for a few months and then they were married. Pat had been selling door to door just for something to do. She was a rich single Mom with one child and a big house which Alan moved into. With her legacy and Alan's contract they had no money worries, something that was new to Alan's experience.

The Hoohah Giftniks that had cost Rosie and Alan their jobs at Hallmark fizzled out. The novelty salesman never intended anything more than a one time go at selling a small spinner rack full of fake gift boxes. There were no second printings or any way for customers to reorder best sellers. But Alan and Rosie had their jobs writing and drawing cards for AG, and they made plans to improve Hoohah. American Greetings took their suggestion to expand Hoohah by offering contracts to me, Lou Marak and Jimmie Fitzgerald.

There were weeks of intense negotiations. George Burditt, head of Hi Brows at AG, and Dave Davis, vice president of Creative at AG, came to Kansas City to wine and dine us and tell us how much AG appreciated our talents and wanted to make us happy. Lou, Jimmy and I never talked to McCloskey about this. We knew Rosie and Alan were blackballed at Hallmark, so if we wanted to work with them again, it would have to be with AG and Hoohah Studio. It was either stay at Hallmark, or jump ship.

The offer made by AG was a lump sum of money for Hoohah and we could divide it however we pleased. We wanted a partnership with everyone receiving the same amount. But the lump could not be divided equally five ways without Rosie and Alan earning less than the contract they already had. So Lou, Jimmie and I had our own little conference and decided to make a final counter offer. We wanted equal pay for all five of us, or no deal. We thought AG would not agree to this, and were relieved to have the tense negotiating over with.

But George Burditt called me on a Saturday and said, "You got it." I was joyful. Lou and Jimmie were stunned and hesitant. I couldn't stand the tension of further negotiations. So on the next Monday I told Lou and Jimmie that I was going into McCloskey's office to tell him I was leaving, and they should do what they thought was best for them. I wouldn't say anything about their involvement in this, so if they decided to stay at Hallmark they wouldn't suffer any recriminations.

When I talked to McCloskey I fibbed a little to protect Lou and Jimmie. Well,

actually, I lied a lot. I said I was quitting to work freelance, and hadn't decided yet whether to work exclusively for one company or not. I planned to see what was the best deal I could negotiate. McCloskey assured me that he could make me a good offer. Then Lou walked in wearing a shit kicking grin and sat down in another chair.

"Dean just told me he is leaving us," McCloskey said.

"Yeah," said Lou. "We got this offer that is just too good to refuse..."

I quickly interrupted Lou so he wouldn't say we had a contract offer from American Greetings that included me, Lou and Jimmie. I repeated the lie I had just told to McCloskey. Then it went like the bamboozle we played on Dick Noel about turtles taking off their shells to make love. Lou picked up on what I said, but he didn't fully understand where it was going, and we went back and forth weaving a humorous tale of deception. McCloskey got confused, and started looking down the hall to see if anyone else was coming to quit this morning. I expected Jimmie to pop in soon, and make things more complex. But Jimmie didn't, and Lou and I got out of there with our stupid lie intact.

Jimmie kept fretting about it the rest of the week, and on Friday she decided to join Hoohah. She told McCloskey the whole story, and then came to a contract signing party at a little drugstore across the street from where we had rented an apartment for the Hoohah office. American Greetings had gutted the Hallmark Contemporary department staff. Jimmie was writing more than half the Hallmark line at the time with her gags going to staff artists and freelance artists Paul Coker and Bob Harr. Lou was illustrating about half of the cards in new programs, and I was writing and illustrating about a quarter of the new cards.

We all got a nice bump in income, but the big reason Lou quit Hallmark was because he had been promoted to Contemporary Department Art Director. Lou was being pressed to turn in a tardy report each week, and he was not nonchalant enough to fake it as Alan had done. "I figured everybody would start hating me," Lou said. "I just want to draw, not be a boss."

On a card that Hoohah produced for American Greetings, Lou Marak drew caricatures of the Hallmark Contemporary staff. The names were not on the card as they are in the drawing shown below, and AG editors didn't know who the tramps were supposed to be. The card published by AG said, "Goodbye....don't forget us when you are rich and famous." We thought it was a prediction of the future success of Hoohah Studio.

Hallmark Contemporary Department 1960

Larry Bowser Dick Bennett Jack Jonathan Robert McCloskey John Stith Don Branham Dick Noel Jerry Roach Jimmie Fitzgerald

caricatures by Lou Marak © AGC, Inc.

Hallmark Contemporary Department 1959

Robert Mcloskey
John Stith
Alan Denney
Bob Harr
Rosemary Smithson
Jack Jonathan
Dick Noel
Don Branham
Jo Ann Barham
Lou Marak

Robert McCloskey
Alan Denny
Bob Harr
Rosemary Smithson
Lou Marak
Don Branham
Dean Norman
John Stith
CITY LIMITS
Anita Atkins

© Hallmark Cards, Inc.
caricatures by Lou Marak

Jack Jonathan

Hallmark card that read, "Everyone is eagerly waiting for your return."

114

Hallmark Contemporary Department 1964

Top row: Kipp Schuessler, Gordon MacKenzie, Dill Cole, Gordon Long
Middle row: Russell Myers, Jim Bray, Stan Allen, Jane McCullogh, Sydney Wade,
 Bob Nix, Carolyn Anderson, Jeannette Jung, Robert McCloskey, Mike Rokoff
Bottom row: Carolyn Yates, Maurice Wright, Dean Vietor, Ed Sievers, Keith Cox,
 Dick Bennett

Kipp Schuessler drew caricatures of the Contemporary staff on a birthday card given to the boss, Robert McCloskey. Because McCloskey's birthday was close to Halloween, Kipp drew each person in a costume that seemed appropriate for the person. Bruce Cochran warned me not to take the images seriously, however. For example, Kipp only drew Bob Nix as a KKK member because Nix was from the South. Nix was a nice guy...the opposite of a cross burning KKK member. From 1960 to 1964 there was almost a complete change of in-house staff people in Contemporary. Only Kipp, McCloskey and Dick Bennett had been there in 1960, and many others had come and gone during the period.

Hallmark Contemporary
dept. 1957-1968
caricatures by Kipp Schuessler

Dick Gorelick

Basil Taylor

Ted Bick

Don Hall

Robert McCloskey

Dennis McNaboe

Bill Bridgeman

Dill Cole

Mike Rokoff

Gordon MacKenzie

Morris Fine

Keith Jacobshagen

Charles Barsotti

Walt Scott

Joe Isom

Jeanette Jung

John Norman

Maurice Wright

Dick Noel

Bob Harr

Ed Sievers

Hallmark Contemporary
Dept. 1957-1968
caricatures by Kipp Schuessler
(some identifications)

Joe Kipp

Carolyn Yates

Byron McKeown

Jack Jonathan

Sydney Wade

Jane McCullogh

Stan Allen

Larry Bowser

Russell Myers

Jerry Roach

Dean Vietor

Kipp Schuessler

Bob Nix

Dick Bennett

Sam Van Meter

Jim Bray

John Stith

Bob Dole

Gordon Long

Jimmie Fitzgerald

Phil Frank

Keith Cox

Bruce Cochran

Lou Marak

Alan Denney

Don Branham

Paul Coker

Tom Eaton

Carolyn Anderson

119

Chapter 23: Jimmie Fitzgerald and Hoohah Studio

I don't think anyone who ever worked with Jimmie Fitzgerald thought they could outwrite her at comedy. She hired on in the Hallmark Editorial department about the same time I did in 1956, and had written a lot of funny cards that were published in the Contemporary line before she was transferred to Contemporary in 1959. Then she wrote most of the line for a while. We were thrilled to have her as part of Hoohah.

The Hoohahs agreed to work flexible hours. We would come in about nineish most days, and leave about threeish or fourish. But anyone could really work any hours they wanted so long as we all carried our share of the load. So at nineish the next Monday morning Rosie, Alan, Lou and I were at our desks in our new studio. We glanced at the clocked as it ticked toward tenish, but no one said anything. About elevenish when we were thinking lunchish, the phone rang and Rosie got to it first.

"Jimmie! Where are you? We have been eagerly awaiting....oh...uh huh. Yes.. well..."

"What's happening?" Alan hissed. "Is that little bitch chickening out?...."

Rosie put her hand over the phone, and said, "Stop it! She's crying. She's been crying all weekend and couldn't sleep."

So we shut up and waited for Rosie to give us the scoop. We got most of it just listening to Rosie's side of the conversation. "That's all right, Jimmie. No, we won't hate you. We'll still invite you to our orgies, only goodness knows it's been a long time since we've felt up to having one. I know you signed a legally binding contract, but AG won't sue you. They will just be as sorry as we are that you're not with us. But you have to do what you think is best for yourself. Say hello to McCloskey for us."

Rosie was mistaken about Jimmie's state of mind during the phone call. Jimmie remembers this day vividly, and told me, "Crying? Couldn't sleep? NOT true! Actually--bullshit! I am not a crier. The only thing I ever cry over is when a horse gets hit by a freight train in movies. I did not cry--never did over business stuff. When I went to Hoohah Studio that day you were all out, so I went home and had a good think. The security of Hallmark for my girls proved too great for me to cut out. That's the story."

Jimmie was a young single mother with no financial back up. She was afraid to leave a staff job with medical benefits and job security for the risky Hoohah Studio adventure. A few years later Jimmie negotiated a freelance contract with Hallmark. She moved to Los Angeles for a year and tried to break into TV comedy writing. Two former greeting card writers, Phil Hahn and Jack Hanrahan, had become head writers on the award winning *Laugh-In* show. They were good friends of Jimmie, and recommended her highly to the producers. But the producers wouldn't give her a shot. "We have a staff of ten guys, and we do a lot of team writing. The guys kick ideas around and the conversation gets pretty raunchy. They would be inhibited if there was a woman in the room."

"Dirty words don't make me blush," said Jimmie. "I can take it and dish it out if you want to talk dirty. Just give me a chance."

They wouldn't. Jimmie got the same slap in the face that Hallmark gave to the black cartoonist who was turned down at Hallmark. "It doesn't matter how good you are, you are a _____ so we can't use you." Fill in the blank with whatever you are, and maybe you can understand how unfair and cruel that attitude is. The producers

did hire Jimmie to help develop a new comedy show titled *Turn-On,* but again left her off of the staff when the show went into production.

In 1969 I worked with Jimmie again for three weeks in Hollywood when Jack and Phil hired both of us to ghost write some gags for *The Banana Splits,* a children's TV show produced by Hanna Barberra studios. Neither Jimmie nor I liked to team write, so we would just chat a bit and then turn to our own typewriters and pound out gags. Then we would go to lunch, laugh about old times, talk about what we hoped for in the future, go back to the office and pound out more gags. We didn't compare our stuff much, but Jack and Phil were pleased, and I know Jimmie outwrote me. She was good.

Jimmie was giving up on TV at that time and going back to Kansas City to continue her Hallmark contract, and I had just gotten to Hollywood to try for a TV career. Our paths crossed again when Jimmie was Editorial Director at a card company in Dallas called The Drawing Board, and she offered me a job. That job never quite happened, and we met again in Cleveland when I was back at American Greetings and AG had bought The Drawing Board. Jimmie stayed in Dallas as a creative consultant. When she retired Jimmie moved back to Kansas City where her personal roots remained.

Before Jimmie became a Hallmark card writer she had tried a stand-up comedy act. An agent wanted to book her to travel the nightclub circuit. "I have this other girl I represent who is doing pretty well, but she isn't really very funny," the agent told her. "YOU are REALLY funny! Let me represent you, and you'll make the big time." Jimmie decided not to continue nightclub comedy. The other girl who wasn't so funny continued and did pretty well. It was Carol Burnette.

But to pull this story back to some sequential narrative that makes sense, in 1960 the Hoohah four began in a dingy apartment on the second floor of a building that wasn't supposed to rent any office space. It was mostly tenanted by welfare people. The landlord didn't fix anything, and didn't care what we did to it so long as we paid the rent on time. Lou, Alan and Rosie planned the decorating, and I helped paint to make our office a creative environment. I have no color preferences, and really don't care much what my workplace looks like so long as it is comfortable. But appearance mattered a lot to the others.

The living room was decorated with big panels painted in bright, flat colors. We bought a table and chairs at a drug store auction across the street, and this was our reception room for clients. We never had any, but they might have been impressed if they had come. The next room connected to our reception room through wide double doors. There were our desks and drawing boards where the magic actually happened. An opening from this room led to a kitchen that we painted in olive green. The dark color covered up the dirt, and we only used the kitchen to plug in a coffee pot and keep cold drinks in the fridge.

A door at the back of the kitchen led to the bathroom. The walls and floor were so dirty we painted them solid flat black so they disappeared completely. Going to the bathroom was like stepping into a black hole in the universe. There was a white john, sink and tub hanging in limitless space. We didn't plan to be in the kitchen or the bathroom for long periods, so didn't decorate them to impress anyone. Well, we did put a big red Day Glo heart on the toilet seat to make it more obvious.

Alan had an interesting conversation with the phone company when we got our Hoohah telephone account. "What category do you want to be listed under in the Yellow Pages?" the phone company lady asked.

"We don't want any listing in the Yellow Pages," said Alan. "We just want a phone."

"Well, you have a business phone, so you have to be listed in the Yellow Pages. A simple listing doesn't cost any extra, but if you would like a nice ad..."

"No, we don't want any listing at all in the Yellow Pages."

"Well, you HAVE to be listed. Pick a category."

"OK, list us under humorous writing and design."

"We don't have that category."

"All right then, just list us under dynamite."

"Do you manufacture or sell dynamite?"

"No, we write and draw funny greeting cards, and we're dynamite at that!"

I forget what we finally picked as our Yellow Page listing. We really wanted dynamite. When we were moving out of this apartment a year later, a little old lady dressed in clean white lace made an inspection of all the rooms and had only one thing to say, "Well, it doesn't appeal to me." The landlord didn't express any anger at what we had done to the place, and I'm sure he found another tenant. It was so cheap. Only people who needed the cheapest possible rental apartments would consider it anyway, and it was better than nothing.

Hoohah Studio had a good first year, so we figured we could afford a better office. If we had looked more carefully before, we would have discovered that it cost no more to have a really nice office in a commercial building within walking distance of Kelly's. Rosie, Lou and Alan decorated the new office while I was on vacation. The toilet was down the hall, but it wasn't a black hole.

Several of our old friends at Hallmark visited our new office and wanted to come to work with us. If AG had been willing to spend the money, they could have hired most of the Hallmark Contemporary staff. We negotiated small raises for ourselves, and hoped to expand, but AG said they didn't need any more talent yet. We were sure this would happen soon, however. We had pleased AG with our card submissions, sold some party goods designs to Monogram of California, created a funny new baby album and sold it to a publisher, and had several more projects in the works. We were certain that Hoohah Studio would soon be the next big thing.

HOSTESS WHO DIDN'T DREAM ANYONE WOULD ARRIVE ON TIME....

© Hoohah Studio

NIPKINS...The napkin to use when you're having a nip.

NEIGHBOR WHO CAME OVER TO COMPLAIN ABOUT THE NOISE

© Hoohah Studio

HELLO WORLD
....THE STORY OF MY LIFE (SO FAR)

BY _____
(NEW BABY & FUTURE CELEBRITY)

© Hoohah Studio Baby album cover design

DEDICATION

THIS BOOK IS DEDICATED TO MOM AND DAD WITHOUT WHOSE COOPERATION IT WOULD NOT HAVE BEEN POSSIBLE

THE AUTHOR

CHAPTER 11

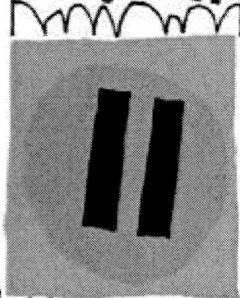

THINGS I DID FOR THE FIRST TIME and WHEN I DID THEM......

I HATE TO BRAG, BUT IT SEEMS LIKE EVERY TIME I TURN AROUND I DO SOMETHING NEW. SOMETIMES MOM AND DAD GET PRETTY EXCITED ABOUT IT. (IT TAKES SO LITTLE TO AMUSE GROWNUPS.) HERE IS AN OFFICIAL RECORD OF MY FAMOUS FIRSTS. SOME OF THESE THINGS I PRACTICED BY MYSELF BEFORE I DID THEM OFFICIALLY. (IT DOESN'T COUNT UNLESS A GROWNUP SEES YOU DO IT.)

FIRST TIME I COULDN'T WAKE UP MOM OR DAD AND THEY THOUGHT
 I SLEPT ALL NIGHT_____

FIRST TIME I DRANK MILK OUT OF A GLASS_____

FIRST TIME I ATE REAL FOOD INSTEAD OF BABY FOOD_____
 WHAT IT WAS_____

FIRST PERSON I BIT_____

FIRST PERSON WHO BIT ME BACK_____

FIRST TIME I SAT UP_____

FIRST TIME I CRAWLED_____

FIRST TIME I STOOD UP_____

FIRST TIME I WALKED_____

FIRST WORD THAT MOM AND DAD LEARNED TO UNDERSTAND FROM ME_____
 WHEN THEY FIRST HEARD IT_____

FIRST NAUGHTY WORD I SAID_____
 WHO I LEARNED IT FROM_____

FIRST VALUABLE THING I BROKE (BESIDES MY TOYS)_____

FIRST PERSON WHO OFFERED TO BUY ME FROM MOM AND DAD_____

FIRST TIME THEY WERE TEMPTED TO SELL_____

Chapter 24: Hoohah Unravels

When Rosie told her mother that she was no longer working at Hallmark, but was a partner in Hoohah Studio, Mrs. Leitz was worried. "If you're going to be working with those beatniks," she said, "you'd better put your name on your typewriter."

Rosie's typewriter was safe around us, but our venture was insecure. Just when we got our raises from AG, Lou announced he was going back to Hallmark. They offered him a contract almost identical to what we had with an opportunity to work overtime every month and make a little more money. He had a young wife and four young children and a big double mortgage on a house, so he

Hoohah Studio...Rosemary Smithson, Dean Norman, Alan Denney

needed the little bit more very badly. Technically Jimmie had been the first to leave Hoohah, but she had only been a member for one weekend and never drew a paycheck. We all felt that Lou's leaving was a blow that put the future of Hoohah in jeopardy. But we understood his problem and parted good friends.

When Hallmark lost so much talent to AG in a few short months in 1959 and 1960, the company developed an official freelance contract policy. McCloskey described it this way, "We realized that a lot of our writing and artistic talent just wasn't attracted to the benefits of a long career on the staff at Hallmark with possible promotions to management jobs. Artistic people wanted to keep writing and drawing all their lives, and they loved to work at their own place and their own hours. So we offered a freelance contract to anyone with a little experience who thought they could meet a production quota. No benefits, but they could live and work anywhere, and spend as much time as they wanted on other work so long as they kept up their production for us."

It worked and Hallmark stopped the brain drain. Lou went back to them, and Dick Noel, Larry Bowser, Bruce Cochran and Jimmie Fitzgerald took contracts. I was tempted, but I knew Rosie and Alan were still blackballed at Hallmark, so I felt an obligation to stay with them. I didn't have a pressing need for a little bit more money.

A few months later Alan announced he was moving to Los Angeles. His first wife, Dodo, wanted him back. "I've always been in love with Dodo," Alan explained. "I know it's awful of me to leave Pat, but I really love Dodo and our kids. Dodo wants to move to Los Angeles and try to break into the movies and TV. So we're going, and I will keep drawing my cards for AG."

In 1966 AG dropped Alan's contract in a budget cutting move, and Hallmark immediately put him on contract to work for them again. When Alan had been fired in 1959, he lost his cool and cussed out McCloskey...a very rare thing for Alan to do. Fortunately, McCloskey was a forgiving man, and the company was able to forget

about the Hoohah Giftniks incident that had caused Alan to be fired. Eventually Alan came back to Kansas City to rejoin the staff at Hallmark.

The various projects that Hoohah created in our first year did not amount to much. The baby album was marketed as a give away by businesses that give presents to customers who have a baby. Your bank, for instance, might have given you one. The album was never put on sale in stores. Most people are very serious about having a baby, especially the first one, so a funny album for this occasion did not appeal to everyone. Only to the lunatic fringe like us who made jokes about everything.

Our problem in selling our creations was that we were all creators and none of us were salesmen. Rosie wrote nice letters when we mailed stuff out, but she didn't want to travel and hustle the stuff. We couldn't afford to consider looking for a partner who could do that. We should have had a Kennedy. Jack Kennedy was our president, of the United States that is, and Bill Kennedy was co-owner of Box Cards. We had a first look contract with AG, and sent our rejected ideas to other companies. Box Cards bought some of them. Bill Kennedy visited us when he was passing through Kansas City selling his card line to card shops. He told us Box Cards was in trouble.

Box Cards had begun in 1954, two years before Hallmark and AG began publishing studio cards. Box continued to grow rapidly through the 1950s even as all of the major companies began producing studio cards. Box hired more cartoonists, and a sales force to spread their product more rapidly. A magazine article in 1958 said that 25 million studio cards would be sold in the U.S. the next year, and 5 million of them would be Box Cards. Bill Box once

FOREWORD

THIS BOOK IS VERY INTERESTING BECAUSE IT IS ALL ABOUT ME. IT IS THE FIRST BOOK I HAVE EVER WRITTEN SO I KNOW IT ISNT PERFECT. YOU MAY READ IT, IF YOU PROMISE NOT TO LAUGH.

BUT FIRST YOU MUST WASH YOUR HANDS AND DONT PUT THE BOOK IN YOUR MOUTH OR STICK YOUR GUM BETWEEN THE PAGES OR DRAW SCRIBBLES ON THEM OR TEAR THEM APART.

appeared on the Jack Paar Show, and Jack often read some funny Box Cards on the show after that.

A book collection of Box Cards titled *Burn This* published in 1960 showcased the work of six Box artists: Bill Box, Nellie Caroll, Harry Crane, Bill Brewer, Bob Guccione and Jerry Lee. The book has become a collectible that sells on Internet used book stores for $25 to $80.

"But we made a mistake of trying to go from being a good small company to being a big company," said Kennedy. "When I try to get an account away from one of the major companies, the store owner says, yeah, you guys have got a great studio line, but you don't have any conventional cards. If I throw out Hallmark, Gibson, Rust Craft or Norcross and take your line, all I have is studio cards. And those companies want exclusive space in my store, so I can't just buy your studio line.

"So we can still only get our cards into the small shops that pick and choose a few cards from lots of small studio card companies," said Kennedy. "We're going to have to cut back our costs."

Kennedy also told us that some new funny products were creative successes but commercial failures. A line of back-to-school products with irreverent cartoons appealed to kids, but they were sold in gift shops where parents don't usually go for back-to-school supplies. We loved an ashtray with a Smokey the Bear cartoon showing Smokey dropping lighted cigarette butts on the ground. But the U.S. Forest Service sued to stop Box from using their trademarked character in this way.

It was worse than he said. Soon afterward we got some rejects and a hand written letter from Bill Box who had been buying some of our freelance. "Great stuff, but can't buy any. My company has been sold, and I don't know what I am going to do." Buzza-Cardozo bought Box Cards and put their artists to work in a studio in Anaheim, California. A talented Box cartoonist, Bill Brewer,

congratulations...

IT'S HERE

that rainy day you have been saving for

© Box Cards, Inc. Bill Box, writer/artist

became director of the department, and Bill Box became a freelance artist. When I visited Buzza offices a few years later I asked to meet Bill Box, and Brewer said, "His drawing board is right over there. But he comes and goes, and he's not here today." Bill Box had been an inspiration to every studio card writer, and we were sad to hear things had gotten worse for him instead of better.

Then I saw "Bill Box" in the credits as writer for a story shown on a TV show called *Love American Style*. The story was about a funny greeting card writer whose girl friend broke up with him, because she couldn't stand the practical jokes he constantly pulled. She was a greeting card artist who painted pretty scenes and flowers on conventional cards. The guy promised to reform, and was given one more chance to prove he could behave nicely on a date. He appeared at the girl's apartment with flowers. She expected the flowers to squirt her, or to be dusted with sneeze powder. But they were nice flowers, and she was so pleased that her boy friend had really reformed and kicked the habit of practical joking. He produced a bottle of champagne, and filled two glasses and made a sweet toast to their new relationship. Then he grinned as she sipped the champagne from a dribble glass and soaked her blouse. He was laughing hysterically as she booted him out the door, "I just can't help it! I can't help it! It's SO funny!"

Bill Box then had a career as a TV comedy writer, and Nellie Caroll also wrote and drew for TV producers when her greeting card career faded. Bill Brewer stayed in greeting cards with Buzza-Cardozo, and later with Hallmark and Marian Heath Card Co.

So in 1962 Hoohah was just Rosie and me. We found it hard to be funny. Then, like Mr. Toad in *Wind in the Willows*, I hit on a new big thing. I decided to become an ecologist. I had

I'm looking for a steady girl

With a steady job

gotten into canoeing Ozark rivers in Missouri and Arkansas, and the beauty of them entranced me. Someone in the Ozark Wilderness Waterways Club suggested I read Aldo Leopold's book, *A Sand County Almanac*. His sermons on the value of wild things captured me. I became like a sinner who is converted to the one true faith, and wants to convert the rest of the world. Greeting cards seemed like a trivial way to earn a living. I enrolled as a part time graduate student at Kansas City University to study ecology with the goal of getting a Ph.D. and becoming a college professor.

My wife Bette was enthusiastically behind this change. When we had bought a new house in the suburbs in 1960 she had an emotional crisis. Unbeknownst to me she had seen a marriage counselor. "I always thought that when I was married and had some kids and my own house I would be perfectly happy," she told him. "I have all that now, and I'm not perfectly happy. What's wrong?" The marriage counselor couldn't see anything wrong with her situation, and told her she should just relax and be satisfied.

The problem was what many young married women experienced in the 1950s. As young mothers in the suburbs they had no daily contact with adults except their husbands when they came home from work with funny stories about what happened on the job. Cleaning house and minding kids wasn't the same. Bette had a degree in Political Science from the University of Iowa where we had met. She had worked at the library in the Music Institute in Kansas City for a year before she gave birth to our twins. So when I said I was going back to school to become an ecology professor, Bette told me she was going back to school to become a high school history teacher. We sold our house in the suburbs and rented a house in the city close to Kansas City University, and within walking distance of Hoohah Studio. Rosie and I juggled our Hoohah working hours around the class schedules of myself and Bette, and our twins started school so we didn't need day care.

Having a goal that seemed important gave me new energy, and it even seemed to perk up Rosie although it would mean she would not have a working partner when I made the final transition. But that could take a lot of years. So we wrote our funny cards with a renewed enthusiasm. Rosie had been building her family during the early Hoohah years, she and Lowell had two daughters. She hadn't missed a paycheck during either pregnancy, because she kept up her work load on a monthly average basis. Now that we were the Hoohah Two she sometimes asked me to work at her house instead of our office whenever her baby sitter had to cancel suddenly. This worked out fine, and her kids were very tiny, quiet and cute during afternoon nap time when we usually did our card writing.

I visited Rosie and Lowell years later when their daughters were 17 and 15. Both parents were tall, and the girls seemed destined to be even taller. Carol, a high school senior, was one of the tallest, slim beauties I ever saw. I made some joke about her height at which there was not even the slightest smile or come back. No, she didn't remember the days when she was in a playpen or crib and I worked with her Mom writing funny cards. Her personality was more like Lowell, quite serious, and unlike Rosie who would have turned a tall girl joke back at me in a flash, because she heard them all when she was a kid.

Lee, the 15 year old, was almost as tall, and she had the Rosie touch in her conversation. "Oh, you have dogs!" she exclaimed when she saw the two dogs that traveled with me in my car. "I have always wanted a dog, but I have absolutely no say in the matter whatsoever. Can I go with you to give them a walk?" So we walked the dogs around the block, and she was delighted to be holding the leash and have

me tell her about the adventures of Fawn and Biskit. Later her school basketball teammates came to pick her up for practice. She stood at the door in the midst of a bunch of girls that were her same age but about half as tall, and called, "Mom, I'm going out with the short people. I'll be back in time for dinner."

Flashing back to 1962, when I was a missionary to save the ecology of the planet, I invited Rosie and Lowell to go with my family on a canoe trip in the Ozarks. We paddled down the Big Niangua River in south central Missouri on a fine summer day. We were miles away from any roads or buildings when a thunderstorm caught us. Bette, our four-year-old twins, myself, and Rosie and Lowell sought the best shelter we could find. I was full of nature lore about this. "We shouldn't be out in the open, or under the tallest tree either. We should be among a group of small trees. We shouldn't stand up or lie down, but sit or crouch on something that won't conduct electricity."

As we huddled on a small gravel beach sitting on our lunch packs, the rain poured down in buckets, or like they say in the Ozarks, "It came down a frog strangler". Or as the shit kicking country boy Lou Marak might have said, "It rained like the old cow pissin' on a flat rock". Lighting flashed and thunder boomed. Then Lowell revealed a side of his personality I had not seen before. We all thought he was a rather straight stick, a perfect foil for Rosie's barbs. He enjoyed being made fun of, but couldn't come up with snappy retorts.

I think all of us were really scared, but maybe Lowell wasn't. He told us a story. "This is a funny coincidence. My law firm just won a suit based on the premise that lightning is really totally unpredictable. FLASH...CRASH! Yes, people say, don't stand out in the open, don't get under a tall tree, etc., FLASH...BOOOM...RUMMMMBLE... but the truth is...and we presented convincing evidence of this...that no matter what you do to protect yourself...DOUBLE FLASH...DOUBLE CRASH...lightning might strike you. We had examples of this. So a transformer that had been blown out by lightning had to be replaced by the insurance company. FLASH...EAR SPLITTING CRASH....The insurance experts said the power company must not have properly grounded the transformer, but we proved it was properly grounded and lightning destroyed it anyway. FLASH FLASH FLASH...KABOOOOOM!"

Lowell did a better number on us than we had ever done on the New Boys in the Contemporary department. We had to admit he was a funny guy in his own way. We thanked him for jangling our nerves during the peak of the storm.

Chapter 25: North Dakota

DEAN

In the summer of 1964 I was accepted for graduate studies at the University of North Dakota on a National Defense Education Act fellowship. It would pay me enough money for my family to live on, and I could earn a Ph.D. in three years. It was good-bye to greeting cards and the end of Hoohah Studio.

Rosie kept working for AG on a part time contract for several years, but put most of her energy into volunteer work with organizations like Planned Parenthood. Many years later she felt like being paid for work again, but she was still mad at the way she had been fired at Hallmark, so didn't look for work there. She got a job on the staff of The Kansas City Star writing feature stories. During this time her marriage with Lowell ended. Rosie and Paul Coker had dated when he came to Hallmark in 1955, but Paul didn't want to commit himself to the obligations of a wife and family when he was going off to New York to be a starving artist. After three decades of cartooning he was no longer starving, and Rosie was single again, so Rosie and Paul got married in 1993.

Whoops! I've slipped through the time machine again. Let's get back to 1964 when I left greeting cards and moved to Grand Forks. I loved North Dakota. I grew up in Iowa and we had winters in Iowa. But the winter of 1964-65 in North Dakota was REAL winter. The creeks froze over Thanksgiving weekend, and I didn't see a puddle until the next March. For several consecutive weeks the thermometer stayed below zero, from 1 below to 20 below. But it wasn't a hard winter. Only a couple of blizzards and snirt and snuss storms. "Snirt" a fellow student told me, "is when the wind mixes blowing snow with dirt from the bare crop fields, and it creeps into your house around the sills and frames of your windows. If you go outside during such a storm and get some in your mouth, the snirt grits between your teeth. Snuss, however, is snow and dust mixed so fine that you can't feel it between your teeth." Both of them left little piles of black dirt on the window sills when the snow melted.

I walked to class at the University on a route that took me through a cemetery. I was studying ecology and I liked to see the plants and animals that lived there. There were thirteen-lined ground squirrels, and red tree squirrels. I learned that

ground squirrels hibernate in burrows in the ground, but tree squirrels have nests in trees and do not hibernate. Tree squirrels store nuts to eat during the winter.

After a couple of heavy snows I had trouble breaking a path through the cemetery, but I walked the same route four times each day, Monday through Friday, and managed to keep a trail that I could follow for the entire winter. I don't think another fool followed my tracks. However a squirrel living in a burrow in the ground made tracks all winter also, from his burrow to a tree about six feet away. Then it appeared that he climbed the tree and ate horse chestnuts which he must have collected in the fall from another tree. Horse chestnut is not a native tree to North Dakota, so it had been planted just to make more variety in the cemetery. It fed the squirrel all winter. Every day there were fresh tracks in the snow where he had come out of his hole and gone to the tree, and fresh chips of nut shell on the snow.

Since he lived in a hole in the ground he should be a ground squirrel. There was no nest or hollow in the tree he climbed. But because he was not hibernating, but eating food he had stored in the fall, he must be a tree squirrel. For weeks I didn't see him, so I wasn't sure. Was this a ground squirrel who hadn't read the books and wasn't hibernating, or a tree squirrel who hadn't read the books and was living in a ground squirrel burrow? I finally saw him one day--a red tree squirrel.

I brought an ear of corn to give some variety to his diet. He ate the corn and then used the cob to plug the opening in his burrow and keep the new snow from falling into it. Now he didn't have to shovel snow every day. He could just push the cob out when he came out to eat his chestnut, and pull it back when he went back to bed. Why would he come out and climb the tree to eat a chestnut that he kept stored in his burrow? I guessed he was like me. He just liked to get out for a while each day no matter what the weather was like.

When the thaw came in March it was followed by a quick freeze. On my way to class I saw the corn cob frozen in a slab of ice and sticking out of the burrow. It looked like a miniature tombstone, similar to the many in the cemetery. How awful to die by flood and freeze after surviving such a long winter. There was no new snow on the ground then to make tracks in. But a day or two later the ice had thawed, the corn cob was removed from the hole, and there were fresh chips of nut shell under the tree. It was a happy ending.

During that winter people told me there would be a January thaw, but there wasn't. Then they expected a February thaw, but there wasn't. When the ground finally thawed in March a bunch of new graves were dug. It looked like spring planting in the cemetery. "We used to dig graves in the winter," a caretaker told me, "but after some grave diggers had heart attacks trying to dig through the frozen ground, we stopped that. Now we just have graveside services beside a cement block building, and the bodies are stored there until spring thaw."

Well, I learned more than that during my time at the University, but to get back to the topic of this book which is greeting cards, I decided to join the staff at American Greetings. Bette had developed multiple sclerosis. The doctors told her not to panic. Lots of people lived long and productive lives while fighting the disease. It tended to attack you and put you in a wheel chair or bed for a while, and then go into remission and let you get back to your life. The way to fight it was not to fight it. Take it easy when it attacked, wait patiently for the remission, and always be optimistic and positive. In other words, there wasn't a damn thing the medical profession could do to help other than tell you that you had multiple sclerosis.

We had gone to North Dakota with Bette getting around pretty well and only a tentative diagnosis that she might have MS, or might not. But her ability to get

around went into a steady decline. There was no sudden attack, and no remissions. After a year and a half I decided it wasn't a good idea to continue toward my goal of a Ph.D. and college teaching. Bette needed a wheelchair often then, and there was no hope of finishing her plans to teach high school history. We couldn't afford to hire house tending or nursing care while I studied and worked long hours to finish a degree and prepare lesson plans for first years of teaching. It would be better if I had an eight hour a day job, and could help her when I was home. A staff job at AG would pay enough so we could hire someone to help her while I was at work, and we would have medical benefits. Medical expenses were not much now, because the doctors couldn't do anything for her. But if someone discovered a cure, it might be expensive.

When I left North Dakota I visited McCloskey at Hallmark, and he offered me a freelance contract. I decided not to try that because it would not include medical benefits, and they would not offer me a staff job at that time. Hallmark had outsourced all of their work for veteran card writers and artists. The last of the Old Gang left the staff in 1963 when Sam Van Meter and Jerry Roach were fired for coming back to work a few minutes late after lunch.

McCloskey said, "Gee, I wish it had been anybody but you two guys. We decided coming back late from lunch was a bad habit of everybody in the department, so we set a trap. The next person to be late would be fired as an example to the others. Since you both were late together, I have to fire both of you. Gosh, I wish it had been anybody else but you two!"

That sounded like bullshit to Sam and Jerry. Sometimes the whole staff went out for lunch and came back a little late. Would they have fired everybody as an example to the others if the trap had caught the entire group? Hallmark management must have had other reasons for wanting to get rid of Sam and Jerry, but didn't want to discuss it with them. The Contemporary department was expanding rapidly and producing a variety of special promotions in addition to cards. It became stressful for people like Sam and Jerry who wanted to hang on to the old days when Contemporary was a small and close-knit group.

Sam gave up on greeting cards then, and went to work for Meredith Publishing in Des Moines, Iowa. One year he sold a lot of cartoons to *Playboy* magazine, and proudly told his friends to watch for them in upcoming issues. He was at his wife's family reunion in Des Moines, and one fellow sidled up and slyly muttered, "I hear you drew some cartoons for *Playboy* magazine. I sometimes sneak a peek at it when I'm in the dentist's office. What name do you sign on your cartoons?"

"My own name, of course," said Sam.

"Your OWN name?! In *Playboy* magazine?"

"Yes," said Sam. "And I sign it with letters two inches tall...PAT DAVIS."

The man was mortified to think the Davis family name was going to appear in *Playboy*!

On the way to Cleveland I also passed through Cincinnati where Gibson was looking for a new editor of their studio card staff. I told them I would rather write and draw than supervise, and the director said, "Well, you could be first among equals...be editor and still write and draw." I didn't think that would work, and the pay was no better than the offer at American Greetings. So Bette and I moved to Cleveland, Ohio, where I joined the Hi Brows staff at American Greetings. We hated to give up our dreams of becoming teachers, but we felt lucky to be able to get a situation that might enable her to avoid being confined in a nursing home.

Chapter 26: Hi Brows

American Greetings Hi Brows department was at the peak of its zaniness when I moved to Cleveland in 1966. Imagine that you are in a group that has come to take a tour of the company headquarters. You are driven through a run down residential neighborhood that has some bisecting commercial streets where small businesses are struggling to hang on. Then you enter a parking lot, and see a four story, dirty, crumbling brick building that has no artistic decor at all. When Alan Denney first saw it he said, "Oh my God! I'm working for Uneeda Card Co."

WHERE DO WRITERS GET THEIR IDEAS ?

DEAN

You enter the building and are taken though many rooms where artists sit at drawing boards, writers and editors sit at desks pecking at typewriters, and various other workers do various other tasks. Except for some artists who dress like hippies, everything is quiet and orderly like any other office. Then the tour guide grins and says, "Now we'll show you the Hi Brows department where they make those crazy cards."

You enter a gloomy industrial stairway and clang up flights of metal stairs that can be cleaned by hosing them down. On the last landing before the top there is a coffin. It was made to celebrate Halloween, and when someone stepped on the landing it activated a mechanism that lifted the lid of the coffin. Inside a macabre Dracula said, "Come closer and let me bite your neck. Ha ha ha ha !" Drac was made of paper mache, and his voice was a tape recording. At Christmas they dressed him as Santa Claus, and recorded a voice of a drunken Santa Claus cussing and complaining about kids. The mechanism was not activated at other times, but the coffin and the corpse remained on the landing for a long time.

At the top of the stairs is an ordinary door with the top half a window, but you can't see through because it is covered with headlines clipped from magazines and newspapers. I wish I could remember some of them. The artists and writers would clip and mix headlines to make funny remarks. Through the door, and now you are in the inner sanctum where these crazy people make those crazy Hi Brows cards.

But you don't see anything crazy at first. Just artists sitting at drawing boards. Some of them dressed like hippies, but you saw that in other art departments downstairs. The artists are working quietly and pay no attention to you. The tour director is giving his spiel, and you notice a tiny doll house on a window sill with a sign that reads, "Mousie's House". You point this out to the rest of group, and then a mouse bursts out of another doll house at the other end of the window sill, runs across the sill and into "Mousie's House". It was a paper mache mouse, and the animation was done with a hidden string pulled by an artist who is pretending not to notice you. A few steps along the aisle of the department, and a huge hairy spider drops from the ceiling and dangles in front of your face. Another paper creature animated by a hidden string pulled by an artist.

When everyone has recovered from the spider, you start moving through the department along the aisle where the writers have desks. One very serious young

man is staring vacantly into space. There is a human brain in a jar on his desk with wires leading from the brain to his temples. This is Larry Raybourne, about whom more will be said later.

Now you notice that a writer's cubicle at the far end of the studio has a high wall made of bamboo. There is a spear at the corner with a bloody human head on it. Well, paper mache, of course, and red paint instead of blood, but it looks pretty scary. When everyone is looking at the jungle hut, a living head rises slowly above the top of the wall. The person must be nine feet tall, and his skin is dark with bones stuck through his nose and ears. The ugly head disappears behind the wall. So the group hustles down the aisle to see what this kook looks like. When you look in you see me instead of a savage head hunter. I'm a very ordinary looking guy, wearing slacks and a sweater, and just doodling on some paper.

"Where is the guy we saw?" you ask.

"What guy? I'm the only one here," I say. I hid the savage mask in a desk drawer as soon as I climbed down from standing on my desk. The bamboo walls were my idea, but Larry put the head on the spear and bought the headhunter's mask. When I was not there, someone else jumped onto my desk to do the bit for the tourists. People got their money's worth when they visited Hi Brows, but the tours cost nothing so that's not bragging. The company loved the show we put on, but when the tour guide started talking it up too much we quit doing it. It was just for own amusement really, and when people stopped being surprised we moved on.

One time the Hi Brows artists spent some spare time drawing fake greeting cards. The ideas made no sense whatever, but they were very nicely illustrated with equally nonsensical cartoons. These were put on a rack near the door to the department as if they were new cards for visitors to look at. Tour groups would often stop and read the cards, and look puzzled. Near the card rack was a soft foam rubber mallet that made a sound like "BONK" when you hit somebody on the head with it. So if you came into the department and started reading the nonsense cards, an artist would pick up the mallet and hit you on the head. You had been Bonked— made a fool of for trying to find any meaning in the fake cards. They had so much fun with this in the Hi Brows department they decided to market the nonsense BONK cards to the public as a promotion. The name was changed to ZONK. But unfortunately there were no rubber mallets in the stores for the clerks to hit customers on the head with, and the cards did not sell very well. You have to go all the way with nonsense humor, or else it doesn't make any sense.

I think it was no coincidence that the popularity of Hi Brows cards was peaking at this time. We had fun and we made a fun product for the company. *Life* magazine sent a reporter and a photographer to visit Hi Brows for a week and do an article about the hot new Hi Brows greeting cards. When they first talked to Hi Brows director Tom Wilson about this he was not enthusiastic. "It really isn't all that exciting here. We just write and draw like any art studio, and yeah, every now and then something funny happens, but it isn't crazy all the time"

Then he had a second thought, "O.K., you come here and we'll try to remember all the funny things that have happened over a period of time, and reenact them for you. I guess it is pretty good publicity for the company." So we clowned for a week, and it really got out of hand. It happened to be a week when Rosie visited as she was still on freelance contract. Rosie had no trouble getting into the fun. Just like the old gang at the Hallmark studio, only wilder. McCloskey had never let us decorate the studio with crazy stuff. Hallmark never brought tour groups through and asked us to be crazy for them. At the end of the week of craziness at AG they took a group

A personal card Tom Wilson drew to invite Maxine Masterfield to lunch with him.

photo. Rosie was tall so she stood in the back row. The photographer asked us to look funny, so Rosie hung a leg over somebody's shoulder. But the week of fun seemed silly and forced. The writer claimed she lost her notes on the trip home, so there never was an article in *Life* magazine. And we gratefully went back to having fun only when we felt like it, and only for our own pleasure.

The company cafeteria was adjacent to Hi Brows studio, but it restored our creative juices to get out of the building for lunch. Creative juices must contain at least 3.5 percent alcohol, and none of these were served in the cafeteria. Maria's Restaurant was our favorite. A short drive, and we could get 10 to 15 people around a long table in the back room. It often took a long time for our orders to be served, but we never complained. It was nice to sip a beer and talk. Lunch hour at AG was 42 minutes, but because our pizzas came so late our lunch hour extended to an hour and a half. Tom Wilson, the Hi Brows boss, was always with us, so we didn't have to worry about being docked pay for the extended lunch hour. We found out that the reason our pizzas took so long was because we never complained to the waitress. She said, "I have a lot of other AG people in the front room, and they tell me to hurry because they have to be back to work in 42 minutes."

When Jim Elliott started work at AG he was given a book of guidelines for new employees that said, "No alcohol should be consumed at lunch!" When Hi Brows Art Director Ralph Shaffer took Jim out for lunch on his first day and ordered beers, Jim asked about the no alcohol rule. "Nobody pays any attention to that," Ralph explained. "Have a beer."

The guidelines also said employees should dress neatly, so Jim came to work in a double breasted business suit. He saw the other artists wearing wild T-shirts and jeans, and a guy with long blond hair and a screw in his ear (Larry Raybourne...we'll get to him later). They asked Jim why he was wearing a monkey suit, and he stopped wearing it.

Maxine Masterfield was an artist who never worked in Hi Brows, but often went to lunch with us. Maxine had never been a minute late for work during her first ten years at AG, so she was rewarded by being taken off the clock and made a salaried employee. The next day Maxine was ten minutes late for work. When her boss

Maxine Masterfield

DEAN

CLICK CLIK CLICK CLICK CLICK CLICK CLING CLING CLING CLING CLING CLING CLING CLIK CLIK CLIK CLIK CLIK CLIK

DEAN

chewed her out, Max said, "What's the reward of being a salaried employee if I can't come in a little late and not be docked for it?" She never came to work on time after that, and often joined us for long lunches at Maria's. Max's co-workers in Humorous art were jealous, and eventually the company let everybody in creative departments take an unofficial hour and a half for lunch.

While waiting for our pizzas many of the artists doodled on the place mats. Some very imaginative stuff was created, and we just left them on the table. One day we asked our regular waitress what happened to the doodles. "I've got them," she smiled. "They're wonderful. I love them!" We were pleased to know the doodles had a good home.

Occasionally we splurged and lunched at a classy place. One I particularly remember was a Greek restaurant with some very talented belly dancers. We stared so intently at their marvelous performance that our food was mostly ignored. Jack Clements then showed us how to watch and eat at the same time by moving his fork in time to the beat. He shoveled in bites at the same pace that the bells on the dancer's hips and bust were jingling. When the dance ended we rolled up dollar bills and tucked them into the dancer's costume. John Gibbons was so embarrassed he couldn't look while he was doing this, and he did a lot of fumbling before he got the dollar safely tucked in.

Flex-time at lunch helped boost morale, but a cursed time clock continued to deduct from paychecks whenever we came in late in the morning. One minute late, and you were docked 15 minutes pay. It wasn't fair, and Jack Clements finally solved the problem. There was a grease fire in the company cafeteria kitchen one day, and the fire department was called. By the time the firemen arrived the fire had been put out, and few people even knew there had been a fire. But this happened on a rare day when some Hi Brows people had eaten in the cafeteria, and Jack Clements was walking past the Hi Brows time clock just as the firemen burst upon the scene. They had come running up four flights of stairs and through the Hi Brows studio in their big boots, rubber suits and funny hats to reach the cafeteria. Our time clock was hung on a wall just outside our

DEAN

137

studio and opposite the cafeteria kitchen. "Where's the fire?" an eager fireman asked.

Jack pointed to the Hi Brows time clock, and said, "Right there!" The firemen went at the clock with an ax, and Tom Wilson decided it was just as well and never asked to have it repaired or replaced. The clock was replaced with an honor system sign-in sheet. It was amazing how many people got to work at exactly 8:00 a.m. each day. A lot of them got there one or two minutes before 8:00 a.m., but no one was ever just a few minutes late. A supervisor once said, "I suspect some of you are not reporting the correct time when you arrive."

And someone shouted, "Hey! You don't expect me to rat on myself?"

The Hi Brows staff in 1968 was caricatured on this published Hi Brows card. Jack Clements remembers they were surprised when it became a best selling card. Apparently there were a lot of office groups who could identify themselves with the Hi Brows gang, even though card buyers would not have known that specific people were drawn in the picture.

Top Row: Barbara Brown, Jack Clements, Leslie "Norbert" Friedland

Middle Area: Dan Henrich, Ralph Shaffer, Tom Wilson, Larry Raybourne, Gayle Steinberger, Jan Olin, Jackie Ludwig, Ray Abrams

Bottom Row: John "Roughhouse" Gibbons, Walter Lee, Glen Imhoff, Les Taylor

YOU CAN TELL A LOT ABOUT A PERSON BY LOOKING AT HIS FRIENDS.........

© AGC, Inc.

Happy Birthday from all of us who are ruining your reputation!!

writer unknown Les Taylor, artist

138

American Greetings
Hi Brows staff 1964
Caricatures by R. Crumb

Ray
Abrams

Ralph
Shaffer

Tom McGreevy
John Gibbons

Larry Raybourne

Alyce
Weber

Tom
Wilson

Robert Crumb

R. CRUMB

Dan
Henrich

Jackie
Ludwig

Al Margolis

Joyce
Johnson

Walter Lee

Glenn Imhoff

Teresa Satow

Chapter 27: George Burditt

George Burditt was director of the Editorial department at American Greetings in 1955, and pushed the company to begin a line of funny studio cards. He remembered that the first AG studio card was a drawing of a frowsy woman standing in a doorway and saying, "Hey, Big Boy!" It was drawn by Tom Wilson in the AG Humorous Art department. Tom couldn't think of a punch line, but felt that something could be done with it. Bill Buckley, a young man from George's hometown Winthrop, Massachusetts, came to interview for a writing job. Bill looked at the card and came up with an inside line, "You forgot your green stamps." He was not hired, and unfortunately never received pay or credit for his contribution.

HI BROWS

"Hey, Big Boy! You forgot your green stamps." was a best seller among the first Hi Brows cards, and a few years later the gag line was assigned to Barbara Brown for new art. She drew a similar frowsy lady sitting on a bar stool, and the card sold well again. But this time there was strong objection from one of the company's biggest accounts, Walgreens. Mrs. Walgreen threatened legal action unless the card was removed from their stores. So the same drawing was published with a less suggestive copy line, "Stay as Sweet as You Are."

"Stay as Sweet as You Are" was the copy line published in 1948 by Panda Prints with a drawing of a lady drinking herself under the table. The line was copied by many card companies, and usually with a drawing of someone who was misbehaving in some way. Several Hi Brows cards were produced featuring the cute prostitute cartoon character, one them saying, "When I say I want you for my Valentine—I mean business!"

Nancy Johnson, an Editorial department writer, suggested "High Brows" as a name for the new line of funny cards. George said, "Hmmm...these are going to be tall, thin cards so let's shorten that a bit and make it "Hi Brows". Tom Wilson then created a logo of a hand holding a lorgnette, and a line of cards that profited AG for 35 years was born.

Tom also designed the size of the new card line. After much measuring which made him confused, he just folded a piece of paper and whacked it in the paper cutter until it looked good. Then he measured the result and the official Hi Brows card size was 8 and 7/8 by 3 and 13/16 inches. When about a dozen funny Hi Brows cards had been written and illustrated, they were rushed to a printer, and AG hoped to be the first major greeting card company to publish studio cards. Hallmark's Fancy Free line of studio cards appeared in the stores a few weeks before the Hi Brows cards were ready, but it is significant that neither company was looking at what the other was doing. The staffs at both companies were looking at small card companies, and trying to compete by doing something original.

Lily Fueger designed some of the first Hi Brows. "The World's Greatest Lover" shows how AG was making the transition from complimentary humorous poems to insult humor. The insult was an eight line verse. Hi Brows gags soon became short conversational slang instead of long rhymes. "When Hi Brows became a separate department and moved upstairs, I was left behind," Lily told me. "Tom said he

Stay as sweet
as you are!

writer unknown Barbara Brown, artist

needed me to stay in Humorous Art and train new artists. It worked out better for me in the long run, but I was disappointed at the time."

George Burditt first lured me to work for AG in 1959. They did not have a separate studio department at that time. The Hi Brows cards were written in the Editorial department and designed in the Humorous Art department. Tom Wilson told me they could not hire an artist who specialized in cartoons, because all of their artists had to be able to draw in almost any technique from air brush flowers to scenic water colors or line cartoons. I was hired as a staff writer, but to work out of town and mail in my gags and sketches. During this time I moved to Duluth, Minnesota to be in the canoe country.

I didn't want to consider moving to Cleveland then, because I was not a good all-around writer or artist...I was only good at funny cartooning. George believed that the Hi Brows line was going to grow enough to justify a separate department similar to Hallmark's Contemporary department, and he convinced Irving Stone to take this step. George was able to pick the writers and artists for the new Hi Brows department, and among these were Larry Raybourne, Tom Wilson, Jack Hanrahan, Judy Gretz, and Barbara Brown.

George then became the first director of Hi Brows in 1960, and signed the Hoohah Studio to freelance contracts. Nick Laviach was a Vice-president of Creative who had some wonderful ideas for writers and artists at AG. "After a year on the staff, if people proved their abilities, they could work flex-time. They would have a desk or drawing board in the building, and could work there all the time if they wanted to. Or they could take their work home or to a personal studio anywhere else in or out of town. They would have to be in the building for a few specific hours each week so the managers could hold meetings to assign work. But the rest of the time they could be anywhere, and work anytime of night or

141

day. So long as they completed all assignments on time. If they couldn't handle the freedom, then it was either work regular hours in the building, or quit."

Nick knew artists and writers, and this deal would have kept many talented people working for AG at modest pay rather than look for better paying jobs at other places. But he couldn't sell the idea to AG's CEO, Irving Stone. So Nick quit and bought the Cooper School of Art in Cleveland, where he was happy teaching art classes and training talent for AG.

The person who replaced George Burditt as Editorial director didn't work out, so Irving asked George to go back to directing Editorial and Tom Wilson became Hi Brows director. By 1963 Hi Brows and Editorial were doing well, but George had not received promotions promised by Irving. So George quit AG and prepared to move to Boston and become head of Creative Division at Rust Craft. After his going away party at AG, George was at home packing for the move when Irving came to see him, and made an offer George couldn't refuse. A huge cash bonus, and promotion to head a department that would develop new concepts. He could pick any writers and artists he wanted from other departments (except Hi Brows). George decided to stay with AG, and one day it hit him that he had sold out for money. The anxiety caused him to black out while he was shopping in a drug store. Most of us in greeting cards never had our virtue tested in that way, so it is hard to understand George's reaction. Anyway, Irving gave George an indefinite vacation with pay to recover. It was winter in Cleveland, so George went to Florida for a couple of weeks to play golf and get a tan on the beach. When he felt O.K., he hurried back to Cleveland to set up his New Concepts department.

One of George's first successes was signing Johnny Hart to a licensing contract for the cartoon characters in the *B.C.* and *Wizard of Id* comic strips. They were two of the hottest newspaper comics in the 1960s, and Johnny Hart had turned down almost all licensing offers. He didn't want other people to be messing with his characters, and he didn't have the time to write and draw the comic strips and do extra work. But George convinced him that the AG staff would treat his characters properly, and make Johnny proud and even richer than he already was. But what clinched the deal was that George Burditt was a very short man with a high pitched voice, and good sense of humor.

"Hallmark sent a tall, serious SOB from their Sales Department, and offered me more money than AG," Johnny told him. "And they have done so well with the *Peanuts* characters I was tempted. But I'll be dammed if I'll work for somebody who is taller than me. You're the first guy I've talked to in a long time where I don't have to look up to see your eyes. You've got a deal, George."

Johnny should have taken the Hallmark deal, because AG bailed out of the contract after a year. The *B.C.* and *Wizard of Id* cards sold all right, but not better than the rest of the line, and Irving didn't want to pay the cost of licensing royalties. He couldn't see that having a unique thing was worth some extra cost. Hallmark has always bought some special licensing work which even lost money for them in order to have unique properties.

While AG had the *B.C.* and *Wizard of Id* characters, I sold a lot of freelance writing and sketches to George's department. I was a big fan of the comic strips and knew the characters well. An AG artist named Paul Gringle had an amazing talent for being able to ghost draw any cartoon style. It took him a couple of weeks of research and practice, and then he was able to draw Johnny's characters so well on AG cards that no one could see any difference. I should mention that the *Wizard of*

Id characters in the newspapers are drawn by Brant Parker. Johnny Hart learned how to cartoon while working with Brant Parker, and they both draw very much alike.

Other projects that George's new department developed had a hard time getting approval. Then one weekend it came to a sudden end. On a Friday I met George and took home some freelance assignments. I came in the following Monday and walked into an empty room. I thought I must have made a mistake. So I went back to the outside door and retraced my steps, and came again to the door that opened into George's department. There was no sign on the door anymore, but I really expected to see all the writers and artists sitting at their desks when I opened the door this time. It was still an empty room. It was Irving's revenge for George's disloyalty in thinking about being Creative Director at Rust Craft. The room had been cleaned out over the weekend. George had forgotten that when he got the big bonus there was a five year contract. He thought he would stay at AG forever, but on the day the five years expired Irving told him, "We don't need you anymore, George."

George went home in a daze and watched a new TV show titled *Laugh-In*. "I could write that stuff," George thought, so he went out to Los Angeles and called Jack Hanrahan. Jack had been a writer at AG, and often called George to say, "Come out to L.A. The streets are paved with gold." Hanrahan was one of the writers on *Laugh-In*, and suggested that George stay at the motel where the writing staff worked and get to meet them. George was able to show some samples of his writing to the head writer, Digby Wolfe, and got a job on a new show called *Turn-On*.

Turn-On made the Guinness Book of World Records as the shortest series produced in TV history. George was at a staff party with his wife on the night of the premier of the show on TV. A Cleveland TV station received so many angry calls they made an apology to viewers, and promised not to show any more episodes. An affiliate in Denver threatened to cancel their relationship with the network if *Turn-On* was not cancelled. The people at the party were laughing and counting their chickens, (eight shows had been completed), when there was a phone call from the network offices in New York to tell them *Turn-On* had just been turned off.

Nellie Caroll did some art for the show, and told what happened at the party. "It was at a very upscale, sophisticated, tres chic dump in Beverly Hills, and **POOF** even before dinner was served yet. Like a fool I didn't make copies of my work, so my best work is **GONE** because George Schlatter said they were all destroyed".

Alan Denny had gotten a job as a cartoonist for some cartoon spots on *Turn-On*, and he told me why he thought the show angered so many people. "It was a lot like *Laugh-In* with quick jokes and short skits. I don't think the jokes were any dirtier than *Laugh-In*, but there wasn't any audience laughter. Instead there was background music, well, actually it was background noise...a nervous beeping...like invaders from outer space music. When an audience laughs at an off-color joke, you get the feeling maybe it isn't so bad because so many people think it is funny. But with the beeping sound track the jokes just seemed to hang in the air like a bad smell. Anyway, I was sorry the show was cancelled, because I had bought a new car just to drive to work in, and now I had the payments to make and no salary."

Another greeting card artist, Jan Coffman, was at the party when *Turn-On* got turned off. Jan had left Hallmark to become an Art Director at Rust Craft in Boston in 1960. She quit there and moved to New York City in 1964, and continued to work as a freelance artist for Rust Craft. Then Jan made a move to Los Angeles and became Art Director on the *Laugh-In* show for a few months before becoming Art

Director for *Turn-On*. She missed living in New York, so moved back there to work on contract with Hallmark and other projects.

But the move to LA was good for George and his family. As soon as *Turn-On* ended he got work writing for a Dean Martin summer show, and through the years wrote and produced for *Andy Williams, Sonny and Cher, All in the Family, Sanford and Son, Three's Company, Silver Spoons* and *Sunday Dinner*. His wife, Joyce Burditt, had been a writer at AG, and in L.A. she wrote a best selling book, *The Cracker Factory*, other novels, and worked in TV for Andy Griffith and Dick Van Dyke. One of their sons, Jack Burditt, is currently a TV writer and producer.

George was able to use his AG experiences for some of his first TV comedy writing scripts. One day he was telling some fellow writers about how good it had been to have a secure job at AG instead of the insecurity of TV writing. "I had a good salary, a profit sharing pension plan, paid vacation, medical benefits."

"So why did you leave such a great job, George?" they asked.

"I got fired."

It got a laugh, and they developed it into a skit. An even better skit came from an experience when George was Hi Brows Director. A young writer was hired who became enamored of the craziness in the studio. The funny writings and drawings on the walls, the irreverent humor in the conversation. But he began taking his attempts at irreverent humor outside of the department, and it became a problem. George wanted to fire the new kid, but Irving said keep him for a while longer.

"But Irving," George said, "He tricked the PA system announcer into paging Adolph Eichmann, the Nazi war criminal who is on trial in Israel. Your family is Jewish, and a lot of your employees are Jews who had relatives in the Holocaust. It made them really mad."

"HE did that?" Irving chuckled. "It's, O.K., George. The kid is just a rebel. Creative people are rebels. I know his father. Give the kid another chance."

"But Irving," George continued. "On the anniversary of Stalin's death, he wore a communist symbol and a black arm band on his sleeve, and walked through the cafeteria. That made a lot of employees mad, too."

"HE did that?" Irving laughed. "He's just a rebel, George. Creative people are rebels. He will be a good Hi Brows writer. I know his father. The kid is O.K."

"But Irving," George went on. "He's talking to the writers and artists, and saying they should join a union, and go on strike for better pay."

There was a pause. Then Irving barked, "I've been telling you, George. You gotta fire that punk."

The names were changed when the skit was performed on a variety comedy show, but George had his revenge.

The World's Greatest Lover

unknown writer Lily Fueger, artist

© AGC, Inc.

Romeo, those thrilling tales

Of conquest that you tell us

Would be enough to make Don Juan

And Casanova jealous _

But if those stories all are true

How does it come about,

That every time you make a pass

You end up striking out?

This was one of the first Hi Brows cards. I suspect the verse was copied from an old Valentine known as "Vinegar Valentines" or "Penny Dreadfuls" which first appeared in the early 1800s. In the late 1800s such comic Valentines became so insulting and sometimes so raunchy that sending Valentines was banned in some countries, and the Chicago Post Office refused to deliver 25,000 Valentines they deemed too indecent to send through the mail. In his book, *The Romance of Greeting Cards*, Ernest Dudley Chase was glad that such Valentines had disappeared by the mid 20th century.

Or maybe an AG writer just copied the form of Vinegar Valentines. Dennis Brown said his friends called this type of rhyming insult card "Horse's Ass" cards. Studio cards as they developed in the 1940s and 1950s rarely used such long rhymes and obvious insults.

Chapter 28: Tom Wilson

If genial, balding Robert "Bob" McCloskey was the genius at Hallmark Contemporary cards, then husky, smiling Thomas "Tom" Wilson was his counterpart at American Greetings. McCloskey had a degree from the prestigious Rhode Island School of Design. Tom had a high school diploma from Panther Lick Run. Well, Tom actually went to school in Uniontown, Pennsylvania, but his house was in Panther Lick Run, West Virginia. He told about a family down the road where the oldest son had to beat up the father in a fist fight to get permission to leave home. It became a tradition in that family. Every son had to beat up the father in a fist fight before the old man would allow as how the kid was grown up enough to be on his own. Tom's family wasn't that rough, but Tom never imagined any sort of professional career for himself.

After high school he was drafted, spent two years in an Army band playing a tuba, and worked for a while as an artist for a newspaper in Uniontown. Then Tom and his brother came to Cleveland, Ohio, to look for better paying jobs. A steel company Personnel Director thought Tom was a big enough kid to be a steel worker. He was taken to a furnace and told to start shoveling coal. Tom nearly passed out from the heat before he even picked up a shovel, and said he could not do this job. So he was taken outside where it was cooler, and down some railroad tracks where coal was unloaded from freight cars.

"There were some big, tough looking, black men scowling at us," Tom remembers. "They looked like guys who had been through hard times and had nothing to lose. The foreman said to them, "All right, you lazy bastards. This is your new boss, and he will kick your ass if you don't get to work!"

"No, I won't," said Tom as he walked away from the steel company. Tom had been a pretty good artist in high school, and somebody told him American Greetings employed a lot of artists in Cleveland. Tom was hired and his pleasant manners soon got him promoted to be an art director of one of American Greetings' art departments.

That's where he was when AG decided to create a new line of studio cards, and Tom drew a few designs for it. Hallmark did not consider AG a competitor because Hallmark cards were sold in gift shops, and AG cards were sold in drugstores. Even though AG was second in total sales, Hallmark thought their only serious competitors were Rust Craft, Norcross and Gibson who also marketed cards to gift shops.

However, AG did consider Hallmark as competition, and the head man at AG, Irving Stone, always looked to see what Hallmark was doing. But Hallmark had not yet published any studio cards, so the competition to look at was Box Cards. Irving thought the AG Hi Brows cards should be printed in just black and white, like the very funny Box cards. Tom argued with him. "Box would use color if they printed enough cards to afford it."

DEAN

"No, no!," insisted Irving. "The public thinks studio cards are just black and white." The argument was resolved by allowing the artists to put just a tiny spot of color on each card. Tom remembers how excited he was when the first Hi Brows cards were sent to the printer, and then he walked into a card shop and saw the Hallmark studio cards for the first time. "Damn! They beat us to it!" he thought. No one at AG seems to remember whether the first Hi Brows cards were published in 1956 or 1957. Hallmark's studio cards were first published in 1956, but perhaps they were not distributed in Cleveland until 1957. At any rate, when the Hallmark studio cards came out in full color, there was no trouble convincing Irving to use full color.

During his entire life Irving always wanted to do what Hallmark was doing. He figured the Hallmark Research department knew things he didn't know, so he would follow the Hallmark path. He loved to hire artists and writers away from Hallmark to get both their talent and their knowledge of future directions at Hallmark. When Irving heard that Hallmark had all of their verses and art stored in a bomb proof shelter, he stored the AG archives in an abandoned coal mine in Pennsylvania.

Tom became Director of Hi Brows in 1961, and supervised the gang of writers and artists for 10 years as Hi Brows cards became the hottest new thing in greeting cards. McCloskey had built Hallmark's Contemporary line by finding and keeping talent, and providing a buffer from upper management policies that irritated writers and artists. Tom performed the same tasks in Hi Brows, but in a more personal style. Tom was about the same age as the people he hired, and he partied with them at lunch and on weekends.

Tom remembers one lunch hour where the staff decided to play touch football in a nearby park. He was a little late in arriving, and three people already had broken ribs. Another football game was played at a party in Tom's backyard. A new artist from England, Walter Lee, wasn't familiar with American football rules, but he had been a good rugby athlete at home. The gang decided to play tackle football, and nobody was able to tackle Walter. He left a trail of moaning and bruised bodies on the ground with every scoring run.

Walter Lee

DEAN

Tom spoke to Walter about it. "Some of the girls are mad because you are running so hard and knocking them on their ass. Take it easy, Walt, and let people pull you down when they get a hold on you."

Walter agreed, but the next time he got the ball his competitive spirit took over his mind and body, and he plowed through the group to score another touchdown. Tom was mad and told everyone, "Stay out of the way, and let me tackle him on the next play." There was a violent collision, Tom was knocked unconscious and Walter scored again. The gang decided the game was over, and they moved indoors to continue the party with less violent activity.

When I came to Hi Brows in 1966 I was still full of zeal to save the Earth by educating people about the beauty of nature. So I organized some canoe trips on the Mohican River south of Cleveland. The core group that made most of the trips were Tom and his nine year old son Tom II, myself and my nine year old twins David and Susan, Ralph Shaffer, Walter Lee, Jan Olin and Maxine Masterfield.

I particularly remember one trip when we were waiting at a bridge for our pick up in late afternoon. Tom II had caught a frog from the river. He wanted to take it home as a pet. The kid loved all kinds of animals, furry and creepy. Many dads might have said, "Let the frog go. We're not taking it home." But Tom talked softly to his son for about 20 minutes. "I know you think the frog will be happy, because you can make it a nice cage with a pool, and give it bugs to eat, and be its friend. But what if some big monster grabbed you from your backyard, and took you away and you never saw your Mom or your Dad or your friends again? Would you be happy? Well, that little frog has his family and friends in this river, so if you really want him to be happy, you should turn him loose." Tom II sadly said goodbye to his new friend, and put him back into the river.

Tom had a Doberman pinscher dog, and it had puppies. Several of the Hi Brows staff bought puppies. It was a doggy family reunion when I invited the staff to a party at a farm I was renting, and said, "Bring your dogs. There's plenty of room for them to run." There were three big Dobermans, a tiny dachshund, and my big golden Labrador playing chase through the afternoon. With ten acres to run in, they just kept running circles near the picnic, occasionally bumping an elbow and spilling food. When you heard the thundering paws approaching you had to tuck in your elbows and hope they missed you.

Tom's relaxed style of management was demonstrated when a Hi Brows artist was caught stealing food from the cafeteria. Al Margolis was working overtime late at night. He hadn't any dinner, and got very hungry. Most of the food in the cafeteria was locked up, but he was reaching to get a fudgsical from an ice cream freezer when the night guard nabbed him. Al was a very short person, and the guard lifted him up by the collar and demanded his name and department. Al was too scared to fib, so he gave the correct information.

The next day Tom got a call from Personnel saying one of his employees had been caught stealing food and should be disciplined. The name was Elmer Golis. "There's no one by that name in Hi Brows," said Tom. "He must be in another department." The call puzzled Tom and he wrote out the name, and then sounded it out, and realized the name was really Al Margolis. Tom decided that stealing a fudgsical when you were hungry was not a serious crime, so he didn't say anything more about it to Personnel. The guard had taken care of the problem by not hearing the name correctly.

As a way of motivating the writers to turn in some work regularly, Tom would ask them to post card ideas on a bulletin board with push pins. Late each day Tom would look at the day's work, and put a check on each idea that was accepted for the next level of judgment. When he rejected an idea, Tom would turn the piece of paper over and pin it backwards on the board. One day Larry Raybourne noted that a lot of the ideas that John Gibbons had written were rejected. "John," he said, "some day I will come to work and you won't be at your desk. You will be hanging backwards on this board with a push pin in your back."

Tom's management skills got the most severe test early on when he had just become Hi Brows director. The staff in Cleveland found out how much the Hoohah Studio people in Kansas City were being paid, and wanted similar freelance deals for

themselves. "I had a mutiny on my hands," Tom said. "I told them, O.K., anyone who wants the same deal can have it, but think about this. The company isn't going to have empty desks and drawing boards here. We will hire new people. And if sales take a hit sometime, and we have to cut the budget, the freelance contracts will be the first to go. Those Hoohah people are taking that chance. Do you want to take that chance, too?"

"I was taking a big gamble," Tom admitted. "I didn't know if the company would back me up on this or not. I didn't want to mess around and talk about it with upper management, because my artists were hot and wanted immediate answers. Well, it worked. Not one person wanted a freelance contract, and there was no more complaining."

Everyone who worked at Hi Brows thought about greener pastures. Tom once considered joining Jack Hanrahan in buying a small greeting card company named Country Cousins. Tom developed a comic feature named Ziggy and tried to sell it to syndicates. The female editor at King Features looked at it unsmilingly and said, "Well, I don't think it's funny to make fun of short fat people." Tom was about to explain that Ziggy was really just an everyman who got kicked around by life. A lovable looser, but not necessarily because he was short and fat. But he noticed the lady was short and fat, and realized there was no way to win this argument.

He put Ziggy away for a few years, and then drew the character on a small book published by American Greetings titled *When You're Not Around*. He hadn't done any finished art in a long time, but the staff was working overtime on the *Hi Brows Funny Books* project, so he pitched in to illustrate one of them with Ziggy. The book sold 400,000 copies, and one day Tom got a call from an owner of Universal Press Syndicate. Could Tom possibly develop that character into a newspaper comic feature? Tom pulled out the cartoons he had drawn years before, and Ziggy began appearing in newspapers.

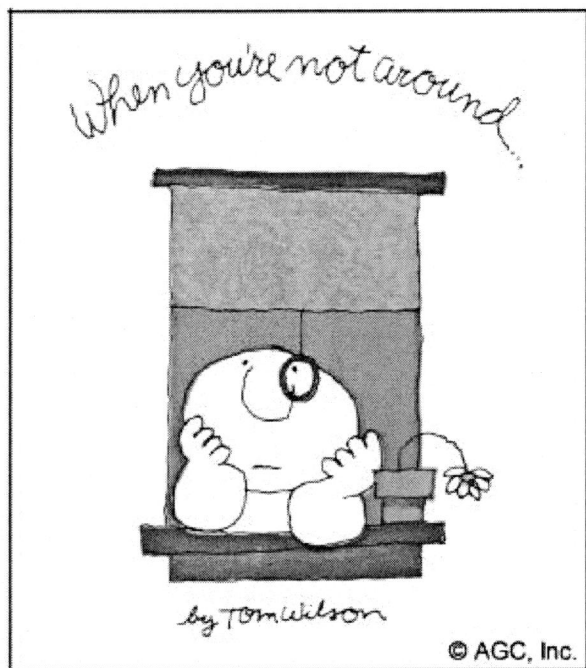

The Hi Brows Funny Book that sold 400,000 copies and led to Ziggy as a newspaper comic feature.

When he signed the Ziggy contract with Universal Press, Tom was a little worried about providing a daily cartoon while still doing his full time job at AG. He phoned Johnny Hart to ask advice about syndicate contracts. Would it be a good idea to ask for a no-editing clause so he wouldn't have some ideas rejected and have to do extra work?

"Don't ask for that!" Johnny said. "I think I am the only one in this business that has a no-editing contract. I got that after my first 5 year contract expired, and *B.C.* was a big hit. I said I was taking it to another syndicate if I didn't get a no-editing clause. It was a bluff, because I didn't have any offers from another syndicate. Well, my bosses gave in, but they hated me for it. As a beginner with an unproven feature, you have no chance. It will only make them mad if you ask for a no-editing clause. I mean,

how would you react if your writers and artists asked for a no-editing clause? That's your job...to edit what they write and draw."

So Tom didn't ask, and after a while he noticed that some Ziggy cartoons appeared in the papers very shortly after he sent them to the syndicate, and some he had sent weeks before hadn't appeared yet. He asked about it, and was told, "Oh, well, we like to put the really best ones in the papers right away. And we're keeping the others to use later." They didn't say some were rejects, but Tom realized that was what was happening. So he began sending fewer cartoons until the ones they were holding had been used.

The syndicate asked Tom to send more cartoons and work a little ahead of the deadline. "Oh, yeah, I'll try to do that," Tom promised. "But AG is sending me to Japan next week to negotiate a greeting card deal there, and...but I'll get ahead as soon as I can."

Meanwhile, Irving offered to buy Ziggy from Tom. "You're a top man with AG, Tom. I don't want you to spend too much time on this Ziggy thing and neglect the Hi Brows department."

"Don't worry, Irving", Tom said. "I buy a lot of the ideas from writers, and it doesn't take me too much time to knock out this daily cartoon. I drew some of them while I was on the plane going to Japan. Doing Ziggy won't take time away from Hi Brows." Of course Tom saw the potential in a syndicated newspaper comic, and wasn't about to sell it at an early stage.

A lot of cartoonists quit their day jobs as soon as they sell a syndicated feature, but Tom balanced both jobs for many years. In effect he got an unspoken no-editing deal with the syndicate, because he kept promising to work ahead on Ziggy, but always sent just enough cartoons just before each deadline so they had to use them all.

After a year in the papers, AG licensed Ziggy for greeting cards, and it became one of their best selling licensed characters. Tom stayed with AG for many years while also drawing Ziggy for the newspapers, but eventually he retired from AG to concentrate on Ziggy. Then there was a falling out with AG, and Ziggy was licensed with Hallmark from 1995 to 2000.

Tom was one of the few of us who made it big in something besides greeting cards, and we felt he deserved every bit of his success. He is a great cartoonist, and was a great boss. John Dragan who worked many years at AG and saw a lot of executives come and go, once said, "Anyone who ever worked for Tom loved him and said he was a great boss."

When Tom's son, Tom II, grew up he began writing and drawing Ziggy cartoons. Look at the feature in your newspaper, and notice that both names appear on the feature---Tom Wilson & Tom II.

THE VOICE OF ZIGGY

If you know someone who is a film trivia expert, you might ask him who did the voice of Ziggy in the TV cartoon *Ziggy's Gift*. Four actors did voices for the animated cartoon: Richard Williams, Tom McGreevey, Tony Giorgio and John Gibbons. Richard Williams was the owner of the animation company doing the art for the production.

Tom wrote and sketched a storyboard on 3 x 5 index cards. As he showed the first parts of the show to the network executives they liked it, but noticed that Ziggy didn't say anything. "Well," Tom explained, "I want the show to start with visual gags but no dialogue, like an old silent movie comedy. I want it to be sort of Chaplinesque. You know, like the early Charlie Chaplin movies."

The execs liked that, but said, "We want Ziggy to talk. People want to hear what Ziggy sounds like." That was what bothered Tom. What should Ziggy sound like? When people read a newspaper comic they usually hear a little voice in their head. Different people would have different ideas of what Ziggy's voice sounded like. How could Tom create a voice that would satisfy most Ziggy fans? The more Tom thought about it, the more confused he became. So Tom decided that Ziggy would not talk in the film, even though other characters would talk.

As the story board was shown to the network execs bit by bit, they kept bugging Tom to make Ziggy talk. "He will," Tom promised. "I just haven't gotten to that part yet. At this point the story is still sort of Chaplinesque." Tom told me later, "I got a lot of mileage out of that word "Chaplinesque". They liked it, and I kept using it as an excuse for not making Ziggy talk."

But eventually the execs said, "Ziggy HAS to talk!" It was a direct order. Then Richard Williams' Los Angeles studio went bankrupt, and the completion of the film was in doubt. Now the execs worried more about having the show completed than what Ziggy would sound like when he finally talked. Tom paid the animators in William's former studio to stay at their drawing boards and complete the show. It cost Tom $50,000 that he never recovered.

© Ziggy and Friends, Inc.

Near the end of the film Ziggy, Santa Claus, a policeman and a butcher sing a Christmas song. So the voice of Ziggy is one of the voices you hear in the group. Which one is it? Tom doesn't know. "All the actors are singing," Tom told me. "Ziggy's mouth is moving as the song is sung, but there isn't another actor in the mix besides the ones who are doing the voices of the other characters. So I kept my promise. Ziggy sang, but I don't know what his voice sounded like. If you listen to the song and think you hear Ziggy— that's fine."

Chapter 29: Ralph and Anni Shaffer

Ralph Shaffer graduated from Akron Art Institute in 1963 and was hired at AG. The AG system was to put newly hired artists through an Art Training Program, and then assign them to one of the company's art staffs. When Ralph finished art training he was sent to Humorous Art and asked to draw a cute fuzzy bunny. This was not the sort of thing he liked to draw, so he drew a skuzzy looking bunny with its neck in a noose on a gallows. The Humorous Art Director thought perhaps Ralph would fit in better somewhere else, and asked Tom Wilson to take a look at him.

It was a lucky moment because the best stuff in Ralph's portfolio was graphic designs, and Tom Wilson was looking for that type of artist to add some variety to the cartoon rich Hi Brows line. So Ralph was happy doing the type of art he most enjoyed, and while he was at it he began experimenting with cartoon styles and did some of that, too.

The position of Hi Brows Art Director was unfilled much of the time after Tom Wilson became department director. A few people tried it and didn't like it, so Tom asked Ralph to give it a try. Ralph continued to design a few Hi Brows cards occasionally, especially when someone on the art staff would be out sick or just be out of it and not producing. The eccentric nature of many of the artists was the reason it was difficult to keep an Art Director. Ralph was exactly what the department needed.

"I loved those crazy people," he told me. "I don't mean they were all my best friends. I loved all of them for the unique art styles and attitudes they brought to the card line. Hi Brows was sort of a department of misfits...I mean the way I was a misfit in Humorous Art. Most of them just wouldn't fit into any other part of the AG art system.

BON VOYAGE!
...enclosed is a little something in case the trip gets a bit rough.....

© AGC, Inc.

writer unknown Ralph Shaffer, artist

(An Alka Seltzer packet attached inside of card)

MY DOG REMINDED ME OF YOUR BIRTHDAY! GOSH, SOMETIMES THAT POOCH IS SO SMART I THINK HE'S JUST LIKE YOU AND ME......

....ALMOST HUMAN!

© AGC, Inc.

Dean Norman, writer Ralph Shaffer, artist

And, you know, the crazy humor of Hi Brows cards was something for the millions of misfits in society to enjoy...people who didn't want to send conventional or sweet cards, but wanted something outrageous and funny. Those nutty artists made our line great."

So Ralph was able to tolerate and enjoy craziness that most bosses would have not been able to deal with. For example, the birthday present from his staff. Well, the story begins with Ralph's days in the Art Training class. Robert Crumb was in the same class and they became friends. After Ralph became Art Director in Hi Brows, he went downstairs to visit Crumb and see how he was doing.

Crumb had been assigned to Finished Art and was trying to learn how to copy original art in shades of gray for camera reproduction. This was probably the biggest mismatch of art talent that ever occurred anywhere. Crumb's only interest was to draw original comics, and he had decorated areas of his drawing board with comic doodles. "That's great stuff, Bob," Ralph said. "Can I show it to Wilson?"

Bob said O.K., so Ralph took a knife and cut out a piece of masking tape on which the doodles had been drawn. Wilson looked at them and wanted to see more, so Crumb came upstairs with his only portfolio...a sketch book of crazy comic doodles. Bob transferred to Hi Brows and began sketching all the writers' ideas for approval meetings. In a short time he was promoted to drawing for publication.

Now to get to the birthday present for Ralph. "We always pulled some stunt on anybody when it was their birthday," said Ralph, "so I knew something would be done to me. I heard the staff singing "Happy Birthday" and marching toward my desk, and I braced myself for it. The rest of the gang stood back and sent Bob Crumb forward holding a huge birthday cake. Lots of frosting, but no candles, so I knew what was coming. A cake in the face. Crumb slammed the cake into my face, and it felt like I had been hit by a hammer. There was a six-pack of beer under the frosting!

"For a few seconds everything went black, then I saw stars, and then came out of it and they all were laughing. Crumb was jumping around like a frog and going "Hee hee hee". They didn't notice me unscrew the lid from a jar of rubber cement. Then I said, "O.K., Bob...your turn!" and poured a quart of rubber cement on his head. He had long stringy hair, and it freaked him out. I had been mad when he hit me with the loaded cake, but now I felt sorry for him.

"So I apologized and said, "I'll fix it, Bob", and led him over to the sink. I plugged the sink and filled it half full with rubber cement solvent. Then I started washing Crumb's hair. He passed out several times from the fumes, and I had to revive him and continue washing. Then I drained the solvent, filled the sink with soapy water and finished the job. I guess it was lucky I didn't blow up the building. That solvent is very explosive and there was always somebody smoking around the art area. Anyway, Bob's hair was clean, and we were still friends."

My guess is that Bob had been set up by the rest of the staff, and not told that there was a six pack under the frosting. Ralph was a big guy, and I can't think of anyone who would have had the nerve to knowingly slam that loaded cake into his face. Maybe they thought Ralph wouldn't hit Crumb, because Bob was such a short, skinny guy. Or maybe Crumb was so far into cartoonville in his imagination that he didn't realize how much it would hurt. Like the Coyote who always popped right back into perfect shape after being slammed by the Roadrunner.

Maxine Masterfield was an AG artist who didn't work in Hi Brows, but she hung out with us a lot. Maxine would tell her husband about the fun in Hi Brows. He was a manager in a company that didn't hire any writers or artists. Instead of laughing at the stories, he would scowl and say, "If I was their boss, I would fire all the bastards!" It took a special kind of person to be a boss of people who created funny stuff.

My best caricature of Ralph shows him giving advice to Jan Olin, a Hi Brows secretary. I should explain it. Jan had been to a company party and flirted with a lot of guys. One big drunk started coming on to her too much, so she ran to the Hi Brows guys for protection. There was almost a fight, and Ralph blamed Jan for the trouble. Another company party was going to happen after work, and Ralph didn't want Jan to repeat her flirty behavior. "Don't talk to no guys!" was his good advice, and Jan frowned and clearly intended to flirt wherever and with whomever she wished.

Ralph remained Art Director of Hi Brows though its best years. He became Director of Soft Touch department when that line of cards with soft photos and soft prose became extremely popular in the 1970s. When AG licensed characters such as *Ziggy, Holly Hobby, Strawberry Shortcake*, and the *Care Bears*, Ralph became co-director with Tom Wilson of a new company called Those Characters From Cleveland. He finished his career with AG as creative director of americangreetings.com when that new company launched a gallery of online cartoon features. My online comic strip titled *Wally's Woods* was one of the features.

So in 1999, nearly ten years after I had retired from AG staff, I had the opportunity to work with Ralph again.

Ralph Shaffer gives advice to Hi Brows secretary Jan Olin

154

Ralph Shaffer doodles
during a dull meeting

Americangreetings.com canceled their online cartoon features after a year, and Ralph retired soon after that. He had a long career with AG, and sort of feels like I do. The best part was near the beginning when Hi Brows cards were defining what a funny greeting card should be.

Anni Shaffer

In second grade Helen Ann McFarling was asked to print her initials on a piece of paper. Another student looked at it and said, "H.A.M.! That's like a pig! Oink oink oink!" Helen Ann thought it was funny, too, and began doodling a drawing of a pig when she printed her initials. When I asked Anni how she had become a Hi Brows artist, she wrote this explanation for me.

"In 1967 I was in Des Moines, Iowa, working for the phone company and taking night school art classes at Drake University. One of my classes was titled "Creative Imagination", and as an assignment for this class each student was to create a resume directed toward obtaining a "dream job". Since my initials were H.A.M., I made a portfolio centered around pigs and targeted doing greeting cards as my "dream job". I had been a fan of studio cards since the time I discovered them, about 1959. I laughed at them, sent them, collected them and tried to write and draw them.

"One day after a happy fix of card shopping, on impulse I decided to send my class portfolio to American Greetings. Not having any interest in greeting cards other than the funny ones, I addressed it to "Mr. Hi Brow". Tom Wilson contacted me and arranged a trip to Cleveland for an interview. I became a Hi Brow artist in training on Valentine's Day, 1968."

Coincidentally, the Hi Brows artists were drawing pig jokes on the walls of the studio when they were told that a girl calling herself H.A.M. was coming to work with them. When Anni arrived the pig jokes mushroomed. She went through the teasing every new artist and writer received and enjoyed it. She drew pigs on greeting cards when it would fit the joke.

Within two years Anni married Ralph Shaffer. The pig jokes never stopped. On one birthday Anni was given ten pounds of pork chops instead of the traditional cake. Then at an office Christmas gift exchange

HOGS AND KiSSES
ON YOUR BiRTHDAY!

© AGC, Inc. Anni Shaffer, writer/artist

ROSES ARE PUTRID, VIOLETS STINK....

BECAUSE MY FRIEND AIN'T IN THE PINK!!

© AGC, Inc.

writer unknown Anni Shaffer, artist

she received a live pig. Ralph and Anni lived in an old farm house in a rural area south of Cleveland, so perhaps the giver of the pig believed it would not be a problem for them. Or more likely the giver knew it WOULD be a problem, and that was the point. The Hi Brows gang was sort of like The Three Stooges when it came to celebrations. Ralph had to cancel meetings planned for the afternoon so the pig could be driven home, because the pig had not come with a suitable crate. It had no collar or harness. The pig was loose, and wiggling and squealing and demanding proper accommodations.

When the pig was introduced to the Shaffer's cat, Koshockton, the cat went ballistic and chased the terrified pig through the house. So Ralph and Anni put the pig back into their car, and drove about the countryside looking for a farm home that would adopt their Christmas porker. One house had five old people who were hard of hearing, and it just wasn't possible to communicate the offer. Finally, a family with a proper pen took the pig, and said it would be a wonderful pet for their little girl. However, the next spring the same family brought the Shaffers a package of bacon as a thank-you gift. Anni didn't ask. They might have been joking. Perhaps the pig was still the little girl's pet.

I was fascinated to hear that Anni's dream job in 1967 was to be a greeting card cartoonist. The writers and artists who were hired by greeting card companies in the mid 1950s took the jobs reluctantly. We had not seen funny greeting cards when we were young, and our dream jobs never included greeting card employment. It was pleasing to know that our creative efforts had been so appreciated that kids grew up wanting to be like us. I wonder if that is still so?

Chapter 30: Larry Raybourne

Larry Raybourne was Hi Brows before Hi Brows was cool. I first met him in 1959 when I interviewed at AG and negotiated a writing contract with the company. The Editorial department was a very sedate, suit and tie, neat desk environment. Larry blended in and we had good conversations about cards and humor writing.

When Hi Brows became a separate department in 1960, and Hoohah Studio was signed to a freelance contract with AG, I met Larry again in the new digs on the top floor of the AG building. I told him about a funny letter I had written to the editors of Superman comic books. It had been a long time since I read Superman, and when I picked up a comic I was surprised to see that the man of steel now had a team to help him fight crime— Super Girl, Super Boy and Super Dog. I was inspired to write a letter in which I said I was 70 years old and had read Superman comics since I was a kid. This was impossible, because if I was 70 in 1960, I would have been 48 years old when the first Superman comic was published in 1938. The letter went on to say I wished they would create a Super Old Man so there would be a super hero that I could identify with personally. I suggested they call him "Super Codger" or "Super Geezer".

Larry got excited. He had never stopped reading Superman comics, and he showed the issue where they printed my letter (I hadn't even looked for it), and there was an editor's answer that they were already working on an old Superman. Larry said this might not have been true. They may have said this so I wouldn't ask for money for giving them the idea. Then he showed me another issue where they drew Superman as he would be when he grew old.

In this story Superman was saying, "What's happening to me? My super powers are fading." If I had written the story I would have had Superman try to leap over a tall building and smack into the 12th floor. He would go the eye doctor and say, "My X-ray vision is getting weaker, Doc. When I look at Lois Lane I can't see her naked anymore. I can see through her dress, but not through her panties and bra." But Superman was a serious kind of guy which is why I lost interest in him long ago. Larry admitted he also preferred super heroes who had a sense of humor. Batman made smart remarks when he punched out bad guys, and Batman's enemies were clownish characters like the Riddler and the Joker.

When I came to the Hi Brows staff in 1966 the place had blossomed into beautiful craziness, and Larry was leading the charge. He had made himself a Batman costume to wear to Halloween parties, and everyday was Halloween for him. He was living with a very tall roommate who had a Robin costume. When Batman and Robin swooped into a party it was impressive and funny. Then Batman suddenly became the New Big Thing on prime time TV, and Larry was a bit miffed. He had been a loyal Batman fan before Batman was cool. But it gave him more opportunities to strut his stuff around Cleveland in his Batman threads.

Larry happened to look so much like Adam West, the actor who played Batman on TV, that Larry could have been a show biz double. Larry, or rather Batman, was the hit of the annual AG Art Fair that year. Staff artists sold their fine art work at an evening outdoor show in the AG parking lot. Many people brought their kids, and there was a long line of kids by the booth where they could get their picture taken with Batman. After posing and chatting with the kids for a couple of hours, Batman needed a break. As he walked away the kids called, "Where are you going, Batman?"

"I'll be back in a few minutes, kids," he said. "I have to go to the batroom."

But instead of walking into the building and using the AG toilet, he walked up the street to Bud's Bar. A gang of neighborhood kids followed Batman to Bud's, but the kids weren't allowed inside the bar. They pressed their faces against the windows, and the crowd grew as the word spread that Batman was in Cleveland and drinking a beer at Bud's. Batman smiled and waved at the kids as he quaffed his refreshment. When he came out he stretched, flexed his muscles and said, "Kids, you'll never know how good it feels when ol' Batman has a beer at Bud's and takes a good piss." Then he dashed down the street with his cape flapping to return to the line of kids waiting to have their pictures taken with Batman.

Larry and fellow writer John Gibbons often hung out at Bud's Bar on afternoons when they had writers' block. Native American activist Russell Means used to hang out there, too, and complain about how the White Man had killed the buffalo, and taken the water and land away from Indians. Larry couldn't resist teasing Russell, who was a very serious guy, and sometimes John grabbed Larry and dragged him out of Bud's before there was serious trouble. This was in the days before Russell did make serious trouble on the reservations in South Dakota. Larry had nothing against Russell or Native Americans. He just couldn't resist any opportunity to tease serious people with jests. Larry got himself and the entire Hi Brows department banned from Klucks Restaurant when he teased some other customers and a waiter during a lunch time. His original humor delighted us in Hi Brows, but did not always go over well in other venues.

Larry had a photo collection of the many costumes he had made and worn in the past. One of his best was a mummy. He had put on white long underwear and a hood, wrapped it with adhesive tape until only his eyes were showing. Then he cut a tiny breathing space under his nose, and a slit near his mouth for talking and drinking. He made this six months before Halloween so he would have time to age it. The costume was buried in his backyard.

"When I dug it up the day before Halloween, it was perfect!" said Larry. "Stained, decayed, tattered...just like it had been in the ground for thousands of years." It was his routine on Halloween to go to many parties, and then go into bars downtown really late when there would be some barely conscious drunks hanging out. Larry had freaked them out with Dracula one Halloween, and he was sure the Mummy would scare the shit out of the drunks this Halloween. "Then I put it on, and I almost passed out!" Larry said. "It stunk so bad it was impossible to wear it. I had to throw it in the garbage and wear one of my old costumes that Halloween."

A Hi Brows writer Jack Hanrahan invited the staff to his house for a Halloween party, but Jack's wife asked him not to invite Larry, because she was afraid of what outrageous costume Larry might wear. Larry came in blackface with a black girl as his date. Jack met them at the door and said, " Come on in, Larry, but please pretend to be somebody else so my wife won't know you are here." Larry pulled it off, and partied under an assumed name all night.

One dull afternoon Larry and John Gibbons sat in the Hi Brows conference room and made a tape recording they titled "Confessions". Larry played the part of a Catholic priest and John played the roles of various people who came to confession.

John: Bless me, Father, for I have sinned.

Larry: Sit down, my Son, and tell me about it.

John: I work at a lumber yard, and I just can't stop stealing lumber. Taking it home and using it for various projects. I know it's wrong, Father, but I just can't stop doing it.

Larry: You are forgiven, my Son. Say three Hail Marys and make a Novena.

John: Uh, I don't know how to make a Novena, Father. But if you can get the plans, I can get the lumber!

There were about 20 short skits like this on a half hour tape recording. Howard Shoemaker, a *Playboy* magazine cartoonist who did some freelance Hi Brows designs, thought it was so funny he insisted they make a copy of the tape for him to enjoy at his home in Omaha. One of the bits had the sinner confessing he looked at *Playboy* magazine and got impure thoughts. The priest took the magazine away from the sinner to remove temptation. Then while the sinner confessed some really bad things the priest wasn't paying attention, and you could hear the pages of the magazine being turned and the Father reacting to what he was seeing with little yelps of joy.

The police raided Larry's home one evening, took him into custody and searched the home for bad things. A neighbor had told the police about the weird guys who dressed like Batman and Robin, and had strange friends visit at all hours, so there must be something illegal going on. The police found no illegal activities or things, so they released Larry and returned his possessions...except for the tape titled "Confessions". They had probably zeroed in on this as possible evidence of crime, and it would have been fun to be there when they listened to it. Apparently they thought it was funny, and wanted to keep it.

Larry said, "Where's my tape recording of...?"

"Get out of here!" the policeman growled, and Larry took the advice without further complaint.

Larry was a highly original writer. He never produced a large quantity of ideas, but he came up with some of the best ones. He always swung for the fences. What if you hit a single every time you came to bat, and never hit a home run? And when Larry hit one, it didn't just clear the fence...it sailed over the upper deck and landed in another country.

Because he worked so hard to polish and perfect truly original gags, there were periods when he could think of nothing. He would do a lot of goofing off (such as afternoons at Bud's with John), and come in late often. Tom Wilson would lecture John and Larry about coming in late, and Larry's creative powers which couldn't write cards at the moment would nonetheless enable him to come up with funny excuses.

For a while Larry rented a house right across the street from AG's front door on West 78th Street. It took him less time to walk across the street and into the building than to get from the front door to his desk. But one morning Larry was late again, and Tom wanted an explanation. "I was on my way to work at five minutes before 8:00 a.m.," Larry said. "But the traffic was so bad I couldn't get across the street. So I went back inside and waited for rush hour to clear up." The traffic at five minutes before 8:00 a.m. was heavy on West 78th Street, because AG employees were driving down the narrow street to enter the parking lot, and they were in a rush to get

parked and get in and punch the time clocks. If Larry had a car, he could have gotten into the rush, but as a pedestrian the drivers wouldn't give him a break. So there was a tiny grain of truth in his excuse, and Tom choked back his laughter and growled, "Get out of my office and try to get to work on time tomorrow."

One example of Larry's great funny cards is more entertaining than a thousand ordinary jokes. Larry was not an artist, but there was one card he both wrote and designed. First, he tried the gag on Tom Wilson by making a special card for the boss on Valentine's Day. That version is shown below, but unfortunately I could not find the version published later as a Hi Brows card. But as I remember it, on the cover of the card was a note written in a very pretty feminine style. It said something like, "Just sending you a little note to thank you for last night. When we met each other for the first time at the party, I knew immediately there was a special connection between us. And then when I had a few too many drinks and was in no condition to go home alone, you took me to my home, carried me in and tucked me into bed. You were so sweet! And I especially appreciate that you didn't try to take advantage of me in my condition. I hope we can get together again, and just in case you have forgotten what I look like, I have enclosed a little picture of myself."

When you opened the card you saw the small black and white photo of Larry in one of his costumes. A pretty young man with hair slicked and parted in the middle, drooping eyelids and long lashes, a limp wristed hand holding a cigarette in a long holder. The card was a best seller, and it confirmed what we had long suspected about the popularity of Hi Brows cards. These funny greeting cards were not always just personal expressions as the industry called them. Sometimes people bought them just for entertainment. Customers at card shops would show this card to the clerk and say, "I could never send this to anyone I know, but it is so funny I just HAVE to have it!" They would carry the card around and show it to people to make them laugh. People who knew we worked at American Greetings would mention the

For dear Tom Wilson,
The only person at
American Greetings
who has really and
truly allowed me to
express
myself.

A version of his "Agnes" card that Larry Raybourne gave to his boss, Tom Wilson, on Valentine's Day.

Thankyou.
XOXOX OXOX

card, and tell us it was the funniest thing they had ever seen. Did we know the guy whose picture was in the card? Yes, we did. Was he really like that? No, he was a master of disguise and a very funny writer. Those were the peak days of Hi Brows when people working in offices would go to card shops on their lunch hour and read Hi Brows cards just for entertainment. And then they would buy some that were so funny they just had to have them, or they were going to save them until a friend or relative had a birthday that might be ten months in the future. There were always new, funny jokes in the Hi Brows rack.

A few years after the card had been published and was no longer in any stores, Larry asked a Hi Brows artist to reproduce the funny photo on a T-shirt. He went to New Orleans on vacation and walked down the street wearing the shirt. Two guys pointed at Larry and shouted, "Agnes! Agnes!" and they rushed forward. Larry turned and looked around to see if someone named Agnes was walking nearby. There wasn't anyone. The men stopped in front of Larry, pointed at his T-shirt and said, "Where did you get Agnes? We want one of those shirts."

Their story was that they had seen the funny greeting card, and liked it so much they named the person in the photo Agnes. There was an Agnes fan club that met every Thursday in a nearby bar. All of the members would want to have a T-shirt with Agnes' picture on it. They were very sad to hear that the T-shirt was a one-off, and they couldn't buy one anywhere. Then Larry asked them to look very carefully at the picture on his shirt, and see if they could ever recall seeing any person who looked like that. They stared, they hesitated, their eyes flickered back and forth from the shirt to Larry's face, and finally made the connection. "You're Agnes!" They grabbed Larry's arms and hustled him down the street to the bar where the Agnes fan club met on Thursdays. "We've got Agnes!" they screamed, and the crowd exploded in cheers. Larry was an instant celebrity in New Orleans.

One of Larry's wildest adventures occurred when he became a pen pal of the Hallmark cartoonist, Don Branham. When Branham concluded a three day New Year's Party in 1961-62, he shoved some trays of leftover ham sandwiches and bottles of champagne into the trunk of his gold Cadillac Branhammobile, and drove west with a friend. A day or so later McCloskey received a phone call from the Chief of Police in a Kansas town, asking "Does a Don Branham work for Hallmark Cards?"

"Yes, he does," said McCloskey. "What...is there a problem?"

"No, just checking," said the Chief.

It was reasonable to suppose the strangely painted vehicle had attracted some attention. A few days later Branham was in Aspen, Colorado, where he met Larry Raybourne at the airport. Larry had received letters and phone calls from Branham asking Larry to quit his job at AG, and join Don in establishing a new University of Creativity in Aspen. Larry didn't quit his job, but he took two weeks vacation to check out the opportunity.

"When Don met me in the airport, he handed me a big wad of money," said Larry. "He told me this was for my expenses in the next few days. Then he decided he had given me more than I needed, so he took back some of it. But it was still a lot of money."

They checked in at a hotel, and that evening Branham sat down at a piano in the bar and began playing and singing. The customers applauded, and the hotel manager offered Branham a job to do his act every night. "Oh, I'm much too busy to do that," Don said, "but my friend here is just as good on the piano as I am, so why not hire him?" He pointed to a short quiet guy who had driven from Kansas City with

Branham, and the manager hired Branham's friend without even an audition.

"It was like that for a week," Larry said. "Branham took us into shops all over town and charmed the pants off of everybody. He bought expensive things, and wrote the checks for more than the price because he needed some cash and was too busy to go to the bank. That's how he had gotten the cash he gave to me. He told everyone how he had come to town to establish a new creative university that would bring the most creative minds in greeting cards, art and everything to Aspen, and they would change the world with their projects. I guess they bought it, because they cashed his checks and gave him extra cash. But after a week I decided this was too wild, and Branham must be on some imaginary trip without the aid of alcohol or drugs.

"One day Branham was driving and asked me to get some music on the radio. Every station I tried didn't please him. Then I got some static, and Branham said, "That's it! Turn it up!" He was blowing everybody's mind, but I decided to leave before trouble hit the fan. I told Branham I had to go back to Cleveland to pack my stuff, some of it was too delicate to just let movers handle it all. I had spent all the money he gave me, but I still had my plane ticket and luckily had not quit my job at AG."

So Larry participated in Branham's last great eccentric adventure. After two weeks Don and his sidekick left Aspen just as the checks began to bounce. Back in Kansas City he had nowhere to live. His furniture had been repossessed, and the landlord not only wouldn't let him continue to rent, but insisted that the wildly decorated exterior and interior be restored to original condition. Don had painted the house much like he had painted his car with artist's gold spray paint and other unconventional colors.

Branham went home to Oklahoma City, and perhaps his family and Hallmark paid the bills to stop the people in Aspen from pressing charges for fraud. Perhaps Branham really believed he had the money to cover the checks. He probably really believed in his plan for the University of Creativity. He had listened to a motivational record made to pump up salesmen which said, "If you want something, you must believe you already have it. When you go to make a sales pitch, believe that you have already clinched the sale. Then you will have so much confidence, that you WILL be able to clinch the sale." Branham had used this technique on the staff at Contemporary when he told us he was the department director, but we knew him too well and it didn't quite work. But his confidence had bought him two years of wild times in Kansas City and a final two weeks in Aspen.

Larry was considered the wildest one of the Hi Brows, but he easily conceded the title of Wildest One in Greeting Cards to Don Branham. In later years when the fun began to go out of the Hi Brows studio, Larry quit and moved to New Orleans. He had been one of the original Hi Brows. One of the first writers and one of the most original. He goofed off so much of the time, many of us thought he didn't justify his pay. The only record kept regularly was to show how many accepted cards a person wrote each month. But Ralph Shaffer said they once researched the sales records of published cards to see which writer wrote the most cards that became best sellers and made the most profits for AG. It was Larry. He might write only six cards in a week, where others wrote six a day. Or some weeks Larry might write one or none. But most of his ideas went right through the selection process and into production, and sold well in the stores.

For comparison, one new staff writer once wrote 60 ideas in one day. That writer cut 30 published Hi Brows cards in half, wrote new outsides for the insides, and new insides for the outsides. This meant none of the 60 ideas was very new or original.

© AGC, Inc.

> I WAS JUST SiTTiN' HeRe, SLUOGiN' RATS iN THe GUTTeR, THiNKiN' OF THe DAY I MiGHT See YOU AGAiN.....
>
> AND i SORTA GOT ALL MiSTY.....

Larry Raybourne, writer Kay Rudin, artist

This kind of rewriting of old cards eventually made the Hi Brows line stale and not so profitable.

After Larry moved to New Orleans, we heard a story about his pet python getting loose and terrorizing the French Quarter. During the Vietnam war a young friend Larry was living with was going to be drafted. So Larry, who was almost 40 years old, claimed to be 18 and registered at the draft board. If his friend went into the Army, Larry intended to go with him. He registered as Larry Raybourne, Jr., and said his father was Larry Raybourne, Sr. who lived in Cleveland. Larry called his ex-wife and asked her to back up his lie if anyone checked on it.

Larry got the idea that he could pass for being his own son when he was reading some war comics in a drugstore. The clerk said, "A couple more years, and you will be over there in Vietnam...Bing! Bing!" Larry replied, "A couple more years, and I will be 40...Bing! Bing!" But Larry and his friend broke up before the draft board called, so Larry abandoned his plan to become a forty year old teenage Vietnam warrior.

Larry came back to Cleveland occasionally to write some freelance for Those Characters From Cleveland, but he never returned to Hi Brows. I tried to find Larry and check the accuracy of these stories, but he had moved several times and the trail was cold. Wherever you are, Larry, I hope you are still creating gags for somebody.

Chapter 31: John "Roughhouse" Gibbons

DEAN

John and Larry, Larry and John, they were the hard core of the original Hi Brows studio. Other writers would come and go, but John and Larry persisted.

Well, John came and went a few times, also, but in a way he was there even when he wasn't. Or he wasn't there when he was. He was the most undependable guy I ever met, and yet you could always depend upon him. It was a matter of what your expectations were.

When Tom Wilson hired John Gibbons in 1962, he expected him to write funny cards, and John went at it like a fiend. His typewriter would pound out streams of gags. A lot of them were unusable nonsense, but when he connected it went a country mile...like the best of Larry Raybourne. And there was an original touch to John's humor that couldn't be duplicated by hiring anyone else. So Tom kept John on the staff through some hard times. Tom loved originality in writers and artists. Original funny people were not a dime a dozen. Well, you might be able to hire them for a dime, but there weren't dozens of them available.

John and Larry would do their "This is why I was late for work" act, and manage to keep their jobs by coming up with funny reasons for being late. Sometimes John would walk in late unnoticed by Tom. So John would go out, put on his coat, and walk past Tom's office again until he was noticed. John enjoyed getting scolded, particularly when he had a funny excuse ready to deliver. When both John and Larry were in a funk, (also a condition known as writer's block), they would take off after lunch and spend the afternoon drinking at Bud's or some other bar in Cleveland. There was a time clock in all departments at AG, so John and Larry had their pay docked for any time when they weren't there. When John would come into Tom's office to complain that his paycheck was short, Tom would only have to say, "Well, come in on time, and leave on time, and that won't happen again."

When he was on, whether he was there or not, John wrote lots of great stuff. Every writer knows the experience of trying to write something and not being able to. Then when you stop trying, everything comes together and suddenly you are inspired. When John was in the department, he often spent most of the day talking to people about anything they would listen to. "*Car and Driver* magazine says the 1966 Jaguar convertible diggy diggy diggy.... Wild Bill was at the Hermit Club last night and he was blowing diggy diggy diggy... Ward Kimball and the Firehouse Five wanted to tour the world, but Walt Disney wouldn't diggy diggy diggy..." Fellow writer George Hart was the one who noticed that after a few minutes of listening to John, everything sounded like diggy diggy diggy.

Then after wasting the day and a lot of his fellow workers' time, John would hit a few bars, eventually get home, stay up late watching *The Three Stooges* on TV and

eating popcorn, and the card ideas would begin flooding his brain. He would bring a pile of good ideas to work the next morning, and start his routine of diggy diggy diggy again.

Sometimes the ideas he brought in weren't quite finished. In fact they might only be straight lines that needed punch lines to become card gags. Then John would actually sit at his desk and stare at his typewriter with a childish grin on his face as he whacked the keys. He reacted as if he saw funny things leap out at him and he was not doing it, but only watching it happen. John had a phrase in his notes for a long time that he couldn't find a punch line for. "Somewhere, somehow, someway, someday..." He tried punch lines like, "I'm gonna get you" or "You'll get what's coming to you", but none of them satisfied him. When AG created the Soft Touch line of soft photos and romantic prose, "Somewhere, somehow, someway... someday" became a best seller. But John's heart was in comedy, so he didn't try to write a lot of Soft Touch romantic prose. He couldn't resist adding a gag line to a romantic line.

One day a beautiful new typewriter was delivered to the department. Tom had hired a new writer, Marvin Honig, and ordered a typewriter from the supply department. AG didn't spend much money on new stuff, so Tom expected a reconditioned old typewriter. John saw the new typewriter delivered and knew it was probably ordered for Marv. John rushed into Tom's office and said, "Wow! They just brought us a wonderful new typewriter. I wonder who it is for?" This was his way of asking to have it.

Tom conferred with Marv. "The new typewriter is for you, but John has this old antique relic of a typewriter...it works fine...but it's old. I know John wants the new one, but he won't ask for it directly. He wouldn't take it if he thought it would make you mad." Marv said it made no difference to him, and John had more seniority so give John the new machine. Tom said, "O.K., but YOU have to tell John personally that you really want him to have the new typewriter, or he will feel bad about taking it from you." Marv told John, and John sat down to write on the new machine like a kid with a new sled at Christmas. He banged away and watched the words appear magically on the paper.

Later that day there was a problem. John shuffled over to Marv's desk, shyly twisted his toe on the floor, and said, "Uh...Uh...I just can't write anything funny with that new typewriter. The words don't look funny. Would you mind taking it and let me have my old typewriter back?" Marv agreed to the switch. John's old typewriter did type funny looking words. It was a large oversize type face, and several keys needed adjustment, so the words came out in uneven lines. It made a big difference in prompting John's imagination to keep twisting the words until they said something funny. He kept that magic typewriter for the rest of his life, and it never failed to write funny stuff for him.

His funny stuff went into personal letters as much as in his work. He had files full of letters from people like musicians Ward Kimball and Wild Bill Davison, and people he met at work--Les Taylor, Walt Lee, George Hart, Jack Clements, Tom McGreevy, Robert Crumb, and myself. When we scattered around the country we kept in touch through letters we wrote to John. John particularly loved to read Crumb's letters which were written just the way Crumb lettered his comic books. Over the years Crumb drew lots of letterhead cartoons for John to use on his stationery, and a three page comic resume that is printed here. John sent out the resume to many people, and got job offers he had no interest in taking. But it also

A RESUMÉ of the LIFE of JOHN P. GIBBONS

WRITTEN BY JOHN P. GIBBONS DRAWN BY ROBERT CRUMB

BORN SEPTEMBER 2, 1937

EDUCATION: ATTENDED ST. JEROME'S GRADE SCHOOL IN CLEVELAND.

ATTENDED CATHEDRAL LATIN HIGH SCHOOL FOR ONE YEAR....

ATTENDED ST. IGNATIUS HIGH SCHOOL FOR ONE YEAR....

ATTENDED COLLINWOOD HIGH FOR ONE YEAR...

AND FINALLY GRADUATED FROM WITHROW HIGH SCHOOL IN CINCINNATI...

COLLEGE: BUTLER UNIVERSITY, INDIANAPOLIS, INDIANA...

MILITARY SERVICE: ENTERED U.S. ARMY IN 1956...

COMBAT EXPERIENCE: COLUMBUS, GEORGIA

RECIEVED HONORABLE DISCHARGE AND SERVED SIX YEARS IN RESERVES...

BUSINESS EXPERIENCE: AFTER WORKING FOR A NUMBER OF COMMERCIAL RADIO STATIONS AS ANNOUNCER, WRITER, ENGINEER, ETC, ETC...

I DECIDED TO BECOME STRICTLY A WRITER...

...AND FINALLY FOUND MYSELF IN THE HI-BROW STUDIO OF AMERICAN GREETINGS CORPORATION...

...A NEWLY FORMED GROUP OF WRITERS AND ARTISTS...

DEVOTED TO BRINGING FRESH, ORIGINAL AND TRULY FUNNY MATERIAL TO THE GREETING CARD BUSINESS...

167

...AFTER SIX YEARS, I HAVE DONE ALL I CAN FOR THE STUDIO...IT MUST NOW STAND OR FALL ON IT'S OWN MERITS...

TRY AS THEY MAY, THE COMPANY OFFICIALS CANNOT PERSUADE ME TO STAY...

EVEN HUGE RAISES IN PAY CANNOT DISSUADE ME FROM MY DECISION TO LEAVE AMERICAN GREETINGS...

I AM VERY INTERESTED IN WORKING FOR YOU, BUT MUST WARN YOU THAT I AM BEING CONSIDERED FOR A BIG RAILROAD JOB...

...A KEY POST IN ONE OF THE LARGER ADVERTISING AGENCIES....

... A POSITION WITH A MAJOR AIRLINE...

...A TOP-FLIGHT JOB IN COMMUNICATIONS....

...AND AN EXECUTIVE OPENING IN A FAST-RISING YOUNG ORGANIZATION.

I'LL HOLD THEM OFF AS LONG AS I CAN, PENDING HEARING FROM YOU...

got him work he did want. The resume had a fourth page added later when John was looking for voice-over work in Los Angeles, but I haven't been able to find that version. I remember the story ended with John saying, "I don't necessarily need full time work, as I have other means of earning income." And the picture was John in an alley pointing a gun at a guy and saying, "Hand over your wallet!"

Some of Crumb's best card cartoons were illustrating ideas John wrote. Even though John could not draw or doodle, he could imagine a funny picture and describe it to the artist. John once bragged to me, "I have Crumb completely in my power. I can make him laugh any time I want to. Watch this!" Then John got up from a large table at Maria's where the Hi Brows staff was eating lunch, and he walked to the other end and whispered something in Crumb's ear. Crumb had been sitting quietly and watching the scene like a skinny owl. A few words from John, and Crumb burst into hysterical laughter. John looked at me and held up his thumb and finger in a circle as a sign of his power over Crumb. I can't remember what John had said to Crumb. It was just nonsense. I have heard that George Burns had the same power over Jack Benny. Burns could say anything to Benny, and Benny had to laugh.

I owe John for turning me on to traditional Dixieland jazz. I had enjoyed Louis Armstrong music when I was a kid, and saw him at a concert in Kansas City, but hadn't really gotten into listening to any kind of music. When I came to work in Hi Brows in 1966, John kept talking about Ralph Grugel and the Bourbon Street Bums who played at Fagan's in The Flats every Friday and Saturday. Finally I went there with him.

We had to get there an hour before the band started playing to get a seat. By 9:00 p.m. it was standing room only, and by 10:00 the room was filled and people had to stand outside and wait for someone to leave or go somewhere else. When Fagan's had opened in 1962 there were no lights on at all in the Cleveland Flats at night. It was abandoned stores and warehouses near the steel mills and lake freighter loading docks. Harry Fagan loved trad jazz, so he opened his club and hired some musicians who could play it. The trombone player, a short 300 pound friendly bear named Ralph Grugel was voted leader, and they began to rip. In the 60s there was a generation of young people who had never heard trad jazz, and it suddenly became the New Thing for them. Fagan's overflowed, and other people opened clubs along the street and hired trad jazz bands.

So the city boosters in Cleveland had nothing to do with the beginning of the entertainment district in Cleveland known as The Flats. But eventually they noticed how many clubs and restaurants were opening there,

Ralph Grugel and the Bourbon Street Bums, the band that began the nightclub district in the Cleveland Flats.

DEAN

and began promoting it. It was better than having your city known for the river that caught on fire, literally, when an oil spill ignited. The Flats was on fire with hot music. Hearing it played live got to me, and it remains right next to cartooning and canoeing as one of my passions today.

Ralph Grugel and John became good friends, and it was Ralph who gave John the nickname, "Roughhouse" Gibbons. One night they were both just drinking and listening to music in the Theatrical Lounge, a long established night club in downtown Cleveland. Celebrities had been going to the Theatrical for decades whenever they had a gig in Cleveland. That night several of the New York Yankees baseball team were in the lounge. John approached the manager, Billy Martin, and said, "Hi, Billy. You don't know me, but my uncle Frank Gibbons used to be the sports writer for the old *Cleveland Press*, and...."

The Yankees had lost a double header to the Cleveland Indians that day, and Billy Martin was in a foul mood. When he heard the name "Frank Gibbons", Billy may have remembered some critical columns written about Billy Martin. He leaped out of his seat and began pummeling John. John had been imbibing freely that evening, and he didn't feel the blows. He just kept talking nicely to Billy Martin while Martin slugged him. John remembers hearing people say, "John, he's hitting you!"

Yankee teammates pulled Martin off of John quickly, and the owner of the Theatrical led John to a booth and apologized profusely. "You're a good customer, John, and everybody knows Billy Martin is an asshole. Please don't sue him or anything, huh? Your tab is on me tonight, John." Grugel had watched the donnybrook at the bar, and now said to John, "Well, Roughhouse, there's a bunch of the Pittsburgh Steelers sitting over at another table. You want to take them on now?"

John became a pretty good amateur jazz cornetist. But he never had the nerve to play with a band. Once he brought his cornet to a Hi Brows party to play some tunes for us. "This is a tune written by Lu Watters and recorded in 1945, and it goes..." then he played one note. "Well, it sounds better in the key of F, like this..." and he played another note. "But I'm going to play a Fats Waller tune instead," and John played a couple of toots. He went on like that for 15 minutes, introducing different tunes and mixing in some jazz history, but never playing more than three notes in succession. It was a great comedy act, but John wasn't trying to be funny. He was so nervous about performing for an audience that he either blanked out on the tunes, or was afraid of fluffing a note. Years later he did the same bit at a comedy club in Los Angeles, and got big laughs.

One night I visited John at his house in Cleveland Heights, and we took turns playing tunes for each other on our cornets. He was pretty good when he wasn't nervous. A very sweet tone. He had a big collection of cornets and mouthpieces, always trying to find the magic horn that would make him a good musician. We had been playing for about an hour, and John said, "I'm going to play *High Society* now, and that little dog will start to howl. Don't be nervous. He just always sings when I play *High Society*." I didn't think the dog really would howl. There were five poodle type dogs in the room that had been sleeping through the music until now, and the little one looked completely unconscious. John hit three quick notes, and the dog erupted into doggy ecstasy. I laughed, and John laughed and lost his lip tension and had to start over again. He never got past the first three notes of the tune, because the dog sang so loud and made us laugh so loud. So there was at least one soul on this planet who really appreciated King John Gibbons, jazz cornetist from Cleveland.

When Tom Wilson was promoted to vice-president at AG, and new managers

took over Hi Brows, they had less tolerance for John's habit of not being around the studio much. He was fired on a day when he had just earned his second five-year pin at AG. John was actually crying as he walked around the studio showing people his pin and telling them he had been fired. His marriage was on the rocks then, too, for about the same reasons that he had been fired at AG.

After a period of grieving John pulled up his socks and moved to Los Angeles where he began bugging former Hi Brows writer George Hart who had moved there just a year earlier. George told me, "I moved to Los Angeles to get away from John Gibbons, and now here he was bending my ear every day with diggy diggy diggy!"

George and John really got along very well, and they visited a lot and collaborated on some writing gigs. One of them was a TV comedy variety series that was made so some rich guys could lose money in show biz and pay less taxes on money they made somewhere else. George and John wrote scripts, and then because it was low budget, they also acted in some of the skits. One of them was titled "Return to Paper Plates", a take off on the popular book *Peyton Place*. I can't remember any of the gags they told me, but it sounded more like *Hee Haw*.

If John had been an unreliable writer when he was on the staff at Hi Brows, he became a reliable writer on freelance contract. Nobody cared how or when he worked, and he mailed in big batches of card ideas regularly and always met his production quotas. He would fly back to Cleveland a couple of times each year and stay for several weeks visiting old friends and his ex-wife. John and Carol got along pretty well now that all she expected from him was funny conversation when they met for lunch.

John got a variety of comedy writing gigs, but never got the big break. He wrote some radio commercials for the comedy team of Jerry Stiller and Anne Meara. He wrote gags and skits for a TV pilot filmed in Cleveland that featured Dave Thomas and the Second City Improv Comedy Workshop from Toronto. A local aluminum siding company wanted Rodney Dangerfield to do radio commercials for them, because he used to sell aluminum siding before breaking into comedy. The ad agency and the client loved John's script. But Dangerfield looked at it and said "Hey! This stuff implies I was a bad salesman. I was a GOOD aluminum siding salesman. I got RESPECT when I sold aluminum siding. I won't read this." The client said, "If we wanted straight copy we wouldn't hire Rodney Dangerfield." So John got paid, but the ads were never produced.

I mentioned the fight in the bar with Billy Martin, but that was the only time John got in trouble for approaching a celebrity. After moving to Los Angeles, John found out where the celebrities hung out, and went there to meet them. Almost all of them liked John, because he wasn't hustling them for anything. He sincerely admired their work, and just wanted to tell them some funny stories. Once I told John I was going to a concert in Cleveland by the Salty Dogs with Carol Leigh as singer. "I wish I could be there!" John said. "Please say hello to Carol Leigh for me."

During a break I saw the band sitting at a table and chatting with customers who came by, so I thought I might as well keep my promise. I didn't really expect Carol Leigh to know John.

"John Gibbons!" she shouted. "I love John. Where is he?"

"He's not here," I said, "but he asked me to say hello to you."

"I'm so glad you did," she said. "You know, it's funny, I don't really know John very well. I've only met him at a few gigs where I was singing and he came up to talk to me. But he's such fun. It's so nice to talk to him."

I visited John in Los Angeles and he took me to a bar where Johnny Guarniere played piano and Disney employees came in after work. He kept introducing me to various old friends who were, or had in the past, worked in show biz, and then we went to another place and partied until 2:00 a.m. John never got the big break, but he looked like maybe he had. Once he parked his red Jaguar convertible on a street and got out wearing neat slacks, a black T-shirt and sunglasses, and a kid said, "Gee, Mister, are you a movie star?"

"Just keep watching TV, kid," was John's answer.

John never stopped being a kid himself. When police stopped him for a traffic violation and asked for identification, John handed the officer a card that read, "This certifies that Johnny Gibbons is a member of The Three Stooges Fan Club". George Hart once told him, "You don't need to have any children, John. You are your own child."

When this big lug with a Peter Pan philosophy was a kid of 50 years he got incurable cancer. His best friends were Tom Wilson and Walt Lee. Tom had hired him at AG, and John would brag, "I created Ziggy!" What he meant was when Tom had sold the comic feature to Universal Press Syndicate, he didn't have a name for the character yet. John used to get bad haircuts from a barber named Zigmund, or Ziggy for short, and got a teasing every time he came back from visiting Ziggy. The reason he kept getting bad haircuts was Ziggy told him funny stories while butchering the hair.

John said, "Why not call your little cartoon guy "Ziggy"? Tom did and it made John proud. Over the years John sold a lot of cartoon gags to Tom, and Tom sometimes drew a caricature of John Gibbons in the cartoon. When Tom heard that John had not long to live, Tom flew to Los Angeles to see him for the last time. Tom hired a friend to nurse John while he lay in bed in his apartment and faded away.

John's friends took turns taking him for chemotherapy treatments. Once George Burditt took John to the hospital and asked, "Is there anything more I can do for you?"

"Yes, there is," said John. "See that girl over there? Tell her you are John Gibbons and you are here for your chemo treatment."

Walter Lee was drawing a syndicated comic strip titled *Sherman on the Mount*, and John wrote many gags for the feature. Walt stayed with John while he was sick. John had written many greeting card ideas for Sherman when the character was licensed by American Greetings. I never could figure out how to write jokes about religion without offending a lot of people. John could do it. For example..."I had a long talk with God about you last night. He's still plenty steamed, but I think I got you off the hook."

One of John's cartoon images of himself was Biff Gibbons, sports writer and announcer. Biff Gibbons once appeared in a Hi Brows Funny Book when John posed for a photo. A real sports writer, Grantland Rice, once wrote, "When the last great scorer comes to mark against your name, he writes not whether you won or lost..... but how you played the game." John played the game as well as he could. He loved us all, and he made us laugh. He also did some things that may have steamed God. I hope our prayers got him off the hook.

Chapter 32: Crumb

Skinny, giggling, Robert "Bob" Crumb was the undiscovered genius at American Greetings in 1963. It was his first job out of high school, and he probably never paid attention in art class. He and his brother Charles were self-taught cartoonists who read comic books, drew their own comic books, and tried to sell them to other kids. Crumb's style looked sort of like E. C. Segar's, when Segar drew the *Popeye* comic strip in the 1930s. Crumb had no portfolio of art samples other than a sketchbook he always carried with him. I have already told in the chapter about Ralph Shaffer how Crumb came into the Hi Brows department, because Ralph Shaffer cut a patch of doodles off of a drawing board and showed it to Tom Wilson.

Since he had no previous greeting card experience, Crumb began in Hi Brows by drawing quick sketches for all of the funny card ideas created by writers who couldn't draw. After that it became a tradition for a new artist to be an idea sketcher for a while. Whenever Crumb was caught up on his card assignments he would work in his sketchbook. That kid loved to draw. John Gibbons took a special interest in Crumb, because he liked to talk and Crumb enjoyed listening to John's constant patter. John loved the stuff in Crumb's sketchbooks, because it seemed so meaningless. It was like a musician warming up by running up and down the scale or playing chords.

DEAN

Crumb never tried to write any card gags. He just sketched, and when his pen line was more controlled, he began drawing finished art. He had the very important ability to see what the point of a gag was, and create a character and scene that put the gag across well. Many good artists never learn to do that, because they wing off into some graphic design or beautiful scene that they want to paint, and regard the words on the card as something that take up space. But Crumb liked gags, and he especially liked the strange meaningless gags John Gibbons sometimes wrote. Crumb could sketch them, and suddenly they had meaning and were hilarious.

And sometimes Crumb added value to the gags with his imagination. For example, he illustrated a card that read "The Old Gang Misses You!" by drawing a scene in downtown Cleveland at East 9th and Short Vincent streets. All sorts of disreputable characters were in the scene...bookies, bums, hookers, panhandlers. After the card had been printed someone noticed that there were dozens of women's tits drawn on fireplugs, street lamps, building cornices, etc. AG salesmen were told to get the cards out of the stores before people complained about pornography in Hi Brows cards. But the stores had quickly sold out the cards, and wanted to order more...no customers had complained

As his cartooning talent blossomed, Crumb's social skills remained primitive. He was a funny looking guy, and so damn shy. He also had an unusual attraction to

A POOR OLD MAN SAVED ALL WEEK TO BUY A CUP OF PORRIDGE.... AND THERE WAS A HAIR IN IT.

© AGC, inc.

A page from The Sad Book

John Gibbons, writer Robert Crumb, artist

heavy women. As Tom Wilson put it, "Crumb digs fat chicks." Crumb once hugged a large woman passing him in the aisle and said, "Oh, baby, you're too much!"

She literally slammed him against the wall and said, "You're not enough!"

Crumb began approaching various women as they passed through the Hi Brows department on their way to the cafeteria, and Tom received several complaints. "Well, tell them to take another route to the cafeteria," said Tom. "I can't watch him all the time, and he's a great cartoonist."

Crumb fancied a plump young artist called Gigi who worked in another AG department. His way of courting was to slip down the stairs to her department when she wasn't there, and leave a tiny drawing of a frog on her desk. Meanwhile, he was drawing a new comic story in full color, with a hero who was a tiny frog and a heroine who was a cute fat chick. I mean a girl, not a real chick. Both of them were naked in the story, but of course a frog doesn't have to blush when he is naked. But the girl in his comic didn't blush either, and it was not at all pornographic. It was a take off on the fairy tale, *Jack and the Beanstalk*, and if you asked him nicely Crumb would let you look at it as the story progressed. He had no idea where it was going. He just wrote it and drew it in spare moments, and let it go where his imagination at the moment took it. Unlike his other sketchbook comic stories, this one was a long narrative. It didn't make sense, but it was fun to look at and wonder what Crumb was going to do with it next. Many years later, when he had forgotten about Gigi and was living far from Cleveland, the story was published as *The Big Yum Yum Book*. The first publisher to see it said, "The girl is naked. Draw a bathing suit on her, and I'll publish it." Crumb wouldn't let his ideas be edited. That is probably why he never attempted to write card gags. So *The Big Yum Yum Book* wasn't published until he found a publisher who wasn't bothered by the nudity. It wasn't as popular as his other comics, but I'm sure that Crumb collectors prize it very much.

Crumb's one sided affair with Gigi ended when she came back from lunch one day, and found yet another tiny frog cartoon on her desk. She reacted like someone getting the black hand from the Mafia, and screamed. Her boss told Tom Wilson to keep that pervert in the Hi Brows department, and not let him harass Gigi or any other woman at American Greetings.

Crumb's social skills improved, and in 1964 he met and married Dana Morgan. Then he left the AG staff, and he and Dana went to New York and Europe while he drew cartoons for *Help!* magazine, and freelance card designs for AG. When Crumb got off the train in New York City, a nice young man came up and said, "Can I take your bags for you, Sir?" Crumb said O.K., and the guy ran away with the luggage.

175

Crow and pig figurines by Robert Crumb.
Cat in middle by Walter Lee.

Crumb gave chase and recovered his bags.

After adventures in Sweden and Bulgaria, Bob and Dana ran out of money in Denmark when their AG check got delayed in the mail. They had to steal from vegetable stands to eat. Bob decided to return to the AG staff in 1966, so he was there when I came back to greeting cards that year.

One week in Hi Brows Bob Crumb, Walter Lee and I modeled small cartoon figures in clay. Then the writers tried to think of funny bits to go with the characters. AG decided there wasn't as much profit per cubic inch in figurines as in cards, so nothing was produced. But people who saw the animals done by Crumb and Lee wanted to have them, so we spent another week making plaster casts.

Crumb is King Midas of Cartoondom now...everything he has touched has become collectible to his fans. Only about a dozen of each of these were made, so if you see one and are a Crumb or Walter Lee fan, snap it up.

Bob was a fun guy to be with. He had never done any outdoor stuff, so I took him on a canoe trip on the Mohican River in central Ohio. During a rest stop on the bank, Crumb borrowed my sketch book and drew the scene. He worked quickly yet patiently for quite a while. When he handed my sketchbook back to me I saw a beautiful pen line drawing of exactly what the scene looked like. I had thought it was a rather plain view, and I was not interested in sketching or photographing it. Most outdoor scenes need color to look good if they are summer scenes when the leaves are on the trees. When Crumb handed it to me he said, "Man, it's so tough to draw nature. All those leaves on those trees. It's just too much!"

Mohican River 1966

R.CRUMB

John Gibbons shows
Robert Crumb how to
Keep On Truckin'

sketch by Kay Rudin

I had seen scenes of auto junkyards and city clutter he had in his sketch book, but didn't realize until then how it interested Crumb to draw whatever he saw and make it special.

One night in January of 1967 Crumb took off with some guys driving to San Francisco. When Dana found out where he was, in the Haight-Ashbury district with the hippies, she went West with an envelope of art assignments from Hi Brows. Crumb had angered Tom and Ralph by leaving without notice, and with unfinished work on his drawing board. "Bob is confused," Dana said. "He's out there with no money and no friends. Please give him some work so he can earn some money." Tom and Ralph were still mad at Crumb, but they liked Dana and gave her some assignments. Bob continued to work on occasional freelance assignments for AG for another year, but in November 1967 he took a step that led him away from greeting cards. He published one of his sketchbooks as the first issue of *ZAP Comix*. One of the sketches was the "Keep On Truckin' " drawing that became an icon of the hippie 60s and into the 70s.

John Gibbons claimed credit for the phrase. "Crumb was at my house one night and I played an old jazz record with a vocalist singing "Keep on Truckin' ", John said. "Crumb loved old jazz records and collected them. But he had never heard of truckin' before and asked me what it was. I showed him the dance step that was called truckin' in the 1920s, and Crumb broke up in giggles. The next day he drew the cartoon of a line of funny people doing the truckin' dance step. It never had anything to do with trucks, but truckers bought decals and mud flaps to put on their trucks. Crumb lost a lot of money by hiring a lawyer to sue people who ripped off his cartoon from the comic book. It was everywhere. It was just too much!"

The first issue of *ZAP Comix* was

pretty much just the sketchbook Crumb drew in his first tour at Hi Brows. Then he began writing and drawing long stories that made sense, and most of them were either biting satire of current values, or very pornographic, or both. The hippies loved his stuff in the first issue of *ZAP* and had no trouble with his later comics. He quickly became the King of the Underground Comics, and has had a career doing that ever since. Crumb often turned down offers to make a lot of money writing and drawing material that would be more acceptable to decent folks. Every cartoonist would like to be able to create exactly what he likes the most, and have it printed without editing, and that's what Crumb does.

A series of stories first published in *Cavalier* magazine became the first X-rated animated cartoon film, *Fritz the Cat*. Even though the film followed Crumb's comic book story pretty closely, Bob did not want it to be made. I was told that Dana Crumb signed the agreement with the movie producers when Bob was not at home. Bob unsuccessfully tried to stop production of the movie, or have his name removed from it. During the production of the movie the producers sometimes called Crumb asking for some additional material, but he wouldn't do it. I thought the movie was a pretty good animation of his comic story, except where the producers added scenes that were violent and lacked cleverness.

I met Bob again in 1971 when he was passing through Cleveland, and he drew a few more greeting card designs for a new AG promotion called ZONK. Crumb's designs sold well, because his art was hot with young people then, but the rest of ZONK zonked. At that time Crumb was traveling across the country, and drawing new comic books for various publishers that would be sold only within the state where they were published. That way the Feds could not arrest him for interstate commerce in pornography. The Attorney General in New York promised to put Crumb in jail if the punk came to New York, but others didn't bother him.

A lot of Crumb's art from his comics was ripped off and printed on T-shirts, posters, etc. so he hired a lawyer to sue people. Crumb never collected much, but the lawyer collected his fees off of the top, and suddenly Crumb was broke and owed the government for taxes. In 1978 I saw an article in an alternative newspaper that said Robert Crumb was living in Mexico, because if he did any work in U.S. the IRS would take the money for back taxes before Crumb could cash any checks. The article asked fans to donate money to pay off what Crumb owed the IRS. The fans came through, and Crumb was soon able to return to his cartooning work in the U.S.

Even Crumb's raunchiest stories have funny touches that make you laugh if you can look at the stories as fantasy and not reality. His comics and book collections are sold in many comic shops. A web site *www.crumbproducts.com* showcases the cartoons of Robert, his second wife Aline Kominsky-Crumb, his brothers Charles and Max, and his two children, Jesse and Sophie. Another website *www.crumbmuseum.com* shows a nice collection of Crumb's art. In the 1990s Crumb stopped rejecting opportunities to draw for aboveground publications. His work has appeared in *The New Yorker* and *Outside* magazine. In 1994 he cooperated in making a documentary film titled *Crumb,* which is now on video.

It's amazing how Robert Crumb looks almost like he did when he was 19, but now he looks good instead of geeky. Maybe it's the hat or the mustache he wears now. Or maybe he is just more or less content with the way his life is going, which wasn't true back in his Hi Brows days.

Chapter 33: Jack Clements

Jack Clements made an unusual transition from straight man to funny man. His young wife, Bette, got polio in 1955 just one week before a vaccine was available. She lived her last nine years in an iron lung. One day she told Jack, "I'm tired of getting sweet sympathy get well cards. I need some laughs. Bring me studio cards." So Jack went to a card shop and asked if they had any studio cards. The first one he saw was Herb Gardner's Nebbishes saying "Next week we've got to get organized". Jack worked a desk job at 3M in Cincinnati, and was Bette's nurse evenings and weekends. He read a book titled *The Joker is Wild* about a nightclub comedian Joe E. Lewis. After seeing the 1957 movie starring Frank Sinatra, Jack decided he could be a nightclub comic. At the next company Christmas party, a comedian who was scheduled canceled at the last minute, and Jack tried out his new act. It was a hit, and he was hooked on comedy for a career.

DEAN

After some gigs in local clubs he got a contract for a year on the Playboy Club circuit. "It was good pay," Jack said. "But I hated the customers. I was second banana in the club. A well known act would be playing at the same time in another room. My audience was salesmen trying to make a sale, or trying to impress a girlfriend, and they wouldn't shut up and listen to me." Most of his income went to pay nurses taking care of Bette at home. So Jack decided not to accept a second year on the Playboy circuit, and he turned down many out of town jobs that Phyllis Diller and Jack E. Leonard set up for him.

Jack continued to do his act in Cincinnati, and he particularly loved hecklers. He would begin with some prepared material, but as soon as someone heckled the rest of the show was heckle and put downs. He worked over anyone in the audience who opened his mouth. Jelly Wehbe, a friend of many show biz people, was often in the audience and became Jack's good friend. Sometimes a drunk heckler would take offense at Jack's put downs, and charge the stage. Jelly would put his 5 ft. 11 in., 300 lb. body in the way, and the drunk usually sobered up enough to find his way back to his chair.

When Jack got a late night radio show on WNOP there wasn't much of an audience so he heckled the guests. One night an airline pilot for Allegheny Airlines was there. "When are you guys going to start flying OVER that mountain in Pennsylvania instead of trying to fly through it?" Jack asked. "Your planes have hit it ten or twenty times now, and not one of them ever got through. You can't do it." Often his guests were not prepared for this sort of questioning, and they got quite huffy. Occasionally there was a group of people who been drinking in a bar and heard his show, and they would be waiting outside the studio to beat him up.

WNOP specialized in broadcasting jazz and comedy. Comedian Shelly Berman recorded some announcements to explain the station's call letters—"Where Nonsense Occasionally Prevails" and "We Never Offend Porcupines". When the producer of the TV comedy *WKRP in Cincinnati* visited the WNOP facilities located on floating oil drums in the Ohio river, he said, "If we had seen this when we were creating our show, we would have put WKRP here."

In 1966 Tom McGreevy, a former Hi Brows writer who had moved to Cincinnati, caught Jack's act and told John Gibbons and Tom Wilson. John and Tom traveled to catch the act, and Tom offered Jack a job as a Hi Brows writer. To their surprise, he accepted it. Jack's first wife had died, and he had remarried and wanted a steady job without travel so he could provide a home for their kids. Jack and Marge moved to Cleveland, and combined their kids to fill a house with two adults and five children.

At the first department party Jack did his act for us. We would take turns heckling him, and he put us down. He could sum you up with a few insults about your looks, your talents and your weaknesses with amazing accuracy. It became the high point of every party. Sometimes people who didn't work at AG and didn't know Jack as we knew him would get mad at the insult jokes. If the mad guy was big and drunk and wanted to fight, Ralph Shaffer would get between them. "Jack is our boy," Ralph would growl. "You can't fight him until you fight me first!"

If Jack's act came early in the party, his jabs were razor sharp but never really hurt. He had an amazing ability to know just where your soft spot really was, and he would punch close to it, but never actually hit it and hurt you. But if he did his bit when he had a few drinks in him, Jack's timing was off. Occasionally a jab would hit your soft spot and really hurt. But we forgave him, because we knew his life was rocky.

Jack and Bette's two sons, Jeff and Shawn, had lived with grandparents in Cincinnati since Bette's illness. Shawn had been born a short time after she went into the iron lung. The boys missed their friends at school in Cincinnati, and didn't want to live in Cleveland with their Dad and his new wife and step-siblings. His second marriage broke up. Jack quit Hi Brows and moved to Chicago, but continued to freelance greeting card gags.

A few years later Jack came back to Hi Brows with his third wife, Lillian. He rented a U-haul truck and came to my house to stay until they could find an apartment. With him was a friend who drove the truck, because neither Jack nor Lillian had driver's licenses. They were city people of the old school who preferred public transportation. As we visited in my living room that evening Jack told his driver, "You better not sit too close to the window. You are the only black guy on the West side of Cleveland tonight." It was probably true in 1971.

One of the few AG products that allowed writer and artist bylines was a book titled *The Moon on $5.00 a Day*. When the rocket was launched in 1969 to put men on the moon, Jack was on vacation in Cincinnati, and received a phone call from Tom Wilson. "We want to publish a funny book about this, and have it in the stores when these guys get

page from *The Moon on $5.00 a Day*
Jack Clements, writer Dan Henrich, artist

180

back from the moon. Can you write it?" Jack said he probably could. "O.K." said Tom. "Give me the title right now so we can get started printing a full color cover."

Jack thought for a moment and said, "The Moon on $5.00 a Day".

As Tom rushed this into production he had to reassure the company CEO, Irving Stone.

What if they crash?" said Irving. "Our book will be wasted money."

"Irving," said Tom. "If we want to be first to publish a funny book about men on the moon, we got to take chances. Just like the astronauts are taking chances. We're doing it for America, Irving."

During the ride from Cincinnati to Cleveland, Jack wrote the 22 page book. Dan Henrich illustrated it, and it was in the stores the day after the astronauts returned to Earth. Someone who saw Neil Armstrong in a parade told Jack, "I saw Neil waving a copy of your book at the crowd. I think it had been given to him as soon as he stepped out of the capsule." If anyone is looking for Hi Brows collectibles, *The Moon on $5.00 a Day* should be a good one. Internet used book stores price it between $10 and $20.

Jack has an entertaining way of handling wrong number phone calls. His philosophy is, "If anybody dials my number by mistake, it's not my fault. It's his fault, and he deserves any trouble I can cause for him. How hard is it to pay attention and get the numbers right when you are dialing a phone?" So here is an example of a conversation when someone dials Jack's number instead of a pizza place.

"I want to order a large pizza with sausage and mushrooms."

"Do you want a drink or salad with that?" Jack asks politely.

"No, just the pizza."

"Pick up or delivery?"

"Deliver it to 1222 Elm Street. How long will it be?"

"About half an hour. Thanks for your order, sir," and Jack hangs up. He amuses himself by wondering how long the guy will wait for his pizza before calling the pizza place again and complaining.

Another time a guy calls late at night, and says, "Is Janet there?"

Jack does not know any Janet that might be at his house, so this is obviously a wrong number. He says, "Yes, she is, but she doesn't want to talk to you."

"What do you mean she doesn't want to talk to me?"

"She's had it with you, Buddy. Get lost."

"Who the hell are you, anyway?"

"I'm the ghost of Christmas yet to come. You are history in Janet's life. She wants you to go to hell."

"I'm gonna come over there right now and punch out your lights!"

"Oh, you do that! And better bring your buddies, and just try to get past the vicious Doberman in the hall!" and Jack hangs up. I've never had the nerve to try that with a wrong number, but it is tempting.

Telephone solicitations annoyed Jack as much or more than wrong numbers, so he requested an unlisted number. His annoyance increased when told he would pay extra for this service. "What extra service? It saves you money NOT to print my name in your phone book. I should get a discount."

"No," the phone company clerk told him, "It makes extra work for us NOT to print your name and number in the phone book."

"Really?" Jack said. "By that reasoning I suppose if I canceled my phone service completely, you would charge me even more NOT to give me a phone line. Just out of

curiosity how much do you charge people who don't have any telephones?"

To be sure he gets his money's worth from phone service, Jack sometimes makes interesting calls to friends. Jim Elliot got a call late one night and heard a husky voice say, "This is The Brothers. We're going to blacktop your driveway tomorrow at 6:00 a.m. We charge $5,000 and only take cash. That won't be any problem for you, will it?"

"Wha...wha...wha..." Jim struggled to wake up and comprehend the information. "You can't just blacktop my driveway. I didn't order that."

"Sure, we can do it. The Brothers have been doing it all over Cleveland, and all our customers are very satisfied. Just have $5,000 cash in hand at 6:00 a.m. tomorrow morning when our truck arrives." Then Jack couldn't help snickering, and Jim figured out who was calling.

Jack was one of the Hi Brows staff who bought a Doberman puppy from Tom Wilson. Baron was Jack's first Doberman, and they became so attached that Jack has always had a Doberman since. One day Jack got into an elevator with his dog, and there was another man with a very unattractive woman already in the elevator. The guy looked at Jack's Doberman and said, "If I were you, I wouldn't get into an elevator with a dog like that."

Jack smiled and replied, "I was going to say the same thing about you."

Jack has continued to write comedy, greeting cards and Ziggy cartoon ideas through the years, most of the time on freelance contract after another move back to Chicago. Surprisingly his cards are mostly gentle jokes, and not the insults that were the feature of his act. It is hard to remember his put downs, because most of them were integrated into the moment and not witty sayings that you would remember and repeat. But he made a memorable performance at the opening of an art show in downtown Cleveland.

Tom Wilson, Ralph Shaffer and Walter Lee trained as fine artists, and if they could have had their dreams they would be famous artists like Van Gogh, Rembrandt, and such. Jack was introduced at the wine and cheese opening of the art show as a famous art critic. People in the audience who were not from AG believed this, at least for a few minutes. Jack thought a comedian whose club billing was "Professor Irwin Corey, the World's Foremost Authority" was a hoot. Jack's art critic persona was just like that. He began talking quite seriously. He turned and pointed to the paintings on the walls and said, "As we look at these remarkable works of art, I mean REALLY look at them." He paused to really look at them, and screwed up his face as if searching for deep meanings. "As we look at these wonderful paintings, we must ask ourselves....if these guys are so great, why are they in greeting cards?"

The rest of his act was good, but he had hit the high note right at the start. Why were we in greeting cards? Not because we had always wanted to be. But being in greeting cards with guys like Jack Clements made it a fun place to be. Jack critiqued each work of art with comments similar to the captions shown here.

Pen art by Walter Lee..."What do you get when the chicken crosses the road and crosses with a furry fish?"

Painting by Tom Wilson "The Committee will give serious consideration to your ridiculous proposal"

Drawing by Ralph Shaffer......Super hero device invented by Leonardo Da Vinci in 1502 a.d. Not actually tested until the tragic incident at Niagara Falls in 1906 a.d.

Chapter 34: Rayner

Cartoon by James Elliott

In 1968 Keith Burrows was enticed to move from England to the U.S., and become a Hi Brows artist by his old friend Walter Lee who had made the same move a few years earlier. Then Keith began questioning his place in the universe and the meaning of things. So he went to a guru who told him that his real name in the universal register was "Rayner". He asked his friends to call him Rayner, and we did so without any smirking, at least not when he could see it. When he became Rayner he also joined the Muslim religion, and began observing Ramadan by staying awake every night for a month and meditating. He would sometimes fall asleep at his drawing board. We would see his head on the board, his arms limp, his pen on the floor, and a splot of ink on his cartoon where he had been putting a line when the Sandman dusted his eyes. We took pity and let him get a few winks before waking him. Sometimes Jim Elliot who worked at a drawing board nearby would awaken Rayner with a drum solo. Jim didn't have any drums in the studio, but he made do with pencils, ruler, drawing board, water glass, window, coffee cup and anything he could whack that made an interesting percussion sound.

I have always been interested in deep philosophical thoughts even though I don't have many of them myself. One day I asked Rayner why he meditated only at night. Wouldn't daytime meditation be just as good?

"No, it wouldn't," Rayner said. "During the day people are awake and bustling about, and filling the universe with negative karma by all their activity and anxiety. At night when most people are asleep there is less negative karma, and the channels are open for your meditation to get through to the universal truth."

I thought about this for a while. "Hmm! Is this negative karma that people are spewing out affected by distance? For example, if I am standing next to you, or if I am a hundred miles away, does the negative karma affect your meditation any differently?" I asked.

"Distance doesn't matter," said Rayner. "It's the total amount of negative karma present in the universe at one time that matters."

I thought some more, or pretended to think, because I really had prepared my follow up question during the previous think. "Well, then, have you ever considered that during the night when you are meditating, it is daytime on the other side of the Earth, and people over there are awake and making negative karma? There is probably the same amount of negative karma on the average at any time of night or day."

I felt like Clarence Darrow chatting with William Jennings Bryan at the Scopes Monkey Trial. In fact, my rarely used first name is Clarence, and before I decided to become a cartoonist I had told people I was going to be a lawyer. That was because my friend Dicky North had a Dad who was a lawyer, and he took Dicky on hunting and fishing trips. My Dad never did those things, and I wanted to be a lawyer so I could go hunting and fishing.

But back to Hi Brows and Rayner. Rayner paused just long enough so I was pretty sure he hadn't met this question before. "Well, it's still better to meditate at night," he said.

Rayner was much bigger than me and knew martial arts, so I had no desire to go too far. I accepted his answer and switched the target a bit. "Is your wife Muslim, too? Does she stay awake all night during Ramadan and meditate with you?"

"No, she doesn't observe Ramadan."

"Does it cause any problems?"

"Not really. She gets a bit annoyed sometimes, but I told her last night she was very fortunate to have such a good husband as me. And she got a bit huffy." Rayner was smiling and I didn't feel any negative karma.

"Well, of course," I said. "Wives are like that when they know you are right, aren't they?"

Rayner was a good chap, or a jolly good bloke. Or as we Yanks say, he was a nice guy. He contributed to the fun in Hi Brows as well as drawing good cartoons.

Chapter 35: Instant Hi Brows

Instant Hi Brows were an instant hit. In the early 1960s some writers and artists were taken to a trade show where they created on the spot funny greeting cards for AG buyers. John Gibbons and Larry Raybourne would talk with the person to find out who the card was going to be sent to, and what was the occasion, and then come up with an almost immediate gag. John was particularly good at this. Sometimes they would just recall a gag from the Hi Brows line and personalize it by putting names into it, but often the gags really were new. When the buyer was satisfied with the joke, he would go away and come back later after an artist had drawn a cartoon on an oversize card with a huge envelope to match.

Later a former AG editor, Jim Cantrell, began a business called Custom Cards that created personal funny cards for people who would pay $5.00 or more. The creator of the popular *Calvin and Hobbes* comic strip, Bill Watterson, once applied for work at this shop before he sold his comic strip to a syndicate.

Jim Cantrell was never a Hi Brows writer or artist, but he qualifies to be an honorary Hi Brow for a legendary stunt he performed one day. He was coming back to work from lunch when he stumbled in the parking lot, fell through a basement window, and landed on a conference table where a Marketing meeting was in progress. The consensus of the meeting was that the guy rolling on their table was a bit inebriated from a liquid lunch, and Jim was

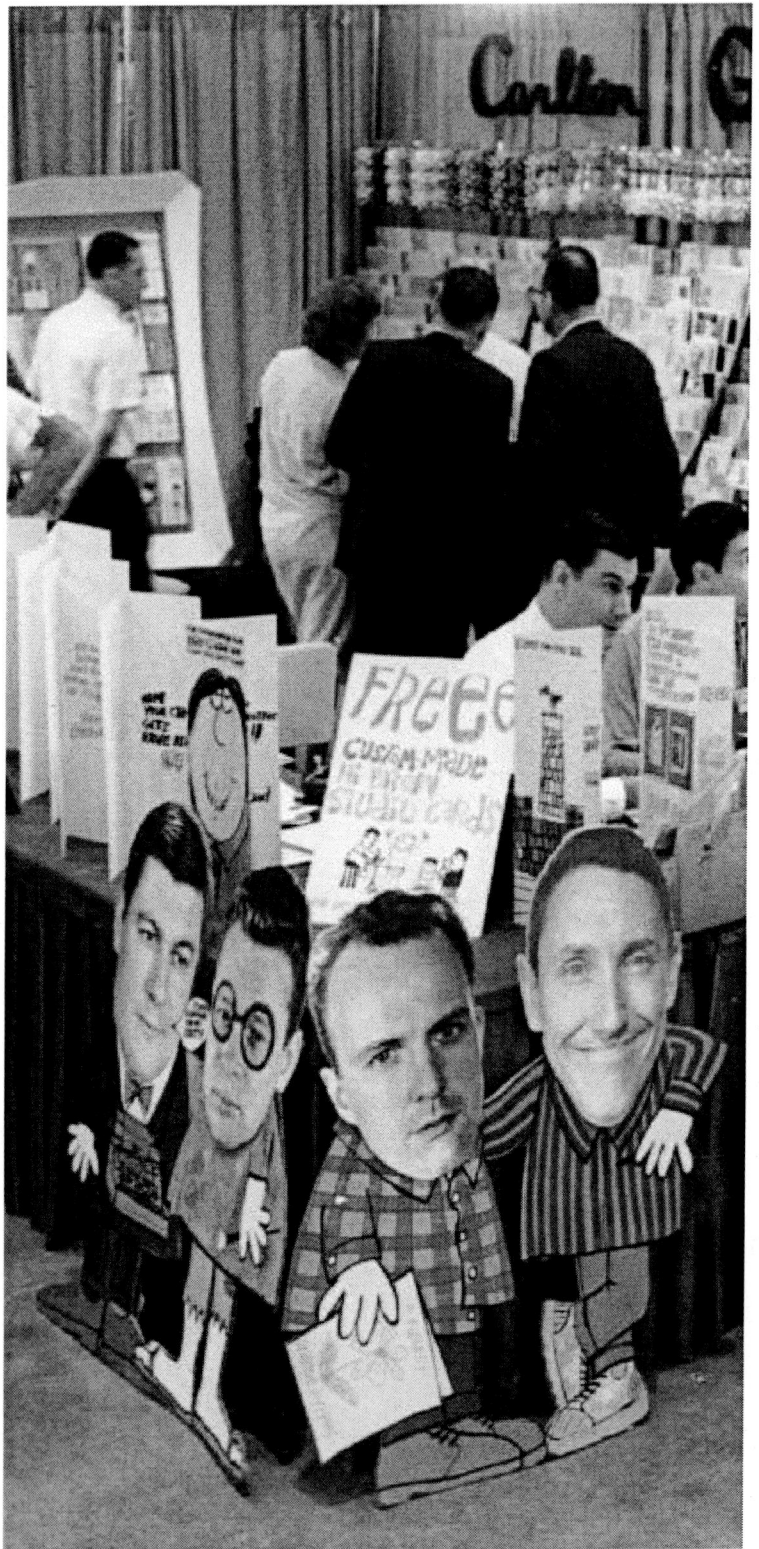

Instant Hi Brows gig in Toronto. Cardboard cartoons of John Gibbons, Al Margolis, Dan Henrich and Larry Raybourne.

186

advised to take the afternoon off.

The first few out-of-town Instant Hi Brows trips were treats for the artists and writers, but they had to work such long hours at the trade shows that they didn't get to have much fun. Barbara Brown recalled doing the Instant Hi Brows at a grand opening of the AG shop in the Pan Am Building in New York City. It was a fancy food and champagne affair that impressed buyers, but the writers and artists doing Instant Hi Brows got no dinner break. The kitchen staff took pity on them and brought them food and drinks. "By the end of the evening we were feeling pretty good!" Barbara said.

At another Instant Hi Brows gig Barbara got a promise from Tom Wilson that the artists would get a dinner hour at dinner time. But when dinner time came Tom Wilson was not around, and the salesmen insisted the artists had to stay on duty. Barb just put down her pens and walked away saying, "I'm going to dinner." John Gibbons and the rest of the slaves followed her as the salesman screamed threats for insubordination.

So it began to be difficult to get volunteers for Instant Hi Brows trips. Most of the gigs were out of town, but on one occasion an AG vice-president wanted the act to be at a party being held by his former college fraternity on the east side of Cleveland. Two artists, Jim Elliot and Rayner Burrows, volunteered for overtime pay to do this.

Rayner and Jim were driving home from the party late at night on a parkway that went through an economically depressed neighborhood with an above average crime reputation. There was an accident. I wasn't there, so I have no opinion as to who was actually at fault. Anyway, two vehicles were coming at each other in the same lane, both swerved, there was a slight brushing of fenders, and the cars stopped on the grass beside the parkway.

Rayner and Jim got out to talk, but four young black kids leaped out of the other car eager to fight. Rayner had some martial arts training. He stood with his back against his car, and made some karate moves with his hands. Jim was a little guy with no training in any kind of fighting. We called him Little Jimmer at work. On this occasion Little Jimmer used a tactic that has been effective in combat since time immemorial....he ran. He didn't abandon his buddy, he just ran a circle around the car with a big kid chasing him and taunting him to fight.

When the kids saw Rayner make some karate swipes, they backed off and then taunted and circled like a pack of wily wolves trying to get at a big bull moose. One or more would leap forward occasionally and throw a punch, but Rayner would fend them off with a hand gesture. "I didn't want to actually hit and hurt any of them," Rayner said. "They were laughing and thought this was great fun. If I hurt someone, they might go to their car and get some weapons...who knows."

Cars were driving by and Rayner and Jimmer yelled, "Call the police!"

Some of the passing motorists were not very helpful. They leaned out of car windows and shouted, "Yea! Get Whitey!"

The police arrived soon, but it seemed like a long time to Rayner and Jimmer. No serious blows had been landed, but Rayner did have one bruise on his temple were someone had caught him looking the other way and landed a punch. So Rayner was in a foul mood, and even when he told me the story a year later he couldn't see much humor in it.

All the combatants were put in one police car, the two whiteys in the front, and four black kids squeezed in the back. The kids started telling their version of the incident, and Rayner started correcting them, but the policeman told everyone to

I DON'T WANT TO SPEND HALLOWEEN WITH JUST ANY BODY....

I WANT YOURS! (Happy Halloween!)

© AGC, Inc.

writer unknown Jim Elliott, artist

shut up until they got to the station. When the police asked for names and addresses, the kids made up things like, "George Washington, The White House, Washington, D.C." and their buddies would laugh. They played an Amos n' Andy act though the interviews. Rayner was furious, and the police pretended to be angry but could hardly suppress laughter.

When it was time to tell versions of the accident, the police said, "Now I will take the statement from one side, and then from the other side. No interrupting! Everybody will a chance to have his say." They began taking the statements from the kids, which was a mistake. Rayner and Jimmer bit their tongues as they heard the lies.

"These tough white guys ran us off the road, and tried to beat us up!" was the gist of what the kids said. Then when Rayner began to speak, the interruptions began to fly from the other side. The police told the kids to stop interrupting, but they never stopped.

"Didn't the police take the kids out of the room so you could tell your story?" I asked.

"No!" Rayner fumed. "They let them stay and interrupt and contradict everything I said. It took forever to tell my side of the story. Then when it was all over, the police said, well, no one had been hurt, so no charges would be filed. Everyone should go home and talk to their insurance companies about the fender damage. Of course the kids had no insurance, so I had to bloody pay for it. I thought AG should pay for it, because I was traveling from doing company work. But the company wouldn't bloody pay for it either! I told them if they wanted me to do another bloody Instant Hi Brows, they would have to transport me in a company limousine with a driver and a body guard, and pay for any bloody damage done to me."

The bloodies in Rayner's language didn't refer to the punch he took to the head, it hadn't bled. He was an old friend of Walter Lee from England, so it was just slang from home that he used often. Needless to say the appeal of Instant Hi Brows had sunk to a low among the artists, so Tom fended off most requests to repeat them.

188

Chapter 36: This Town Ain't Big Enough For Both of Us!

I have heard about managers taking employees to retreats where everyone plays games. These are supposed to be bonding experiences that build team spirit. The same managers usually get ticked off if the same employees fool around playing games during work time. I have never been to such events organized by managers, but the staff at Hi Brows used to play a few games from time to time when the spirit moved us.

One day I brought a pair of rubber band guns, two cowboy hats, and a sheriff badge to work. My kids had gotten bored with the guns, and I had an inspiration. John Gibbons spent most of his time in the workplace chatting with fellow workers, so I had no trouble getting him to be the first to play my game. "Do you want to be the Sheriff or the Bad Guy?" I asked.

John thought it was more fun to be the Bad Guy, so I had him put on the black hat. I put on the badge and the white hat. Then each of us loaded a rubber band gun and stuck them in our belts. We stood facing each other about eight feet apart. "Now you say "This Town Ain't Big Enough for Both of Us!" and I will say, "Go For Your Gun!" Because I am the Good Guy, I can't draw first. You get to draw first, but the moment I see your shootin' hand twitch, I get to draw, too. Then we see who wins the shootout. If I win, I'm still Sheriff. If you win, you get to be Sheriff and somebody else tries to outdraw you."

I forget who won, but it was amusing enough for a rematch. Others began to put down their pens and typewriters to take a shot at the Sheriff. Through the late afternoon everyone in the department had their shot at a shootout, and the Art Director, Ralph Shaffer, beat us all. A few of us managed to keep the badge and white hat for three or four shootouts, but Ralph outdrew everyone at least once and some of us twice. We were about to proclaim Ralph "King of the Old West" when someone noticed Kay Rudin still working at her drawing board in the back corner of the room.

Kay was the newest hire, 19 years old, and usually the most playful one in the room. We had to drag Kay away from the cartoon she was drawing, and ask her to be the Bad Guy and try to outdraw Ralph. "If he doesn't beat you, he can't say he beat everyone in the department," I explained. Being a good sport Kay agreed to take one shot at Ralph.

We had to coach her several times to get her to say "This Town Ain't Big Enough For Both of Us!" correctly. Finally, she got it, and Ralph said, "Go For Your Gun!" and he stood like a giant hulk with arms and hands outstretched and ready to draw and fire. Actually, Ralph WAS a giant hulk, and he always stood like that. But the intensely serious expression on his face made Kay giggle. Instead of going for her gun, she just laughed. And laughed.

"Come on! Go For Your Gun!" Ralph growled. For about three long minutes Kay just stood in a completely relaxed slump and laughed, saying, "You look so silly! I can't believe it!" She was wearing a sweater and skirt, and we had loaned her a belt to

Kay Rudin

DEAN

dearie,
sometimes i think
you're the
WILDEST,
most
far-OUT NUT
i know,
but other times....

...i'm sure of it!

© AGC, Inc.

Alyce Weber, writer
Kay Rudin, artist

tuck the rubber band gun into. She kept laughing, turning her head away, and never making a move with her hand that would give Ralph an excuse to draw and shoot. Finally, Kay just casually lifted the gun out of her belt, raised it slowly, and fired and plunked Ralph in the chest. By standing at high alert for three minutes Ralph had frozen his nervous system, and he couldn't move his arms when he saw Kay go for her gun.

Ralph demanded a rematch, but Kay said, "I only promised to do it just once", and went back to her drawing board. She retired as the undefeated King of the Old West in Hi Brows.

Kay left AG after about a year, and moved to California. She visited Hi Brows in 1971 with her baby, and photos of her husband and the truck camper that they lived in on a California mountain. "A bunch of us live on different hilltops in the area. It's National Forest, and they let us stay so long as we don't hurt anything. My husband chops dead trees in the forest and sells it for firewood. I make a little money by collecting wild plants and drying them for tea. Here's some for you. Don't pay me. This is little present."

She was nursing her baby while she visited and John Gibbons got red faced and had to run out of the room. Then Kay showed me another photo taken on one of her adventures since she left Hi Brows. "Did you see the *Woodstock* documentary movie? I was in that bus that was painted in psychedelic colors. We drove from California to New York through Canada, because we thought the police in the U.S. might hassle us."

Today Kay plays trombone in a West Coast big band, and is videographer recording the efforts of tree sitters and Earth First! to preserve old growth California redwoods. It's hard to be a dull person if you went through the Hi Brows experience.

Hi Brows staff photos

Vaudeville-radio-tv comedy team Smith and Dale present a humor award to Tom Wilson.

Ralph Shaffer cuddles with one of his cute metal sculptures.

Robert Crumb ponders the meaning of life and how to illustrate a Hi Brows card gag.

Walter Lee celebrates a British holiday.

Hi Brows artist Gail Steinberger posed for a funny Father's Day card. The children were borrowed from the families of Tom Wilson, Barbara Brown, Walter Lee and Larry Raybourne.

Barbara Brown's impersonation of a burned out office worker was used on many cards, poster, mugs, etc. The first card said, "Mondays Suck!" After some objections from Mrs. Walgreen, it was changed to "I hate Mondays !"

LITTLE KNOWN GREAT MOMENTS IN SPORTS

Selected by the popular Hi Brows sportscaster, Biff Gibbons.

John Gibbons

Well, folks, here go into the top of the 15th inning.

Jack Clements

Walter Lee

GOLF . . . June 6, 1921 MacBrawny, Scotland

Angus MacVicker shoots an entire 18 hole round in only 18 strokes — every shot — a hole-in-one! Nobody was with Angus at the time, but he was such a big, mean guy, nobody ever doubted his word.

TENNIS . . . June 10, 1946

Famed tennis star "Jumping" Jack Clements is seen here in a tense moment just after he failed to score. Jack was about to make it 6 love, when at precisely five after six, a photographer, hired by the lady's husband, walked in and snapped this picture. Jack grabbed the camera and ran, thus maintaining his amateur status for his greatest moment in sports.

John Gibbons

Jack Clements

Ralph Shaffer

Gayle Steinberger

Walter Lee

Jacob Sapirstein

Irving Stone

Barbara Brown

Dan Henrich

Jan Olin

Caricatures of the Hi Brows
staff in 1966 that Kay Rudin
drew in her sketchbook and
on a Hi Brows card that read
"Happy Birthday from the
Whole Damned Bunch!" The
figures with devil horns on
them came from the printed
card, but of course without
any identifying names.

Larry
Raybourne

Robert Crumb

John
Gibbons

Dean
Norman

Kay Rudin

GUESS WHICH ONE WE HIRED?

(ALL OF THEM) Because they have one thing in common talent — and that's what counts at American Greetings. Talent for producing top, up-to-date art clever, original writing with the feel of today.

In 1973 the Hi Brows and Soft Touch staff posed for a photo that was printed on an envelope containing recruiting information to give to people who might be interested in applying for work as writers or artists.

Back Row: James "Little Jimmer" Elliott, Ray Abrams, Greg Nelson, Les "Doc" Taylor, John "Roughhouse" Gibbons, Tim Wallace, Ted Bick, James Craig

Middle Row: Dan Henrich, Dara, Anni Shaffer, Bill Bridgeman, Dean Norman, Rayner Burrows

Front Row: Clovis Martin, Jack Clements, Tanya, Rene "Phoot" Strickland, Barbara Brown

Chapter 37: Mr. Hall and Irving

I don't think Joyce Hall and Irving Stone ever met. They are both gone now, and if they meet in the hereafter I wonder how they would get along? They might compare bank accounts to see who made the most money, but it is hard to imagine them kidding around with each other. Mr. Hall was remote and powerful. We heard his voice over the Hallmark PA system at Christmas, but we seldom saw him. He was called Mr. Hall.

Irving zipped around the AG departments without any special announcements that he was coming, and talked to everyone. "How are you? How's your family? I love the stuff your doing! Keep up the good work!" You weren't quite sure if he really knew what you were doing, but maybe he did. He was called Irving, not Mr. Stone.

Joyce Hall began selling postcards from a family bookstore in Norfolk, Nebraska in 1905. Five years later when he was 18 years old, he moved to Kansas City, Missouri, rented a room in the YMCA, and continued his postcard business with the inventory stored in shoe boxes under his bed. This humble beginning was remembered in 1987 when Hallmark produced a new line of cards named Shoebox. The postcard business boomed for a while, but Mr. Hall saw it begin to decline and believed it was a fad that would disappear or become a very minor business. He saw greeting cards as a potential business that could grow and endure. His brothers came to join him in Kansas City, they printed their first original cards in 1914, and the business grew steadily. Joyce C. Hall's book, *When You Care Enough*, published by Hallmark Cards in 1979 is an entertaining story of how the company began and grew. *The Very Best from Hallmark* written by Ellen Stern in 1988 shows a variety of cards published by the company over the years.

invitation designed by Rosemary Smithson and Paul Coker

Joyce Hall liked fuzzy bunnies to illustrate humorous greeting cards. The first Hallmark Oldies reunion was held in 1987 close to the former Hallmark farm in Kansas.

Hallmark became the dominant greeting card company in the 1930s and 1940s with two interesting projects. Hallmark sponsored a radio show, *Tony Wons' Radio Scrapbook*. Tony Wons read poems for fifteen minutes with a smooth, pleasant voice. At the end he would say, "Now here is a nice poem on a Hallmark card", and read a greeting card poem. "If you would like to send that card to a friend or relative, you

can buy it at any Hallmark card shop. You know it is a Hallmark card if it has a little crown on the back."

Meanwhile, a Hallmark bus was touring small towns in middle America with an art gallery show. The bus would park on the town square. At a time when there wasn't a lot of entertainment in small towns, (Herb Shriner used to say "On Saturday nights we would go to the barber shop and watch haircuts.") the Hallmark mobile art show was free and it would attract good crowds. The art show was mostly paintings by great masters, but near the end would be some paintings that were printed on Hallmark cards.

In Mr. Hall's book he said it was a Hallmark trailer with exhibits of greeting cards in new display cases the company was offering. Pat White told me it was a bus with art work. So my story may be a little off. But almost every other story I tell about Hallmark is not mentioned in Mr. Hall's book.

While the bus or trailer was parked for a day or so, a Hallmark salesman would try to get the best stationery store in the town to stock the Hallmark line of cards. Many of them did, because this is what often happened after a Tony Wons broadcast. A lady would come into a stationery store and say, "I want to buy that card that Tony Wons read on his show last night."

The store clerk would say, "Well, all of our greeting cards are right over there. Maybe you can find it."

"Are they Hallmark cards?"

"I don't know, but they're good cards."

"Well, if they don't have the little crown on the back, they aren't Hallmark cards. And I won't find the poem I want in your store."

While Hallmark competitors were concentrating sales in larger cities, Hallmark got the greatest market share by selling in almost all of the stationery shops in small towns. When TV became the new entertainment, the *Hallmark Hall of Fame* broadcasts continued Mr. Hall's strategy of associating Hallmark cards with quality art and entertainment.

Another strategy after WWII put Hallmark further ahead of competitors. During the war paper was rationed, and the best quality papers were not available to greeting card publishers. As soon as quantities of good paper were available after the war, Hallmark scrapped their cards in the stores and replaced them with the same designs printed on better paper. Other companies waited for the poorer quality cards to sell out before replacing them, and during that period Hallmark gained new accounts.

When nuclear war seemed possible in the 1960s, and people were told to build their own fallout shelters, Hallmark stored all of the company's verses and art in a bombproof vault dug into the hill behind the Kansas City headquarters. And they had a disaster plan that was known only to high executives until someone mailed a copy to *The New Yorker* magazine, and it was printed without comment as an entertaining filler. The gist of it was that in case of nuclear attack on Kansas City, the key executives should report to an alternative office at the Hallmark Farm in Kansas within 24 hours. But if the all clear had not been sounded yet, they could show up in 48 hours. Civil defense information told citizens to be prepared to stay in their fallout shelters for two weeks, but apparently the important business of

STOLEN FROM WINSTON CHURCHILL

DEAN

getting greeting cards ready for the survivors of Armageddon could not wait more than 48 hours.

Mr. Hall was always looking for things that would give Hallmark Cards prestige even if they might not be profitable. He persuaded Dwight Eisenhower and Winston Churchill to have their paintings reproduced on Hallmark Cards. Mr. Hall took a cigar butt from Winston's Churchill's ash tray, and had it proudly displayed in his Kansas City office.

Hallmark began the tradition of printing Christmas cards for U.S. Presidents when Eisenhower was President. In 1958 the Eisenhowers sent 2,100 official Christmas cards, 300 personal cards, and another 200 funny Christmas cards to close friends. The funny card was designed by the Hallmark Contemporary department, and it is the only time any president has sent a funny Christmas card. The joke was adapted from a good selling card written by Rosemary Leitz, and personalized for the Eisenhowers by pasting in their photographs and an actual lip print from Mamie and a thumbprint from Dwight. The first drawing by Don Branham showed two weird cartoon characters in Santa suits. It was deemed too wild for the Eisenhowers, so Lou Marak drew more conventional characters, but Branham's froo froo borders were used to frame the lip print and thumbprint. Lou also had to retouch the Eisenhowers' prints. No one could tell which was Mamie's upper lip print, and part of Lou's thumb was used to fill in a blank area in Dwight's thumbprint.

Hallmark contracted with Ogden Nash to use his popular humorous poetry on cards. But going through all of his published material the editors could only find a few that could be

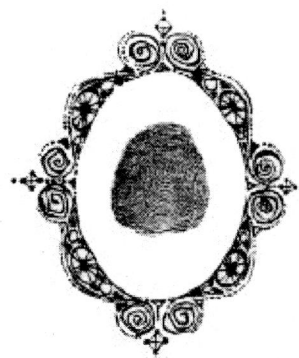

Courtesy of the Dwight D. Eisenhower Library

199

shaped into card messages. So the company gave Ogden the red carpet treatment to come to Kansas City, and take a crash course in greeting card writing. He came, and we loved it when he visited the Contemporary studio and chatted with us for a while. We particularly loved it when he said, in front of our boss, "I think it is impossible to write humor for more than four hours a day. I work four hours every morning, sometimes come up with nothing, sometimes write a lot, and then take the afternoon off." That was what we would have liked for a work schedule.

But when Ogden sent in some poems written specifically for cards, it looked just like what Hallmark already had in their line. It didn't read like the Ogden Nash poem about seduction, "Candy is dandy, but liquor is quicker." That's what Hallmark wanted, but of course something in better taste.

So Editorial Director Carl Goeller visited Ogden at the poet's studio for a week, and coached him on how to adapt his whimsical humor and outrageous rhymes into greeting card messages. At the end of the week Ogden gave a copy of his latest book to Carl, and wrote on the title page, "To Carl Goeller, genial slave driver. Ogden Nash, 1957". Carl treasured the book, *You Can't Get There From Here*, but one day when he took it off the shelf he saw that the author's inscription had been erased. Who could have done such a thing? Carl asked his five year old daughter if she had been looking at the book, and she said, "Yes, Daddy, and somebody scribbled in it, so I erased it!" Carl couldn't get mad at his little girl who thought she had done a good thing. Now he is able to chuckle about it, but at the time he thought, "Oh no! My million dollar book had been destroyed!"

"How could she have erased it?" I asked. "Did Ogden write it in pencil?"

"Oh no," Carl explained. "It was written in ink, and my daughter almost rubbed through the page to clean it up." I wonder if a book with a genuine, lovingly erased Ogden Nash inscription is still worth more than just

Next year SPACE may lie Between us With YOU on MARS or ME on VENUS AUTHORITIES cannot agree on WHAT the POSTAGE RATE will be *** OR promise that THE MAIL WON'T STRAY AnD VANISH in the MILKY WAY, SO while we both are SAFE on Earth I send you GREETINGS, ① ① ⊢ ① 4 cents' worth.

Merry Christmas

© Hallmark Cards, Inc.

Ogden Nash

an ordinary book?

Most of Ogden's greeting card poems were put into the regular Humorous card line, but I remember Don Branham illustrating a few for the Contemporary line. Don's whimsical characters and hand writing was a perfect match for Ogden's whimsical humor. I was not able to find any of those cards, but Ogden's daughter, Linell Nash Smith, sent me the Christmas card shown here. Published as part of a boxed set with 4 cards each of 3 designs, this is a collectible of the 1950's. Space exploration was new, and first class postage was only 4 cents.

Carl Goeller saw the Ogden Nash stamps issued in 2002 to commemorate the 100th anniversary of the poet's birth, and noted that some verses were printed in the background. With a magnifying glass Carl was able to read them, and two were poems that Ogden wrote specifically for Hallmark cards. One was Carl's favorite.

"Old age begins and middle age ends
The day your descendants outnumber your friends."

Mr. Hall especially liked that one, too. And now that Carl is in his 70s, he appreciates the truth as well as the humor of the verse.

In his book, *When You Care Enough*, Mr. Hall tells a great deal about his meetings with Eisenhower and Churchill. There is nothing, however, about a product he introduced when I was working at Hallmark in 1958...Rumba Rings. Mr. Hall returned from a trip to California with a wonderful new product that would be sold exclusively at the Hallmark store in downtown Kansas City...the Rumba Ring. It looked a lot like a Hula Hoop. In fact it was exactly like a Hula Hoop. Hula Hoops were a new fad that had not yet been marketed beyond the West coast. The product was a simple ring of plastic, so I suppose it could not be patented. But the name Hula Hoop was a trademark.

Employees at Hallmark got the first chance to buy a Rumba Ring after a lunchtime demonstration in the cafeteria. A professional dancer was hired to demonstrate the product on a stage, and it would have been a greatly appreciated performance if she had worn a costume that she might have worn in another venue. But at squeaky clean, good taste Hallmark she was required to wear a kiddie sailor suit with baggy bell bottom pants and a very high necked blouse. She looked like the character on a box of Cracker Jack.

She performed the sexy pelvic gyrations that make a Hula Hoop...excuse me...a Rumba Ring circle your waist accompanied by some innocent and forgettable music. Then we were told we could buy this product at a discount in the company store and be the first folks east of California to have them. I don't know if Mr. Hall really expected to sell the world Rumba Rings instead of Hula Hoops. But we in the Contemporary department thought it was tacky of him to pretend he had discovered or invented something new, when he was really ripping off another company's product. We vowed not to buy Rumba Rings.

Sam Van Meter returned from lunch to his drawing board in Editorial, and began ranting to an appreciative audience that anyone who would buy the rip off Rumba Ring was a company fink. He turned and saw the department head, Carl Goeller, coming down the aisle with a big red Rumba Ring over his shoulder. "Carl!" Sam exclaimed, "Did you really buy one of those?"

"Why, yes, I did, Sam," said Carl.

"Too many moons you have walked the white man's paths," Sam intoned very seriously. "You are no longer one of our people." Carl got very red faced and walked away saying nothing. Hula Hoops soon became a national fad, but I don't think Rumba Rings were ever seen outside of Kansas City.

Irving

Most of the major greeting card companies in the U.S. got started in the early 1900s by individuals who put their names on the companies...Hallmark (J.C. Hall), Rust Craft (Fred Rust), Gibson (E.P. Gibson), Norcross (Arthur and Jane Norcross), Sapirstein Cards (Jacob Sapirstein). Sapirstein Cards became American Greetings, and today that company is the only major competitor to Hallmark. Jacob began in 1906 buying and selling postcards using a horse drawn cart to get around Cleveland. In 1932 Jacob's oldest son, Irving, talked his Dad into publishing and selling their own greeting cards. Irving designed the first few cards printed by the company. A replica of the horse drawn cart is on display at the company headquarters in a Cleveland suburb.

Irving began working for the company at a young age. Once an IRS investigator came to Mr. Sapirstein's home wanting to see the company books. Jacob called out, "Irving! Come here! A man wants to see you!" A ten year old boy wearing short pants came running to the door. When the IRS agent was told that this was the company accountant, he was satisfied that no further investigation was needed.

Irving and two brothers changed their last name to Stone, and became executives as the company grew. Jacob was Chairman of the Board as long as he lived (to age 104), but as it grew from a family business into a Fortune 500 corporation the complexity overwhelmed the founder. There were entertaining stories that while his sons were running the business, he would prowl about looking for small things to correct.

Jacob once pulled a sheet of paper out of a writer's wastebasket, shoved it under her nose and said, "You only used ONE side!" When he saw a telephone repairman loafing on the job, Jacob said, "You're fired!" He fired a copy machine repairman for the same reason. Neither of them were employed by AG, but Jacob figured if they were in his building he could fire them. After working hours Jacob would retrieve paper clips from wastebaskets, and put the caps on artists' ink bottles. One time he was poking around in the back of a truck at the loading dock, and the door was slammed shut. The driver went all the way to Akron before he heard the pounding in the back, and discovered he had abducted the founder of the company.

The father also made it difficult for the sons to spend money on anything he considered an unnecessary luxury. There was no national advertising of the brand name as Hallmark was doing. AG grew by marketing to chain drug stores in cities, and began to overtake Hallmark in sales as shopping habits changed. The company headquarters remained for a long time in a decaying brick building where WWI airplanes and Baker electric cars were once manufactured. AG didn't even buy the building. They leased it, and probably got cheaper leases as the building crumbled and the owner figured no one else would buy or lease it.

When they tried to spruce up the interior of the building by redecorating executive offices, Jacob did not want an expensive rug on the floor of his office. An unnecessary luxury! "Dad", Irving pleaded. "The Presidents of big corporations like Walgreens will come here to meet you. They have expensive rugs in their offices. They won't think our company is good enough for them if you don't have a nice office, too!" So they got the rug for Dad's office and a few nice touches for the sons' offices, too, but not much more. AG did eventually move out of the old brick wreck on W. 78th Street in Cleveland to nice new headquarters in Brooklyn, Ohio, a Cleveland suburb. But the move was slow and delayed many times during the 1970s and 1980s when interest rates were high.

Many of us thought that the old building on W. 78th street would be torn down, but in 2002 a new owner began fixing it up. Where the AG executive offices used to be there is a new art gallery named Thirteen Hundred (*www.thirteenhundred.com*) that displays the works of local and national artists. The gallery owners have their spacious apartment on the third floor where AG used to have an art department.

When Hallmark announced they were constructing a new eight story building in Kansas City in the 1950s, several bankers came to see Mr. Hall the next day. "Why are you gentlemen here?" asked Mr. Hall.

"To offer you loans at very good rates for your new building," said the bankers.

"Oh, that won't be necessary, Gentlemen. We are going to pay cash."

AG never achieved a cash flow like that, and always borrowed for growth. The artists and writers were the last to move to the new AG building, and when it happened they became nostalgic for their old digs. A new line of cards was named "W. 78th Street" to make the artists feel better, but they had to accept fancy new drawing boards and chairs instead of the old beat up equipment that they had become fond of.

When the Hallmark Contemporary cards burst into popularity in the mid 1950s, Mr. Hall's main contribution was to stay out the way. I mentioned before how he said he didn't understand that kind of humor. He looked hard at every design to prevent anything that was poor taste from being published, but he didn't question why many people laughed at things he didn't understand.

Irving got most of the gags, and he loved humor that was in poor taste. Well, let's be more polite and call it jokes that were double-entendre, suggestive, romantic, a little off-color but awfully funny and cute. At the AG final judgment meetings Tom Wilson would bring a stack of the latest Hi Brows gags with sketches and keep them turned over on the table. The meeting would work through all the conventional (not funny) card ideas, and humorous (not very funny) card ideas, and save Hi Brows for last. Then Irving would say, "Now we get to have some fun. Show us the new Hi Brows, Tom." Tom would hold up the sketches and read the cards one at a time. If Irving laughed hard, everyone else laughed, and it was a card accepted for publication. If Irving didn't laugh very hard, there might be some discussion, but the card was usually rejected.

Knowing that Irving liked sexy humor, Tom would include a few gags that were too dirty to print. He would put these near the top of the stack. "If Irving really cracks up on a gag, then he is in such a good mood he laughs at almost everything, and we can get most of our cards accepted," Tom explained his strategy. It worked very well except for one time.

As a meeting broke up Irving said, "Tom, you put that great card in the wrong pile. You put it in the reject pile."

"Oh, I just brought that gag to the meeting to give everybody a laugh," said Tom. "We could never print that."

"Tom, you gotta print that card!" Irving said. "It's the funniest card ever!"

"We can't print it, Irving!" said Tom. "We'll get angry letters from people. We'll lose accounts in stores, especially like Walgreens where Mrs. Walgreen already objects to some of our suggestive humor." Tom had to argue harder to stop Irving from printing that card than he ever argued to get a card accepted.

The taste standards Walgreens insisted upon gave AG problems for many years. Not wanting to lose the Walgreens account Hi Brows would tone down the sex humor for a while, and the company would lose many smaller accounts at other stores. The

HEE HEE HOO HA...

WE GOTTA PRINT THIS CARD!

NO, IRVING! NO!

DEAN

buyers would say, "Your cards aren't as funny as some of the competitors. I can't use Hi Brows anymore." The obvious solution would be to send the sexy cards to everybody except Walgreens, but the production and shipping departments said it would be too much trouble to do that. Barbara Brown suggested that AG publish a line of Under-The-Counter-Cards sold with plain brown envelopes and without the AG brand name. Eventually Hi Brows published a separate line called "Red Hots", and put all the sex jokes in it. Walgreens passed on Red Hots, and the shops that liked sex humor took Hi Brows and Red Hots cards.

Tom said the only time he got any really mad letters about a card was when the cover read, "Do you know what this is?" and the design was an abstract shape that was nothing. I wrote and designed one of those. "Do you know what this is? (illustrated by a shapeless blob). Inside it said, "I don't know either, but it's a big one of whatever this is." (illustrated by a smaller shapeless blob). Tom got a letter that said, "My 18 year old daughter received this card from her boyfriend, and I have never seen anything so rotten in my entire life! I will never buy any more American Greetings cards if you continue to publish such indecent humor."

Tom said he had no idea what the guy thought the blob was. "It seems that when we ask "Do you know what this is?" and draw an abstract shape, some people don't get that it is nonsense humor. They look at it like a psychology ink blot test, and see something that only they see. And if what they see is dirty, they get very offended at American Greetings."

So he wrote a letter saying, "We spoke to the writer and artist and editors that produced the card, and told them never to do anything like that again. We are very sorry it slipped through our final approval system, and will make every effort to be sure that it doesn't happen again." And Tom was telling the truth. He decided not to approve any more cards that asked "Do you know what this is?"

Sometimes Irving missed the double meanings in gags, so he had his secretary check them out. The checking for acceptable humor was expanded to a group of women who became known as "The Biddy Committee". Irving also sometimes didn't understand current slang expressions. He rejected a card that said in part, "Meanwhile, back at the ranch…" Then his daughter came home from college saying "Meanwhile, back at the ranch…." and Irving told us to write a funny card using that expression.

Irving bopped around the company at such a fast pace that he sometimes

missed understanding all of our jokes. An editor named Jane Farrell tended to switch initial consonants when speaking, so we made a desk name plate for her reading "Fane Jarrell". Irving knew her well, but when he saw the name plate, he started calling her Fane. Apparently he thought he had got her name wrong before.

It was an annual event at AG to get complaints from the Ancient Order of Hibernians about funny St. Patrick's Day cards that implied Irish people get drunk on St. Patrick's Day. Actually, the cards implied that a lot of people get drunk on St. Patrick's Day whether they are Irish or not. The representative from the Hibernians was sent to the AG Public Relations department, and the matter was quickly settled. And we would continue to write and publish drinking jokes for St. Patrick's Day. Tom was curious how the public relations man appeased the Hibernians so easily every year. "Oh, I apologize for any cards we printed that may have been taken the wrong way by some people. And then I give him a bottle of the best Irish whiskey, and he goes away happy." Eventually the Hibernians were not so easily pacified, and AG stopped publishing drinking jokes for St. Patrick's Day.

I remember a letter to Hallmark objecting to a line of Easter studio cards. The gist of the letter was that Easter is a deeply religious occasion, and it offended the person to see Hallmark publish such a large number of silly Easter cards with funny bunnies. I thought she had a good point. The religious part of Christmas almost gets overwhelmed by all the Santa Claus and Red Nose Reindeer jokes, so maybe it would be nice to not make any funny Easter cards. The Hallmark editors struggled with the problem. They advertised that Hallmark Cards were all in good taste, and yet they were selling a lot of funny Easter cards. And one lady thought funny Easter cards were in poor taste. An honest answer to her would be to say, "You are the only person who feels this way so far as we know, so we're going to go ahead and publish Easter Bunny jokes until we get a lot of angry letters." But instead of accepting her point as she made it, they looked at the Easter studio cards and asked, "Which card here is the most objectionable. We will cancel that one card, if we can find it."

She had not complained about any particular card, but Hallmark found one to throw to her anyway. A very laid back bunny was saying, "So it's Easter? What do you expect, egg in your beer?" Oh my! Easter and beer! How could Hallmark have been so insensitive to good taste to let that one slip through. That card was canceled, and the lady was told we had taken care of her complaint.

I once drew an Easter card for AG that implied the Easter Bunny smoked marijuana. But that was in the 70s, and the card sold well with no complaints.

The pay was always pretty average at AG, but it helped that Irving really liked what we created and published it. During the 1960s Hallmark Contemporary cards did not do as well as AG Hi Brows cards. Both companies made a lot of money, but since the cards were sold in different stores there was not often head to head competition. In a few stores where both lines were sold, Hi Brows cards won big. What Mr. Hall would consider poor taste was acceptable humor to most of the public, and the Hi Brows cards became a lot funnier than Contemporary cards.

Irving envied the attention J. C. Hall got by printing Christmas cards for the Presidents, so AG lobbied to get in on the action. Finally, in 1964 Lyndon Johnson was persuaded to let American Greetings make the Presidential Christmas cards. Johnson was reminded that Irving had contributed a lot of money to the Democratic campaign funds. Irving hadn't always been a Democrat, however. When Eisenhower was running for reelection in 1956, AG had a meeting of top company executives, and Irving said the company would probably be more prosperous in the next few years if Eisenhower were reelected. So he wanted all his executives to support the

Eisenhower campaign and urge their staffs to vote for Eisenhower.

There was a brief silence, and then Morty Wyman spoke. "I don't think that what is good for business for American Greetings is necessarily good for the country, and I very much resent my employer pressuring me and asking me to pressure my staff to support any particular candidate in any election. I think that is something that is personal, and the company should keep out of my personal life." This short speech was followed by a long silence, and then Irving dropped the idea that the company should be involved in the election campaign. Morty told Tom Wilson later, "I thought my career at AG was finished when I said that. But it made me so damn mad, I had to say it. Irving, bless his heart, saw my point and I was off the hook."

Eventually AG did spend some money on brand name advertising with a series of funny commercials on prime time TV. A former Hi Brows writer, Marv Honig, wrote the scripts. (Coincidentally, both Marv and John Annarino worked less than a year in greeting cards, Marv at AG and John at Hallmark, and later became directors of the ad agency Doyle Dane Bernbach. Marv was head of the East coast office while John was head of the West coast office.)

The best TV commercial was a mini-story of a young couple having a dinner date in a classy restaurant. The kid had probably saved money from his paper route for years to afford this. The restaurant was packed and noisy as he slipped a greeting card to his girl. As he did this he bumped the arm of a passing waiter. The waiter dropped a load of food on someone, and there was a chain reaction of bumping, jumping, shoving, screaming, food splashing, dishes crashing like an intricate chain of dominos being knocked over. The entire restaurant became a disaster, but the kid and his girl saw or heard nothing. Because she is reading the card with a smile and a tear in her eye. And of course they turn it over to see that it is an American Greetings card. The commercial was classic Hi Brows humor, but the card was a sweet conventional card with no joke at all.

I loved to watch that commercial over and over, but could never stay awake during a Hallmark Hall of Fame Shakespeare play. Both Mr. Hall and Irving made smart business moves, but Irving knew what was funny and it enabled him to put his Hi Brows line ahead. He was a fun guy to work for.

iT's EASTER

AND THE EASTER BUNNY IS MORE HOPPED UP THAN USUAL THIS YEAR!

© AGC, Inc. Dean Norman, writer/artist

206

HE SMOKED ALL THE GRASS IN THE EASTER BASKET !

HAPPY EASTER !!

Pete Seymour was one of the first writers hired to create a line of studio cards for Hallmark. During a twenty year career he was writer, editor, Editorial department Director, consultant, and West Coast Creative Director. Pete's recollections mention many people, but I have included it all here because he was one of few employees to have much personal contact with Joyce Hall.

MEMORIES OF HALLMARK by Pete Seymour

The beginnings of the studio line. I was hired, along with Phil Hahn, as a writer. Rosie Leitz was writing regular humorous cards and was transferred into the studio later. Paul Coker, Bob Harr and two other artists were also hired. We started out in the old building, the new one was still under construction, like in July of 1955. They put us in the basement far away from everyone. I remember big pipes, gray walls and hardly enough light. It was summer and the building had no air conditioning. Tall fans didn't help much, but they did blow paper around. Yes, Bob McCloskey was one of the most terrific people I've ever known. Never really appreciated by Hallmark. He sat down there with the six of us.

When J.C. Hall came back from the hospital the first line of cards was already on the market, and thank goodness proved to be successful. I did the first Contemporary "pop-up" card. Actually, a pop-down. "When you're not around….I'm feeling mighty low." And when you opened the card, a little character's face popped down below the bottom of the card. Coker illustrated it, and it sold well, because as I had quickly learned, it was SENDABLE. John Annarino and I later wrote a musical play titled *Greetings*, and one of the songs was titled "Sendability".

Do you recall how you and I made up funny skits using your tape recorder? We had this harebrained scheme to do skits on 45 rpm records printed on greeting cards. We had in mind to use Jack Benny and characters from his show. You did the Jack Benny voice and I did some others, and we recorded the stuff and got some big shots like Joe Kipp and maybe Dave Hughes to listen. Don't recall what came of that other than nothing.

The Editorial department had some great parties. I recall several Halloween parties where we all wore costumes. One time I rented a knight's costume from the Drama department at the University of Kansas City. Naturally I got fairly well blasted—didn't we all—and fell down some stairs. It took several people to get me upright because the chain mail was so heavy. And once Sam Van Meter fell over backwards and didn't spill a drop. The glass was in his hand, upright on his chest.

I'll never forget when they asked me to tell another new guy about the Editorial operations. He was Conrad Knickerbocker from Public Relations. Conrad smoked like a chimney, and in those days you could only smoke during 10 minute breaks and lunch hour. The morning break happened when I was talking to Conrad, and I watched him chain smoke three cigarettes in 10 minutes.

Thad Nugent and I spent far too much time when we were editors writing dirty limericks, and making up lewd lyrics to popular songs. By the way I was the first male editor after they decided I couldn't write. Mo Nugent decided that, rest his soul. I got divorced in 1960 and fell back into my earlier carousing days. Drank a lot with Lou Nickerson, Larry Bowser, etc. In 1961 Carl Goeller got his walking papers and they made me Editorial department head. It was a Jeckle and Hyde life. Some Monday mornings I didn't make it in, just too hung over. I recall a Saturday when I had to come in to interview Gordon MacKenzie, who had come down from Canada. I was still half stoned and had no idea if Gordon could tell—he was so crazy. Maybe he was drunk, too. But we hit it off so Web Schott and I hired him. (After a 30 year career Gordon wrote a book

about Hallmark, *Orbiting the Giant Hairball*.)

I bought a Morris Minor convertible, and it was fun to drive it standing up using the throttle instead of the accelerator. I was dating a Contemporary department artist named Sydney Wade, and had three other Hallmarkers on board one weekend when I drove the car into Loose Park Lake. Fortunately, it wasn't very deep and the car wasn't very heavy, so we managed to lift it back onto dry land. That event made the rounds, but I guess it didn't get back to management.

I hired the first Afro-American writer in 1961, being into all the civil rights stuff then. When I took her around the department to introduce her, a sketch artist named Bill Hunt asked, "Are you a native?" He meant was she from the Kansas City area, but most of the group couldn't refrain from laughing. It was a bad start. And it turned out she was a "plant" from some Black militant group, and I had to fire her for disrupting things almost every day. She threatened to have me beat up, but at that age we were all pretty fearless.

Of course we were all kind of frightened of J.C. Hall. At Christmas every employee could go into his office and meet him, his wife, his children Don and Adele and their little kids, and some other family members. They were there for hours shaking hands with employees while Christmas carols played.

When I was a lowly editor I got pissed off with the so-called research ratings. Card ratings were based on sales in only one store, Halls downtown gift shop. Writers would buy their own cards to jack up the ratings. So I put together my own research report of the wedding line, and somehow it ended up in J.C.'s hands. One day somebody came running into the department and told me, "Mr. Hall wants to see you! Hurry up!" I didn't know what the hell was going on. Someone had told me a way to overcome nervousness about meeting someone was to visualize them sitting on the toilet. So as I hurried to J.C.'s office, that's what I did. He waved the wedding report at me, and told me he didn't agree with everything I had said, but he liked the way I said it.

After I became Editorial department head I attended card approval meetings, and one day we were reviewing a 3-fold card that had a bunny hopping across it. Mr. Hall liked the art but hated the words. Without thinking I piped up, "How about Hop-Hop-Hoppy Birthday?" Maybe that's what put me into his good graces. He always told me, "Don't scorn corn."

When I told Hallmark I was quitting to go to California in 1963 they tried to get me to stay. Ed Goodman (a vice-president who coined the phrase "When you care enough to send the very best") called me into his office, and told me they were prepared to offer me a significant raise. And they would keep it hidden from my financial records so my ex-wife wouldn't find out and take me to court to get more alimony. What a riot! It makes me think how embarrassing it was to give out raises. The normal was $15 to $25 a month.

We liked to joke about the loud speaker system that was used to make announcements. Bill Harsh would say, "This is Bill Harsh on all floors", and we'd change it to "on all fours".

When I moved to L.A., I had a consulting agreement and worked with Lou Schmitt (of Lou and Stan). Lou had a one room studio on the end of the Santa Monica pier. Several times Lou and I came back to Kansas City together to "consult". They let Lou stay up in the penthouse

apartment above J.C.'s office. I went up there a few times and we would smoke and drink booze out of the liquor cabinet. One time several other guys came up, and I don't think any of us were supposed to be there except Lou. Somehow a wastebasket caught on fire and made quite a mess. I can't remember what Lou's explanation was, but he was damn good at confounding Hallmark authorities!

After I moved to L.A., Mr. Hall started calling me to come out to his big place on the beach in Malibu when he was there. We'd sit looking at those large gray panels full of cards. He had a pointer and would whack a card and ask me what I thought about it. Not giving a damn, I'd tell him what I really thought. He seemed to enjoy it. Then his wife, a cheery, lovely woman, would serve us lunch.

And now for something completely different, Gayle Steinberger recalls her days in the AG Hi Brows studio in the late 1960s.

MEMORIES OF HI BROWS by Gayle Steinberger Adams

I was 17 and just out of high school in 1965 when I came to work at Hi-Brow. I dated Robert Crumb's best friend, Mary Pahls, when I was a high school senior, and got to know Crumb very well. Crumb's sketchbooks, which he let me take home for perusal, were a revelation and inspiration to me, and I began my own imitative, but sincere, underground comic type of social commentary cartooning.

When my parents couldn't afford college tuition, Crumb paved the way for an interview with Tom Wilson and Ralph Shaffer, and I was hired for the regal sum of $75 a week. On my first day of work, Tom, Ralph and several others took me out for the first of many long, alcohol fueled lunches and plied me with numerous Manhattans, my first Manhattans ever, the end result being that I threw up in the parking lot all over my bosses' shoes. I have a foggy recollections of spending the rest of the day recovering in someone's apartment, lying fully clothed in the bathtub.

My Hi-Brow memories have mostly to do with numerous wild parties, long, long lunches, experimentation with psychedelic substances, and close friendships with a number of very creative, quirky and eccentric men. Ralph Shaffer, with his tough-guy-macho-motorcycle image masking a very sensitive interior. Les Taylor, a wild sense of humor mixed with a funk of alcoholic melancholia. Walter Lee, hugely talented also serious about making fine art, whimsical, great sense of the absurd, charming Liverpool accent, strong as a bull from his years of judo practice. Larry Raybourne, practitioner of astrology and black magic, consumer of all manner of books about esoteric religions and philosophies. Larry had spent a good deal of time in Japan during the Korean War and was enamored of Japanese philosophy, culture and arts. He really sparked my interest in those areas, which has turned into a life-long interest for me. Such a bizarre and intelligent man.

I remember lots of hi-jinks going on with those guys, some which involved practical jokes and relentless teasing of some of the straighter, more clueless members of the Hi Brow team. Of course I do remember all the hours spent hunched over our drawing tables in our little cubicles, drawing with our rapidiograph pens. I still have and use the set of sable brushes that were issued to me when I started work at AG. I also remember all the bull sessions spent brainstorming with the writers around the conference table batting ideas back and forth, rapid fire repartees with the likes of quick-witted John Gibbons (a Bix Beiderbeck wannabe), and Jack Clements (ex-Cincinnati D.J. and comedian).

There were so many strongly, vividly, eccentric and wittily talented people at Hi Brow during that era, which also brought with it great social change as the Eisenhower era generation aged and their children rebelled and dealt with questions engendered by the civil rights movement and Vietnam. The Beatles, Simon and Garfunkel, Bob Dylan, Joan Baez, Jefferson Airplane, and others infiltrated the music scene and were listened to by many of us in Hi Brow. The psychedelic era art infiltrated the sensibilities of some of the artists, along with the masterful satirical drawings of R. Crumb, who migrated to San Francisco and became a famous underground comic artist.

I also remember the "field trips" we took on company time. One was my first and only trip to the still existing burlesque theatre downtown, where we watched a movie called "Ruined Bruin" about a bear, played by a man in a bear suit, who constantly ran into situations peopled by nude women. The star of the live show was Busty Russell, a huge-bosomed woman who performed bizarre manipulations with her breasts. This all seems strangely innocent in light of today's Internet porn and strip clubs.

The freedom and latitude we were offered both behaviorally and time-wise that we enjoyed back then probably no longer exists in today's corporate culture, and of course, the era I worked in was pre-computer as well. As a very young woman it was quite an experience to work and play with such an assortment of eccentric, gifted and creative people who took me under their wings and let me become a part of their subculture. I feel extremely lucky to have been hired at Hi Brow, because Hi Brow financed most of my college education. I worked there for two years and then went away to Carnegie-Mellon University, spent a year in Europe, and then went to the Kansas City Art Institute, always returning each summer to work at Hi Brow. I was also given consistent freelance work for a number of years.

I went on to get an M.A. and M.F.A. in painting and art history at the University of Iowa, taking many courses in Japanese and Asian studies. After grad school I lived in Tokyo for five years, where I studied Japanese language, taught Art and English, showed my work, and apprenticed myself to a traditional textile design artisan. From Japan my husband and I moved to Portland, Oregon, where we've lived for the past 18 years. I have two teen age sons, and over the years have worked sporadically as a textbook illustrator and teaching Art to children. I also play Latin and African percussion and am very involved in the dance/music community here.

Stay as Sweet as you are...

...Cause i have an uncontrollable craving for "sweets"

© AGC, Inc.

writer unknown Gayle Steinberger, artist

Chapter 38: The Rest of Us

I include myself in this group. Many writers and artists who created good gags and cartoons for Hallmark and AG, but did not shape the direction of the studios. I have said a lot about a few people who I believe had a strong influence in shaping the direction of studio card humor. And quite a bit about some people just because there were funny stories to tell. This book is not an attempt to publish resumes, or rate the talent of any individuals. Studio cards were fun, and I figure the book should be more fun than serious history. But now I would like to say more about some good people.

George Hart was a writer for Hallmark, AG and Norcross during his long career. His year at Norcross shows how a dull working environment can kill imagination. "There were about 15 writers in a large room with a desk for each of us", George said. "We would put our gags into a box at the end of the room. At the end of each week a secretary would take the box into the editor's office, and we never heard what happened to the gags. We hardly ever saw or talked with the editor. The office was in New York City, and all the writers were trying to get into other kinds of work.... cartooning, TV, books, etc. Nobody gave a damn about greeting cards. It was good pay, but I quit after a year to find a happier place to work."

In another attempt to find a happier place to work, George left AG in 1972 to become editor of Roth cards in California. Small companies often hired a few artists, and one person to be editor and writer of all their cards. George had a very small free lance budget to buy a few ideas, but was expected to write most of the copy himself. Jan Olin, a former Hi Brows secretary, moved to California with George, and they were very happy playing tennis everyday in the sunshine. But one day George was talking to the artists to suggest how they might illustrate some of his gags, and the boss got angry. "Don't talk to the artists and waste their time !" he barked. "They are supposed to keep drawing and not do any talking." George thought about this for the rest of the day, and when he left that evening he put a small note on his desk....I QUIT !

George was editor of *Laugh-In Magazine* for a few months in 1969, and published some cartoon stories from his greeting card friends, Les Taylor, Al Margolis and myself. The magazine was trying to be competition to *MAD*, but it folded when George got homesick for his family in the East and left the job.

There were people who worked for other companies that I didn't meet personally so I can't say much about them. Ann Leaf drew wonderful cartoon characters for Gibson's studio cards. Jack Schneider and Johnnie Wolf were writer/editors at Gibson and Barker Cards, both companies located in Cincinnati, Ohio. Jack eventually came to AG as a writer, and his son Matt was there also. Matt had learned to write studio cards while he grew up by reading his Dad's gags.

What all of us created was nothing really new in comedy or humor, but it was

Gag writing is serious business

sketch of Dean Norman by Lou Marak

new to greeting cards. Mr. Hall's idea that greeting cards should be sweet complimentary verses with no negative thoughts or ugly characters held back the industry through the 1930s and 1940s. Comedy in radio, movies and TV always used a lot of insult gags, and so did cartoons in magazines and newspapers. In the 1950s there were some new nightclub comics doing fresh stuff—Shelly Berman, Bob Newhart, Mort Sahl, Ernie Kovacs, Herb Shriner, Andy Griffith, Dick Gregory, Phyllis Diller, Jonathan Winters, George Gobel, Lennie Bruce, Tom Lehrer, Mike Nichols and Elaine May. We played their records and drew inspiration. The trick was how to bring really funny comedy and cartooning into greeting cards. Just printing a funny gag or cartoon on a card didn't often make it. When you buy a magazine you buy the whole package, not just the cartoons you like. And you buy it for yourself, not to send to someone else. But card buyers pick each cartoon individually, and ones they don't want just stay on the rack.

In the first years at Hallmark very few freelance submissions were accepted, because even good humor writers couldn't shape their gags into card messages. For example, one freelance writer submitted many ideas to Hallmark. Contemporary Editor Rosie Leitz bought one from the first batch, but could never find another idea that was usable. In fact the one she bought was rewritten by Rosie, but she felt the freelancer deserved a check and didn't tell him she rewrote the idea. There was so little freelance coming in the mail at the time, that Rosie patiently wrote encouraging letters. The guy sent letters proclaiming that he was the "King of Greeting Card Writers". He said he had been a struggling night club comedian, and on a whim tried greeting card writing, and "wham...bam...I sold a bunch of cards and discovered I was a genius at this!" His letters included a grinning photo of himself wearing a funny hat. He looked like a young Red Skelton playing the role of Clem Kadiddlehopper. Eventually the letters and card submissions stopped, and then we read a newspaper story about him. Marty Ingels, "King of Greeting Card Writers", had climbed over the fence at a movie studio to meet Jerry Lewis. Jerry thought Marty was funny, and put him in a movie. So Marty gave up greeting cards and moved on to a career as an actor in Hollywood.

But untrained writers who worked on the staff at Hallmark or AG were soon able to figure out tricks to mold gags into card messages, and many of them quit and freelanced successfully. Then after a while some good freelance began arriving in the mail from people who had never worked on a card company staff. The medium had been defined.

I knew we had achieved some respect when I heard a card gag that Rosie and I had written for Hoohah Studio performed on TV by Nipsey Russell. "I'd like to meet the guy who invented sex, and see if he has come up with anything new lately." It was exactly as printed on a Hi Brows card, and though we occasionally stole a gag from a comedian, we knew Nipsy or his writer had stolen this one from us. We felt honored.

Hallmark People

Hallmark published a book *Greetings, Dearie!* in 1962 that was a collection of some of the best Contemporary studio cards. Don Branham was supposed to design the cover and some chapter pages, but he had disappeared on his junket to Aspen. Jim Bray and some others ghosted Branham drawings, and Don was given a byline.

But none of the writers or artists who created the cards were mentioned in the book. Hallmark published two other books about their company and their cards, and again didn't mention the names of any writers or artists who worked for them unless they became famous somewhere else. So I will add a few more names to the list of people who created funny cards.

Two people who were hired at Hallmark shortly after I left achieved cartoonists' dreams. Russell Myers drew some booklet cards for Hallmark featuring a little circus ringmaster and "My dog Evan, the Wonder Dog." I had done a lot of booklet cards for Hallmark, but Russell took it a step further by creating characters that continued adventures on subsequent cards...sort of like a series of Sunday funnies. Then he left Hallmark to write and draw the popular comic strip *Broom-Hilda*.

Charles Barsotti cartooned for Hallmark a few years, then moved to New York and soon became a regular cartoonist for *The New Yorker* magazine. Bob Dole wrote and drew for Hallmark using few words and a unique cartoon style. (This was not the same Bob Dole who made a TV commercial for Viagra.) Gordon MacKenzie came to Hallmark shortly after I left there in 1960, and had a 30 year career of being a cartoonist, creative oddball and "a burr in the saddle" as he described his last three years when his job title was Creative Paradox. His book, *Orbiting the Giant Hairball*, is a hilarious and insightful tale of creative struggle within a corporation.

Thad Nugent and Pete Seymour were editors in Hallmark Editorial who had a particular appreciation of Bob and Ray, a radio comedy team that persisted even after TV took most of the audience away from radio. Thad and

I'd like to Horse around with you.

© Hallmark Cards, Inc. Bob Dole, writer/artist

215

1. HI! IT'S ME AND MY TRULY AMAZING TALKING DOG, EVAN, BACK AGAIN TO WISH YOU A VERY HAPPY BIRTHDAY!

2. OKAY, EVAN, LET'S HEAR IT.

A PENNY SAVED IS A PENNY EARNED.

3. COME ON, EVAN...

WHAT EVIL LURKS IN THE HEARTS OF MEN... THE SHADOW KNOWS...

4. FOR HEAVEN'S SAKE... WE'RE RUNNING OUT OF SPACE...

INDUBITABLY, MADAM, YOUR AUTOMATIC WASHER IS SUFFERING FROM AN OVERABUNDANCE OF SUDS WHICH TEND TO CLOG THE MECHANISM...

5. I'M TERRIBLY SORRY... I'LL JUST HAVE TO DO IT MYSELF....

HAPPY BIRTHDAY!

6. BOW WOW

Russell Myers, writer/artist

Pete made tape cassettes of their own comedy writing in the style of Bob and Ray. Thad quit Hallmark after a few years and went to law school.

The Plum sisters, Bobbi and Kay, were not humorous writers, but the entire Editorial department was inspired one morning when Kay arrived without her skirt. She had dressed in a hurry, put on a long winter coat, ridden a bus to work, and didn't realize her skirt was still in the closet until she whipped off her coat at her desk. I didn't see it, but someone who did said, "Well, it wasn't so bad. She was wearing a slip." I had pictured her without the slip, so I wish they hadn't told me that detail. Bobbi and Kay were inspiring to look at whatever they wore, but the day Kay forgot her skirt was burned into the collective memory of the department.

Bobbi and Kay entertained us again at a New Year's party when they got into an argument that escalated into a battle with foam shaving cream spray cans. Several rooms in Jim Krekovich's house were splattered.

There were many writers in Editorial who contributed regularly to the studio card line...Mary Rita Hurley, Caroline Furr, Mim Landes, Lou Nickerson, and Bill Hunt. Bill had been hired as an artist and sent through the Hallmark Art Training Class before coming to Editorial as a sketcher and writer. In class the teacher told him to draw a baby's eyes as far apart as possible, because it made the baby look cuter. Bill disputed this, and drew the eyes on a baby or any other character as close together as possible. His cartoon characters got funnier as the eyes got closer, and we wondered how long he could keep going in that direction before the eyes merged into a one-eyed Cyclops.

I have said something about everybody I worked with in Hallmark Contemporary department except Dick Bennett. Dick was one of the original people in the department, but he wasn't as skilled a cartoonist as Coker or Harr. So Dick was promoted as assistant to McCloskey. Dick seemed to like his job, but it quietly ate at him that he wasn't doing any art. He quit once to look for other work, but couldn't find another job that paid as well, so stayed on at Hallmark but became rather depressed. Eventually the department expanded beyond cartooning, and he was given art assignments instead of gopher duties.

When I began canoeing rivers, Dick expressed an interest in canoeing with me. So one Saturday we paddled the Big Blue River near Kansas City. The river was high and frisky, and Dick showed a gleeful enthusiasm for life that he seldom exhibited at work. As we relaxed after the white water run, Dick told me a nice fishing story.

"I took my wife Philomene to Bennett Springs State Park for opening day of trout season. The spring branch is stocked with 2 and 1/2 fish for every person who buys a trout fishing tag the day before. Your limit is 5 fish. So you can catch your own fish, and some other guy's fish if you're lucky. A whistle goes off at sunrise when it is legal to start fishing. Well, of course this being opening day the banks of the little creek were jammed. Fisherman elbow to elbow and whipping the water into a froth as soon as the whistle blew. Philomene caught a fish right away. She held it up and said "What do I do with it?" I told her, "Don't bother me. I'm busy fishing."

"I see other people catching fish, my wife caught a fish, and I haven't caught one, so I kept fishing. Well, in about half an hour the fish stopped biting, so I took a break. I asked Philomene what she did with the fish. She had put it in her purse, still hooked on the line. It was the first time she ever went fishing, and the only fish either of us caught all day. We couldn't get the fish stink out of her purse, so that was a $20 fish, not counting any expenses except the new purse."

American Greetings People

At Hallmark just about everyone in the Contemporary department when I was there was a puppy...playful and restless. At AG Hi Brows there were puppies and professionals. The puppies did funny things while the professionals did their work and got pretty annoyed by the antics of the puppies. Tom Wilson recognized the value of both types of people, and did his best to keep everyone functioning.

Perhaps the most professional was Ray Abrams. A very quiet, shy man who kept his irritations hidden. He had a variety of art skills, and Tom relied on Ray for cards that had some special attachments or features that required careful technical work. When AG licensed Ziggy, Ray became one of the best Ziggy artists. Once or twice Ray was on the verge of smacking someone who was annoying him, but Tom managed to cool Ray and tell the rest of us to knock it off. Tom valued Ray's work, and he stayed at AG for a long career.

Barbara Brown could have been a puppy, but she chose to be more professional and stay with Hi Brows and AG for a career. Barb graduated from art school in 1957 and applied for a job at AG because she heard they had recently begun a line of funny cartoon greeting cards. She had to suffer through a dull period in Art Training Class, and then was assigned to Finished Art. This was a highly technical job of preparing art for printing by tracing all of the line work and color areas in black or gray patterns, a skill that is useless now because computer scanning can do it. Barb was no good at this, and didn't want to learn how to do it. She had hired on to draw funny cartoon cards like the Box Cards and Oz Cards she saw at a corner drug store.

She was about to quit and look for other work when "Tom Wilson rescued me, and got me transferred to Hi Brows". When things got dull in the studio, we would ask Barb to cheer us up by doing her impression of Porky Pig's Loony Tunes finish, "Thbu, thbu, thbu, that's all folks!" This was accompanied by a little dance of her own creation. Outside of work Barb and her husband Dennis performed in local theater, an avocation that probably helped her stay the course when Hi Brows and AG became a stressful place to work.

Glen Imhoff was also an artist with a variety of skills who was given difficult cards to design. He left AG briefly for a tour at Rust Craft. When he came back to AG, Glen told me a disadvantage at Rust Craft that I had not imagined. I visited Boston once and drove by the Rust Craft building. It was new, and in a nice neighborhood. How much better than the crumbling old building at AG in a run down neighborhood. "Only the high executives at Rust Craft can afford

Note paper design by Barbara Brown

This passionate Persian
Princess wants to give you
a Big Kiss ! ! !

BUT YOU MUST NOT
REMOVE THE VEIL!!
(just kiss her through the veil)

(A pair of red celophane glasses were inside of the card. When you looked at the girl on the cover through them, the veil dissappeared.)

© AGC, Inc.

Dean Norman, writer
Glen Imhoff, artist

219

to live close to work," Glen told me. "Most of the employees have to be at least 45 minutes away to find affordable apartments or houses. I got tired of the long commute."

Dan Henrich began cartooning in church when he was five years old. He looked at old folks sitting in the pews around him, and saw similarities to animals. Dan's mother scolded him for drawing cartoons in church. But as she looked closely at the animal faces she saw that they really did resemble the people, and she couldn't help laughing.

So Dan pursued art and was hired at American Greetings in 1963. Dan's father had been an artist as a young man, but was told by his parents, "Artists are bums. Become a business man." So Dan's father became a business man, and Dan was never sure if his father approved of Dan as a cartoonist. One day he took his father through the Hi Brows studio, and the father said, "I would give anything to be starting over again."

Dan had more patience and perseverance than most of us. He stayed on the staff at AG for a career while most of us were in and out of the company several times. Dan once told his wife, Barbara, "Anyone who can do what he likes for a living is pretty lucky."

Teresa Satow was appreciated by Tom Wilson, because it was difficult to find women artists with a feminine and funny touch to cartooning. She was a serious person, however, and didn't feel appreciated much of the time. The noise and foolishness of the playful puppies in the department annoyed her. One time Tom came to Teresa's drawing board to talk to her about a design assignment. As he bent over her drawing board he intended to put his hand on the back of her chair. But he missed and his hand landed on the middle of her back and slid down to her butt. "I could tell she was mad as hell, and probably thought I did this deliberately," said Tom. "I was in her bad books at that time anyway. She hadn't been talking to me, so she just added on another week of silent treatment."

Pat Repp was a writer in AG Editorial for a couple of years in the 1960s. She found it difficult to write sweet humorous verse, but enjoyed occasional Hi Brows writing assignments. She remembers *MAD Magazine* writers Jack Hanrahan and Phil Hahn coming to Cleveland for brainstorming sessions. The Editorial and Hi Brows staff would take a long lunch at Maria's Restaurant. Jack and Phil would pepper them with one liner gags which George Burditt tape recorded for future reference.

Robert Crumb took a fancy to Pat (even though she was not a fat chick) and engaged her in long conversations. She remembers Crumb as always wearing a white starched shirt, and talking very seriously. Meanwhile his fellow artists would stand behind Crumb and make faces and gestures to amuse Pat. Because Crumb was not making any jokes, Pat had to fight back the impulse to laugh.

Pat said her biggest thrill at AG was when she and a partner carved a pumpkin that won a prize. "The pumpkin was flown to New York (it actually occupied a seat), and was exhibited in AG's gallery in the Pan Am building. I think we won 10 bucks, probably had to split it between us."

The professionals on the AG staff were mostly on the art side, and the writers were mostly puppies. One exception was the writer Alyce Weber. She was valued by Tom because she worked hard all day, turned in some good work every day, and what she wrote was funny and nice. The Hi Brows needed some of that to balance the funny and raunchy that the other writers enjoyed producing. The raunchy cards annoyed Alyce a bit, but what got to her more was the teasing about her writing. One

CONGRATULATIONS
TO A COUPLE OF
GREAT KIDDERS

on your
GREAT
NEW KID!

© AGC, Inc.

Jack Clements, writer Ray Abrams, artist

WHEN I HEARD YOU WERE GOING IN THE SERVICE I WANTED TO GIVE YOU SOMETHING YOU COULD USE....SOMETHING I'D WANT IF I WERE IN YOUR SHOES!!!!

© AGC, Inc.

(No words inside of card. Just a little foot blister pad.)

writer unknown Dan Henrich, artist

I don't really NEED a friend like You...

I just happen to PREFER the better things in life!

© AGC, Inc.

writer unknown Teresa Satow, artist

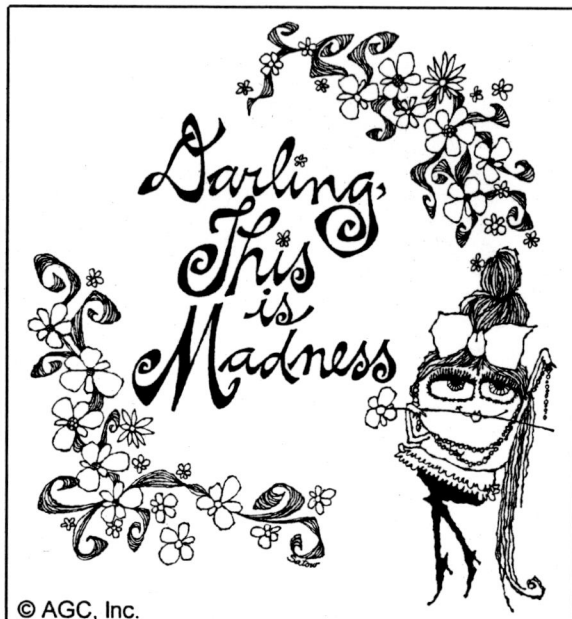

Darling, This is Madness

© AGC, Inc.

Box of Hi Brows stationery designed by Teresa Satow

Dearest, when people ask me what i see in you...

...what should i tell them?

writer unknown Teresa Satow, artist

day Tom read a card Alyce had written at a meeting, and it got a good laugh. Larry Raybourne exclaimed, "That's funny... For ALYCE!"

It was a game to put down each others' gags with faint praise, but Alyce didn't enjoy this as much as the others. "That's funny...For ALYCE!" became a catch phrase whenever she wrote a particularly funny card. It was true that she didn't often write gags that got big laughs. But mildly humorous cards often sold as well or better than big laughers. But Tom's efforts to keep both the puppies and professionals on board didn't work to keep Alyce, since she had to deal with the playful and raunchy writers every day. She decided the job was too stressful and quit.

Walter Lee was recruited from England in 1962, and designed AG cards for nearly 40 years. His impish characters with frilly details filled the "Branham" niche at AG, but Walt insisted he never copied Branham. His early inspiration was the English cartoonist Ronald Searle. Branham was probably inspired by Searle's cartoons also. Walt designed the character for *Sherman on the Mount* which appeared on many AG cards and products. *Sherman on the Mount* was also a syndicated comic strip drawn by Walt for a year.

Don Marquis was a member of the Hi Brows writing staff for a year or two, and then moved to New Orleans to become a jazz writer. He freelanced greeting card ideas for several years, and sold quite a few to one editor who believed he had written the classic humor column *Archy and Mehitable*. When Don admitted that he was not THE Don Marquis, the editor bought not so many gags.

Les Taylor worked in both in the Hallmark Contemporary studio and AG Hi Brows. Alcohol addiction troubled Les for many of his years at Hi Brows, and he says he doesn't remember many of the antics that endeared him to fellow cartoonists. He could trick the company paging announcer into paging fictitious people like Ben Dover, Ilene Dover, and Anita Hump. Les' card cartooning was fine, but he sometimes went over the line with his pranks. Bits of porno photos could appear on company bulletins and outrage readers who didn't see any humor in nasty surprises.

Life is what thou makest it
(so makest it fun!)

YUM!

© AGC, Inc.

Sherman on the Mount gift wrap design by Walter Lee

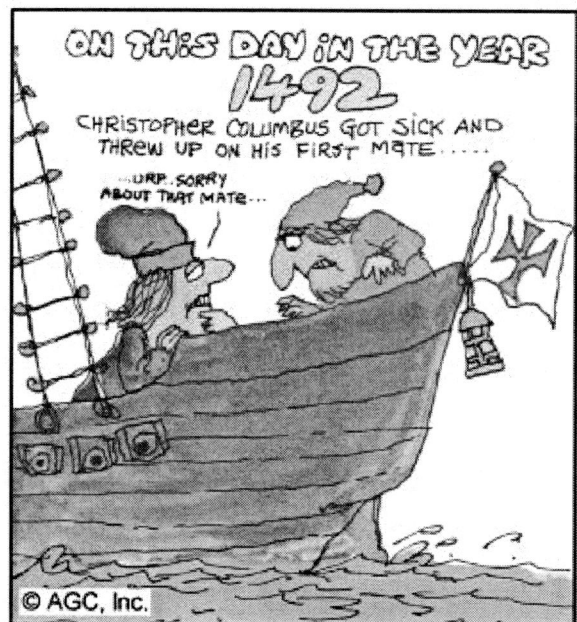

ON THIS DAY IN THE YEAR 1492

CHRISTOPHER COLUMBUS GOT SICK AND THREW UP ON HIS FIRST MATE.....

...URP. SORRY ABOUT THAT MATE...

© AGC, Inc.

Page from book titled Your Day in History
Jack Clements, writer Les Taylor, artist

Les left AG to work for Gibson and Paramount, and finally kicked the alcohol habit.

Les was nicknamed Leston of Leawood when he worked at Hallmark in the early 1960s. Don Branham would phone Les at 2:00 a.m. and say, "Leston of Leawood, you MUST come over for a drink immediately!" And sometimes Les drove into Kansas City to have a drink with Don.

"Don had wonderful nicknames for everybody," Les recalled. "He named Kipp Schuessler "Brilliance Bigdome" for his huge head. Don would come into work, toss a bunch of card designs onto McCloskey's desk, and say, "What do you think of these, Pink?"

In the late 1960s and again in the 1970s Les "Doc" Taylor worked at AG. Cartoonist Mike Ricigliano nicknamed Les "Doc" for his expertise in cutting out photos from magazines and pasting them into weird posters on a "Surgery Wall". It was one of the decorations in Hi Brows that blew the minds of visitors.

The Hi Brows staff used to listen to Don Imus in the Morning on a Cleveland radio station. This was before Don moved his show to New York. The Hi Brows gang would call the show, and tell jokes and do funny talent acts like Little Jimmer and his sound effects. They invited Don to visit Hi Brows, and when he walked in and saw the weird decorations he said, "You guys are crazier than hell!"

Part of Imus' show was to call a phone booth on the street and talk to whoever answered. Les was taking a trip to visit his wife's parents in Venezuela, and gave Imus their number to call. The parents-in-law were impressed when Les received a call from Imus, and was asked to chat on the show.

Dyan Noro and Mary Ellen Kotnick were hired at AG about the same time and worked in booths next to mine. They discussed their dates in loud conversation while drawing cards, and provided nearby artists with soap opera entertainment during the afternoons. I recall one day Dyan was

When you help start a Scout troop, there's no guarantee one of the Scouts will grow up to win an Olympic Decathlon.

A sample from Les "Doc" Taylor's Surgery Wall

Recent surgery performed by Les "Doc" Taylor

putting down the latest guy she had dated, and Mary Ellen said, "The trouble with you is, you are too picky. You'll never find anyone." Mary Ellen was wrong. Dyan married Bill Bridgeman, and when they moved to work at Rust Craft she cartooned for that company as Diana Bridgeman. When that job and marriage ended, she married John Zourelias and now cartoons as Diana Zourelias or Diana Z. When asked to contribute to this book, Diana had this to say...

"M.A. Barnes hired me in the spring of 1973, the day I graduated from Art School. My hiring was the beginning of the end of the craziness in the Hi-Brow Dept.— through no fault of my own! — signified by the departure of Bob Crumb shortly before I arrived. (Crumb had left the staff in 1967, but Diana probably referred to the few weeks in 1971 when Crumb visited and drew some ZONK designs.) Hi-Brow up to this point was a male dominated creative world, which was changing due to the popularity of Tom Wilson's Ziggy. I was hired to create a new cute female character called "Stubby".

I don't know what I ever did to deserve a Friend like You *

* but it must have been something Right!! © AGC, Inc.

Hi Brows Funny Book written by John Gibbons and illustrated by Dyan Noro

"The cartoonists and writers at this time were the best, and American Greetings treated them as such. It was a big creative playground with jokes and laughter eight hours a day and five days a week. I can honestly say that they were the funniest and most talented people I have ever worked with, and they taught me more in four short years than any job or art school could or did. There were cartoonists who did abstract or fine art during their lunch breaks. Writers who had written for comedians, jokes that were funnier than anything on TV. I am truly a better artist/ cartoonist for having worked in Hi-Brow, and still count people I met there as some of my closest friends."

Diana, who was Dyan Noro at AG, created Stubby as a caricature of herself— short, cute and smart-mouthed. Dyan's nickname at Hi Brows was "Stubby Gams" or just "Stubbs". Unfortunately the gags written for the character were not as funny as Dyan, so Stubby did not go very far as a licensed character for AG. In 1999 as

Granny Moments
by Diana

Diana Zourelias she created *Granny's Garden* for americangreetings.com website. This time Diana wrote the gags as well as drawing the cartoons, and she told me "I never realized how tough you writers have it! It was hard!" AG has since stopped using any cartoon features on their website, so Diana may begin drawing Granny for other venues. Her principal work now is illustrating books and magazines with good examples on her website *www.geocities.com/dzignsbydiana.*

Bill Bridgeman was a disciple of Dick Noel who wrote and drew outlandish cards for Hallmark. Bill left Hallmark and was hired at AG in 1973. He drew some of the funniest Hi Brows cards. His get well book titled *Great Moments in Medicine* is a classic of whimsical humor. For example, one great moment was the invention of the first pill. A cave man is shinnying up a palm tree and throwing a big pill at a germ who is coming up the tree after him. The explanation was, "Pills were much larger in those days, because germs were much larger." The cave man was shouting "Eat pill, germ!"

GREAT MOMENTS IN MEDICINE

IN TWO SECONDS, YOU WON'T FEEL A THING!

MY ARM HURTS, DOC.

FIRST ANESTHETIC ADMINISTERED

© AGC, Inc. Bill Bridgeman, writer/artist

Bill became Hi Brows Editor in 1975, and the next year quit AG and became Editorial Director at Rust Craft. I don't know if he did as much writing and art while he was at Rust Craft, but since moving back to Hallmark about 1980 Bill has drawn some very funny books and cards for that company. He is one of the few creators from the studio card era who is still working in greeting cards, now doing good stuff for what is called alternative humor. Bill Bridgeman's humor was always alternative ...different and original from anyone else. You can find some of his books selling as collectibles on Internet used book sites and perhaps on eBay.

David Helton came to AG from art school in 1973, but spent a year in Humorous Designing and Planning before being transferred to Hi Brows. He described his joy at this move by writing: "There was crazy stuff all over the walls, unlike the rest of AG. They got an hour and a half for lunch, unlike the rest of AG. They got to submit ideas, unlike the rest of AG. So the loose creative feeling there was new to me and I LOVED it! I knew I was in a unique place and tried to make the most of it.

"The boss would encourage brainstorming, and for us to be stimulated in some creative way. Once Ralph Shaffer thought it would be great to take all the guys to the porno movie house in downtown Cleveland, the Roxy. We went at lunchtime and thought it was so cool our boss would do this. Suddenly the film goes off, the lights come on—Cleveland police raided the place! We thought we were going to jail, but they sent us on our way. As we exited the manager handed us free passes for the next day!"

Dave was in Hi Brows for two years when he created the buzzard logo for

HEY! WOULD YOU LIKE A BEAUTIFUL WINDBREAKER FOR YOUR BIRTHDAY?

OK, JUST INVITE ME TO YOUR BIRTHDAY PARTY, AND SERVE ME A BIG BOWL OF CHILI!

HA!
HA!
HA!

HAPPY BIRTHDAY!!

writer unknown David Helton, artist

Cleveland's rock music station WMMS. He left AG and made a living designing promotion for the station until 1988 when he moved back to his hometown, Chattanooga, Tennessee. Today he does various freelance cartooning, especially for children's magazines including *Ranger Rick, Highlights for Children, Children's Digest.*

Two AG writers, The Wiley kids, Clark and sister Myra, were incorrigible punsters. Both of them wrote many pun jokes for Hi Brows, and Myra was an all-arounder who could write anything...funny or sweet. She wrote a lot of the Soft Touch photo card lines. But eventually Myra specialized in funny, and went to Hallmark to write Shoebox cards.

During a year when I was on freelance contract and living in Salmon, Idaho, Clark spent his vacation canoeing and backpacking in the mountains with me. We planned more adventures in the wilds, but one summer Clark had a bad cold he couldn't shake off. Finally he went to a hospital for complete tests, found out he was riddled with cancer and died in a few days. He had been exposed to agent orange when in Vietnam as an army photographer, and we wondered if maybe that had cut his life short.

Tom McGreevey was Hi Brows editor for a short time, and then on freelance writing contract with a partner called Auntie Lynn. McGreevey and Lynn Gibson called their partnership "Razzlefratz". McGreevey kept in touch with Tom Wilson through the years, and was available in 1982 when some voices were needed for the Emmy award winning animated TV cartoon, *Ziggy's Gift.* McGreevey was the voice of an Irish policeman who arrested Ziggy for freeing a bunch of Christmas turkeys from a turkey truck.

Greg Nelson was a tall, quiet redheaded guy who cartooned for Hi Brows with a beautiful sweeping brush stroke. The best sample of his work I could find was a personal Christmas card he sent to Diana Zourelias.

John and Mary Ann Kuchera worked at AG in the 1950s, and went to a company masquerade ball as outhouses. Each wore a large cardboard box with a door and a half moon cut. When they were standing, their legs stuck out of the bottom of the boxes. But when they went to opposite sides of the room and sat on chairs, they looked like real outhouses. John said women would open the door and sit on his lap before they realized he was inside of the box.

John invented some unique cards. The Kuchera Fold was a card that opened three times, becoming wider each time. As you unfolded the card a ball bounced across the page and entered Joe's Bar. After he left AG John published some unique slider cards where a character would move across a page to a surprise conclusion.

A freelance photographer, Anita Schuessler, sent in some out of focus photos with sweet prose lines. Anita was the wife of

So, let me get this straight, for Christmas you want 4 calling birds, 3 French hens, 2 turtle doves and 1 partrige?..

HAPPY HOLIDAYS !

Greg Nelson's Christmas card

FOR SOME REAL BIRTHDAY FUN JUST FOLLOW THE BOUNCING BALL

"The Kuchera Fold" invented by John Kuchera was used on several designs drawn by various artists. As the card was unfolded from left to right it produced an animation effect in which a character or object moved across the page. It was a challenge to a writer to think of a gag that used this visual effect.

JOE'S BEER BAR

WELCOME

John Kuchera, writer/artist

John Kuchera wrote and drew a series of cards called "Sliders" for his own company, Joy&Cheer. The card shown below had a tab on the right side. When you pulled on the tab the sheep moved toward the lion, and the words "peace, friend." were revealed.

peace, friend

© Joy & Cheer John Kuchera, writer/artist

Hallmark artist Kipp Schuessler. Her photo promotion was rejected at Hallmark, but coincidentally Tom Wilson had been developing a similar project for AG. Some of Anita's photos were purchased and used when AG's Soft Touch card line was launched. Larry Raybourne, the far out gag writer, came up with the name "Soft Touch". Hallmark then scrambled to play catch up and do a similar line of photo cards. It was then that Hi Brows expanded rapidly to include Soft Touch and part of the Humorous card line. Tom Wilson was promoted to Vice-president, M.A. Barnes become Hi Brows Director, and Ralph Shaffer became Soft Touch Director. In a few years the Hi Brows-Soft Touch department expanded rapidly, and became a confused and stressful environment. M.A. Barnes left AG, and Tom came back as Hi Brows Director for a year. Then a reorganization sent Hi Brows writers into the Editorial department, the artists into a smaller separate department, while Tom and Ralph became co-directors of AG's new licensing company called Those Characters From Cleveland.

Oliver Christianson came to AG in the 1980s after the Hi Brows writing and art departments had been split. He was good at writing and cartooning, and they shuffled him between departments, but mostly made him do one or the other...write or draw. Oliver would fill a panel every day with twenty or more ideas and sketches that were good enough to be finished art. He would have been a great asset when AG finally got into alternative cards in 1987, but by then he was at Hallmark. Oliver signs his cards backwards, Revilo, which sort of stands for the way he looks at the world in his humor. Oliver was still at AG when I married Maureen Farrell in 1983, and he drew a congratulations card for me. It was passed around for everyone in the department to sign, but some people didn't want to sign it because they thought it was too weird and maybe insulting. I saw it as good nonsense, and treasured the opportunity to have an original Revilo cartoon.

Shortly before I retired, two new writer/artists joined AG, Debbie Tomasi and Scott Mendenhall. The company didn't repeat the mistake they made with Oliver. Debbie and Scott wrote and drew complete cards for the new alternative card lines.

In 1979 Carl Goeller was head of Editorial at AG, and he made a trip to California to interview some prospective writers. Three were hired who came to Cleveland and wrote both Humorous and Hi Brows cards for many years. I haven't written much about AG in the 1980s, so perhaps the recollections of Dave Schecter will help fill the void.

A LETTER FROM DAVE

Yes, it was Caryl, Mark and I who were hired by Carl. Carl asked me during the interview what one thing was important in the job to me, and I told him I didn't want anyone telling me how to dress. He agreed, and that's why when it was 97 degrees in Cleveland, I was the only one wearing shorts. Boy, that sure made everyone who was sweating really jealous.

I believe Caryl was the #1 choice, I was #2, and Mark #3. There was another girl who was number three—really sweet—but when she saw how disgusting the building was she went back home to mother and Mark ended up with the third spot.

Too bad you don't cover the early 80s. You could talk about how Carl gave Jane What's-her-name (short, redheaded woman with squeaky voice) her pink slip on the day before Christmas vacation. I went into his office and really laid it on him—amazing considering I had only been working there for a very short spell.

I can still hear you laughing when you'd be up on the writer's board reading what other people had written. Then I realized you were re-reading your OWN cards!

After a few years on staff Dave moved back to Los Angeles, and was a freelance contract writer for AG for many years. Today Dave and his wife, Kathy, operate Monstrous Movie Music (*www.mmmrecordings.com*).

AT LAST...

...a punishment to fit the crime.

Oliver Christianson, writer/artist

From Greeting Cards to TV

A pair of writers who got their start in greeting cards did well in writing TV comedy. Jack Hanrahan, who I have mentioned a couple of times, was on staff a short time at AG, then quit and knocked around various places. In the early 1960s he bought a greeting card company named Country Cousins in Lake Placid, New York. Jack's brother Tom Hanrahan moved from Cleveland to Lake Placid to be a partner in Country Cousins cards. Jack and Tom wrote and drew all the cards. The card company and print shop didn't earn enough income to support two large families, so the brothers had a variety of other projects going at the same time including a milk route and a bar. Someone asked them how they could do so many things at once, and Tom replied, "It's like carrying two tons of canaries in a one ton truck. You have to keep half of them flying at all times."

Jack met former Hallmark writer Phil Hahn when Phil was Editor at Rust Craft, and Phil bought some freelance writing from Jack. They kept in touch and began writing comedy projects together including some bits for *MAD Magazine*. Jack would travel to New York City to meet Phil regularly. Phil thought he might like to do stand up comedy, so Jack invited Phil Hahn to try a comedy act at the Hanrahan brothers'

Phil Hahn, Emmy winning comedy writer on the 1968 TV show, *Laugh-In*

Jack Hanrahan, creator of The Flying Fickle Finger of Fate for *Laugh-In*.

bar in Lake Placid. Phil was extremely nervous, but his act went over great. So he came back in a few weeks and did it again, but this time got very few laughs with the same proven material. Phil performed his act on two or three succeeding nights and was picking up more laughs and getting more relaxed. As he relaxed on the stage he began looking at the audience and recognizing people. Phil realized this was not a club, but a neighborhood bar. He was telling the same jokes to the same people every night. He was so mortified he never tried stand up comedy again.

Jack and Phil's partnership hit pay dirt when they moved to Los Angeles. They got a trial assignment from Hanna Barberra for a Saturday morning TV cartoon, and quickly turned in a script. Then they waited for an answer. Jack decided to take a chance and move his large family, wife and six kids, from Lake Placid. Jack was broke and traveling across the country in a station wagon using his credit cards for food, gas and motels. Every night he called Phil to ask how it was going. Jack was in Kansas when Phil could tell him, "They liked it. We're on their staff for $350 a week...each!" Soon after that they got a chance to write some scripts for a hit TV comedy series *Get Smart,* and then joined *Rowan & Martin's Laugh-In* show when it began in early 1968. They got Emmys for "Outstanding Writing—Comedy or Variety." The next year they were Head Writers on the *Laugh-In* show, and followed successful careers in TV writing in subsequent years. Phil became a writer and producer on variety shows including *The Sonny and Cher Show* and *The Osmond Family.* Jack wrote for *Jackie Gleason, Andy Williams, Sonny and Cher, Bobby Darin* and a lot of TV animation shows. He also acted in plays and did voices for animation.

Jack was the guy who made Cleveland, Ohio the butt of TV comedy. *Laugh-In* aired some dumb Polish jokes, and was getting criticized for negative ethnic humor. So the producers wanted to make fun of a city instead of an ethnic group. Not a

Jack Hanrahan, writer/artist

mythical small town like Podunk, but a real city of moderate size. There was a brain storming session just to pick the name of a city. It descended into one of those moods where if somebody doesn't like your idea, then you don't like his, and soon nobody likes anybody or any ideas. A sullen silence. Then Jack suggested Pittsburgh or Ashtabula, and another writer put him down by saying, "Don't pay any attention to Hanrahan. He's from CLEVELAND." This got a laugh from everyone in the room, and they had their city to poke fun at. Every week they did a different joke knocking Cleveland, and at first these were standard dumb jokes with Cleveland just penciled in. But then things started happening in Cleveland that deserved a put down, and the jokes became topical. "Attention Cleveland: Your lake just died." When the extent of pollution in Lake Erie was reported. "Attention Cleveland: Your River is on Fire!" When the heavily polluted Cuyahoga river did catch on fire in Cleveland. Jack created The Flying Fickle Finger of Fate Award for *Laugh-In*, and saw it awarded often to his hometown.

Hanrahan really did grow up in Cleveland, and the people I know here liked the Cleveland jokes. When the jokes were negative, well, the city deserved it, and something should be done about a dying lake and a river that burns. It only irritated civic boosters who would rather gloss over negative things and make all publicity positive. Like when Cleveland envied New York City's nickname, "The Big Apple". They tried to make people say "Cleveland is a Plum", and printed posters and bumper stickers, but it didn't catch on.

I visited Jack in the summer of 2003 about a week after the blackout in eastern U.S. and Canada. The news said that a power company near Cleveland might have caused the blackout with a faulty switch. Jack grinned and said, "We can award the Flying Fickle Finger of Fate to Cleveland again. Attention Cleveland: Take the penny out of the fuse box!"

Now in semi-retirement in Eureka, California, Jack continues to create new TV projects and write newspaper columns. One of his best was a column published in the Humbolt County Times-Standard in which Jack tells how The Flying Fickle Finger of Fate propelled him into a career as a comedy writer. After graduating from John Carroll University, Jack had a few PR writing jobs, then was drafted into the Army shortly after starting work with the Post Office. Two years later Jack returned to the Post Office, and...

HOW I BECAME A COMEDY WRITER by Jack Hanrahan

So with Army boots akimbo, and bundled to the max for the bitter Cleveland winter, I showed up for my first day. My job was to fill in for regular postmen's days off. I had to learn a new route every day. I had cut the tips off my gloves to better hold the large packs of mail. Didn't help. My hands were blue with frost within minutes. Moreover I was stalked by a cat who insisted on wriggling about between my ankles as I trod the narrow path in the rising drifts of snow.

The cat finally won and tripped me. In slow motion I flew in the air and landed face down. I thought I was bleeding all over my numb face. I was wrong. This was the era of the fountain pen and all the mail seemed to have landed face down and the ink — red, green, blue and black — was trickling down the snow drift from all the soggy mail about me. My new friend licked my face as I groped in the drift for the incomprehensibly soggy mail.

I did the only thing I could. I found myself in front of a mail drop and I stuffed the soggy mess into the drop box for the regular mailman to recycle the next day (very unpostmanlike conduct). By now "Tabby" was working on my bootlace with a fervor. Call it temporary insanity,

call it desperation, call it early postal syndrome... I grabbed my new tabby friend and mailed him, too. Into the box he dropped with a surprised "Wrrrrrror!"

I continued my rounds and somehow got back to the post office to recycle the few letters left in my bag. Ten minutes later another postman came into the post office roaring mad with Band-Aids all over his face. "You'll never believe what some idiot did", he exclaimed as he dumped a bag of what looked like blurred confetti. Everyone laughed except the postman with the Band-Aids.

"What happened to the cat?" someone yelled. He took off apparently no worse for the adventure, his remaining eight lives intact. That evening I found an ad in the newspaper for gag writers and cartoonists at American Greetings. At last I was back where I belonged and the post office was rid of a large liability.

Well, I have written these little bits about a lot of writers and artists, because it may be the only recognition many of them get for their contribution to funny greeting cards. But there were many more people at Hallmark, American Greetings and other card companies that I know little or nothing about. When the Hi Brows writers and artists were split into separate departments in 1978, I had little contact with new cartoonists. So a complete account of the people who wrote and drew funny cards when studio cards were being created is something I can't write. The greeting card industry has done very little to give credit to their talent. While collecting cards for this book, I found the companies' records almost useless. I had to rely on the memories of artists and writers as to who wrote and drew specific cards.

John Gibbons was chatting with someone in a bar one evening, and was asked what he did for a living. "I write greeting cards," John said.

"You're putting me on," the guy laughed. "Nobody writes greeting cards. Greeting cards are just art work."

"Lots of people write greeting cards," John insisted. "How do you think the words get onto the cards?"

"I figure the artist puts those on while he's drawing the picture."

"Noooo," John informed him. "A writer writes the words, and if it is a funny card the writer usually tells the artist what kind of character to draw, the expression on the character's face, and what the scene should be."

When John moved to Los Angeles and was trying to break into TV writing, if he told people he was a greeting card writer it didn't get him much respect. So John would be at a party and Hollywood folks would start telling each other what they did. When they got to John he would put on a smiling but stern face and say, "I am a nuclear submarine commander."

The anonymity of greeting card writing has both advantages and disadvantages. Marv Honig had been on the AG staff for less than a year when he applied for a job at an advertising agency. Marv approached John Gibbons and said, "John, I've picked out a few published samples of some great cards you wrote. Do you mind if I show them as samples of my writing at my job interview, because none of my card gags are published yet?" John said OK, and Marv got the job.

George Burditt and Tom Wilson told me that Hoohah Studio did more to help Hi Brows grow than we were ever told. Irving didn't want us to ask for big raises. We had been on contract a short while when the AG printers made a mistake. They printed 20,000 copies of a batch of Hi Brows instead of 10,000. Should the company throw away the extra cards, or just keep them on the racks until they sold? Well,

Irving never wanted to throw things away. "Ask those Hoohah people to lay off for about six months, because we really don't need any new cards for that long."

"Oh, no, Irving," Tom said. "They've got families, and they don't have other income to make up for our contracts with them. They will have to get jobs, and probably with other card companies. Someday we might want to expand our line, and we won't be able to get them back. Let's just put their stuff in a file, it will give us a cushion for expansion, and keep them working for us."

Irving agreed and Tom's prediction was right. "Your stuff really helped us then," Tom told me much later. "We were able to increase our number of new cards quickly, and they were all great gags. We got a lot of new accounts."

One of the best selling Hoohah cards read on the cover, "SEX!"...and then inside it said, "Now that I have your undivided attention, I just want to wish you a happy birthday!" George Burditt and Tom Wilson once went into a downtown Cleveland card shop to see how the new cards were selling. They entered during lunch hour and the shop was crowded. The lady who owned the shop recognized Tom and George, and she shouted from the far end of the room, "Am I glad to see you guys. I need more SEX!"

What she meant was the popular card had sold out, and she wanted more of them. Everyone stared at George as he shoved through the crowd to help the lady get more SEX, and Tom had to go outside to have his laugh.

The "SEX!" card was redesigned by John Kuchera as an invitation to buyers to see the AG card line during the 1961 Stationery Show in New York City.

SEX

NOW THAT WE HAVE YOUR UNDIVIDED ATTENTION...

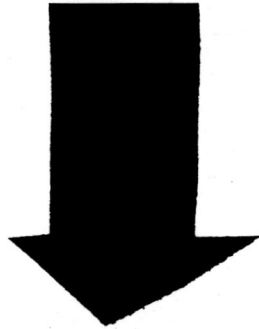

American Greetings

cordially invites you to attend the New York Stationery Show May 14-19, 1961, and visit suites 1118, 1119 and 1120 at The Hotel New Yorker.

WHERE THE BIG

WILL BE ON DISPLAY.

When Diana Bridgeman was Rust Craft Studio Art Director, she asked her freelance artists to draw the weirdest characters they had ever seen. Rust Craft had acquired Barker Cards, and these were artists designing Barker studio cards in 1979.

Len Caron

the monster in the bathroom every morning!

David Helton

JOHN GIBBONS AFTER HIS RECENT VISIT TO NORTH HOLLYWOOD BARBER COLLEGE

239

THE STRANGEST person i have seen by greg nelsoN.
Feb. 15, 1978. Location. West 68th and Lorain Ave.
Cleveland, Ohio. Male cocashion of Hungarian decent.
i made fun of him. i,m sorry but i dislike him much.
Hungarians will sell thier mothers for 2,100$
He was wearing a bright Day-Glo orange winter cap.
Sorry, no photo available. Dyan, please fill in
the orange Day-Glo cap. Hemight be from another planet
or from the humorous planning department at
American Greetings.

Greg Nelson

Jim Carson

Jeff Meyers

OFFICIAL CINCINNATI ARTIST

the Weirdest PersoN I have
ever seen is the Little son of
EMILY AND NATHAN PILCHERD.
DECIDEDLY "WOLFISH" iN NATURE,
LiTtle RODNEY's Favorite SPORT
IS RUNNING Through the PARK
ON ALL FOURS AFteR MIDNIght
OR Howling at the Full moon
Through aN open Rumpus Room
window after supper...

Ray Medici

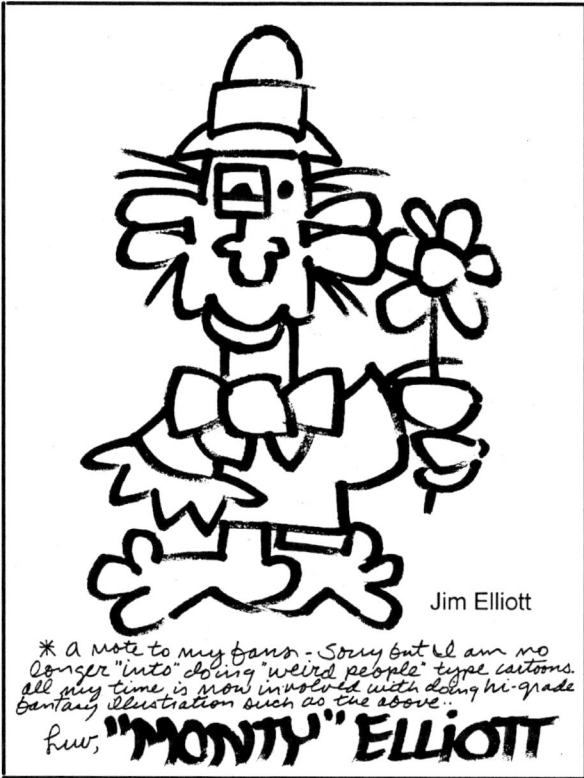

Jim Elliott

*a note to my fans - Sorry but I am no longer "into" doing "weird people" type cartoons. All my time is now involved with doing hi-grade fantasy illustration such as the above..
luv, "MONTY" ELLIOTT

Mark Spangler

Bill Seibert

Many artists who worked for Rust Craft and Barker also worked for AG, Gibson and Paramount during their studio card days. In the 1980s Rust Craft went out of business, and their designs went to Norcross. When Norcross failed, the designs were sold piecemeal to many buyers, and Diana Zourelias has occasionally seen them on various card racks.

AG bought Gibson in 2001 and acquired Gibson's designs, but a search of files for the 1960s could not find any studio card designs. So three of the big five card companies who were major studio card publishers no longer exist, and the cards they published are not available in any well organized files.

Chapter 39: The Last Laugh

Bette and I moved to Cleveland in 1966 hoping that her multiple sclerosis would stabilize, and we could keep our family together. But it didn't work out that way. She kept getting worse. We hired home care, then she was in a nursing home, and Bette spent the last thirteen years of her life being cared for at her parents' home in Bloomfield, Iowa.

I left the Hi Brows staff during this bad time, and moved to Los Angeles to try for big money in show biz. From 1969 to 1970 I wrote scripts and sketched storyboards for animated cartoons at Filmation Associates (*The Archie Comedy Hour*) and DePatie-Freleng Enterprises. Then the networks lost some prime time broadcasting, decided to cut a lot of Saturday morning TV cartoons and I was unemployed. By summer of 1971 my kids were living with Uncle Russell and Aunt Dorothy on an Iowa farm, and I was living with two dogs in my van in the mountains near Kernville, California. Every two weeks I would drive to Los Angeles with some comic book stories (the pay was $11.00 a page), collect an unemployment check, and talk with Walter Bien who was trying to sell an action adventure drama series about the Lewis and Clark Expedition to TV. I wrote outlines, treatments, summaries, pilot scripts, etc., and each week Walter assured me that one more meeting and he would get some development money, and I could live in a house again. But it hadn't happened when school started in September, so I asked AG to hire me back on the Hi Brows staff again. They did and my kids and I were back in Cleveland.

I stayed with AG till 1990, sometimes on staff, sometimes on freelance contract, and there were happy times and not so happy times. The Hi Brows line went into decline just as I came back to Cleveland. Tom Wilson had started drawing Ziggy for newspapers, and was promoted to Vice President at AG. Ralph Shaffer was promoted to director of the new Soft Touch card line. So the team that had managed Hi Brows during its best years was broken up.

It would be too easy to say that Hallmark Contemporary cards started going downhill when they fired Alan and Rosie, and Hi Brows skidded when Tom and Ralph left the department. In both companies there were corporate pressures that would have overcome anyone's efforts to keep a good thing going. One of my favorite philosophers, James Thurber, described this sort of inevitability when he wrote, "The long claw of the sea puss gets us all in the end."

In the 1950s no one was quite sure what a good studio card should be. It was a period of experiment by trial and error. But after a while the editors tried to eliminate the errors and produce only best selling cards by repeating best selling cards. At one time in the 1970s the Hi Brows line was 80% reprints of old card gags, and the 20% that was new had to be written and drawn to formulas that had been divined by studying old best sellers. They developed a computer program that would compare new ideas to old best sellers, and predict the success of the new idea depending on how many words were the same.

In the early days of Hi Brows a particularly timely joke would be rushed into production so it could go from writing to the store in two weeks. A very simple best seller was a cartoon of a hound dog on a card that said, "You ain't nuthin' but a hound dog!" Not a great gag, but when Elvis Presley's song by the same name was playing on the radio every day, a lot of people bought the card and sent it to a friend.

When Fidel Castro changed from friend to enemy in 1960, Hoohah wrote a card saying, "Here's a cheap and easy way to get stoned on your birthday. Stand on a

street corner and shout "Hooray for Castro!" AG rushed the card into production, but Irving was afraid that Castro might be overthrown in a few weeks, so the name to shout was changed to Khrushchev.

As the company grew it became more difficult to rush anything into production and get a card on sale in a few weeks. So "timely" jokes were planned ahead of time. When Comet Kohoutek was predicted to be a dazzling fireworks display in the skies, I wrote and drew a bunch of Comet Kohoutek cards. Kohoutek fizzled, and so did the cards.

The last attempt at timely humor I recall was when the premier of China was coming to visit the U.S. We tried to write jokes about this that would not offend China and start a war. But it was difficult to be both funny and polite when you were dealing with a guy whose name, Deng, was pronounced "Dung" on the network news. Walter Cronkite could say it without cracking a smile on camera, but we could not say it without snickering. We wrote a bunch of "rhymes with dung" cards, but I don't believe any of them were printed. So attempts at timely humor were dropped, and old best sellers were redesigned and reprinted many times.

A friend of Hi Brows artist Dan Henrich said, "Why don't you guys make new cards anymore?"

"We do," Dan said, "We write and draw new cards all the time."

"No, you don't. Every time I look at the Hi Brows cards I see old gags I've seen before. Nobody looks at them anymore." It was true. The lunch time crowds that used to gather around the racks to read cards for entertainment were gone. Card shopping wasn't fun anymore. People only bought a card when they had an obligation.

The failure to produce new stuff at Hallmark and AG was not due to lack of talent. Both companies kept most of the talent that had made their lines great, and we weren't burned out. We were bummed out because anything we created that was new and different was stuffed in the files. And both companies constantly found new talent as good or better than us pioneers who had blazed the trail. Their best stuff was stuffed, too.

One young woman worked at AG as an editor for a while and was surprised to hear someone say there were writers working at AG, too. "Of course we have writers. Where do you think the ideas for new cards come from?" she was asked.

"From the files," she answered.

"How do you think the ideas got into the files?"

"They have always been there, haven't they?"

The lowest point at Hi Brows was when AG was caught spying. Someone went to Kansas City and bribed Hallmark employees to show what Hallmark projects were in the works. The Hallmarkers told their bosses, and some fake art work was produced and sold to the AG spy. This fake art work was shown to us in Hi Brows, and we were told to create something similar. It was awful stuff, and we tried to improve it by suggesting changes. But the answer was, "It has already been decided that THIS is what we are going to do. We just want you to make some little improvements, but no major changes."

In the good years Hi Brows had created many new projects, and almost all of them were good sellers. Hi Brows Funny Books. Small hard cover books with comic stories and card messages that sold for $1.25. The name was changed to Sunbeam Library and they sold well for many years. For a while AG was the largest book publisher in terms of numbers of new titles and total sales.

Fuzzy Friends. Huge cards in the shapes of animals with furry flocking that sold for $1.00. Barbara Brown suggested a little slogan on the back that read, "When you care enough to send the furry beast." We thought that was a neat parody of the Hallmark slogan, "When you care enough to send the very best." But the legal department was afraid of being sued. Anyway, Fuzzy Friends were good sellers, and other companies copied the idea.

We had created these projects without stimulation from outside sources. Now we were being told to just add some cute sayings to very bad projects that came from...who knows where? We found out when a news story said Hallmark had a letter and some checks identifying AG as the company behind the spying and bribery. AG pleaded *nolo contendre* in court. They just wanted to pay the fine, and avoid any more bad publicity.

Both the Hallmark and the AG studio lines were so heavily into repeating old jokes and old themes that it seemed like all the fun was out of greeting cards forever. Then like deja vu all over again, some small companies began taking away bits of market share by printing good new funny cards. Recycled Paper Products hired Sandra Boynton, and her whimsical humorous cards were an instant hit. The company hired Barbara and Jim Dale and other writer/artists, and in a few years grew to be the fourth largest greeting card company behind the big three...Hallmark, AG and Gibson. Just how stale the Hallmark and AG cards had become was shown in a test in a store that stocked Hallmark Contemporary cards, AG Hi Brows and RPP alternative cards. 80% of the sales were RPP cards.

I had lost touch with people at Hallmark in the 1970s so I don't know any details of how they reacted to the sudden growth of RPP cards and Sandra Boynton's cartoons. But at AG every editor, sales person, research person, etc. who went card shopping brought back a batch of Boynton cards and asked us writers and artists to "do something like this". We did, but AG wouldn't print it. We pointed out that many of the Boynton cards were so strangely unique that AG would not have printed them if she had worked for the company. They didn't fit into the mold of our old best selling Hi Brows gags. And AG split up Hi Brows writing and art into separate departments. If they had hired Sandra she could have been a writer, but they wouldn't have printed her cartoons. Or she could have been an artist, but they wouldn't have let her have time to write gags.

We did our best to create cards that would compete with Boynton, but we wouldn't copy her art or rewrite her ideas. We tried to follow the directions she had taken, many of which were directions we had tried to take before, but the stuff was stuffed in the files. The lower level managers didn't take our outspoken gripes about the company up to Irving. It would only make him mad. They praised our efforts, and tried to get Irving to print the new cards, but he wouldn't. Irving had lost confidence in his own gut reaction. He no longer approved cards just because they made him laugh. He insisted every new card should be just like an old best seller, only slightly different. He also became very impatient and changed his mind a lot. One day he told a department manager to cancel an entire line of new cards and do something better right away. "But Irving," the manager said. "Yesterday you saw this line and said you loved it."

"Things change so fast in this business," Irving snapped, "I can't be reminded of what I said yesterday." Irving wasn't such a fun guy to work for anymore.

Then in 1987 there was some slack time in both writing and art departments, and the editors put together a secret team to work on a secret project. I was

delighted to be part of this team, because I would both write and draw finished art on my cards again. Joan Kerber was another AG writer/artist who got one of her few chances to do finished art at AG. Joan had written and drawn some nice cartoon stories for the Cleveland Plain Dealer magazine. We were told to work closely together as the old Hi Brows studio had worked, so there wouldn't be any disconnect between writing and art. Jack Reilly was the chief artist on this project.

Jack had joined Hi Brows in 1975 shortly before the department's writers and artists had been divided. The only drawing board available for Jack had water dripping on it from a leak in the roof. Being new on the job he didn't want to make an immediate complaint, so he worked around the water for a couple of weeks before asking the Art Director to do something about it.

The drawing board had been mine just before Jack, and I had complained about the leak for several weeks. The water dripped every day even when no rain fell. There was a huge water tank on the roof to be used in case of fire, and this tank was leaking. The company decided it would cost too much to patch the leak, and we were going to move into a new building in a few years, so the artists could just put up with it till then. The leak was especially annoying in the freeze and thaw weather of springtime. During the night huge icicles formed on the side of the tank. The morning sun thawed them, and chunks of ice fell on the roof. One chunk knocked plaster off the ceiling above my drawing board. I was afraid the next big ice chunk might come through the roof and clobber me, and that was when they moved me to another place.

Jack sat under the leak after the danger of falling ice had passed, but he still found it difficult to concentrate on his art while mopping up a constant trickle. After a while they managed to find Jack another drawing board, and he stuck with the company rain or shine through many changes. The secret project enabled him to write as well as draw cards. He always had both talents, but when Hi Brows was split into separate writing and art departments, he was discouraged from spending time on ideas.

After several weeks the team had a big batch of funny cards, all new ideas and all new cartoon styles. Each artist did his own thing and was not told to copy anything. At one time the pressure to copy had been so bad that artists were given a Hallmark card with each assignment, and told to copy the art with just enough changes to avoid being sued for copyright infringement. We all loved Boynton's work, but we thought our own styles of writing and cartooning were pretty good, too, so we didn't come close to stealing her stuff.

And there were other good cartoonists at RPP by this time. Barbara and Jim Dale did very funny cards that ranged from innocent to risqué. A former Hallmark employee told Barbara Dale that a Hallmark research project decided that Dale cards were on the cutting edge of what was acceptable to a mass market audience. Barbara laughed and said, "One step further, and I guess I would have fallen over the edge!" A company called Blue Mountain Arts was producing sentimental conventional cards with unique art and writing by a husband and wife team in Colorado. But they didn't try to be funny, so we weren't following their direction in our secret project.

The plan was to wait until Irving was in a good mood, then take the project directly to him, bypassing all the intermediate level editors and managers. The departments of Planning, Research, Sales, Hassling, etc. were kept out of the project. We were weary of them telling us what to write before we wrote it, or what to draw

before we drew it, or what would sell before it was sold. Well, Planning department did sneak one girl into our secret room. But she was cheerful and cute, so we were nice to her and ignored her suggestions.

"When will Irving be in a good mood," we asked.

"We don't know," we were told. "It could be today, tomorrow or never. We'll let you know when it happens."

So it looked like another bunch of great stuff to be stuffed, when suddenly the dam broke. Hallmark came out with 500 new card designs labeled Shoebox, and Irving said, "I want 500 new designs just like Shoebox right now!"

"Gee, Irving. What a coincidence. We just happen to have them ready right now!" Well, no one said that to him, and we didn't have 500 new cards ready. But we went into overdrive and overtime doing finished art on about 125 new cards we had written and sketched. In a few days there were news stories that Blue Mountain Arts was suing Hallmark for ripping off their cards. And the rest of the Shoebox line so obviously copied other small company cards that other lawsuits might follow. They ripped off Sandra Boynton's art style with one artist signing his name "Bowers" in a script that looked just the way Sandra Boynton signed her cards. So a customer might think Boynton was now working for Hallmark. Blue Mountain Arts won millions in settlements from Hallmark, and the big company had to destroy a lot of cards. It was sad that Hallmark had introduced a new line of cards with lots of publicity and deliberately copied material from small companies. When Hallmark had been the first major card company to print studio cards in 1956, their new line of only 12 designs was completely original and snuck into card shops with no publicity at all.

Irving might have initially wanted us to copy Sandra and other small company artists, but when he heard about Hallmark being sued, he said, "Don't copy anybody. Don't get us sued." We cartoonists took this a bit cynically, and when I was given some finished art assignments and told to draw only simple line work, little or no color, I said, "Ah! I see! You want me to copy the Dale's cards. Yes, I can do that. Dale draws simple line art, either Jim or Barbara, I don't know which one writes and which one draws. And I draw simple line art. They sign their cards "Dale" and I sign my cartoons "Dean". See, I can sign my name in the same style of lettering, and with only one little letter different. People will think they are buying a Dale card when they buy a Dean card. Nobody knows who I am, but they know that Dale is good!"

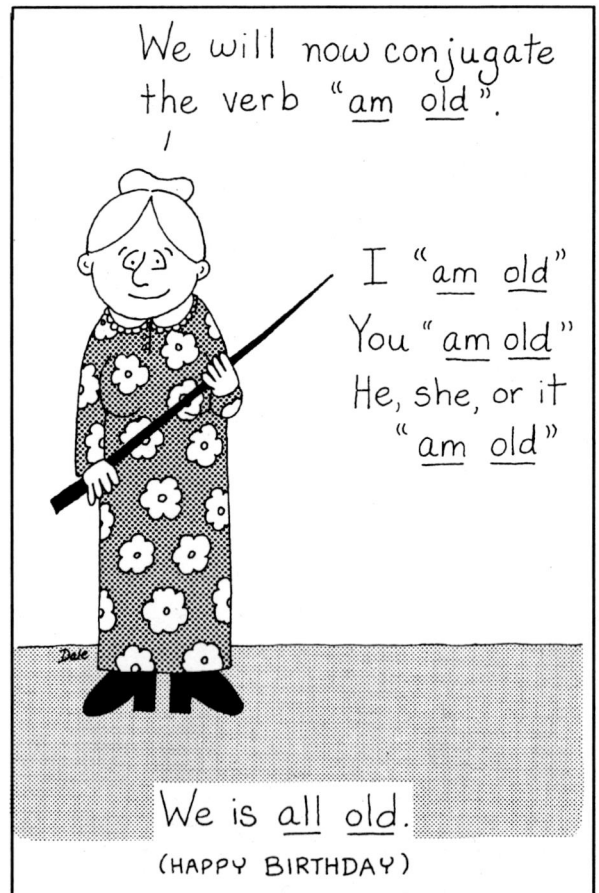

We will now conjugate the verb "am old".

I "am old"
You "am old"
He, she, or it "am old"

We is all old.

(HAPPY BIRTHDAY)

© Dale Ent., Inc.

Barbara Dale, writer/artist
Jim Dale, writer

246

I thought I was being funny, but the next day the art director, Wendell Sartain, told me not to sign Dean on any of those cards. "But I have always signed my cartoons Dean since I began cartooning in high school. I signed them Dean on the few occasions when AG let me sign them. Dean is MY logo."

"Yes, but it might look too much like Dale and get us sued," said Wendy. "Sign them Dean Norman, or Norman, or anything you want— except don't sign them Dean."

Barbara Dale sent me several of her early designs and two of them are in this book. I found out that Barbara wrote and drew some of her cards, Jim wrote many of them, and sometimes they collaborated on the writing. In addition to greeting cards Jim and Barbara collaborated on two cartoon books, *The Working Woman Book* and *Joys of Motherhood*. Since 1996 Barbara does all the writing and art for cards she produces for Recycled Paper Greetings and Smart Alex cards.

Most of the cards I drew for AG's new line named Paper Route used full color art so I was allowed to sign Dean on them. Hallmark and AG had not let staff artists and writers sign their work, because after all they were Mr. Hall's or Irving's cards. But RPP was proud to let people know that Boynton, Dale and others worked exclusively for them. Signed art work looked like it had more value, which is what we had been telling our bosses for many years. So now Hallmark and AG wanted staff artists to sign the new alternative humor cards.

The great new humor produced by RPP in the 1970s and 1980s brought back the lunch time shopping crowds at card shops. People crowded around the RPP rack to read cards, laugh, and buy more than they had meant to. When Hallmark and AG jumped into the field which was now called "alternative cards", I thought it was the start of a new era of experimentation and fun. I hoped AG would create a new department from the team that had written and drawn Paper Route, and we could continue to produce new cards that were really new. And I wanted to both write and draw cards again, which I had done very little since Hi Brows artists and writers were put into different departments. But AG was slow to reorganize, and then I was on

©Dale Ent., Inc. Barbara Dale, writer/artist

247

medical leave for six months with back pain.

When I was able to come back to work, the policy on suggestive humor had taken a strange turn. Years before I wrote a card that said, "I asked the clerk for some help in choosing a birthday gift for you, and she wanted to know if you are a senior citizen. And I said absolutely NOT ! Don't give me that humiliating, patronizing, insulting senior citizen stuff !!!...My friend is just an old fart!" This card sold well, and was in the racks when Mrs. Walgreen made some more complaints about suggestive humor in AG cards. So AG made up a list of words that would be forbidden to print. Most of the words were so awful that none of the writers would have thought about using them. "Fart" was on the list, too, so no more old fart jokes were published.

Then the pendulum swung the other way, and AG decided to use a lot of the forbidden words on the list. Perhaps because the senior citizen-old fart joke had sold so well, the word "fart" was actually requested from the writing staff. I was given a card to design that I had not written. A frog was jumping across a pond on lily pads with the word "fart" appearing at every jump. The original good selling card did not use the word to mean bad smelling gastric emissions, but all of the new fart jokes did mean this.

The swing to suggestive humor in alternative cards caused Sandra Boynton to stop producing greeting cards. First she objected to cards she called "mean spirited" and "raunchy" that were published by Recycled Paper, and wanted the company to only print the whimsical and gentle humor that was her forte. In effect she wanted to edit their entire line, and not surprisingly RPP wouldn't agree to that. For a while Sandra drew some cards for Portal Publications, but since 1995 she has stopped greeting card work and concentrated on children's books.

By 1990 I decided to pack it in and retire. I had suffered chronic back pain since 1975, and my last 15 years on the AG staff were very difficult. I had to avoid air conditioning by working in rooms with the vents and cracks stuffed with paper, and spent long periods each day lying on the floor. One time I was lying on the floor to stretch my back, and fell asleep. Other artists covered me with newspapers. A public tour came through, and the people had to step over my feet which extended

Caricature of Dean Norman by Jack Reilly

into a narrow aisle. The tour director tried to make jokes about it, but some people thought I might be dead and didn't find it amusing. Jack Reilly drew a caricature of me for my good-bye card that showed me drawing with a dripping ink pen while lying on my back. This wasn't possible, of course, but I really did a lot of writing while lying on my back, and sometimes drifted into a trance that might look like napping to people who passed by my desk. I knew my back would not hurt so much if I could exercise more, and stay out of cold buildings in the summer. Doctors diagnosed the problem as fibromyalgia, and said cold temperatures aggravated the condition. Some fibromyalgia sufferers feel pain if they just look at a picture of ice and snow.

With the burst of energy that comes with early retirement I started my own card company, Wolfpup Cards. The timing was not good. Few card stores wanted to try any new lines. As I think about the career moves I have made, I usually zigged when I should have zagged. Or I should have taken the advice that Rosie and I once wrote for a Hoohah birthday card, "It's your birthday! So don't just DO something.... STAND THERE!"

So I stopped squandering my savings and really retired. My back got better, I was married to a good woman (Maureen Farrell, Map Librarian at the Cleveland Public Library), and I created the thing I had always wanted to do... Wally's Woods, a comic strip that educates people about the value of nature. It doesn't cost much to put the cartoons on an Internet web site (www. geocities.com/*wallyswoods*), so I will run out of time before my savings run out. I am richer today than Mr. Hall or Irving ever were. Because I have all I want, but they always wanted more. I copied that line from one of my heroes, John Muir. He said it to multi-millionaire Edward Harriman about 100 years ago. It will still work 100 or more years from now. You can't beat the old best sellers.

A NICE THING ABOUT HAVING A BIRTHDAY IS....

DEAN

YOU GET PROMOTED TO THE NEXT AGE EVEN IF YOU DIDN'T LEARN NOTHIN' LAST YEAR !

© Wolfpup Cards Dean Norman, writer/artist

When Hallmark and AG began producing alternative humorous cards in 1987, it cut into the sales of their studio cards. Just as studio cards had drawn customers away from humorous cards in the 1950s. There was a brief struggle to improve studio cards. Tom Wilson organized a committee to improve the Hi Brows cards at AG. My back was hurting so badly at the time I declined the offer to be part of the committee. I just couldn't sit in meetings for long hours. But I made a suggestion. Coca Cola had produced the New Coke and discontinued their original flavor. When customers complained, Coca Cola brought back the old flavor and called it Original Formula Coke. I told Tom why not call the cards Original Formula Hi Brows, and go back to the original system of creating the cards. I meant have a small department of writers and artists working together, and publish all new jokes instead of reprinting old jokes.

Tom liked the slogan, but as it worked out Original Formula Funny Hi Brow Cards were mostly reprints of the old jokes from the 1960s. There was no reorganization to put writers and artists back together in a small department. In the early 1990s both Hallmark and AG gave up on their studio card lines, and concentrated on alternative cards. As I was collecting old cards to reproduce for this book, I heard that both companies might resurrect their studio card lines. If what they mean to do is reprint the old jokes and art with the Contemporary Cards and Hi Brows logos again, they will miss the target. What made studio cards popular and profitable was the process by which they were created.

First, the companies hired young writers and artists who had strong desires to create original humor in their own styles. Then they allowed these people to have fun while they worked, and published a lot of the experimental humor that was created. Give the artists and writers credit for creating the new funny greeting cards. Give the people who recruited them credit for finding new talent....Bob McCloskey at Hallmark...Tom Wilson, Ralph Shaffer and Bob Hawthorne at American Greetings.

Second, the immediate bosses of the writers and artists allowed the fun to happen in the studios. Bob McCloskey, boss of the Contemporary department at Hallmark...Tom Wilson and Ralph Shaffer, bosses of the Hi Brows department at American Greetings. The fun was often embarrassing and irritating to the bosses. It was intended to be. As Irving Stone once said, "Creative people are rebels."

And last, give credit to the CEOs of the companies who allowed the department bosses to allow the fun to happen. Joyce Hall was once asked, "How do you like Hallmark's Contemporary Cards?" His answer was, "I like the way they sell." He didn't laugh at many of the cards, he didn't like them, but he published them and he let the writers and artists have their fun. Irving Stone liked and laughed at the cards, and he allowed the Hi Brows bosses to allow their employees to have fun. It's not really such a hard thing to do, but it doesn't happen often at large or small companies.

Hallmark is now publishing a line of humorous cards called Expressions from Hallmark which includes many designs in the old studio card size and shape, so perhaps this is sort of a revival of their Contemporary Cards under a different name. And I found the "SEX" card redesigned in the AG line, but no crowd of laughing buyers at the rack. The store owner would have no reason to shout at an AG salesman, "Am I glad to see you. I need more SEX!"

While looking for old card art at AG, I met Brent Cottrell, an artist who had worked at Hallmark when Alan Denney retired in 1993. In 1959 Alan was the Art Director of Hallmark Contemporary department, and he was fired for drawing the Hoohah Giftniks. Alan was rehired by Hallmark on freelance contract in 1966, and in the 1980s he rejoined the Hallmark staff. Brent and others told me that Alan became sort of a father figure to many young artists. One young woman felt that Alan's advice helped her so much that she called him "not my real father, but my wonderful faux pax". Alan had created a lot of the fun in the original Contemporary department in the 1950s. When he retired in 1993, his co-workers organized a retirement party that topped anything that the Old Gang ever did. It shows that there is a new generation ready and able to have fun while they create funny greeting cards.

GOOD-BYE TO ALAN DENNEY by Brent Cottrell

Alan Denney's retirement party was the wildest thing to ever rock the hallowed halls of Hallmark. Everyone from Creative showed up to pack and overflow a fair sized conference room on the 9th floor. Someone made Alan a pair of fake-fur leopard skin boxer shorts which he put on over his pants. Another gift was a black rubber S & M harness. That, too, went on over his clothes. Hard rock music blared from a boom box, and the crowd danced so hard the whole floor vibrated. Word spread that Linda Smith, head of Creative Card Design, was concerned that the floor might collapse.

Alan added to his costume by tying helium balloons to his long gray hair which was normally pulled back into a pony tail. I've never seen anything funnier than Alan in his rubber harness, leopard skin shorts, helium balloons lifting strands of his hair, as he and a mob of artists gyrated to hard rock music.

When the party came to a close, Alan and his wife, Dodo, led a parade through the halls toward the corporate entrance. The crowd pumped their fists and chanted "Al-Lan! Al-Lan!" as they marched. Alan walked triumphantly in front as though he were Grand Marshal of a Thanksgiving Day parade, and waved grandly to the business people who poked their heads out of booths. Alan looked more like a conquering Caesar returning to Rome than an artist retiring from the greeting card business.

When the parade finally reached the corporate entrance, Alan climbed inside of his car and opened the sunroof to let the balloons tied to his hair flutter out above the roof. The crowd chased the car still chanting "Al-Lan! Al-Lan!", and a hand rose through the sun roof to wave as the car turned a corner and disappeared from sight.

That was the last time I saw Alan. He passed away about a year and a half later. His memorial service was a wonderful tribute to Alan's life, but many of us will always remember saying our good-byes on that day at Hallmark when we cut loose and gave our friend a proper send off.

Chapter 40: Hallmark Oldies

In the spring of 2002 my wife and I drove from Cleveland to Lake Arrowhead, California, for the fourth Hallmark Oldies reunion. We stopped in Kansas City to see Kathy Davis, the writer who had taught me how to rhyme and meter humorous verses when I was hired at Hallmark in 1956. Kathy told me that her writing buddy, Pat White, had changed from a devilish pixie to a serious Christian Scientist. Everyone lost touch with Pat as she became a missionary and traveled to foreign lands. We recalled many pranks Pat and Kathy had played to boost morale in the silent days of Editorial.

Hallmark Oldie
Lou Marak

Lou Marak, Larry Bowser, Thad Nugent and Jerry Roach met Maureen and I for lunch at a restaurant in Hallmark's shopping mall, Crown Center. Lou gave me the drawing shown here, and said it was his image of himself as a retired greeting card artist. Actually Lou is very busy painting, and his art sells for big bucks in Kansas City art galleries. Larry Bowser gave me some art for this book, and Thad and Jerry helped me recall stories about the old days at Hallmark.

As old geezers are prone to do, we recalled some of our favorite stories about the departed....Dick Noel in particular. One day Dick took a cottage cheese and peach salad in the Hallmark cafeteria, and asked the cashier, "Does this egg look all right to you?" The cashier said nothing and rang up the price of the salad. The next day Dick made a ball out of rubber cement and put it on a plate. It looked like a booger the size of a tennis ball. The cafeteria cashier hesitated a moment, and then charged him 75 cents for it. Dick never asked her what she thought it was.

The Hallmark cafeteria served good meals at reasonable prices, so even though we made fun of the selections we had no real complaints except that the coffee wasn't so good. One morning the cafeteria manager, Byron Byron (he really had two identical names), was enjoying a cup of coffee after the morning breakfast rush. A cafeteria worker exclaimed, "Mr. Byron, where did you get that cup of coffee?"

"From the cafeteria coffee urn, of course," he replied.

"That isn't coffee. It's cleaning fluid!"

Byron Byron was rushed to a hospital to have his stomach pumped, and he suffered no ill effects. The incident confirmed our complaints when the cafeteria manager couldn't taste the difference between the coffee and the coffee urn cleaning fluid.

The next day in Kansas City, Maureen and I lunched with Oliver and Sylvia Christianson. Oliver and Sylvia met and married while working at AG, and then moved to Kansas City in the mid 1980s to work for Hallmark. They both have good jobs at Hallmark today, but Oliver regrets that he didn't get into the card business until after the fun days of the early studios. The penalty of being born too late. On the other hand, greeting card cartooning gets more respect today. Since about 1990

the National Cartoonists Society has awarded a Reuben for Best Greeting Cards, and Oliver won the award for 2001. (A Reuben is a not a sandwich—it is a small statue designed by cartoonist Rube Goldberg.) The other nominees were Bill Brewer and Barbara Dale. Bill Brewer won the Reuben in 2000, and Oliver was nominated again in 2002.

After much camping and hiking in the Southwest, Maureen and I arrived at Lake Arrowhead for the three day reunion organized by Dodo Denney who lives nearby. Bill Cunningham told me a lot about Conrad Knickerbocker which made my chapter about Conrad much better. Bill also insisted that "Flock and Flitter" was correctly named "Flitter Flock Department", as he had to identify it in many issues of the Hallmark Noon News. But we always called it "Flock and Flitter" because that rhymed and metered better in our jests and songs.

Jan Coffman North helped Dodo organize the event, and filled me in on her days as Art Director for the TV shows *Laugh-In* and *Turn-On*. Carol Wimsatt Fuss told me how to find Mary Edith Smith Flynn, a wonderful writer at Hallmark who I had not been able to locate. Paul and Rosie Coker regaled us with their memories...we all took turns regaling.

Phil Hahn did some of the best regaling and composed a song for our last supper. Phil told more stories about the departed Hallmark Oldies. Bob Harr had once come to a party on Long Island where Phil's aunt lived. In the 1950s people didn't come out and declare their sexual preferences. Bob never dated a woman, and always lived with a male roommate, so we all figured he was homosexual. Phil, however, admitted to being naïve about it. "I just thought Bob was a neuter... someone not interested in sex. After the party there was a huge pile of dirty dishes in the kitchen when everyone went to bed. The next morning I woke up and saw Bob and his roommate in the kitchen, and all the dirty dishes were clean. This reminded me of the fairy tale where the little shoemaker would cut out pieces of leather in the evening, and in the morning would discover that someone had made them into shoes. So I announced, "Oh, look! The Fairies have washed the dishes!" Bob and his friend gave me burning stares, and someone explained it to me later."

Dick Stensrude and John Annarino had served on the same ship in the U.S. Navy in the 1950s, and they had both worked at Hallmark in the 1950s, but they met for the first time at this reunion. Maurice Nugent, a writing manager at Hallmark, was called up for a term of active duty in his capacity as a Commander in the Naval reserve. During this term Mo put on a play to entertain the sailors on his ship. John Annarino wrote some songs for the play. Dick Stensrude sang some of the songs when he acted in the play. They did not meet at that time, however. Mo told both John and Dick to get in touch if they ever wanted to work at Hallmark. John worked there in 1956 and Dick in 1957. At the reunion in 2002 John could not remember any words from the songs he wrote almost 50 years ago, but when Dick began singing one of them it triggered memories and they sang a duet.

As we sat in the lobby of the Lake Arrowhead Lodge on the last night, John regaled us with some of his experiences as an advertising writer. "A few years after I left Hallmark, I applied for a job with Doyle Dane Bernbach. I dumped all of my writing samples into a Rinso box, and figured the interviewer could just take pot luck and pick out as much as he wanted to see. The guy kept getting interrupted by phone calls, and was called away to a meeting. When he came back about 30 minutes later and saw me still sitting there he said, "If you've got this much patience, you're our man. You got the job." He didn't look at any of my samples.

"One of the agency's best TV commercials was the Paul Masson wine bit...We

Sell No Wine Before Its Time! Orson Wells had been up late partying the night before, and was sleeping off a hangover in a back room as we set up. When it was ready I said, "Hey, Orse! We're ready."

"He shook his head and said, "Oh no, it's out of the question. I can't possibly do it now."

"I said, "That's all right. We'll get somebody else."

"Orson was suddenly wide awake and said, "I'm ready!"

"When Orson was seated with the wine glass in hand, the director said, "Action!"

"Orson rubbed his head and mumbled, " Please don't say ACTION! Don't say anything at all."

"So the director wrote ACTION! on a slip of paper and handed it to Orson. He read it and smiled, and everything went smoothly after that.

"Our most fun was shooting commercials that involved animals. A man was supposed to crunch a potato chip and a flock of pigeons on a window ledge would fly away. He crunched the chip, and the animal wrangler pressed a button that gave the pigeons a mild electric shock. But they didn't fly. So he fired a gun, but the pigeons still didn't fly.

"Fire the gun again," said the director, but the wrangler said that wouldn't work because the pigeons had seen the gun and weren't afraid of it. The director got frustrated, picked up one pigeon and threw it at the others...they flew!

"Another time we had a jungle scene set up where Tarzan was going to swing down from the trees and rescue Jane from a ferocious lion. The lion was supposed to roar to prove that he was ferocious, but he ignored the wrangler's command to roar. I said, "The lion looks sleepy. Did you give him a sedative?"

"Well, yes, we gave him something, and maybe we gave him a little too.....but here's what will work. You go behind a bush and pee on a stick. Then wave the stick in front of the lion's nose."

"I peed on a stick, waved it in front of the lion, and he roared. I don't know why the wrangler didn't pee on a stick. I guess it had to be strange pee smell to inspire a roar."

On our way home Maureen and I stopped in Des Moines, Iowa, to visit Sam and Jeanne Van Meter. Jeanne is a bit younger than Sam and I, and she has to occasionally remind us that some of the stuff we recall "Is WAY before my time!" She recalls buying studio cards in the days when Sam and I were first creating them. She bought some she never sent, and particularly remembered the Agnes card created by Larry Raybourne. She was one of the buyers who had no one to send that card to, but she had to have it because it was so funny. After Jeanne married Sam she freelanced some greeting card ideas to Hallmark and American Greetings. Sam tried to help her, but his advice and sketches caused the Hallmark editor to tell Jeanne to send more work, but ignore her husband's suggestions. One verse she sold to Hallmark was printed many times with different art work. "Thinking of you brings out my basic instincts...I think I need a hug."

Sam made his living as a commercial artist, but enjoyed painting portraits the most. In his Kansas City days Sam set up a booth at the Plaza Art Fair with a sign reading, "Your likeness captured with a few deft strokes". He did quick sketches of customers for one dollar, hoping some of them would like the sketches so much they would commission a portrait.

"Right next to me was a guy doing the same thing", Sam recalled. "Before he started he smudged some charcoal on his forehead to make it look like he had been hard at work for a long time. He had very professional patter to amuse the

customers. It looked like I might not get many customers, but my mother was visiting and she shilled for me. Mom pretended to be a stranger, and became my first customer. Then she walked around near my booth showing the sketch I did, and telling people she had never seen such a nice drawing of herself. The other guy complained to the Fair Committee, and they moved him to another place on the grounds."

Sam particularly remembered one young customer. "A 12 year old girl sat for a sketch and then tried to pay me with a silver dollar. "This is the silver dollar my Grandma gave to me," she said.

"Oh, I can't take your Grandma's silver dollar," I told her. "Just come back next year for another sketch and bring paper dollars." The girl came back to the Art Fair three years in a row to have Sam capture her likeness with a few deft strokes.

Sam spent most of his time at Hallmark as a writer/sketcher in Editorial. In the brief time he was in the Contemporary department he created some nice studio cards. Rosemary Leitz-Smithson-Coker summed up Sam's contribution in the early days of studio cards when she said, "Sam was the funniest of us." She meant not only was his writing and art good, but he was such a master story teller. A simple thing like having his car run out of gas would become an epic comic narrative when Sam told it. Or his description of Russell Myers smoking a cigar: "Russell bought cheap cigars by the box. They had so many leaks in the outer tobacco wrapper that he had to play them like a flute when he smoked them."

I was planning to visit Sam again on the way to the Hallmark Oldies 2003 reunion in Coos Bay, Oregon, when I received an unhappy phone call from Jeanne Van Meter. I passed her news along in an email to many Hallmark Oldies.

"Sam Van Meter died in his sleep Saturday night, May 24, 2003. I visited Sam several times in the past few years, and he always prepared a sumptuous feast. It reminded me of a feast he prepared for some Kansas City friends in the 1950s. Sam cooked a dish called "bouef au vin". As guests arrived he served martinis and regaled them with funny stories. Then he checked in the oven and found that the "bouef" was overdone.

"So Sam mixed another pitcher of Martinis, and announced, "I'm sorry, but the bouef will have to cook for another hour. Everyone have another martini!" When he finally served the bouef it was mush, but everyone was so hungry and intoxicated they pronounced it magnificent. We will miss Sam and his stories."

Many people replied with more Sam stories, and I think Jim Bray summed up our feelings the best. "Aw, hell, what a loss. I can still hear Sam telling some weird story to Jimmie....damn!....sleep well, Sam."

As a final tribute I will end this book with one Sam's best Contemporary cards. Great cartoons use as few words as possible, and tell the story with just a few deft strokes.

Sam Van Meter
writer/artist

Front: Dean Norman, Bob McCloskey, Jan Coffman, Lou Marak, Dick Noel,
　　　Larry Bowser, George Hackney.
Middle: Alan Denney, Phil Hahn, Jimmie Fitzgerald, Sam Van Meter, Carol Fuss.
Back: Jerry Roach, Rosie Coker, Paul Coker, John Annarino.

Sam

HALLMARK OLDIES
REUNION 1987

Hoohah Studio
Rosie, Alan &
Dean

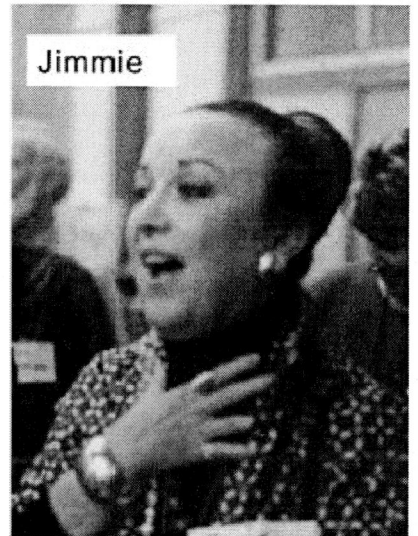

Jimmie

Fancy Free
Cartoonists:
George
& Paul

New Boys: Lou & Dick

STUDIO CARD COLLECTIBLES
by Maureen Farrell Norman

While researching this book, Dean and I found that collections of studio or contemporary cards and associated products such as books, posters and figures were difficult to locate. Are the aging youth of the 1950's and 1960's who once comprised the major audience for studio cards feeling nostalgic? Will their demand (or demise) make these items a new collectible? Hard to say.

Studio cards were produced in great numbers following phenomenal success in the 1950s. In 1962, Hallmark reported that each week "around 5 1/2 million greeting cards in this style and spirit are mailed to people everywhere in the United States." Between 1957 and 1962, Hallmark alone created more than 6,000 designs. By 1971, 15% of Hallmark's total volume was in Contemporary cards. So there should be no shortage of fodder for collectors.

But how many studio cards are left? No one knows. Many people we talked to confessed to having favorites framed, squirreled away in dresser drawers or buried in boxes in their attics. The cards were just too funny to throw away. Some writers and artists saved samples of their own work and the work of those they particularly admired. The number of companies ranged from a handful in the late 1940's to over 125 companies producing everyday studio cards in the 1960s. Many companies have since disappeared or been absorbed by Hallmark or American Greetings. During the 1980s some companies computerized their card files, but often did not go back as far as the 1950s and 60s. Sometimes only the text was stored electronically. Companies may still retain the original cards or artwork in their vaults and storage areas, but access is difficult even for insiders.

Other than *The Very Best from Hallmark* (which reproduces some early studio cards), standard histories of the greeting card industry are short on information and illustrations of studio cards. Two compilations of studio cards were published in the early 1960's, *Burn This* and *Greetings Dearie*. Both can still be purchased on the used book market. *Burn This* displays Box Cards' cool, sparse, Beat and anti-establishment cards, complete with an introduction by satirist Mort Sahl. *Greetings Dearie*, published by Hallmark Cards, is milder but showcases work by some of studio's finest artists.

As a genre studio cards don't seem to have garnered widespread recognition from paper and ephemera collectors. *Warmans Guide to Paper Collectibles* lists no studio cards and indicates that greeting card collectors have not organized the way other collecting groups have. However, Robert Reed in his *Paper Collectibles: The Essential Buyers Guide* (1995) specifically mentions greeting cards in his section on "Future Paper Collectibles". He refers to greeting cards (especially Hallmark) among collectibles which have a potential future but not much of a past, no single price guide, and few articles on the subject. He maintains that "fancy lace valentines from the turn of the century have long been popular, but the much more colorful comic valentines of the 1940s, 1950s and 1960s are still waiting to be discovered." The situation does not seem to have changed much since 1995. We could not locate any published price guides or collecting handbooks for studio cards.

Studio cards may be found at garage sales, thrift shops, flea markets or antique malls, but many people considered them worthless and have thrown them out. Locating the cards on eBay and other Web auction sites can be complex and time-consuming as there are so many companies involved. Cards are generally sold

in lots and listed under "vintage greeting cards". Most of the artwork and writing is unsigned and often the cards carry no copyright date. Only occasionally are cards listed by artist. Prices are often less than $1.00 per card, although the recent winning bid for a late 1960s Hallmark Contemporary card with an attachment (a metal smiley button) reached $32.00 on eBay.

General guidelines for collecting greeting cards could be applied:

1. **Early or scarce examples**.
 Studio cards seem to have appeared in the mid to late 1940s. (William Steig claims to have originated them, Panda Prints is also given credit) Most studio cards are a distinctive shape (approx. 9" x 4") designed to fit a #10 business envelope but many companies also produced other sizes. The defining criteria for studio cards is their unconventional artwork and humor.
 Many cards lack copyright dates but logos and prices ($.25 for early cards) changed over time and may be helpful in determining dates of publication. In general, the earlier the better.
 Panda Prints, *Citation*, *Bernad Creations* (William Steig and Herb Gardner), and *Box Cards* are among the better known early lines, produced before major companies got into the act.
 Some card lines had very short initial runs. Bill Box first produced *Bop Cards*. Nellie Caroll originally had her own line of *Nellie Cards*. Hallmark's first studio cards were issued under the name Fancy Free but were renamed Contemporary Cards after the first year and a half. The variety of names can be confusing. Large companies had different lines for different store accounts, one for card & gift shops, another for drugstores. American Greetings used *Hi Brows*, *Laff Lines* (Laurel), and *Jester* (Forget Me Not) while Hallmark used *Contemporary* in their regular as well as in their Ambassador line.
 Promotions also might have line names. American Greetings *Zonk* cards produced in 1971-72, bombed despite some designs by Robert Crumb.

2. **Condition matters**.
 Are cards clean? Paper stock not yellowed or faded?
 Are colors still bright? In general studio cards were distinct from conventional cards in their use of brighter colors. However, some of the earliest such as Box, Nellie, & Bernad's Nebbishes were stark black & white, others used just a spot of color. In the 1960s intense colors and op art mirrored the psychedelic movement.
 Is there an original envelope with the card? Is it unused or does it bear a postmark to help determine date?

3. **Signed artwork or distinctive styles of well known cartoonists**.
 Most early companies used signed artwork. Look for signatures such as Steig, Welcher, Herb Gardner, WM Box, Nellie. Later, many companies forbade signatures, but clever artists such as Don Branham sometimes worked one in.

Studio card artists such as Paul Coker, Alan Denney, Bob Harr, Don Branham, Ann Leaf and Robert Crumb had very distinct art or lettering styles. A word of caution, successful styles were often imitated. Companies even employed ghost artists to do touch-up work or mimic successful styles.

4. **Landmark cards, bestsellers, or cards used in illustrating articles about studio cards**.

Some have been mentioned or reproduced in this book. Some focus on sentiments, others artwork, but the great ones feature just the right combination of gag and artwork. As studio cards became more popular, some companies imitated the tall, slim format in an attempt to cash in on the craze but continued to use conventional art and mild humor.

Genuine studio cards have snappy, unexpected or even sarcastic or outrageous sentiments. They include such classics as Steig's "people are no damn good", Herb Gardner's "next week we've got to get organized", Branham's "top hat" card, Coker's "lonely social outcast" and "keep smiling", Tom Wilson's "green stamps" (later redrawn by Barbara Brown), and Larry Raybourne's "Agnes" card.

5. **Occasion or theme**.

Many collectors favor certain holidays. Halloween, Valentines and Christmas are the most sought after conventional greeting cards. This may hold true for studio cards also.

Recently, the opening bid on a lot of 5 Halloween studios was set at $9.99. But a Contemporary Halloween mechanical, signed "Cochran" complete with a pull-out casket went unsold at $9.95.

Since studios cards introduced the non-occasion card to the industry (such as "Keep Smiling", "Happy Tax Day", "Happy Monday" etc.) these may be collectible as well.

Collecting could also emphasize subjects, genres or themes such as animals, women, Beatnik, psychedelic.

6. **Unusual formats**.

Most studio cards fit the distinct 9" x 4" format (to fit the #10 business envelope).

Oversize cards like "Fuzzy Friends" were very popular despite the $1 price.

Foldouts (such as the Kuchera fold) and mechanicals such as pop-ups, springs, pull tabs, and cards using enclosures and attachments such as buttons or feathers, can be difficult to locate in complete, working condition.

Associated products Some companies spun off or licensed their popular designs for everything from cocktail napkins, ashtrays, and molded figures to posters and stationery.

Steig's characters and Gardner's Nebbishes were among the first to appear on a variety of merchandise. Recently Nebbish items were offered at prices ranging from $6.50 for a mug to $50.00 for a figure.

Box produced school supplies as well as a Smokey the Bear ashtray. Hoohah Studio first designed boxed gag gifts in the shape of a studio card and called them Giftniks.

Books Some of the better known studio artists and writers created small, hardbound books which had a greeting inside the front cover and could be mailed instead of a card or gift. These are often easier than cards to locate in used book stores, antique malls, and on auction sites. Rosalind Welcher's Panda Prints produced small books in the 1960s. Hoohah Studios' *Hello World* is a baby book with attitude.

American Greetings' *Hi Brow Funny Books* were introduced in a 6 1/4 x 6 1/4 inch format in 1967 and included work by cartoonists Johnny Hart and Tom Wilson. A then unnamed *Ziggy* made his first appearance in *When You're Not Around*. AG later went to a smaller format, *The Sunbeam Library,* of which only a small number were the work of the Hi Brows dept.

Other major companies followed the book trend, including Hallmark with their *Thoughtfulness Library* priced at $1 and measuring approximately 5 1/4 by 4 inches.

Other collectible books include Box Card's *Burn This*, Hallmark's *Greetings Dearie,* and from American Greetings, the Gibbons/Crumb *Sad Book* and Clements/Henrich *The Moon on $5.00 a Day*.

7. **Promotional and advertising materials**

 Displays, and signs from card stores were often oversize and colorful.

8. **Celebrity cards**

 Signed by (or sent to) well-known people such as the Eisenhowers' 1958 Christmas card.

 Artists' or writers' personal greeting cards such as Paul Coker's annual Christmas card.

SOME SOURCES OF INFORMATION:

Gift and Art Buyer-later called *Gift and Decorative Accessories*
Greeting Card Magazine (1960 -) later *Greetings Magazine*

We have concentrated on identifying the best from the companies we know the best: Bernad Creations, Panda Prints, Box Cards, Nellie Cards, American Greetings and Hallmark. But there is a large, unexplored world of studio cards out there. Good hunting! You may not make money but we hope you have half the fun we had looking for examples of studio cards to illustrate this book.

1940s...First studio cards published about 1945. Panda Prints may have been first to publish humorous studio cards in 1947.

1955...List of studio card publishers

Affectionately Yours Greetings
B. A. Chestney
Barker Greeting Card Co.
Bergo-Marvin Inc
Bernad Creations Ltd.
Box Cards
Bradlee Publishers
Bresillo's Inc.
Cardstone Greetings Inc.
Carrol (Carol?) Cards
Citation Cards Inc.
Coolidge Cards
Country Cousin
Crestwick Inc.
D. Forer & Co.
De Mael
Dolphin Designs
Edna Markoe Inc
Encores Inc. (div. of Williamsburg)
Ganeles Hebrew Cards
Gibson Art Co.
Grant Publishing Corp.
Gulf Coast Card Co.
Hand Print Cards Inc.
Hart Vance Company
Inkweed Studios
Jane Jarvis Co.
Kard Kraft
Katydid Cards
Klein's Card Lines
Krazy Kards
Mantice Greetings Inc.
Margit Cards
Millner Card Co.
Murab Co.
Norman Brenner
Nile Running Studio
Norse Co.
Oz Corporation
Pamela Paul Designs
Panda Prints
Pasadena Prints
Paul MacWaugh Associates
Perita Handprints
Philip Stahl

Printed Products Co.
Ransier Studio Cards
Red Farm Studio Inc.
Red Stable Studio
Reed Starline Card Co.
Rex Handprints
Saya Studio
Servo Sales Co.
Sherman Originals
Shosha Cards
Soriano Greetings
Sterling Greetings Inc.
Sue & Larry Cards
Tanylor Greeting Cards
Tessier Studio
Vasari Inc.
Volland (P. F. Volland Company)
Wapiti Prints
Williamsburg Publishing Co.
Workshop Cards Corp

List compiled from *Gift & Art Buyers Directory* 1955-1956, & *The Romance of Greeting Cards* by Ernest Dudley Chase 1956.

1956...Major card companies (Hallmark, American Greetings, Rust Craft, Norcross and Gibson) began publishing studio cards.

1968...List of studio card publishers

4 Season Cards
Alkor Sales Co.
All In Fun Inc.
Allied Greeting Cards Inc.
Amberly Greeting Card Co.
American Greetings Corp.
American Publishing Corp.
Arcadia Greeting Card Co.
Arnold Goldman Enterprises
Artistic Greetings Inc.
B & B Dist Co.
Balladetta Cards
Barker Greeting Card Co.
Beaucard Publishing Co.
Braunstein's Card Co.
Buzza-Cardozo Greeting Card Co.

1968...List of studio card publishers cont'd

C. M. Paula Co., The
Carousel Greeting Cards Inc.
CCC Inc.
Central Card Co.
Charmcraft Publishers Inc.
Cincinnati Card Co.
Clark Sales
Cookcoo Designs
Crystal Greetings Inc.
Curtis Circulation Co.
Custom Card Co.
Custom-House Card Co.
D. Forer & Co. Inc.
Dave Packard Studio Inc.
Del Norte Inc.
Deluxe Greeting Card Co.
Dexter Press Inc.
Dubl'-Take Greetings
Editions Limited
E-Z Card Service
F/S Distributors
Flair Cards Inc.
Fran Mar Greeting Cards Ltd.
Friendly Card Co. inc.
Friendly Greetings
Funco Sales
Gallant Greetings Corp.
Gibson Greeting Cards Inc.
Hallmark Cards Inc.
Happiness Inc.
Harrison Publishing Co.
Harvest Greeting Card Co.
Hebrew Publishing Co.
Hinz Publishing Co.
Holiday Publishing Co. Inc.
Houze Glass Corp
House of Cards
House of Oz Inc.
Hylytes
IMP Press
International Greetings Co.
Irene & George Arndt
J & D Distributors
J. S. Schilling Co. Inc.
Jacob Liberman
John M. Towle Co.
Jones Nelson Publishers
Kahnay Enterprises
Keep 'n Touch Greeting Cards Inc.
Kelley Galleries
Keystone Publishing Co. Inc.
La Com & Associates
Laff Masters Studios Inc.

Laf-Mor Studios Inc.
Langton Creations Inc.
Lerner Industries Inc.
M & T Sales Co.
Marhil Art Studio Co.
Marjo Press, The
Metropolitan Greetings Inc.
Mexicard Greeting Cards
Middaugh Printers
Millner Cards Inc.
Moderne Card Co. Inc.
Mr. B Greeting Card Co.
Mudnest Originals
Muriel Greeting Cards
Nationwide Greeting Cards
Nile Running Studio Inc.
Palmer Card & Gift Shop
Paramount Line Inc.
Philip Stahl Co.
Pleasant Thoughts Greeting Cards
Reed Starline Card Co.
Regal Greeting Card Co.
Regency Prod Co.
Reyton Card Co.
Richman Sales Co.
Roger H. Roseland & Co.
Roth Greeting Cards
Rust Craft Greeting Cards Inc.
S. J. Ruedenauer
S. L. Stokes Inc.
Sangamon
Sholom Greeting Card Co. Inc.
Shosha Cards
Southtex Distributors
Stewart Sales Co.
Studio 66 Ltd.
Success Greeting Card Co. Inc.
Sunshine Sales
Three B's Ltd
Treasure Greetings
Tri-Way Publications
Troubador Press
United Card Co.
United Sales Co.
Vagabond Creations
Variety Distributors
Vaughn Cards of California
Whit Sales Co.
Willowood Cards
Winco Distributors
Wish Greeting Cards Inc.
Yankee Artists Inc.
Yols Card Co.

List compiled from *Greeting Card Magazine* 1968 Directory issue.

1970s...Studio card sales declined as customers began buying Soft Touch prose and alternative humor greeting cards.

1987...Hallmark and American Greetings began publishing alternative humor cards.

1990s...Hallmark and American Greetings stopped publishing studio cards in early 1990s.

2003...Studio card publishers Amberley Greeting Card From *Gifts & Decorative Accessories Buyers Directory,* 2002-2003

The lists found in directories are incomplete and sometimes inaccurate. Some of the companies listed may have been distributors and not publishers of cards. And some publishers did not bother to get their companies listed in the studio cards category.

lower the mistletoe cause I'm a little short this year

don't you be caught short
•
send for FREE sample brochure
•
box cards
949 n. fairfax los angeles 46, calif.

Ad in The Gift and Art Buyers Directory, 1955-56

COLLECTIONS OF STUDIO CARDS

Box Cards Inc. *Burn This*. New York: Bernard Geis Associates (distributed by Random House), 1960. (cards c1955-1960, with an introduction by Mort Sahl c1960) [includes cards signed by Bill Box, Nellie Caroll, Harry Crane, Bill Brewer, Bob Guccione and Jerry Lee]

Hallmark Cards Inc. *Greetings Dearie! A Connoisseur's Collection of Humor from Hallmark Contemporary Cards*. Garden City, NY: Doubleday and Company, 1962. [cover and chapter headings by Don Branham, otherwise artwork is unsigned]

BOOKS

Barr, June. *Writing and Selling Greeting Card Verse*. Boston: The Writer, 1958. *Writing and Selling Greeting Card Verse*. Boston: The Writer, 1966. [include lists of companies soliciting freelance writing for studio cards]

Chase, Ernest Dudley. *The Romance of Greeting Cards*. (revised edition) Dedham, Mass.: Rust Craft Publishers, 1956. ("In Commemoration of the Fiftieth Anniversary of Rust Craft Greeting Cards 1906 - 1956")

Clements, Jack. *The Moon on $5.00 a Day*. Cleveland: American Greetings, 1969. [illustrated by Dan Henrich, designed by Ralph Shaffer]

Crumb, Robert. *The Complete Crumb Comics*. Gary Groth, ed. Seattle: Fantagraphics Books, vol. 3 (third ed.) 1999, vol. 12, 1997.

Your Vigor for Life Appalls Me: Robert Crumb Letters 1958-1977. Ilse Thompson ed. Seattle: Fantagraphics Books, 1998.

Denney, Alan and Lou Marak, Dean Norman, Rosemary Smithson. *Hello World... The Story of My Life (So Far)*. St. Paul, Minn.: Brown & Bigelow, 1965.

Evanier, Mark. *Mad Art—A Visual Celebration of the Art of Mad Magazine and the Idiots Who Created It*. New York: Watson-Guptill Publications, 2002.

Evarts, Susan. *The Art and Craft of Greeting Cards*. Westport, Conn.: North Light, 1975. [Chapter 9, Wilson, Roy. "*Studio Cards*" 148-155]

Fink, Joanne. *Greeting Card Design*. Glen Cove, New York: PBC International, 1992. [updates the histories of major companies]

Fixman, Adeline. *Aim for a Job in Cartooning*. New York: Richard Rosen Press, 1976.

Gardner, Herb. *A Piece of the Action*. New York: Simon & Schuster, 1958.

Goeller, Carl. *Selling Poetry, Verse, and Prose: A Guide to Greeting Card and Magazine Markets*. Garden City, New York: Doubleday, 1962. (drawings by Jan Coffman) *Selling Poetry, Verse, and Prose: A Guide to Greeting Card and Magazine Markets*. (2nd edition) Boston: The Writer, 1967. (drawings by Jan Coffman)

Writing and Selling Greeting Cards. Boston: The Writer Inc., 1980.

Hall, Joyce C. (with Curtiss Anderson.) *When You Care Enough*. Kansas City: Hallmark, 1992.

Hardt, Lorraine. *How To Make Money Writing Greeting Cards*. New York: Frederick Fell, 1968.

Hohman, Edward J. and Norma E. Leary. *The Greeting Card Handbook: What to Write, How to Write and Where To Sell It*. New York: Barnes and Noble Books, 1981. [Chapter 6 "Studio Cards—Good Fun and Good Money!"]

Lorenz, Lee. *The World of William Steig*. New York: Artisan, 1998.

MacKenzie, Gordon. *Orbiting the Giant Hairball: A Corporate Fool's Guide to Surviving with Grace*. Shawnee Mission, Kansas: OpusPocus Publishing, 1996; New York: Viking, 1998.

Moore, Karen Ann. *You Can Write Greeting Cards*. Cincinnati: Writer's Digest Books, 1999.

Sandman, Larry. (Ed.) *A Guide to Greeting Card Writing*. Cincinnati: Writer's Digest Books, 1980. [contributors include Dick Lorenz and Bob Hammerquist]

Seeley, Mary Evans. *Seasons Greetings From the White House*. New York: MasterMedia, 1996.

Stearn, Ellen Stock. *The Very Best from Hallmark: Greeting Cards Through the Years*. New York: Abrams, 1988.

Walker, Mort. *Mort Walker's Private Scrapbook: Celebrating a Life of Love and Laughter*. Kansas City: Andrews McMeel, 2000.

Wigand, Molly. *How to Write & Sell Greeting Cards, Bumper Stickers, T-Shirts and Other Fun Stuff*. Cincinnati: Writer's Digest Books, 1999.

ARTICLES

"About William Steig" and "Steig at 80" (*http://www.williamsteig.com* (June 5,, 2003, Oct. 27, 2003).

"American Greetings Founder Nears Century Mark" *AG News* Special Issue, August 1984.

American Greetings Corp. "*Annual Reports*" 1953, 1954, 1957, 1958.

"Attitudes Toward Drinking Conveyed in Studio Greeting Cards" *American Journal of Public Health* August 1980, p.826-829.

Bach, Deborah. "The Crumbs Are Alike in Their Different Ways" *New York Times* July 7, 2002, p. 31 AR.

Bassett, Ada. "Humorous Greeting Cards and the Free-Lance Writer" *The Writer* December 1960, p.19-22, 37.

Boxer, Sarah. "William Steig, 95, Dies; Tough Youths and Jealous Satyrs Scowled in His Cartoons" *New York Times* (Late Ed. East Coast) Oct. 5, 2003, p.39

"Box's Funny Valentines" *Fortune* July 1956, p. 145. [Box Cards]

"Employees Help Founder Celebrate Centennial" *AG News* Oct. 12, 1984.

"Facts About William Box, William Kennedy and the Provocative, Impudent Box Cards. Free Enterprise Still Alive in the United States." Extension of the Remarks of the Hon. Gordon L. McDonough of California in the House of Representatives Wednesday, April 30, 1958. *Congressional Record* Appendix 1958, p. A3931.

Farney, Dennis. "Inside Hallmark's Love Machine" *Wall Street Journal* Feb. 14, 1990, p.6B.

"Flitter, Flocking, Bump-up and Goop" *Harper's Magazine* Dec. 1950, p.98-100.

"Founder Sees Company Grow for 80 Years" *AG News* Oct. 10, 1986.

Freedgood, Seymour. "Joyce Hall is Thinking of You" *Fortune* December 1958, p.93-97, 194-195, 198.

"Freud Pays Off" *Fortune* Feb. 1947, p. 132, 134. [the "psychology" of greeting cards]

Gleisser, Marcus. "Greetings American Style for Jacob Sapirstein at 100" *Plain Dealer Magazine*, Oct 21, 1994, p.24, 29-30.

Goeller, Carl. "The Greeting Card Market Today" *The Writer* March 1963, p.28-30.

"The Greeting Card King: Joyce Clyde Hall" *Time* Nov. 30, 1959, p. 88.

"The Greeting Card Verse Market" *The Writer*, December, 1959, p. 26-29.

"Greetings" *Commonweal* July 26, 1957, p.414.
 [an editorial on "tasteless and obscene" greeting cards]

"Greetings" *The New Yorker* June 20, 1964, p.26-27.

"Greetings With a Dig" *Business Week* Oct. 26, 1968, p. 154. [political cards]

"Greetings You ... 'Bum' " *Newsweek* Feb. 16, 1959, p.82

Hanrahan, Jack. "Confessions of the Cleveland Joke" *Cleveland Magazine*, Feb. 2002, p.52-55

"Hearts and Darts for Far-Aparts" *Time*, Nov. 18, 1966, p.108.

"Hearts and Profits" *Newsweek*, Feb. 18, 1957, p.88-89.

Hockaday, Laura R. "Look in on...Kansas City People" (column) *Kansas City Star*, May 1987 [Hallmark Oldies reunion]

"How the No. 2 Greeter is Playing Its Cards" *Business Week* Feb. 13, 1965, p.154, 156-158. [American Greetings]

Howard, Jane. "He Cares Enough. Close-up Joyce Hall, Greeting-Card King" *Life*, Dec. 6, 1968, p. 53-59.

Hyams, Joe. "Greeting Cards with No Inhibitions" *Saturday Evening Post* Oct. 25, 1958, p.24-25, 124-126.

Johnson, Fridolf. "Sincerest Wishes! For Artists Interested in Designing Greeting Cards" *American Artist*, September, 1958, p.41-45

Kalinoski, Pam. "American Greetings" *Cartoonist Profiles*, Sept. 1992, p.58-65.

Knickerbocker, Conrad. "[Rosemary Leitz and Contemporary]" *Crown Magazine*, May-June 1958.

Lavoie, Denise. "Here's Looking at Ewe, Sandra" *South Coast Today* New Bedford Standard-Times *http://www.s-t.com/daily/03-96/03-03-96/1boynton.htm* (March 3, 1996).

Leedham, Charles. "Five Billion Greetings Yearly" *New York Times Magazine*, April 3, 1960, p.44, 46, 48, 51, 53.

"Light Slams" *New Yorker* June 7, 1958, p. 27-28. [Barker Card Company]

"Lyle Metzdorf" [obit] *The Examiner* Independence [Mo.] The Examiner Obituaries *http://www.examiner.net/stories/022602/obi.022602017.shtml* [March 3, 2003]

"Marv Honig, An Ad Talent is Dead at 66" [obit] *New York Times* [East Coast Late Ed.] April 6, 2002, p. A16.

Muhlen, Norbert. "The Canned-Emotion Industry" *America* Jan. 10, 1959, p.426-427.

National Cartoonists Society. "2001 Reuben and NCS Award Nominees" *NCS http://www.reuben.org/2002/greetingcard.asp* (May 29, 2002). [profiles Bill,Brewer, Barbara Dale & Oliver Christianson]

"Pearls, Sequins and Black Net" *Fortune* Dec. 1954, p. 194. [Citation Cards]

Pogrebin, Abigail. "Hippos and Chickens and Pigs—Oh, My!" *Good Housekeeping* Nov. 2002, p.101. [Sandra Boynton]

Rowland, Norm. "Being Funny is Serious Business at Contemporary: Flashback" *Crown Magazine* May-June 1977, p. 14-17.

Sanford, Robert K. "City Gains Spot in Humor Industry" *Kansas City Times* Jan. 11, 1962, p. 47. [Hoohah Studio]

Schrift, Melissa. "Icons of Feminity in Studio Cards: Women, Communication and Identity" *Journal of Popular Culture*, Summer 1994, p. 111+.

"Studio Cards Star as Gallant Hits 25 Years" *Greetings Magazine* August 1991, p. 21.

"There Really is a Wolfpup" *Greetings Magazine*, May 1991, p. 53

Todd, Richard. "We Have Several Tons of Excess Sequins - the Hallmark Process" *Audience* March-April 1971, p. 4-11.

U.S. Patent & Trademark Office. *Trademark Filings, Class 038 Greeting Cards*. Trademark Electronic Search System *http://tess2.uspto.gov*

Weiss, Morry. "American Greetings Corporation" *Newcomen Society of North America Publication* No. 1164, 1982. [Speech given Oct. 28, 1981]

"What's Wrong With These Studio Card Ideas?" *Writer's Digest* Oct. 1968, p. 30-33, 95. [includes Bob Hammerquist. "A Pro Who Learned These Rules Comments" p. 32.]

"Ziggy at 25" *Cartoonist Profiles* Dec. 1996, p. 40-47.

NAME INDEX

italics = photo/caricature of...
bold = writing/art created by...

ISBN 141201700-9

9 781412 017008